U0360309

当代英美文学系列教程

总主编 尚必武

当代英国戏剧教程

主编 陈红薇

上海交通大学出版社
SHANGHAI JIAO TONG UNIVERSITY PRESS

内容提要

　　本书为"当代英美文学系列教程"之一。本书聚焦第二次世界大战后英国戏剧发展三次浪潮中的九位剧作家,通过对剧作家及其作品的介绍与评述,呈现当代英国戏剧的戏剧美学及时代思想。本书具备以下特点:① 注重当代英国戏剧的发展,突出其发展的阶段性及其特征;② 注重对单个剧作家的全面把握,突出每个剧作家的特点和风格;③ 在编写内容上不仅注重剧作家及作品的介绍,也注重对两者的评述;④ 在参考书目上,突出各个阶段研究书目的代表性和前沿性。本书可作为高等院校英语专业本科生和研究生的教材,也可供爱好英国文学和戏剧的读者使用。

图书在版编目(CIP)数据

　　当代英国戏剧教程／陈红薇主编. —上海:上海
交通大学出版社,2024.5
　　当代英美文学系列教程／尚必武总主编
　　ISBN 978 - 7 - 313 - 29853 - 9

　　Ⅰ.①当… Ⅱ.①陈… Ⅲ.①戏剧研究-英国-现代
-高等学校-教材 Ⅳ.①J805.561

　　中国国家版本馆 CIP 数据核字(2023)第 216189 号

当代英国戏剧教程
DANGDAI YINGGUO XIJU JIAOCHENG

主　　编:陈红薇
出版发行:上海交通大学出版社　　　　　地　　址:上海市番禺路 951 号
邮政编码:200030　　　　　　　　　　电　　话:021 - 64071208
印　　制:上海万卷印刷股份有限公司　　经　　销:全国新华书店
开　　本:889 mm×1194 mm　1/16　　印　　张:15.25
字　　数:382 千字
版　　次:2024 年 5 月第 1 版　　　　　印　　次:2024 年 5 月第 1 次印刷
书　　号:ISBN 978 - 7 - 313 - 29853 - 9
定　　价:68.00 元

本书系北京科技大学"十四五"校级规划教材，也是教育部首批新文科研究与改革实践项目"理工科高校外语'新文科'课程体系与教材体系建设探索"（编号 20210700112）成果之一。

本书的编撰得到了北京科技大学研究生院教材建设项目的支持。

2012 年，国务院学位委员会第六届学科评议组在外国语言文学一级学科目录下设置了五大方向，即外国文学、语言学与应用语言学、翻译学、国别与区域研究、比较文学与跨文化研究。2020 年起，教育部开始大力推进"新文科"建设，不仅发布了《新文科建设宣言》，还设立了"新文科研究与改革实践项目"，旨在进一步打破学科壁垒，促进学科的交叉融合，提升文科建设的内涵与质量。在这种背景下，外语研究生教育既迎来了机遇，同时又面临新的挑战，这就要求我们的研究生培养模式为适应这些变化而进行必要的改革与创新。在孙益、陈露茜、王晨看来，"研究生教育方针、教育路线的贯彻执行，研究生教育体制改革和教育思想的革新，研究生专业培养方案、培养计划的制定，研究生教学内容和教学方法的改革，最终都会反映和落实到研究生教材的建设上来。重视研究生教材建设工作，是提高高校研究生教学质量和保证教学改革成效的关键所在"。① 从这种意义上说，教材建设是提高外语研究生教育的一个重要抓手。

就国内外语专业研究生教材而言，上海外语教育出版社推出的《高等院校英语语言文学专业研究生系列教材》占据了主要地位。该系列涵盖语言学、语言教学、文学理论、原著选读等多个领域，为我国的外语研究生培养做出了重要贡献。需要指出的是，同外语专业本科生教材建设相比，外语专业研究生教材建设显得明显滞后。很多高校的外语专业研究生课堂上所使用的教材基本上是原版引进教材或教师自编讲义。我们知道，"教材不仅是教师进行教学的基本工具，而且是学生获取知识、培养能力的重要手段。研究生教材是直接体现高等院校研究生教学内容和教学方法的知识载体，也是反映高等院校教学水平、科研水平及其成果的重要标志，优秀的研究生教材是提高研究生教学质量的重要保证"。② 上海交通大学外国语学院历来重视教材建设，曾主编《研究生英语教程》《多维教程》《新视野大学英语》《21 世纪大学英语》等多套本科和研究生层次的英语教材，在全国范围内产生了较大影响。

① 孙益、陈露茜、王晨：《高校研究生教材建设的国际经验与中国路径》，载《学位与研究生教育》2018 年第 2 期，第 72 页。
② 同上。

为进一步加强和推动外语专业,尤其是英语专业英美文学方向的研究生教材建设,助力研究生培养从接受知识到创造知识的模式转变,在上海交通大学出版社的大力支持下,上海交通大学外国语学院发挥优势,携手复旦大学外文学院、上海外国语大学英语学院、北京科技大学外国语学院、东北师范大学外国语学院、中南财经政法大学外国语学院、山东师范大学外国语学院等兄弟单位,主编《当代英美文学系列教程》。本系列教材重点聚焦20世纪80年代以来的英美文学与文论,由《当代英国小说教程》《当代美国小说教程》《当代英国戏剧教程》《当代美国戏剧教程》《当代英国诗歌教程》《当代美国诗歌教程》《当代文学理论教程》《当代叙事理论教程》8册构成。

本系列教材以问题意识为导向,围绕当代英美文学,尤其是21世纪英美文学的新类型、新材料、新视角、新话题,将文学作为一种直面问题、思考问题、应对问题、解决问题的重要途径和方式,从而发掘和彰显文学的能动性。在每册教材的导论部分,首先重点概述20世纪80年代以来的文学发展态势与特征,由此回答"当代起于何时"的问题,在此基础上简述教材内容所涉及的主要命题、思潮、样式、作家和作品,由此回答"新在哪里"的问题。本系列教材打破按照时间顺序来划分章节的惯例,转而以研究问题或文学样式来安排各章。例如,教材纳入了气候变化、新型战争、族裔流散、世界主义等问题与文学样式。在文学作品的选择标准上,教材以类型和样式的标准来分类,如气候变化文学、新型战争文学等。每个门类下均选取数篇具有典型性的作品,并对其主题特色、历史背景及其相关文学特质进行介绍,凸显对文本性敏锐的分析能力以及对相关文学研究视角及理论知识的掌握。除此之外,教材还有意识地呈现当代英美文学的新的创作手法、文学思潮和文体特征。教材的每章集中一种文学样式、类型、思潮或流派,选择2~3篇代表性作品,单篇选读篇幅在5 000~10 000词(英文)左右,每篇附有5 000字(中文)左右的分析导读以及若干思考题。教材对作家或理论家及其著作的选取,不求涵盖全部,而是以权威性、代表性和重要性为首要原则,兼顾年代、流派、思潮等因素。本系列教材适合国内高校外国文学尤其是英美文学专业的博士研究生、硕士研究生、高年级本科生、文学研究者与爱好者使用。

本系列教材在编写过程中得到了上海交通大学外国语学院、上海交通大学出版社以及国内外同行专家学者的关心、帮助与支持,特此谢忱!

尚必武

2023 年 3 月

　　《当代英国戏剧教程》在编写中坚守"新类型、新材料、新视角、新话题"的原则。在理念上,本教材立足新文科、课程思政、学科交叉,以学术前沿、科研成果、研究问题为导向,是集前沿成果、系统知识、价值引领为一体的新型教材。在材料上,本教材紧扣"当代"两字,重点关注 20 世纪 90 年代和 21 世纪以来英国戏剧的发展态势与特征概论,在保留当代经典剧作家的同时,突出新作家、新作品。在内容上,本教材强调当代英国戏剧的新视角、新话题,通过当代政治戏剧、当代女性戏剧、当代直面戏剧、当代莎士比亚改写戏剧、当代神话改写戏剧、当代科学戏剧、当代黑人戏剧 7 个章节,以 12 部经典剧作家的代表作为研究对象,对当代英国戏剧的发生进行分类介绍和分析,以探讨当代英国戏剧舞台上不同类型戏剧作品的特征。但由于教材篇幅有限,为了突出主流剧场,选取当代政治戏剧 3 篇,当代女性戏剧、当代莎士比亚改写戏剧、当代神话改写戏剧各 2 篇,当代直面戏剧、当代科学戏剧和当代黑人戏剧各 1 篇。各章安排如下:

　　第一章介绍和分析当代英国政治戏剧。以爱德华·邦德的《战争三部曲》(*The War Plays*,1984—1985)、哈罗德·品特的《尘归尘》(*Ashes to Ashes*,1996)、霍华德·布伦顿的《罗马人在英国》(*The Romans in Britain*,1987)为例,分别探讨当代英国主流剧场中的暴力政治、权力政治和神话政治主题。

　　第二章介绍和分析当代英国女性戏剧。以卡里尔·丘吉尔的《顶尖女子》(*Top Girls*,1982)、伊莱恩·范思坦和英国女性戏剧组集体创作的《李尔的女儿们》(*Lear's Daughters*,1987)为例,呈现 20 世纪 80 年代后期崭露头角的女性剧作家的代表作,揭示她们参与集体创作,从边缘走向主流剧场的戏剧成就。

　　第三章介绍和分析当代英国直面戏剧。以马丁·麦克多纳的《丽南山的美人》(*The Beauty Queen of Leenane*,1996)为例,探讨直面戏剧的独特美学和对人性的思考。

　　第四章介绍和分析当代英国莎士比亚改写戏剧。以阿诺德·威斯克的《商人》(*The Merchant*,1976)、汤姆·斯托帕德的《多格的〈哈姆雷特〉,卡胡的〈麦克白〉》(*Dogg's*

Hamlet，*Cahoot's Macbeth*，1979)为例，分析 20 世纪后半期风靡英国乃至整个西方剧场的后现代莎剧改写创作。

第五章介绍和分析当代英国神话改写戏剧。以爱德华·邦德的《女人》(*The Woman*，1978)、汀布莱克·韦滕贝克的《夜莺之爱》(*The Love of the Nightingale*，1989)为例，介绍当代英国剧作家的神话重述经典。

第六章介绍和分析当代英国科学戏剧。以迈克尔·弗雷恩的《哥本哈根》(*Copenhagen*，1998)为例，分析当代英国戏剧中以科学为题材的科学剧场。

第七章介绍和分析当代英国黑人戏剧。以威萨·平诺克的《说方言》(*Talking in Tongues*，1991)为分析对象，考察当代英国黑人戏剧对黑人命运共同体的文化意义。

作为一个戏剧研究者，笔者在编写本教材的过程中尽可能地保证该教材在内容上的基础性、理论性、系统性和前沿性。本教材也涉及一些目前国内研究尚且不多的戏剧领域，如当代英国黑人戏剧和当代英国科学戏剧，为此，笔者组建了一个前期编写团队，博士生杨健林、杨洪霖、裴梦洁、王晶等参与了第三章、第六章、第七章的资料收集和部分章节的前期编写及后期校对工作，特此致谢！书中存在不足之处，恳请读者批评指正。

陈红薇

2023 年 10 月

Contents | **目录**

导论 ·· 1

第一节　战后英国戏剧的第一次浪潮 ··· 2

第二节　战后英国戏剧的第二次浪潮 ··· 3

第三节　战后英国戏剧的第三次浪潮 ··· 5

第一章　当代英国政治戏剧 ·· 6

第一节　当代英国政治戏剧概论 ·· 6

第二节　爱德华·邦德及其《战争三部曲》 ·· 12

第三节　哈罗德·品特及其《尘归尘》 ·· 27

第四节　霍华德·布伦顿及其《罗马人在英国》 ··································· 37

第二章　当代英国女性戏剧 ·· 57

第一节　当代英国女性戏剧概论 ·· 57

第二节　卡里尔·丘吉尔及其《顶尖女子》 ··· 61

第三节　伊莱恩·范思坦和英国女性戏剧组及其《李尔的女儿们》 ········ 75

第三章　当代英国直面戏剧 ·· 93

第一节　当代英国直面戏剧概论 ·· 93

第二节　马丁·麦克多纳及其《丽南山的美人》 ·································· 101

第四章　当代英国莎士比亚改写戏剧 ·· 113

第一节　当代英国莎士比亚改写戏剧概论 ·· 113

第二节　阿诺德·威斯克及其《商人》 ·· 118

第三节　汤姆·斯托帕德及其《多格的〈哈姆雷特〉,卡胡的〈麦克白〉》 ······· 138

第五章　当代英国神话改写戏剧 ·· 150

第一节　当代英国神话改写戏剧概论 ·· 150

第二节　爱德华·邦德及其《女人》 ·· 153

第三节　汀布莱克·韦滕贝克及其《夜莺之爱》 ·· 172

第六章　当代英国科学戏剧 ·· 187

第一节　当代英国科学戏剧概论 ·· 187

第二节　迈克尔·弗雷恩及其《哥本哈根》 ·· 195

第七章　当代英国黑人戏剧 ·· 210

第一节　当代英国黑人戏剧概论 ·· 210

第二节　威萨·平诺克及其《说方言》 ·· 217

导　论

　　20 世纪英国文学的一大盛事便是第二次世界大战(以下简称"二战")后"战后英国戏剧"(Post-war English Drama)的出现。自莎士比亚开创了辉煌先河以来,戏剧在英国文学中一直占有举足轻重的地位。20 世纪中叶,英国戏剧迎来了自文艺复兴以来的第二个春天,进入了一个长达 70 年的繁荣时代。

　　像 400 多年前的文艺复兴时期一样,20 世纪后半期是一个英国戏剧人才辈出的时代。1956 年,约翰·奥斯本(John Osborne)的《愤怒的回顾》(*Look Back in Anger*)的上演成为英国戏剧史上划时代的里程碑,它标志着战后英国"新戏剧"(New Drama)的诞生。跟随奥斯本的足迹,阿诺德·威斯克(Arnold Wesker)、哈罗德·品特(Harold Pinter)、爱德华·邦德(Edward Bond)、迈克尔·弗雷恩(Michael Frayn)、汤姆·斯托帕德(Tom Stoppard)、霍华德·布伦顿(Howard Brenton)、大卫·埃德加(David Edgar)、卡里尔·丘吉尔(Caryl Churchill)、萨拉·凯恩(Sarah Kane)、汀布莱克·韦滕贝克(Timberlake Wertenbaker)等一批又一批的剧作家创作了大量风格不同的戏剧作品,如"荒诞剧""政治剧""威胁喜剧""记忆戏剧""直面戏剧""改写戏剧""女性戏剧""科学戏剧""黑人戏剧"等等。在此过程中,经典剧作层出不穷,波澜壮阔,这促进了延续至今的战后英国戏剧的繁荣。著名剧评家克里斯托弗·英尼斯(Christopher Innes)曾在《20 世纪现代英国戏剧》(*Modern British Drama: The Twentieth Century*,2002)一书中写道:"20 世纪尤其是二战后的半个世纪,是英国戏剧史上最有活力的阶段。这一时期的戏剧不论在内容上还是在风格上都堪与伊丽莎白时代相媲美,剧作家的作品内容之广、风格之异,均超于此前的任何一个时期。"[①]

　　回顾过去的近 70 年,英国戏剧的发展大致可分为三个阶段,这三个阶段又被称为"三次浪潮"。第一次浪潮中的代表者是 1956 年之后崛起的剧作家,如威斯克、邦德、品特、约翰·阿登(John Arden)、彼得·谢弗(Peter Shaffer)等;第二次浪潮中的代表者则是 1968 年之后涌现出的剧作家,包括斯托帕德、布伦顿、埃德加、丘吉尔、帕姆·杰姆斯(Pam Gems)、大卫·黑尔(David Hare)、特雷弗·格里菲思(Trevor Griffiths)、霍华德·巴克(Howard Barker)、艾伦·艾克本(Alan Ayckbourn)、穆斯塔法·马图拉(Mustapha Matura)等;第三次浪潮中的代表者是 80 年代后期在英国剧坛上涌现出的一批新秀,如韦滕贝克、凯恩、马克·雷文希尔(Mark Ravenhill)、威萨·平诺克(Winsome Pinnock)等,随着这批极具个性的剧作家在英国主流剧场上崭露头角,当代英国戏剧表现出更加多元化的走向。

① Christopher Innes, *Modern British Drama: The Twentieth Century*. Cambridge: Cambridge University Press, 2002, p.1.

第一节　战后英国戏剧的第一次浪潮

关于战后英国戏剧,西方学者通常会提到1956年奥斯本的《愤怒的回顾》的上演,它标志着战后英国戏剧的诞生和第一次浪潮的开始。通过真实展现当代城市生活和青年一代的思想,尤其是通过主人公吉米对现代英国社会传统阶级意识的愤怒呐喊,奥斯本为英国戏剧确立了一个新的标准。如果说奥斯本是英国新戏剧史上划时代的一个突破,那么品特作为继萧伯纳(George Bernard Shaw)、塞缪尔·贝克特(Samuel Beckett)之后第三位获得诺贝尔文学奖(2005)的英国剧作家,则是战后英国戏剧史上一个永恒的神话,他那种超越意识形态的政治立场、诗一般的记忆话语和扑朔迷离的"品特式风格"(Pinteresque style)永远地改写了当代英国戏剧的"规则",改变了人们对英国戏剧的期待。但在这批剧作家中,若论谁是最有争议、最不妥协的剧作家,则非爱德华·邦德莫属。他在半个多世纪的创作生涯中,以激进的政治诗学和公众的戏剧视角捕捉时代精神,表现社会问题,关注人类危机,成为当代欧洲舞台上最具震撼力和挑战力的经典剧作家。[①] 2008年,随着品特的去世,邦德更是被视为英国在世的最伟大的剧作家。

第一次浪潮中的剧作家表现为两种走向:一种是社会性剧作家(socially committed dramatists),另一种是个性化剧作家(private dramatists)。前者沿着奥斯本开启的政治剧场的道路,坚持戏剧服务社会的宗旨,以分析和批评社会问题为己任,关注社会主题,其代表者主要有邦德、威斯克等。第二类剧作家则是侧重戏剧创作的艺术个性,其主要代表者为品特。需要指出的是,这两种走向既有差异,又有重叠。比如品特,他不仅是战后英国最优秀的剧作家之一,也是最有个性、最难定位的剧作家之一。一方面,品特与奥斯本等力图用戏剧来评述社会和改变社会的剧作家不同,他所坚守的非意识形态性政治立场和"品特式风格"使他与当时大多数剧作家在风格和艺术目的上格格不入,从而游离于战后英国戏剧的"大流"之外,甚至被视为战后"新戏剧"中社会性剧作家的对立面;但另一方面,在半个世纪的戏剧长河里,他却一直在领导英国主流剧场,成为战后英国戏剧界的一个神话。品特不入"大流"的同时却又能代表"主流"的原因就在于其戏剧作品的双重性特征:一方面,品特的内在性视角和独特的艺术特征使他远离同时代的大多数剧作家;另一方面,他的社会性视角则使他在更深的层面上与时代暗合,即在本质上与战后"新戏剧"中的社会性剧作家产生一种内在的重叠。

① Michael Billington, "If You're Going to Despair, Stop Writing". *The Guardian*, 3 Jan. 2008.

第二节　战后英国戏剧的第二次浪潮

1968 年,英国戏剧审核制度的废止是战后英国戏剧的又一个分水岭,它标志着第二次浪潮的兴起。[①]

第二次浪潮中的代表者通常是指继"愤怒的青年"(Angry Young Man)之后,在 20 世纪 60 年代末、70 年代初崛起的一批年轻的英国剧作家。与后期的第三次浪潮相比,第一次、第二次浪潮带有一定程度的共通性和延伸性。第二次浪潮中的剧作家也表现为两种走向:一种是和品特一样忠实于自己个性的剧作家,代表者是斯托帕德;另一种则是像奥斯本、邦德、威斯克一样根据自己的政治立场来创作的"政治性"剧作家,代表者主要是布伦顿、埃德加、黑尔、格里菲思和巴克这样的"左翼"剧作家。但与第一次浪潮不同的是,第二次浪潮的剧作家在思想和创作上都更加激进。如果说第一代剧作家批评的是现存的社会秩序和体制,那么第二代剧作家则将矛头直接指向了当时的撒切尔政府,主张推翻整个资本主义制度。在追求理想的过程中,两代人都经历了理想破灭的打击,但不同的是,第一代"左翼"剧作家因各种原因大多都随时光流逝而退出伦敦主流剧场,但第二代"左翼"剧作家却像凤凰涅槃一样,在梦想破灭后走出了绝望,一直活跃到 21 世纪初。

与第一次浪潮中的剧作家一样,第二次浪潮中的剧作家也是时代的产物。除了 1935 年出生的格里菲思外,大多数剧作家来自中产阶级家庭,而不是工人阶层,所以他们不像第一代剧作家那样有着强烈的阶级意识。此外,他们虽都受过良好的高等教育,但却痛恨正统的大学教育,在创作中表现出强烈的反文化倾向。从时代背景看,他们出生于 20 世纪三四十年代,刚好赶上 60 年代后期全球范围内波澜壮阔的左派运动和东欧社会主义阵营内部的剧变,如 1962 年的核裁军运动、1968 年苏联对捷克斯洛伐克内政的粗暴干涉和 1968 年 5 月发生在巴黎的学生运动。在这些历史事件中,巴黎学潮对他们的影响尤其深刻,它改变了无数年轻人的信仰。运动高潮时,学生们甚至接管了法国国家剧院,所以对他们来说,有那么一瞬间,梦好像近在咫尺。学潮的失败对英国"左翼"知识分子的思想产生了巨大的影响,正如布伦顿所说:

> 1968 年的那个 5 月从两个方面割断了我们这代人与过去的纽带:第一,它摧毁了我们对正统文化仅存的一点感情,现实告诉我们,历史长河里的所有伟人都不过是压在我们背上的尸体——高尔基、贝多芬——他们都是大骗子。第二,它毁掉了我们对个人自由、嬉皮士文化和其他自发性自由的狂热追求,摧毁了我们对无政府政治行为的概念。一切都失败了,都完了。一代追求理想国梦想的人被重重地踢了一脚——没有死去,但却被踢醒了。[②]

① 苏珊·拉辛科在《英国戏剧批评史:1950 年至今》一书中将 1968 年后的英国戏剧称为"第二次浪潮"。参见:Susan Rusinko, *British Drama 1950 to the Present: A Critical History*. Boston: Twayne Publishers, 1989, p.18.

② 转引自 Catherine Itzin, *Stages in the Revolution: Political Theatre in Britain since 1968*. London: Eyre Methuen Ltd, 1980, p.195.

60 年代的政治事件使"信仰马克思主义的(英国)知识分子们开始重新审视他们关于社会变革的理论,并进而改变这些理论"。①

尽管 1968 年的巴黎学潮和捷克斯洛伐克事件让英国的"左翼"剧作家感到理想破灭了,但他们的政治热情并没有消失。进入 20 世纪 70 年代中期,尤其是 80 年代以后,情况发生了变化。当回忆 70 年代中期以后的思想变化时,埃德加说道:"70 年代初,当我开始写剧本时,我是一个年轻的托洛茨基分子,一个非常年轻的托洛茨基分子,那时的立场很坚定。那时我认为,戏剧的目的就是鼓励人们走出门去,到街上设置路障……显而易见,现在看来,这并不是最好的途径。"②从他们走过的政治道路和他们的早期戏剧创作来看,几乎每一个"左翼"剧作家都在诉说着"失败""幻灭""变化"。当记者问大卫·黑尔,是否是 80 年代的撒切尔主义改变了他的写作时,黑尔回答说:"是的,我想,你可以清楚地看到,所有在70 年代信仰社会主义的作家最后都因撒切尔政治而陷入了困境。在这里,一个重要的原因就是,我们热切争论中的变化终究没有出现。"③

政治观点的改变体现在他们的写作上。除极少数剧作家仍坚守着戏剧宣传的阵地外,大多数"左翼"剧作家都意识到了政治口号式的戏剧越来越不适应现实的要求,于是,他们纷纷离开激进的政治性宣传剧场,转向更加深刻的戏剧创作。在他们当中,黑尔是最早进入边缘小剧场进行创作,也是最早放弃了这种尝试的剧作家。1971 年,他的《矿渣》(Slag)一剧在皇家宫廷剧院(Royal Court Theatre)上演,这标志着黑尔向伦敦西区商业剧场迈出了第一步。1972 年,他成为皇家宫廷剧院的驻团剧作家。1973 年,布伦顿的《高尚》(Magnificence)在皇家宫廷剧院上演,这成为他创作道路上的分水岭,标志着他脱离边缘小剧场,从此加入主流剧场行列。

正是由于这种经历,相对于上一代人的社会现实主义剧作,这批"左翼"剧作家主要采取两种戏剧形式来表达他们的政治观点:一种是当代社会政治剧,这些戏剧中的主人公大多是有着和剧作家一样政治追求的年轻人,作品反映了他们政治梦想破灭后所承受的困惑和迷茫;另一种是对英国传统文化和神话的颠覆性改写,在这些剧中,剧作家们的政治热情更多的是通过对传统文化的反思而获得释放。

① Finlay Donesky, *David Hare: Moral and Historical Perspectives*. Westport, Conn.: Greenwood Press, 1996, p.16.
② David Edgar, "Pentecost(1994)". In Duncan Wu, ed., *Making Plays: Interviews with Contemporary British Dramatists and Their Directors*. Basingstoke: Palgrave Macmillan, 2000, p.119.
③ David Hare, "David Hare, Arm's View". In Duncan Wu, ed., *Making Plays: Interviews with Contemporary British Dramatists and Their Directors*. Basingstoke: Palgrave Macmillan, 2000, p.172.

第三节　战后英国戏剧的第三次浪潮

作为战后英国戏剧发展的第三个阶段,80 年代后期之后的英国戏剧与前两次浪潮不同,它在创作风格、戏剧主题和发展趋势方面都难以界定。从严格意义上讲,它甚至不能被称为一次浪潮,因为前两次还有某种共通的轨迹,而第三次浪潮的剧作家呈现出如此多元的走向,以至于很难用某一种概念来描述它。

作为第三次浪潮的黄金阶段,20 世纪 90 年代是当代英国戏剧史上令人兴奋的十年。进入 90 年代后,一方面,品特、丘吉尔、斯托帕德、黑尔等老一辈剧作家仍在继续创作,另一方面,一批年轻剧作家以全新的风貌在舞台上崭露头角,如马丁·克林普(Martin Crimp)、萨拉·凯恩、汀布莱克·韦滕贝克、马克·雷文希尔、安东尼·尼尔森(Anthony Neilson)和马丁·麦克多纳(Martin McDonagh)、威萨·平诺克、夸梅·奎-阿尔马(Kwame Kwei-Armah)、杰兹·巴特沃思(Jez Butterworth)等,他们的出现使 80 年代沉闷的伦敦剧坛再次充满了生机。

与前两次浪潮的剧作家不同,这批剧作家在创作中普遍面向年轻的一代,以对抗、挑战、感性、阴郁、灰暗、暴力、破除禁忌等特征而见称,成为新一代“愤怒的年轻人”。他们从不同的角度,以各自的风格向世人描述了一个当代英国社会和市场文化的广角画面。如剧评家本尼迪克特·南丁格尔(Benedict Nightingale)所说,1994 年至 1996 年,英国出现了一大批引人注目的年轻剧作家,他们年龄多在 22 岁到 34 岁之间,他们笔下的人物多在城市的景观中徘徊,那里到处是暴力、威胁和陷阱。这批剧作家的一个共同特征是,他们既没有明显的意识形态立场,也没有政治信条和社会议题;他们在戏剧创作中看重的是人物和环境,而不是戏剧冲突、剧情张力,他们喜欢使用生动的快照画面而非混合情节来表现时代主题。他们的作品中充满了古怪而不合群的人物,这些人物被各种无助和痛苦所困扰,但他们的恳求中散发着道德的关怀,他们是撒切尔夫人时代迷失的孩子。[①]

总之,进入 20 世纪 90 年代后,英国舞台上涌现了一代新人,他们创作出的直面戏剧、神话改写戏剧、族裔戏剧、科学戏剧、同性恋戏剧等在 20 世纪末的英国舞台上大放异彩,从而将战后英国戏剧的发展推向了又一个高潮。

① Benedict Nightingale. In John Smart, *Twentieth Century British Drama*. Cambridge: Cambridge University Press, 2001, p.55.

第一章
当代英国政治戏剧

第一节　当代英国政治戏剧概论

大卫·伊恩·雷比(David Ian Rabey)曾对政治剧做过如下界定:

> "政治剧"强调的是对社会问题的关注和以政治的眼光来解释这些问题的努力。它向观众传递的是两个信息:一是这些社会问题是可以避免的,二是戏剧应该直接或间接地批判使这一系列问题出现和延续的政治环境……既然社会问题是可以避免的,那么"政治剧"的宗旨理所当然不同于那些力求维持社会现状的观点。[1]

根据雷比的定义,政治剧不仅要反映广阔的社会现状,更要以批评家的眼光来揭露社会问题,并指出改变社会现状的途径。这一观点在爱德华·邦德等当代左翼政治剧作家那里得到了响应。作为战后英国戏剧的大家之一,邦德曾这样阐明自己对戏剧的看法:"一部戏剧作品不应只靠自身而存在,而是应该建立在对人性现实的理解和对社会洞察之上,所以,个体永远是社会运动的一部分。我希望《被拯救》(Saved,1965)能使观众更好地意识到这些社会问题和它的本质,并找出解决这些问题的途径。"[2]

战后英国政治剧场的开山之作无疑是约翰·奥斯本的成名作《愤怒的回顾》。通过对城市生活和青年一代的描述,《愤怒的回顾》开辟了一个新的戏剧标准——表现当代社会问题成为20世纪后半期英国戏剧的主旋律。如柯林·钱伯(Colin Chamber)所说,战后英国戏剧的一大特点就是在社会的框架内开拓了一个政治的天地,一个公众的而不是个体的戏剧视角。他们关注的是社会,是那些与社会政治共鸣的个人的命运。[3] 事实上,不论是20世纪50年代后期崛起的第一批剧作家,还是1968年后涌现出的第二批剧作家,他们中的大多数人都是某种意义上的社会评论家,因为他们均坚信戏剧为社会服务的目的和宗旨,并力图用手中的笔来评述和改变社会。但由于他们的艺术风格不同,他们对政治的书写表现

① David Ian Rabey. In Susan Hollis Merritt, "Pinter and Politics". In Lois Gordon, ed., *Pinter at 70*, *A Casebook*. New York and London: Routledge, 2001, pp.140 – 141.
② Simon Trussler, *New Theatre Voices of the Seventies*. London: Eyre Methuen Limited, 1981, pp.27 – 28.
③ Colin Chambers and Mike Prior, *Playwrights' Progress Patterns of Postwar British Drama*. Oxford: Amber Lane Press, 1987, p.100.

出不同的样式。

一、社会政治戏剧

1956 年,《愤怒的回顾》的上演不仅是战后英国戏剧的起点,也是当代英国社会政治戏剧的起点。这类剧作是战后英国戏剧中的大流,其目的是通过戏剧来反映社会问题从而改变社会现状。在这类剧作中,既有奥斯本的作品所代表的用舞台来反映社会问题的现实主义剧作,也有邦德的后期作品所代表的后现代社会政治戏剧。

在《愤怒的回顾》中,通过主人公吉米·波特的形象,奥斯本描写了二战后那代年轻人的愤怒和反叛情绪,展现了他们心中的迷茫。剧中的吉米出身于工人家庭,虽接受了大学教育,并娶了中产阶层的女子爱莉森为妻,却发现自己仍被排除在中产阶级之外。吉米之所以成为"愤怒的青年",是因为他对社会的虚伪、冷漠和空虚感到厌烦,看不到人生的出路或目标,只能以愤怒来发泄内心的愤懑。通过吉米,奥斯本真实再现了那一时期很多观众的生活状况,表达了他们对没有希望、沉闷无聊的现实生活的无奈和愤怒。通过对城市生活的真实刻画和对英国现存社会阶层制度的批判,奥斯本为英国戏剧开辟了一个新的标准,这个标准用钱伯的话来说,就是"戏剧的目的应是向观众展示偏离常规之后可能带来的变化"[1]。总之,在战后戏剧史上,奥斯本的地位不可动摇,因为他打破了战后英国"死水一潭"的封闭思想,掀起了一个反对现存体制的戏剧之风。

紧跟奥斯本的"愤怒"之声,英国舞台上出现了第二个代表性政治剧作家:阿诺德·威斯克。1956 年,威斯克创作了首部剧作《厨房》(*The Kitchen*),并在 1958 年至 1960 年期间完成了代表作《威斯克三部曲》(*The Wesker Trilogy*),即《掺麦粒的鸡汤》(*Chicken Soup with Barley*,1958)、《根》(*Roots*,1959)和《我在谈论耶路撒冷》(*I'm Talking about Jerusalem*,1960),到达事业的巅峰。《威斯克三部曲》开创了 20 世纪 60 年代流行的"激进现实主义"的先河,从而将奥斯本所代表的当代现实戏剧之风又往前推进了一步。

但在第一代政治剧作家中,最重要的社会政治剧作家则是爱德华·邦德。邦德既是一个剧作家,也是一位哲学家和无畏的斗士。在他看来,暴力政治是一切政治问题的核心,它源于西方社会错误的道德体系和社会观念。剧场的责任就是要打破这种观念,将理性从传统错误的"善、恶"观念禁锢中解放出来。《被拯救》是邦德的成名作,也是其政治剧创作信念的集中体现。在本剧的第 6 场中,一群无所事事的年轻人在公园里开玩笑似地把一个童车里的婴儿砸死,这成为当代西方剧场中最暴力的画面之一。邦德认为,戏剧创作是一种社会行为,一个作家应该尽最大努力来追问人类最基本的问题:为什么会存在政治? 奥斯维辛错在何处? 邦德戏剧的最大特点就是透过戏剧直书暴力,以"重新创造人性的意义,重新界定人与世界的关系"[2]。通过《被拯救》中的弑婴事件,邦德迫使人们思考:在人类的历史长河中,是谁扔出了第一块石头? 扔向了什么? 扔向了谁?[3]

邦德对政治的书写在中后期创作中发生了很大变化,转折点是 1984 年至 1985 年完成的《战争三部

① Colin Chambers and Mike Prior,*Playwrights' Progress Patterns of Postwar British Drama*. Oxford:Amber Lane Press,1987,p.100.

② Peter Billingham,*Edward Bond: A Critical Study*. Hampshire:Palgrave Macmillan,2014,p.171.

③ Peter Billingham,*Edward Bond: A Critical Study*. Hampshire:Palgrave Macmillan,2014,p.171.

曲》——《红、黑、无知》(*Red，Black and Ignorant*，1984)、《罐头人类》(*The Tin Can People*，1984)和《伟大的和平》(*Great Peace*，1985)。《战争三部曲》以冷战后期的欧洲为背景，探讨核战争带给世界的灾难。在剧中，邦德让"一个胎死腹中的人物来讲述他没有机会经历的人生"[①]。剧中这个被称为"怪物"的人物是在母亲子宫里被核战争杀死的一个婴儿的幽灵，他浑身漆黑，像一尊黑炭雕像。该剧不仅是在谴责战争的暴行，更是从整个人类政治的角度，质疑作为平民的"我们"对战争和暴力的接受、合谋和间接性的参与。当谈及《战争三部曲》时，邦德说，它与由《李尔》(*Lear*，1971)所代表的早期作品一样，都在讲述同一个主题，即暴力政治——它也是社会的核心问题。两者所不同的是，《战争三部曲》力图以未来主义式的碎片叙事和"戏剧事件"手法，表达"邦德式的英雄"在两难的伦理困境中所经受的人性考验。

社会政治剧在第二次浪潮中得到发扬光大，最主要的代表者包括霍华德·布伦顿、大卫·埃德加、大卫·黑尔等。其中，布伦顿的系列代表作《幸福的武器》(*Weapons of Happiness*，1976)、《疼痛的嗓子》(*Sore Throat*，1979)和《绿地》(*Greenland*，1988)反映了其所代表的欧洲左翼剧作家在 20 世纪 60 年代后期对政治理想的反思。布伦顿感到，他的作品和其他在主流剧场上演的很多剧作一样，都在扮演着政治剧场的重要角色。1987 年，他在采访中说："我觉得作为一个'红色'作家，我们应该把有着社会主义思想的剧作推向舞台中心。剧场是一个社会机构，它和其他社会机构一样……它是保守的、统治性的和父权性的，但不同的是，在它的下面却有着一个红色剧场。"[②]即便是在 80 年代，布伦顿对政治理想仍旧充满了渴望，他写道："我梦想着自己能写出一句话，让它能变成一句歌词，或是描写出一幅画面，使它能成为一面旗帜，或是刻画出一个人物，让他能从台上走下，步入人们在现实中的争论、进入人们的情感。"[③]

除了布伦顿的作品，社会政治剧还包括埃德加的社会主义戏剧系列，如《五朔节》(*Maydays*，1983)、《桌子的形状》(*The Shape of the Table*，1990)等，以及黑尔的《一张世界地图》(*A Map of the World*，1982)、《狂奔的恶魔》(*Racing Demon*，1990)等。《五朔节》是埃德加的代表作。整个剧作共分 3 幕 24 场，剧情跨越了 1945 年至 1980 年的历史时期，地域背景覆盖从英国到匈牙利、美国到苏联等多个国家。在剧中，埃德加用片段式的视觉叙事，将人物置于广阔的社会背景中进行塑造和分析。通过历史的镜头，埃德加在这部剧中不仅透视了战后西方国家的左派政治，也剖析了西方社会主义理想破灭的根源。

同时期的另一位代表剧作家黑尔与埃德加有很大的相似性，他们均在戏剧中对欧洲政治进行了深层的反思，但黑尔的不同之处在于他以新的视角追问同一个问题：到底是什么导致了欧洲革命运动的失败？黑尔曾说："为什么在发达的工业社会里，革命运动的经历会如此惨淡，走入如此的低谷？"[④]当谈到《秘密的狂喜》(*Secret Rupture*，1988)的创作初衷时，黑尔说："我想告诉世人，英国式的道德在 80 年代发生了重大的转变。"[⑤]《秘密的狂喜》既有对撒切尔主义和资本主义的批判，也有对当代社会道德观

① Edward Bond，*The War Plays*. London：Methuen Drama，1998，p.4.
② Howard Brenton. In interview with Tony Mitchell，"The Red Theatre under the Bed". *New Theatre Quarterly*，11 Aug. 1987，p.196.
③ Howard Brenton. In interview with Tony Mitchell，"The Red Theatre under the Bed". *New Theatre Quarterly*，11 Aug. 1987，p.198.
④ David Hare，"Introduction". *The History Plays by David Hare*. London：Faber and Faber，1984，p.28.
⑤ David Hare，*Writing left-Handed*. London：Faber and Faber，1991，p.157.

念和善恶观念缺乏的质疑。《狂奔的恶魔》《低声抱怨的法官》(*Murmuring Judge*，1991)、《战争的空缺》(*The Absence of War*，1993)被戏剧界称为"反映英国(宗教、法律和政治)社会体制的三部曲"。当这些戏剧在英国国家剧院上演时，剧场仿佛又成了一个令人瞩目的政治论坛。

二、权力政治戏剧

由于奥斯本《愤怒的回顾》的上演，英国戏剧在此后的几十年里一直以社会现实主义为主流格调。在此背景下，当1958年哈罗德·品特的戏剧出现时，不少剧评家认为其戏剧缺少社会政治的内涵，给他的剧作贴上了英国"荒诞派戏剧"(theatre of the absurd)的标签。但事实上，如品特本人后来所说，早在他创作《生日晚会》(*The Birthday Party*，1958)、《升降机》(*The Dumb Waiter*，1959)等剧作时，他已是某种意义上的政治剧作家了。① 但在这里，品特所说的政治不是奥斯本、邦德等剧作家作品中的社会政治，而是基于权力关系之上的政治。

1960年，品特曾说："我不是那种为了某个观点而创作的剧作家。"②也就是说，品特对政治的理解不是意识形态立场上的政治，不以"左翼"或"右翼"的标签来衡量，他说的政治是指强与弱的"权力关系"和由此带给人类的毁灭和恐惧。正如他在访谈中提到政治主题时所说，他的剧作"讲的都是强者与弱者的故事。如《新世界的秩序》(*The New World Order*，1991)……一个人被蒙着双眼坐在那里，手无缚鸡之力，另外两个手握大权的人即将对他施以酷刑，这一意象体现了一切"③。

在戏剧中，品特对政治主题的探讨是从内在和外在两种视角展开进行的：外在性视角是社会性的视角，指的是对人与人外在社会关系的探索；内在性视角指的是心理性的视角，是对人类内心现实的探索。一方面，从外在性社会政治的角度出发，他认为"政治"是渗透于一切人类社会交往中的权力关系，是一种强与弱、权威与个体、压迫与被压迫的关系。这一声音包含了品特作为一个世界公民的道义感，反映了剧作家对世间一切不平之事的痛恨和对社会权威的反叛。1987年，品特曾在一篇题为《必须制止美国这头大象》("The US Elephant Must Be Stopped")的文章中这样援引林登·约翰逊(Lyndon Johnson)的话："美国是一头大象，塞浦路斯是一只跳蚤，希腊也是一只跳蚤。如果这两个家伙胆敢在大象身上搔痒，大象一定会把它们踏扁在地……"④这篇文章里的"大象"和"跳蚤"的意象成为贯穿品特政治主题的中心。他说："我相信，我的戏剧影射到了政治镇压，那些与'常规'不太合拍的人们都会被视为'另类'，受到压制和惩罚。"⑤这种对权力关系的理解构成了品特戏剧中的社会性视角。但另一方面，从内在性权力政治的角度出发，品特发现政治又具有很强的主观性。与同时代的左翼剧作家不同，他对政治的书写不是直接对靶社会现实并指出解决问题的出路，而是转向人物的内心，展现人物在权力关系中的内在心理现实。事实上，品特在戏剧创作中一直迷恋于人类关系中的折磨、背叛、罪疚等主题，他在访谈中一次次地提到大屠杀："大屠杀是人类有史以来最可怕的灾难……也许，我们永远都无法真正弄清

① Mel Gussow，*Conversations with Pinter*. New York：Limelight Edition，1994，p.82.
② Drew Milne，"Pinter's Sexual Politics". In Peter Raby，ed.，*The Cambridge Companion to Harold Pinter*. Cambridge：Cambridge University Press，2001，p.196.
③ Mel Gussow，*Conversation with Pinter*. New York：Limelight Edition，1994，p.102.
④ Harold Pinter，*Various Voices: Prose，Poetry，Politics，1948-1998*. London：Faber and Faber，1998，p.171.
⑤ Mel Gussow，*Conversation with Pinter*. New York：Limelight Edition，1994，p.69.

德国人对自己行为罪疚的深度。此外,我还想知道的是在这场罪恶中,那些曾经扮演着帮凶角色的人们,那些参与了罪恶但现在却表现得像什么都没发生过似的人们,他们的心理。"①

这种双重视角直接决定了品特权力政治的书写模式。从政治主题的角度来看,品特的创作可分为三个阶段。其第一阶段的主要代表作为《生日晚会》《升降机》等。在《生日晚会》中,两个神秘人物戈尔德贝格和麦卡恩突然现身一家海滨旅馆,为那里唯一的一个客人斯坦利举行了一个生日晚会。虽然剧中两个陌生人和斯坦利的身份都像谜一样,但很显然,他们曾同属某个"组织",而两人此次的任务是来抓捕组织的"叛徒"斯坦利。那场生日晚会既像是一个神秘的"仪式",又像是一场政治审问。在剧中,经过一个晚上的洗脑,清晨神志恍惚、失去了"声音"的斯坦利被带走,去接受新的"治疗"。其第二阶段的主要代表作为《送行酒》(*One for the Way*,1983)、《山地语言》(*Mountain Language*,1988)和《晚会时刻》(*Party Time*,1991)。在这些剧中,品特不再用模棱两可的语言来描写不可名状的威胁和恐惧,而是以鲜明的道德旗帜,直接将强者与弱者的政治对抗呈现在观众的面前。第三个阶段以《尘归尘》的问世为标志,在该剧中,政治以大屠杀和集体迫害的意象出现在人们的面前,激发观众对创伤性历史事件的再反思。

三、政治神话戏剧

在战后主流政治剧场中,另一类政治戏剧是政治神话戏剧。这类政治戏剧肇始于邦德在20世纪六七十年代的作品,经布伦顿80年代的作品得到继承和发展。

在这类政治神话戏剧中,最负盛名的要数邦德的代表作《赢了》(*Bingo*,1973)。在这部作品中,邦德戏剧一改《被拯救》中的现实主义风格,以莎士比亚历史神话为其创作源泉,从西方文化的内部走进政治主题。

关于社会神话,邦德这样阐述道:"资本主义不想弄清什么是人,只想操纵人,为此他们构建了一套关于人与社会的神话,此神话就是其文化。"②邦德提出,传统社会神话的最终目的是服务不公正的社会,当代剧场的责任就是要修正这些神话。在邦德看来,尽管莎士比亚在悲剧《李尔王》中让李尔王看到了人性的善恶,但剧中李尔王对现实的接受及顺从却是错误的,它是人类社会暴力政治得以延存的根本原因。因此在创作《李尔》时,邦德立意在历史的坐标系中重塑莎士比亚的形象,对暴力政治展开全新思考。该剧以李尔修筑城墙开始,又以他拆除城墙时被打死结束——城墙这一人类防御意识的古老象征既承载着李尔身为王者的政治梦想,也是他滥施暴力的道德天平,他说:"我死后,我的人民会生活在自由和平的环境之中……[(说罢)开枪打死了第三个工人]。"③剧中的李尔在"城墙政治"的名义下滥杀无辜,最终自己也成为新一轮暴力政权的牺牲品。通过重述莎士比亚神话,邦德旨在揭示"城墙政治"思维定式下的暴力本质:一代代君主打着民众和国家的旗号,将个人的仇恨冲动演变为国家的集体意志,赋予残暴以合法的外衣。④ 在邦德看来,政权最可怕的一面正是这种理想掩盖下的血腥杀戮。

① Harold Pinter, *Various Voices: Prose,Poetry,Politics,1948-1998*. London:Faber and Faber,1998,pp.15-16.
② James C. Bulman,"*The Women* and Greek Myth:Bond's Theatre of History". *Modern Drama*,4(1986),p.505.
③ Edward Bond, *Lear*. In Edward Bond, *Plays: Two*. London:Methuen Ltd,1972,p.17.
④ Edward Bond,"Author's Preface". In Edward Bond, *Lear*. In Edward Bond, *Plays: Two*. London:Methuen Ltd,1972, p.3.

不论在风格上还是主题上，霍华德·布伦顿都是第二代战后英国剧作家中与邦德最相似的剧作家。在《幸福的武器》《丘吉尔的戏剧》(*The Churchill Play*，1974)、《血淋淋的诗歌》(*Bloody Poetry*，1984)、《罗马人在英国》等代表作中，布伦顿通过再写政治神话，表达了他对文化政治的理解和其政治思想。布伦顿在 20 世纪七八十年代创作的一系列剧作无不是那一代年轻人理想、幻灭、反思等政治情绪的外化。作为一个经历了政治涅槃的理想主义者，这一阶段的布伦顿在戏剧创作中不再像早期那样直抒政治，而是通过对文化、历史、政治的反思，以异托邦叙事来警示人们在未来的乌托邦追求中不要重蹈覆辙。

《幸福的武器》是一部典型的布伦顿式社会主义戏剧，故事以异托邦叙述为主，其间夹杂着乌托邦梦想的幽影。该剧讲述的是 1968 年捷克遭入侵后，发生在一个薯片厂中的故事：工人们得知老板将要出售机器，于是策划攻击老板并占领工厂。该剧通过 1952 年被处以绞刑的历史人物约瑟夫·弗兰克的形象，将东欧社会主义历史与英国背景融合在了一起，使一个理想主义者的幽灵回到现实，再次经历失败，最终对其受到的教训做出反思。弗兰克在 1968 年复活，和新一代的工人运动者一起占领工厂。但由于工人们缺少统一的策划，他们的抗议从一开始便注定会以失败告终。本剧的故事从伦敦延续到莫斯科广场，整个行动的结果如噩梦一般，崩溃的工厂仿佛是英国经济体制的微观缩影。

《丘吉尔的戏剧》是对丘吉尔政治神话的改写。剧中故事发生在爱尔兰的一个英国政治集中营里，囚犯们为迎接政府代表团的到来在排练一场关于丘吉尔的戏剧。在节目中，丘吉尔从威斯敏斯特的灵柩里出来，走向守卫的士兵。本剧结束时，演出变成了政治犯们的大逃亡。当谈到丘吉尔政治神话时，布伦顿写道："世人总在说，丘吉尔受到那场战争经历者的拥戴，人们说……'他给了我们自由'。事实上，对于自由这一至高无上的问题，我们不禁要问：'什么是自由？我们该如何处理自由？我们为了这个自由都干了些什么？'"①在布伦顿看来，正是在丘吉尔政治神话的引导下，英国军队开进了北爱尔兰，使英国失去了民主堡垒的地位。布伦顿立意通过再写政治神话，解构世人赋予历史的虚假光环，用新的话语重新诠释历史、诠释神话。

《血淋淋的诗歌》是布伦顿于 20 世纪 80 年代创作的另一部政治神话戏剧。该剧讲述的是 1816 年雪莱被流放到瑞士和意大利时发生的故事。他在日内瓦城与拜伦相遇，随后一起生活。布伦顿以"血淋淋的诗歌"为剧名，意在从文化唯物主义的角度探讨革命理想和残酷现实之间的矛盾。作为作家，雪莱和拜伦的责任是让世人看到现实的真相，唤醒大众为理想而战。但作为现实中的个体，他们却屡遭失败。拜伦为自由而奔赴希腊，却在到达希腊之后，未上战场便因热疫而亡。在世人的眼中，拜伦的结局可谓是一个悲剧，但在布伦顿看来，作为一种精神象征，拜伦的死对希腊自由事业的贡献远超他可能在战场上的厮杀。事实上，不论是拜伦，还是雪莱，他们虽如彗星般逝去，但他们的梦想和热情却像燃烧的火把照亮了人类的梦想。所以，面对雪莱燃烧的尸体，拜伦豪放地说道："燃烧吧！把我们都烧掉吧！""这是一把血色的美丽大火！"②

本章选取了战后英国主流政治剧场中的三部经典之作——邦德的《战争三部曲》、品特的《尘归尘》、布伦顿的《罗马人在英国》，以此为例来分析以社会政治、权力政治、神话政治为主题的不同类型的政治戏剧。

① Howard Brenton. Interviewed by Catherine Itzin and Simon Trussler. In James Acheson，ed.，*British and Irish Drama since 1960*. Macmillan：St. Martins's Press，1993，p.136.

② Howard Brenton，*Bloody Poetry*. London & New York：Methuen，1985，p.77.

第二节　爱德华·邦德及其《战争三部曲》

一、爱德华·邦德简介

作为当代英国最有实力的剧作家之一,爱德华·邦德和奥斯本、品特等同为战后英国戏剧第一次浪潮中的核心人物。他在半个多世纪的戏剧生涯中创作了近50部剧作,是战后英国舞台上最多产的剧作家之一,其剧作在60多个国家上演。

与很多同时代的剧作家一样,邦德出身于工人阶层,参加过二战。战争给邦德留下了关于暴力的创伤性记忆和认识,使他对所生活的世界充满了邪恶的印象。在战争中,他目睹了被炮火剥光了枝条的树林,看到了被削去了脑袋的小鸟儿,他说这是他后来写《被拯救》的一个原因——暴力就像一颗炸弹,它会"炸"飞整个社会。邦德在英国戏剧舞台上的成功颇具传奇性。1965年,当皇家宫廷剧院将邦德的《被拯救》作为一场私人俱乐部演出搬上舞台时,剧院受到起诉,经理和导演也遭到逮捕。这一事件引发英国众议院的激烈讨论,最终导致两年后英国戏剧审查制度的废除。

邦德的戏剧创作以《战争三部曲》为转折点,可分为两个阶段:第一阶段(1962—1985)是经典戏剧创作时期,第二阶段(1985—至今)是后现代暴力戏剧创作时期。

在第一阶段中,邦德的主要作品有《教皇的婚礼》(*The Pope's Wedding*,1962)、《被拯救》《清晨》(*Early Morning*,1968)、《弄臣》(*The Fool*,1975)、《李尔》《赢了》《女人》等。不少剧评家认为,这是邦德戏剧创作的巅峰阶段。在这一时期,邦德围绕其政治诗学形成了独特的"理性剧场"(Theatre of Reason)。邦德提出,暴力攻击是一种能力,而不是必然,是人类社会的法律、秩序观念和政治体系给予了暴力一种"道德的神圣性",从而使它成为人人接受的"正义"。[①] 作为该阶段的代表作,《被拯救》是邦德"理性剧场"和暴力政治主题的起点。在该剧中,一群青年在公园里一边嬉笑着,一边用石头砸死了童车中的婴儿,这是20世纪西方戏剧舞台上最为惊悚的一幕,该画面在英国社会引起了巨大公愤。对于公众的反应,邦德解释说:"他们对剧中隐含的谴责感到震惊,该剧向人们揭示了一个可怕的真相,即奥斯维辛和广岛暴力并非封存于历史的铅盒中,而是潜伏在英国社会的肌体中,随时都可能从压抑的底层爆发。"[②]《被拯救》中的暴力政治成为贯穿邦德戏剧的核心主题,并在70年代的系列作品中反复出现,发展成了独特的"理性剧场"。

在第二阶段中,邦德的主要作品有《战争三部曲》《咖啡》(*Coffee*,1995)、《21世纪的罪恶》(*The Crime of the Twenty-first Century*,1999)、《假如一无所有》(*Have I None*,2000)、《平衡行动》(*The Balancing Act*,2003)、《破碎的碗》(*The Broken Bowl*,2012)等。其中,《咖啡》是邦德后期的一部力作。

① Edward Bond,"Author's Preface". In Edward Bond,*Lear*. In Edward Bond,*Plays: Two*. London:Methuen Ltd,1972,p.3.

② G. Saunders,"Edward Bond and the Celebrity of Exile". *Theatre Research International*,29(2004),p.257.

在该剧中,主人公诺尔德以士兵身份卷入内战,他们小队的任务是杀死身后深谷中的俘虏。①舞台上出现了本剧的核心事件:士兵要完成屠杀任务,却因弹药不够而被迫放弃机枪,改用步枪点射。于是,在点射的过程中,士兵便有机会"看到"机枪扫射时被忽视的细节——被杀者如何哭泣、流血、倒下。这一画面不仅放大了屠杀的血腥,也放大了人性被暴力机器化的过程。在舞台上,当士兵们在执行射杀任务时,另有士兵在旁边为小队煮着咖啡,这便是剧名用"咖啡"一词的原因。舞台上这群一边煮着咖啡、一边屠杀无辜者的士兵,仿佛是《被拯救》中那群嬉笑着用石头砸死婴儿的青年,这种可怕的画面促使观众反思暴力背后的人性真相。通过对人性本体的探索,邦德将哲学思考融入暴力政治主题之中,将"理性剧场"发展成被称为"事件剧场"(Theatre of Events)的新型舞台叙事。

从"理性剧场"到"事件剧场",耄耋之年的邦德在革新艺术的道路上依然坚定而倔强,他说我们必须把戏剧推向终极情景,因为如果我们不能在剧场中直面广岛,我们就将会在现实中遭遇广岛。② 在由屠杀和咖啡构成的戏剧事件中,意义的焦点不是"为什么士兵要在巴比谷杀人",而是"巴比谷——奥斯维辛——怎么会成为可能"。③ 所以邦德一再强调,奥斯维辛不是历史,而是当下,"人类最大的问题就在于,我们一直在容忍不该容忍之事,唯一能使人类免于崩溃命运的不是经济,而是文化,是一种接受人类责任、接受终极天真、追求真相而非生存的文化"④。所以,他一再重申自己的戏剧立场:"剧场的起点是奥斯维辛的大门和广岛的废墟,如果你不知道我在说什么,那我就是在浪费自己的时间。"⑤

二、《战争三部曲》⑥介绍

《战争三部曲》由《红、黑、无知》《罐头人类》《伟大的和平》构成。本节选的是第一部《红、黑、无知》。

在该剧中,主人公"怪物"是一个未出生就被核爆炸烧焦、"从母亲的子宫里被直接抛到火堆之中"(4)的地球未来居民,他也是引导观众进入剧情的叙事主体。本剧讲述的是"怪物"如果能来到这个世界,他将会经历怎样的人生。该剧以"怪物"跨越生死两界的叙述展开,充满了时空跳跃和情节省略,其间记忆片段把现实和虚幻糅合在一起,观众需要通过想象来参与性地建构整部戏的逻辑关系。第一场讲述的是"怪物"在核爆炸中的"出生"。第二场叙述的是"怪物"的校园时代。第三场是他的青春时代。第四场是他的婚姻生活,他对妻子的虐待显示出他开始蜕化为丧失人性的"怪物"。第五场中,他卖掉了自己的孩子。第六场中,为了得到一份工作,他从废墟中把一个受困的妇女救起。第七场是插曲《士兵歌》——他把儿子送去当兵。当上新兵的儿子却受命回到家乡,完成一项特殊的任务:为控制核战后饥荒的蔓延和维护公众的利益,每名士兵奉命在家乡的街区里杀死一名平民。儿子最后选择杀死自己的父亲。第八场中,"怪物"被自己的儿子打死,他的幽灵却赞叹儿子的"道德"行为:"赞美这个士兵吧! /他宁肯杀死自己的父亲也不伤害陌生人/……人类最早的戏剧家说:认识你自己/我的儿子从他们的话

① 该剧情源于历史上的一个真实事件:1941 年 9 月德国党卫军特别行动队曾在基辅郊外的巴比谷用机枪扫射大量犹太人,两日内共有 33 771 人被杀死。

② Kirsten Bowen, "Edward Bond and the Morality of Violence". 1 Apr. 2005. http://www.amrep.org/articles/3_3a/morality.html.

③ Edward Bond, *The Hidden Plot*. London:Methuen, 2000, p.165.

④ Carl Miller, "Theatre Begins at the Gates of Auschwitz". *Theatre*, 1996, p.5.

⑤ Carl Miller, "Theatre Begins at the Gates of Auschwitz". *Theatre*, 1996, p.5.

⑥ Edward Bond, *The War Plays*. London:Methuen Drama, 1998.以下出自该剧本的引文页码随文注出,不单列脚注。

中明白了,要杀只能杀自己所爱的人/即便旁边有个不能理解这个世界为什么受苦的老弱病残者。"(38)最后一场是"怪物"的葬礼。

《战争三部曲》的意义在于,它是邦德后现代"事件剧场"的开端。所谓"戏剧事件",是指从一部剧中提炼出的部分"事件",如《战争三部曲》中的"弑父"、《奥利的牢房》(*Olly's Prison*,1993)中的"弑女"、《咖啡》中的"屠杀"等。关于"事件剧场",邦德认为每一个严肃的戏剧都有一个中心,它是"戏剧事件"的聚集地,每当事件交锋并具有批判性时,戏剧"效果"便由此诞生。在《战争三部曲》中,邦德大量使用了"戏剧事件"策略:"这部作品长达七个小时,其间一再回到某些事件之上,这种事件在剧中多次出现,我称之为'戏剧事件'。"①根据邦德的"戏剧事件"理论,"若想透过距离审视一个事件,剧场必须改变'承载'它的故事"(300)。在《红、黑、无知》中,核心事件有两个:"怪物"成为漆黑如炭的幽灵、士兵挑选父亲为杀死的对象。本剧以"怪物"与母亲回忆那场葬送其生命的核战开始:

> 母亲:一个巨大的火球在空中膨胀……我坐在房里/那天早上,孩子在子宫里蠕动着,仿佛/要从这世间逃走/透过子宫的墙壁,他感到了世界末日的恐惧/……/我血肉崩离,他被抛落在熊熊燃烧的房子里。(5)

该叙述揭露了所有暴力的真相——在试图终止暴力的过程中新的暴力被不断孕育出来。对于回乡的任务,"怪物"的儿子说:"我不必羞愧地告诉你们我此行的目的,所有新兵都奉命回乡杀死一个平民……说到底,部队如此行事也是为了公众的利益。"(31)在街区内只有两户人家的情形下,儿子选择放过一对老弱夫妻而杀死自己的父亲。而作为父亲的"怪物"不仅没有怪儿子,反而对儿子这一"人性"的决定大加赞赏,他认为自己的儿子知道人何以为人,明白杀死至爱要胜过杀死一个老弱病残之人。

邦德曾解释过,在"戏剧事件"发生的瞬间,时间将被刻意放慢,就像是在一场飓风或龙卷风中,观众位居飓风的中心("戏剧事件"的聚集处),那一瞬间,一切被放大,周围是猛烈旋转的风墙——剧本、记忆、各种碎片悬浮于上,它们在无悲剧的交锋中被掀起。而"戏剧事件"的最终目的是呈现事件中被隐蔽的聚焦点,即"事件效果"。② 所以,从戏剧功能来看,这些被提炼出来的"事件"在性质上就像是导火索,其目的是引导观众跳出传统思维,去质疑和改变既有的价值体系。在本剧中,士兵挑选枪杀对象的事件被放大到令人瞠目的地步,通过他的"人性"选择——放过弱者,杀死亲人——邦德旨在震撼每一位观众思想中某种根深蒂固的观念,一种非理性的"正义感"。多少世纪以来,人类一直打着"正义""道德"的旗号实施暴行,士兵看似"人性"的选择实际上掩盖了人性中最不人性的真相:士兵没有理由杀死任何一个人,即便是自己的父亲。在剧中,邦德不仅在谴责战争,更是从人类政治的角度指出社会意识对人性的扭曲,它使一代代人成为暴力的合谋者。

在邦德的后期作品中,"戏剧事件"策略成为其戏剧的核心策略。"戏剧事件"在《星期二》(*Tuesday*,1993)中是一场海湾战争,在《咖啡》中是巴比谷的屠杀,在《在有岛屿的海上》(*At the Inland Sea*,1995)中是发生在学童卧室中的爆炸,在《奥利的牢房》中则是一场发生在父女之间的谋杀。在《奥利的牢房》中,父亲迈克因女儿拒喝他为之准备的一杯茶而将其扼死。在此过程中,茶杯成为一个被放

① Hilde Klein, "Edward Bond: An Interview". *Modern Drama*, 38(1995), pp.410-412.
② Edward Bond, *The Hidden Plot*. London: Methuen, 2000, pp.16-17.

大的"客体瞬间",一个迈克生活的缩影和放大——他的"自我所在"和"世界所在"——也是迈克最后扼死女儿的原因。在邦德看来,这一"戏剧事件"的核心是现代生活的现实,即一个充满自我断裂和无法逃避的社会。它折射出现代生活的诸多悖论:剧中很多场景均发生于牢房,剧名中的"牢房"与其说是指监牢本身,不如说是指监牢以外的整个世界。①

　　本书节选的是《战争三部曲》的第一部《红、黑、无知》中的第一场、第二场的片段。第一场的开篇是"怪物"的独白,他用悲戚的独白讲述了人类从爱和善坠入恶的非理性过程。第二场中,"怪物"和其他关联的人物先后登场,过往、现在、未来拼合在一起,演绎出他们本该拥有却因核爆炸而未发生的生活。

三、《战争三部曲》选读②

The War Plays

One

Introduction

The MONSTER *comes on*.

MONSTER:

1

Alone of creatures we know that we pass between birth and death

And wish to teach each new mind to be as profound as a crystal ocean through which we may

　　see the ocean bed and from shore to shore

2

We speak of our children before they are born

Carry them before we can hold them

Fold their clothes and lay their bed before they can wake

Sew and harvest and market their food before they can eat

For them we build streets before they can walk

And guard them from sickness before they can draw breath

For three seasons they grow in the womb while the world may age ten thousand years

When they are born the hands of mechanics housekeepers masons pilots designers administrators

　　drivers gardeners are held together to receive them

No exiled hero could return to a land more welcoming

No president be received into office with such preparation

①　Edward Bond，*The Hidden Plot*. London：Methuen，2000，pp.18 - 19.

②　Edward Bond，*The War Plays*. London：Methuen Drama，1998，pp.3 - 5，pp.28 - 39.

No victor be greeted with so much joy

We should not wonder that in the past children thought the world was watched over by gods

3

But now we kill them

The MOTHER *comes on*.

MOTHER：

1

In the past there were survivors to tell that suddenly the world became a place of toys

A huge red ball inflated in the sky

Houses shook as dolls' houses shake when they're carried by children

Small things became big and big things vanished

Many reported that the cloud glowed like a bonfire

And that the wounded babbled in the strange tongues spoken by children when they pretend to
 be foreigners

2

I did not see or hear these things

I sat alone in my room

That morning the child had moved in my womb as if it wanted to run away from the world

Through the womb's wall it had felt the world's fear

Now my head was bent as I listened

I was so intent I did not hear the explosions and passed into death without knowing

My body's spasm crushed the child

My flesh burst open and threw him into the furnace of my burning house

The MONSTER *sits on the bench beside his* MOTHER.

MONSTER： When the rockets destroyed the world everything whistled

Every hard surface and hard edge whistled

Mouths of medicine bottles and whiskey bottles

Cornices of law courts and office blocks

Cracks in rocks

Whistled in derision

As the tyres stopped screeching the winds whistled in the broken windows

Doors and wheelchairs—some empty, others carrying sick and maimed—whistled as they flew
 high over the great plains

The mountains whistled

The last breaths whistled from dead mouths

And as the flesh burned from faces the skulls whistled

Surfaces too soft to whistle burned and the fires whistled

The heart leapt like a bird in its burning cage and the ribs whistled

The earth whistled in derision

In final derision at the lord of creation

In derision derision

That drowned the sounds of explosions and the last screams of the world's masters

The whole earth whistled in derision at the lord of creation

MOTHER: This is the child my womb threw into the fire

The MOTHER *goes out*.

MONSTER: Now we will show scenes from the life I did not live

If what happens seems such that human beings would not allow it to happen you have not read the histories of your times

The MONSTER *goes out*.

...

Eight

No one can willingly give up the name of human

MONSTER: No one can willingly give up the name of human

The MONSTER *comes on*.

MONSTER: When my son reached the age at which I fathered him

There were so many rockets the world looked like a hedgehog

It could have been destroyed as easily as if it had been a little apple and a giant stood up in space and devoured it in one bite

People walked on tiptoe in the street as if they feared the vibration of their steps would set off the rockets

They stopped moving the furniture in their houses: the movement might show up on radar screens and bring destruction on them and their neighbours

Security was so great all were suspected

Even as they lay in their silos the rockets destroyed the societies they were said to protect

The SON *comes on with a gun*.

MONSTER: Anyone see you enter the house?

SON: Why?

MONSTER: It would be marked as the home of a soldier. Why d'you carry guns in the street?

SON: To protect ourselves from you mother-stranglers

The MONSTER's WIFE *comes in.*

WIFE：My son

She embraces him.

Are you on leave?

SON（*takes off his helmet*）：There's an action

WIFE：Dont talk about it now

Have you eaten?

SON：Not since yesterday

WIFE：I thought the army ate

SON：The civvie-corpses ambush our trucks and steal our fodder

WIFE：Come into the kitchen

I'll get you a meal

MONSTER：He does things he cant tell his parents

WIFE：He's in the army because he couldn't work as a civilian

You stopped him

SON：Its an offence under martial law to slander soldiers

You're the sort who turn out with the corpse-mobs of mother-stranglers when they shoot us up

and then bellyache because we're armed

WIFE：Both of you stop it

SON：There's nothing wrong with him a good postmortem wouldnt put right

WIFE：The army wont let him out and if he didnt obey orders he'd be shot

Can you change that?

SON：I like the army

When you're a soldier all your problems are solved by training

Kill or be killed

No apologies or explanations

You always gab about right and wrong

Do what's right? —its as much use as an overcoat to a corpse

In a storm the gaps between the raindrops dont stop you getting wet

Can you *stop the storm*?

Im not ashamed to tell you why Im here

Every squaddie's been sent back to his own street to shoot one civvie-corpse

He chooses which

Make the decisions hard

Test the potential

Know yourself

When you've got gunsights for eyes and triggers for fingers you can call yourself a soldier

MONSTER：You'd do that?

As the SON *talks the* MONSTER *turns away in pain.*

SON：Following the reason yeh

You think this is a famine?

Next year you'll be so hungry you'll be like corpses who eat the nails out of their coffin and then look round for something else

He takes off his jacket and gives it to his MOTHER.

After this action you'll be so corpse-scared if we stood you against the wall you'd offer to load our rifles in case we did something really nasty

The streets'll be as quiet as a churchyard where the mourners are deaf and dumb and the corpses've taken a vow of silence

After that we can put down the food riots with a few bursts of armalite and a few hangings from the helicopter platforms

Otherwise we'd've had to go over you with the human lawnmower

In the end the army's doing this for the public good

WIFE：There's only two families left on this street：

Us and the old couple still in the house on the corner

MONSTER：He's known them since he was a child

SON：We dont have to come up with a choice

The order says we could leave it to the officer

WIFE：No no no

He'd choose me or your father

He'd do it to punish you for being a coward

Dont argue with him

It torments him for nothing

He didnt make this mess：we're the ones who

MONSTER：He sits there in human clothes and speaks our language

Doesnt the food humans eat poison you?

WIFE：Stop it

Its easy to talk！

You're like a judge who gives a verdict in an armchair

MONSTER：Run and hide in the ruins

There are whole communities living outside the law

WIFE（*explaining plainly and simply so that he will understand*）：No no I told you

If he doesnt choose the officer wont even ask who else is left in the street

He'll shoot both of us to punish him

Two will have been shot instead of one

MONSTER (*flatly*): We live like prisoners in a death-cell facing death every day

Once there were gaps between bars: they've filled them in

If a pardon came they'd use it to make a list of the condemned

Perhaps its better to die

WIFE: What if they shot me?

MONSTER: I hope it would be me but I cant help what happens now

WIFE: Then you're the monster not our son!

What can we do in the end?

Fight for our own

Your son or your husband

I'll fight for them!

Tooth and nail!

So would the woman on the corner!

She embraces her son.

Poor boy

I dont blame you

Never never would I do that

If you were free you'd help these people

You were a kind boy

You always whistled when you turned into the street

I listen out for it

Now your face is like stone at the top of a mountain

Did you tell the officer you'd go to the corner house?

SON: No

WIFE: Silly silly

If you'd told him it would've all been settled now

It would be too late to let him choose: he'd punish you for changing your mind

Sudden suspicion.

Why did you come here?

Why didn't you go straight to the corner house?

SON: I don't know

WIFE: Its silly

When you're given these things to do you must make it easy for yourself

Otherwise they cant be done

Quickly!

Go and do it

She puts the SON *into his jacket*

I'll help you with your jacket

There，I'll fasten the buttons

My boy I'll help you as I did when you were a child

I'll always be here to help you whenever you need me

I'll go with you to the corner house

SON：No...

WIFE：Look：a loose button

That must be sewn on when you come back

There isnt time now

She gives him his helmet.

We cant let the officers see you without a button

They're so intolerant

Yes you look smart

Take your gun to the corner house

She gives him his gun.

They'll be home：the curfew's begun

Come back quickly

The SON *takes his gun and goes.*

The WIFE *sits on the bench.*

After the WIFE *has been speaking for a while the* MONSTER *goes to the bench and sits facing away from her.*

He wont shoot the woman

The old man's ill

He's the one

Wouldnt last two days in a famine

I tell you when I saw him I wanted to run away

Crossed to the other side of the street

A dog put its head down and barked at him

Staring eyes and thin：my life!...

He had that white face you see on the freaks in the ruins

I thought he was carrying two big stones but they were his hands

The empty carrier bag she'd tied round his neck on a string had more in it than him

Perhaps our son will be lucky：if he could find him dead everything would be simple

Lift him out onto the floor and gently put a bullet in him

If I cook will he eat?

MONSTER: It's just another job for him

He didn't go straight to the corner house because it didnt even occur to him to get it over quickly

WIFE: What planet d'you come from?

No one's life was ever saved because they couldnt find someone to kill him!

If it says you're killed you're killed

Its better if he does it

He wont gloat or be crueller than he has to be

What d'you want from him?

Would it make killing more human if he was ashamed of doing it?

I know what they did to him before he could do it

Pity him

She lifts the MONSTER's *hand and with formal intimacy kisses the back of the wrist.*

Pity him...

How often are we allowed to live in our own century?

I've walked in it once or twice

Put my hands into it once or twice as if I was blindfold and groped inside a strange box

We lay the table and eat off the floor

We dont own our lives

They're owned by savages: that's why we're cruel

I'll prepare the meal and first we'll wait on him and then sit down and eat with him to show respect

Things may happen that will make today seem so trivial we'll forget it

As long as we can sit at our table its an ordinary day

The roof's over our heads: the walls arent burning

If we havent learned to sit at our table while the murderers walk the streets we dont know how our neighbours have had to live for years

If they put a pistol to my head I'll go on washing the dishes as if they hadnt entered my house

How else shall we live?

The SON *arrives at the* ALISON's *house* (*another part of the stage*).

SON:

1

When we were children we called this the corner house that stands where three roads meet

2

Mrs Alison

Its your neighbours' son

The soldier

Open the door

Is it all right to come in?

No I wont sit down

If you like

The SON *brings a chair and sits.*

3

You have to leave the house every week to collect your security?

You'll be all right if you hurry

Dont stop even for people you know

Has Mr Alison been to hospital?

No，his tie：its mostly only officials who wear ties

Your generation tries to keep up standards

4

Ten years since I played in the street

Now it'd be safer to play in a minefield

Thank god for the government child pens

I suppose the changes bewilder you

The old days wont come again

You're tired of the new ones

（You can shoot now they're calm）

5

The room seemed bigger when I was a child

I could touch the ceiling

My mother (why dont you kill him?) is cooking

Its late

（He'd lie on the floor like a raincoat in a jumble sale

For anyone to buy

You put it on and look in the mirror：

The stranger's still wearing it）

My mother said hurry

Bolt the door after me so that even I couldnt get in

The SON *leaves the* ALISON*'s house. He stands lost. The* MONSTER*'s* WIFE *fetches a breadknife and the remains of a loaf，sits on the bench and cuts the loaf into slices. The* SON *goes to the bench.*

WIFE：You didnt let the meal get cold

That's right

Do your hands need a wash?

The supermarkets have soldiers to guard the tins

I'd like to see a full saucepan again

The MONSTER's WIFE *offers bread to the* MONSTER *and the* SON.

The MONSTER *holds his bread in his hand.*

The MONSTER's WIFE *eats mechanically.*

I should go and watch with her

You sent her out of the room but she came back when you fired

I'd ask her here if I thought she'd come

She wouldnt speak to me

That'll pass

She'll have to put up with it like the rest

We live with what there is like bees getting honey from flowers on a litter heap

SON: Dad I couldnt kill him

He was old

His bones were as weak as a broken fence

A few sprawling sticks on an allotment that wouldnt keep out the three-legged dogs

The SON *shoots the* MONSTER.

The MONSTER *dies immediately: he drops his bread.*

WIFE: He's dead!

You're mad!

He's come to kill us all!

The MONSTER's WIFE *runs out.*

The SON *picks up the pieces of bread and sits on the bench.*

MONSTER: Praise this soldier

Why did he kill his father and not the stranger?

Under his scars the flesh was whole

Praise him as you would the first wheel

The first pitcher that held water

The first wall that stood on the earth as still as a startled animal

The first cutting that gave fruit to a barren tree

For all of us there is a time when we must know ourself

No natural laws or legal codes will guide us

Notions of good and evil will say nothing

The problems these things solve are not serious

We stand more naked than when we were born

Our life can be crushed as easily as an ant by an army

But at this time we could not be crushed even by the weight of the continent on which the army marched

We know ourself and say：I cannot give up the name of human

All that is needed is to define rightly what it is to be human

If we define it wrongly we die

If we define it and teach it rightly we shall live

The first playwrights said know yourself

My son learned it was better to kill what he loved

Than that one creature who is sick or lame or old or poor or a stranger should sit and stare at an empty world and find no reason why it should suffer

The MONSTER *goes*.

SON：The massacre has begun in the streets

There is a string of clouds in the sky

Sit here for a while

Then go to the ruins where the people are

The SON *goes*.

四、思考题

1. 如何理解开篇中"怪物"和母亲各自的独白？如何理解剧中"怪物"这一人物？他以何种口气开始讲述这个故事？在其开篇第一句话"Along of creatures we know that we pass between birth and death/And wish to teach each new mind to be..."中，"我们"指的是谁？

2. 在"怪物"开篇的独白中，他说："在所有生物之中，唯有人类知道自己要从生走到死/却又希望把每个孩子的心调教得像清澈的大海/无论从岸边的哪个位置，都可以一眼望到底……我们完全不用怀疑孩子们认为的那样，世界被上帝看守/但是，我们现在却杀了他们。"这段话如何反映了邦德的"理性剧场"戏剧理念？邦德如何通过这段独白，提出本剧的核心主题：人类何以从爱的传播者变成了恶的制造者？

3. 对于"怪物"和剧中其他人物来说，"人性"的内涵是什么？邦德是怎样对这种人性观进行批判的？

4. 在第八场中，"怪物"的儿子又是怎样陈述他的士兵身份和回乡要执行的任务的？对于他的任务，怪物和他妻子的态度如何？这折射出怎样的道德观念？

5. 批评家彼得·比林厄姆(Peter Billingham)曾说过，"戏剧事件"的目的是凸显场景中的重要瞬间，目标是超越瞬间，实现对造成这些事件的社会及政治语境的分析，推动观众参与意义的生成。你对此如何理解？在本场中，邦德构建出了一个怎样的"戏剧事件"？这个"戏剧事件"的核心是什么？

五、本节推荐阅读

［1］Acheson，James，ed. *British and Irish Drama since 1960*. Macmillan：St. Martin's Press，1993.

［2］Billingham，Peter. *Edward Bond: A Critical Study*. Hampshire：Palgrave Macmillan，2014.

［3］Mangan，Michael. *Edward Bond*. Plymouth：Northcote House Publishers，1998.

［4］Bond，Edward. *Plays: Two*. London：Methuen Ltd，1972.

［5］Bond，Edward. *The Hidden Plot*. London：Methuen，2000.

［6］Roberts，Philip，ed. *Bond on File*. London：Methuen，1985.

第三节　哈罗德·品特及其《尘归尘》

一、哈罗德·品特简介

作为 2005 年诺贝尔文学奖的得主,哈罗德·品特是当代英国戏剧史上最伟大的剧作家之一。他所形成的"品特式风格""威胁喜剧"(Comedy of Menace)和"记忆戏剧"(Memory Play)已成为戏剧词典里的重要术语。

1930 年,品特出生在伦敦东区一个普通的犹太家庭,祖上来自东欧。和邦德一样,二战改变了他的人生观和世界观。战争期间与家人的分离、盖世太保、大屠杀等事件让品特看到了人性的残暴,感到暴力和威胁无处不在。这一经历给品特留下了终身的影响。一方面,纳粹的暴行使品特一生都在关注人类社会关系的心理现实,他想知道,为什么如此惨绝人寰的大屠杀会出自德国这一高度文明的民族之手,这种困惑在品特的思想中几乎发展成了一种德国情结。这使他在戏剧创作中一次又一次地回到暴力、迫害、恐怖和背叛的主题,用舞台情景来展演和思考隐藏在暴行之下的人性现实。另一方面,大屠杀的经历也使他对现实中的迫害、摧残和暴力有一种本能的道德反叛,使他对一切不平之事深恶痛绝。1948 年,18 岁的品特曾拒服兵役,他的理由是:"我清楚战争带来的灾难和恐怖,无论如何我都不会为战争出力。"[①]为此他两次被送上军事法庭,险受牢狱之灾。品特在这一事件中表现出的对社会权威的反叛情绪后来发展成了对恃强欺弱者的愤怒和对弱者的同情,使他在任何情况下,都本能地站在受害者一方来对抗任何形式的权威。

品特的创作始于 1957 年的《房间》(The Room)一剧,这也是他的第一个"房间剧"(room play)。在接下来的 10 年中,他创作了一系列具有"品特式风格"的戏剧作品,如《生日晚会》《升降机》《看房人》(The Caretaker,1960)、《归家》(The Homecoming,1965)等。作为他的首部经典作品,《生日晚会》在上演时几乎被一片批评之声淹没,剧中那种不可言状的威胁感、模糊不清的意义和谜一样的对白不仅使导演和演员感到茫然,也使评论界感到震惊。在很多剧评家眼里,这部剧就像是一个无法类比的怪物,令人费解,人们纷纷指责它的晦涩和空洞。直到后来《看房人》出现,人们才逐渐意识到这是一种全新的戏剧创作,在品特看似荒诞的剧情中隐含深刻的政治和哲学意义,这就是著名的品特式"威胁喜剧"。

20 世纪 70 年代之后,品特进入了以"记忆戏剧"为特征的第二个创作阶段。对于品特来说,这段时间是他一生中最为困惑的 10 年:在思想上,他感到自己早期"威胁喜剧"中的非政治性创作与他本人的真实政治立场之间存在着巨大的矛盾;在生活上,他因与妻子的婚姻出现危机而陷入了 10 年的离婚历程,直到 1980 年才得以解脱。在这种精神困境之中,他写了《昔日》(Old Times,1971)、《虚无乡》(No Man's Land,1970)、《背叛》(Betrayal,1978),直到创作出《他乡三部曲》(Other Places: Victoria Station, A Kind of Alaska, Family Voices,1982),这种困境才被打破。品特这一时期的戏剧与早期

① Michael Billington,The Life and Work of Harold Pinter. London:Faber and Faber,1996,p.24.

的"威胁喜剧"相比,在创作风格和主题上发生了很大变化。在主题上,他从早期的"威胁"主题转向了婚姻、性别、背叛等主题。在风格上,他开始从"威胁喜剧"转向"记忆戏剧"。这些剧作之所以被称为"记忆戏剧",是因为人物对白中提到的"过去"是一个可以随意编织、篡改和穿梭的记忆文本,人们无从知道人物所说的记忆到底是真是假,甚至无法确认剧中人物是否真的存在过。但重要的是,不管他们的谈话内容真假与否,这些由记忆构成的对白反映了讲话者的内心现实。

进入 20 世纪 90 年代之后,《月光》(Moonlight,1993)和《尘归尘》两部力作将品特的创作再次推向高峰。在艺术上,品特式的"记忆"话语和充满弦外之音的文字游戏仍主宰着他的戏剧策略;在内容上,这两部作品虽在主题上回到了他一直关注的家庭、政治议题上,但此时的他已没有了早期的模糊和中期的困惑,走过了 50 年的写作生涯,品特在很多问题上悟出了自己的答案。

2005 年,品特获得诺贝尔文学奖。瑞典文学院在给品特的授奖辞中写道:"品特使戏剧的基本元素得以恢复:一个封闭的空间,以及难以预知的对话,人物在这些对话中受到彼此的控制,一切虚伪土崩瓦解。他的戏剧揭示出隐藏在日常闲谈之下的危机,并强行打开了受压抑的封闭空间。"[①]这一评价指出了品特戏剧的本质。品特无疑是当代英国戏剧史上的一个神话,正如批评家金博尔·金(Kimball King)所说,不管贝克特的戏剧呈现出何种意义的浓缩,也不管奥斯本对英国舞台的贡献具有何种里程碑的地位,品特戏剧诗一般的品质使他最终凌驾于所有同辈人之上。[②]

二、《尘归尘》[③]介绍

《尘归尘》是品特后期创作中最具代表性的政治剧作。在该剧中,政治以大屠杀的记忆和集体迫害的意象出现在人们的面前,该剧展现了国家权力对个体意志的渗透和瓦解。

关于《尘归尘》,品特明确表示,它的创作灵感来自纳粹德国。[④] 虽然剧中只有两个人物,但它却深刻展现了人类历史上那段骇人听闻的记忆。本剧以一幅两性关系的画面开始:"他将另一只手放在我的脖子上,把我的头拉向他的身旁。他将拳头……紧贴着我的嘴唇,让我吻他的拳头。"(395)这幅画面所呈现的主宰与被主宰的性别关系,在接下来的情节中被赋予了历史和政治的内涵,并最终升华到了人类集体意识的高度:画面中的"他"(德夫林)成了无数个法西斯式人物的代表,而那个被迫"吻"他拳头的女人(丽贝卡)则成了遭受凌辱的人类受害者的化身。

在女主人公丽贝卡的"记忆"中,"他"是一个"旅行社"的"导游"(guide,也可以理解为"领路人""领航员")。"他"曾带着她去过"他"的"工厂",工厂像是一艘"大船",那里的人们狂热地追随"他"所代表的信念,在合唱中和"他"一起走向悬崖,跳进大海。在这个意象中,"他"无疑就像德国纳粹精神的代表,而"工厂"的意象不禁让人想到臭名昭彰的杀人工厂,工厂中的工人则是民众的化身,如此高度文明的一个民族竟跟在法西斯分子所谓的责任、信仰、种族等狂热的国家民族主义大旗后面,走向了民族自杀的"悬

① 品特,转引自石剑峰:"诺贝尔奖得主哈罗德-品特:一生都在做演员"。2008 - 12 - 27.http://yule.sohucom/20081227/nz614s1489.shtml.

② Kimball King,"Harold Pinter's Achievement and Modern Drama". In Lois Gordon,ed.,*Pinter at 70*,*A Casebook*. New York and London:Routledge,2001,p.243.

③ Harold Pinter,*Ashes to Ashes*. In *Harold Pinter: Plays 4*. London:Faber and Faber,1993. 以下出自该剧本的引文页码随文注出,不单列脚注。

④ Harold Pinter,*Various Voices: Prose,Poetry,Politics,1948 - 1998*. London:Faber and Faber,1998,p.65.

崖"。这种盲从的意象透过丽贝卡的"记忆"出现在舞台上：

> 我看见一大群人，穿过林子，朝着大海走去……一些领路人带领着他们走着……我远远地望见，他们穿过树林，走过了悬崖，向大海走去……那是一个晴朗的日子，阳光明媚，周围一片静谧。我看见所有人就这样走进了大海，海水慢慢地淹没了他们，他们随身带的包裹在波浪中漂来漂去。(416)

在女人的"记忆"中，这个没有个体意志、只有集体意识的群体是一个国家暴力的生产者：作为那个旅行社的"导游"，剧中的"他"曾经的工作是"到火车站的站台上，从一个个哭喊着的母亲手里夺走她们的婴儿"(406-407)。所有这些——抢夺孩子、杀人工厂、跟随狂人领袖走下悬崖的意象，无不唤起人们对二战的记忆。二战是人类历史上最恐怖的噩梦之一，虽已过去几十年，但关于它的记忆却没有消失，它被永远地封存在人类创伤性的集体意识里。对品特来说，二战是强权对弱势的野蛮吞噬，他在所有暴行中都看到了它的影子。

但是，在品特的作品中，没有哪一部能像《尘归尘》那样如此深刻地揭示政治关系的心理现实。在《尘归尘》中，品特对政治的书写角度更多的是从迫害者的心理转向了受害者的心理，以此向世人揭示，权力关系不仅是强与弱的道德关系和政治关系，也是一场双方共同参与的"权力游戏"。从心理层面上讲，剧中身为受害者的"她"和作为权力拥有者的"他"一样渴望获得权力。虽然从传统性别的角度来看，丽贝卡是一个"受压迫者"，但在剧中，她在被压迫的同时，也一直努力以自己独特的方式来制定规则，以此操纵权力"游戏"。在这对权力关系中，丽贝卡并没有被动地接受被人宰割的命运，相反，我们在她身上看到了渴望主宰他人的愿望。在剧中，虽然她处于屈从的地位，但她不时也会表现出强烈的颠覆性，甚至主宰性的冲动。随着剧情的发展，我们意识到，剧中人物其实生活在两个不同的世界里：男人的世界是由"社会语言"构建的父权世界，女人的世界则是由"记忆语言"构建的话语世界。在与"他"的对白中，丽贝卡死死地抓着手里的那支"笔"——那支可以使她随意编写自己故事的"话语之笔"。当她对"他"说"笔是没有父母的""这是一支清白无辜的笔"(410)时，她在努力构建一种自己的叙述，以此超越传统父权话语的束缚，从而获得自我构建的空间。所以，尽管"他"竭力要把她的叙述拉回到"现实"的框架中，她却一再拒绝从虚构话语的保护壳里出来，因为只有在这种话语世界里，她才能重新"书写""他"的历史，为自己赢得一片天地。

随着剧情的发展，观众开始怀疑丽贝卡"记忆"里的那个男人到底代表着什么？她"记忆"中的"他"是否是她本性中的另一个声音？是否是她无法实现的欲望的象征？如果真是这样的话，人们将不得不重新理解"工厂"所代表的含义。那个"工厂"就像是一个权力工厂，在那里，每一个人都跟着权力狂人的指引，集体生产着暴行。所以，丽贝卡在花园窗口里看到的那个画面——一大群人在走下悬崖，走向大海——不仅仅是德国民族盲从的一个意象，也是整个人类跟随权力欲望走向灾难的象征。

有人曾问品特，是什么原因使他如此执着于书写恐怖的主题？它是否意味着他心里装满了黑暗和恐怖？品特的回答是，不仅他的"心里装满了黑暗和恐怖，我们每个人的心中都装满了恐怖"①。透过这部剧，品特意在向所有人亮起红色的警告，告诉人们政治暴力的源头存在于每一个人的心中，从这一点

① Michael Billington, *The Life and Work of Harold Pinter*. London: Faber and Faber, 1996, p.93.

上讲,《尘归尘》和威廉·戈尔丁(William Golding)的《蝇王》(*Lord of the Flies*,1954)似乎在讲述着同一个故事。

《尘归尘》是一个独幕剧,没有场次之分。本书节选该剧中间的一部分。

三、《尘归尘》选读①

Ashes to Ashes

...

REBECCA:By the way,I'm terribly upset.

DEVLIN:Are you? Why?

REBECCA:Well,it's about that police siren we heard a couple of minutes ago.

DEVLIN:What police siren?

REBECCA:Didn't you hear it? You must have heard it. Just a couple of minutes ago.

DEVLIN:What about it?

REBECCA:Well,I'm just terribly upset.

Pause.

I'm just incredibly upset.

Pause.

Don't you want to know why? Well,I'm going to tell you anyway. If I can't tell you who can I tell? Well,I'll tell you anyway. It just hit me so hard. You see...as the siren faded away in my ears I knew it was becoming louder and louder for somebody else.

DEVLIN:You mean that it's always being heard by somebody,somewhere? Is that what you're saying?

REBECCA:Yes. Always. For ever.

DEVLIN:Does that make you feel secure?

REBECCA:No! It makes me feel insecure! Terribly insecure.

DEVLIN:Why?

REBECCA:I hate it fading away. I hate it echoing away. I hate it leaving me. I hate losing it. I hate somebody else possessing it. I want it to be mine,all the time. It's such a beautiful sound. Don't you think?

DEVLIN:Don't worry,there'll always be another one. There's one on its way to you now. Believe me. You'll hear it again soon. Any minute.

REBECCA:Will I?

DEVLIN:Sure. They're very busy people,the police. There's so much for them to do. They've got so

① Harold Pinter,*Ashes to Ashes*. In *Harold Pinter: Plays 4*. London:Faber and Faber,1993,pp.407 – 419.

much to take care of, to keep their eye on. They keep getting signals, mostly in code. There isn't one minute of the day when they're not charging around one corner or another in the world, in their police cars, ringing their sirens. So you can take comfort from that, at least. Can't you? You'll never be lonely again. You'll never be without a police siren. I promise you.

Pause.

Listen. This chap you were just talking about...I mean this chap you and I have been talking about...in a manner of speaking...when exactly did you meet him? I mean when did all this happen exactly? I haven't...how can I put this...quite got it into focus. Was it before you knew me or after you knew me? That's a question of some importance. I'm sure you'll appreciate that.

REBECCA: By the way, there's something I've been dying to tell you.

DEVLIN: What?

REBECCA: It was when I was writing a note, a few notes for the laundry. Well...to put it bluntly...a laundry list. Well, I put my pen on that little coffee table and it rolled off.

DEVLIN: No?

REBECCA: It rolled right off, onto the carpet. In front of my eyes.

DEVLIN: Good God.

REBECCA: This pen, this perfectly innocent pen.

DEVLIN: You can't know it was innocent.

REBECCA: Why not?

DEVLIN: Because you don't know where it had been. You don't know how many other hands have held it, how many other hands have written with it, what other people have been doing with it. You know nothing of its history. You know nothing of its parents' history.

REBECCA: A pen has no parents.

Pause.

DEVLIN: You can't sit there and say things like that.

REBECCA: I can sit here.

DEVLIN: You can't sit there and say things like that.

REBECCA: You don't believe I'm entitled to sit here? You don't think I'm entitled to sit in this chair, in the place where I live?

DEVLIN: I'm saying that you're not entitled to sit in that chair or in or on any other chair and say things like that and it doesn't matter whether you live here or not.

REBECCA: I'm not entitled to say things like what?

DEVLIN: That that pen was innocent.

REBECCA: You think it was guilty?

Silence.

DEVLIN: I'm letting you off the hook. Have you noticed? I'm letting you slip. Or perhaps it's me who's slipping. It's dangerous. Do you notice? I'm in a quicksand.

REBECCA: Like God.

DEVLIN: God? God? You think God is sinking into a quicksand? That's what I would call a truly disgusting perception. If it can be dignified by the word perception. Be careful how you talk about God. He's the only God we have. If you let him go he won't come back. He won't even look back over his shoulder. And then what will you do? You know what it'll be like, such a vacuum? It'll be like England playing Brazil at Wembley and not a soul in the stadium. Can you imagine? Playing both halves to a totally empty house. The game of the century. Absolute silence. Not a soul watching. Absolute silence. Apart from the referee's whistle and a fair bit of fucking and blinding. If you turn away from God it means that the great and noble game of soccer will fall into permanent oblivion. No score for extra time after extra time after extra time, no score for time everlasting, for time without end. Absence. Stalemate. Paralysis. A world without a winner.

Pause.

I hope you get the picture.

Pause.

Now let me say this. A little while ago you made...shall we say...you made a somewhat oblique reference to your bloke...your lover?...and babies and mothers, et cetera. And platforms. I inferred from this that you were talking about some kind off atrocity. Now let me ask you this. What authority do you think you yourself possess which would give you the right to discuss such an atrocity?

REBECCA: I have no such authority. Nothing has ever happened to me. Nothing has ever happened to any of my friends. I have never suffered. Nor have my friends.

DEVLIN: Good.

Pause.

Shall we talk more intimately? Let's talk about more intimate things, let's talk about something more personal, about something within your own immediate experience. I mean, for example, when the hairdresser takes your head in his hands and starts to wash your hair very gently and to massage your scalp, when he does that, when your eyes are closed and he does that, he has your entire trust, doesn't he? It's not just your head which is in his hands, is it, it's your life, it's your spiritual...welfare.

Pause.

So you see what I wanted to know was this...when your lover had his hand on your throat, did he remind you of your hairdresser?

Pause.

I'm talking about your lover. The man who tried to murder you.

REBECCA: Murder me?

DEVLIN: Do you to death.

REBECCA: No, no. He didn't try to murder me. He didn't want to murder me.

DEVLIN: He suffocated you and strangled you. As near as makes no difference. According to your account. Didn't he?

REBECCA: No, no. He felt compassion for me. He adored me.

Pause.

DEVLIN: Did he have a name, this chap? Was he a foreigner? And where was I at the time? What do you want me to understand? Were you unfaithful to me? Why didn't you confide in me? Why didn't you confess? You would have felt so much better. Honestly. You could have treated me like a priest. You could have put me on my mettle. I've always wanted to be put on my mettle. It used to be one of my lifetime ambitions. Now I've missed my big chance. Unless all this happened before I met you. In which case you have no obligation to tell me anything. Your past is not my business. I wouldn't dream of telling you about my past. Not that I had one. When you lead a life of scholarship you can't be bothered with the humorous realities, you know, tits, that kind of thing. Your mind is on other things, have you got an attentive landlady, can she come up with bacon and eggs after eleven o'clock at night, is the bed warm, does the sun rise in the right direction, is the soup cold? Only once in a blue moon do you wobble the chambermaid's bottom, on the assumption there is one—chambermaid not bottom—but of course none of this applies when you have a wife. When you have a wife you let thought, ideas and reflection take their course. Which means you never let the best man win. Fuck the best man, that's always been my motto. It's the man who ducks his head and moves on through no matter what wind or weather who gets there in the end. A man with guts and application.

Pause.

A man who doesn't give a shit.

A man with a rigid sense of duty.

Pause.

There's no contradiction between those last two statements. Believe me.

Pause.

Do you follow the drift of my argument?

REBECCA: Oh yes, there's something I've forgotten to tell you. It was funny. I looked out of the garden window, out of the window into the garden, in the middle of summer, in that house in Dorset, do you remember? Oh no, you weren't there. I don't think anyone else was there. No. I was all by myself. I was alone. I was looking out of the window and I saw a whole

crowd of people walking through the woods, on their way to the sea, in the direction of the sea. They seemed to be very cold, they were wearing coats, although it was such a beautiful day. A beautiful, warm, Dorset day. They were carrying bags. There were...guides...ushering them, guiding them along. They walked through the woods and I could see them in the distance walking across the cliff and down to the sea. Then I lost sight of them. I was really quite curious so I went upstairs to the highest window in the house and I looked way over the top of the treetops and I could see down to the beach. The guides...were ushering all these people across the beach. It was such a lovely day. It was so still and the sun was shining. And I saw all these people walk into the sea. The tide covered them slowly. Their bags bobbed about in the waves.

DEVLIN: When was that? When did you live in Dorset? I've never lived in Dorset.

Pause.

REBECCA: Oh by the way somebody told me the other day that there's a condition known as mental elephantiasis.

DEVLIN: What do you mean, 'somebody told you'? What do you mean, 'the other day'? What are you talking about?

REBECCA: This mental elephantiasis means that when you spill an ounce of gravy, for example, it immediately expands and becomes a vast sea of gravy. It becomes a sea of gravy which surrounds you on all sides and you suffocate in a voluminous sea of gravy. It's terrible. But it's all your own fault. You brought it upon yourself. You are not the *victim* of it, you are the *cause* of it. Because it was you who spilt the gravy in the first place, it was you who handed over the bundle.

Pause.

DEVLIN: The what?

REBECCA: The bundle.

Pause.

DEVLIN: So what's the question? Are you prepared to drown in your own gravy? Or are you prepared to die for your country? Look. What do you say, sweetheart? Why don't we go out and drive into town and take in a movie?

REBECCA: That's funny, somewhere in a dream...a long time ago...I heard someone calling me sweetheart.

Pause.

I looked up. I'd been dreaming. I don't know whether I looked up in the dream or as I opened my eyes. But in this dream a voice was calling. That I'm certain of. This voice was calling me. It was calling me sweetheart.

Pause.

Yes.

Pause.

I walked out into the frozen city. Even the mud was frozen. And the snow was a funny colour. It wasn't white. Well，it was white but there were other colours in it. It was as if there were veins running through it. And it wasn't smooth，as snow is，as snow should be. It was bumpy. And when I got to the railway station I saw the train. Other people were there.

Pause.

And my best friend，the man I had given my heart to，the man I knew was the man for me the moment we met，my dear，my most precious companion，I watched him walk down the platform and tear all the babies from the arms of their screaming mothers.

Silence.

DEVLIN：Did you see Kim and the kids?

She looks at him.

You were going to see Kim and the kids today.

She stares at him.

Your sister Kim and the kids.

REBECCA：Oh，Kim! And the kids，yes. Yes. Yes，of course I saw them. I had tea with them. Didn't I tell you?

DEVLIN：No.

REBECCA：Of course I saw them.

Pause.

DEVLIN：How were they?

四、思考题

1. 在选读部分的开始，丽贝卡提到黑夜里的警笛时说道：“我恨别人拥有它，我希望它永远都是我的，警笛的声音是那么优美。”你如何理解此处“警笛”这一意象和它的语义？

2. 在节选中，丽贝卡和德夫林围绕着“笔”进行了一场精彩的话语博弈。丽贝卡坚持说，那是“一支清白无辜的笔”，而德夫林却否认说：“那是因为你不知道这支笔从哪里来，你更不知道有多少人的手曾经握过它，用它书写过……你对它的历史一无所知，对它父母的历史一无所知。”对此，丽贝卡则驳斥说：“一支笔是没有父母的。”分析上下文，这段对话表现出两人怎样的权力交锋？

3. 请对选读中丽贝卡和德夫林的对白进行系统分析，思考一下：他们的权力交锋表现出怎样的模式？

4. 品特曾说过：“在《尘归尘》中，我不仅仅是在说纳粹，也在讲我们每一个人。”你如何理解这句话？

五、本节推荐阅读

[1] Billington，Michael. *The Life and Work of Harold Pinter*. London：Faber and Faber，1996.

［2］Demastes，William W.，ed. *British Playwrights，1956－1995*. London：Greenwood Press，1996.

［3］Esslin，Martin. *Pinter: The Playwright*. London：Methuen，1973.

［4］Gussow，Mel. *Conversations with Pinter*. New York：Limelight Edition，1994.

［5］Innes，Christopher. *Modern British Drama，1890－1990*. Cambridge：Cambridge University Press，1992.

［6］Peacock，D. Keith. *Harold Pinter and the New British Theatre*. Westport：Greenwood Press，1997.

［7］Raby，Peter，ed. *The Cambridge Companion to Harold Pinter*. Cambridge：Cambridge University Press，2001.

［8］陈红薇：《战后英国戏剧中的哈罗德·品特》,北京：对外经济贸易大学出版社,2007 年.

第四节 霍华德·布伦顿及其《罗马人在英国》

一、霍华德·布伦顿简介

霍华德·布伦顿是第二次浪潮中社会性剧作家的主要代表人物。他于 1942 年出生在波特茅斯,父亲先是一位警察,后来成了一名卫理公会牧师。1962 年,布伦顿进入剑桥大学学习,但后来却陷入了强烈的反文化倾向,弃学写作。为了维持生计,他曾在工厂和后厨里做过零工,这段经历使他对劳动阶层的生活和价值观有了深刻的认识。

布伦顿和大多数同代人一样也有过政治理想,也曾热烈地投身于暴风骤雨般的政治运动,1968 年发生在欧洲的一系列事件对他也是一种精神上的洗礼——巴黎学潮的失败标志着 20 世纪 60 年代欧洲无政府主义运动的终结,它对英国左翼知识分子产生了无法估量的影响,改变了无数英国年轻人的政治信仰。经过此洗礼,布伦顿开始像众多第二次浪潮的剧作家一样,用批判的目光重新审视传统历史和神话。他发现,现代社会之所以充满暴力和不公,是因为无数个世纪以来人们都生活在各种历史和政治神话的幻影之中,他决定通过舞台来解构世人在思想上的虚幻,用新的话语来重新诠释历史。

1973 年的《高尚》是布伦顿创作的一个分水岭,它标志着布伦顿从边缘剧场向英国主流剧场的转变。从内容上来讲,布伦顿的剧作大致可分为两类:一类是以社会主义政治为主题的系列作品,另一类是对英国政治神话和历史的再写作品。第一类主要包括《幸福的武器》《疼痛的嗓子》《血淋淋的诗歌》《绿地》,它们反映了布伦顿在左翼事业受到致命打击之后对政治理想的反思。关于《幸福的武器》,他曾说过,每当回想 60 年来的斗争,它都让人感到一种刻骨的痛苦,剧中人物弗兰克所代表的就是这种痛苦。[1] 接下来的三部剧作《疼痛的嗓子》《血淋淋的诗歌》《绿地》通常被人们称为"乌托邦三部曲"。其中,《血淋淋的诗歌》的核心是探讨革命热情和严酷现实之间的矛盾。剧中始终回响着玛丽·雪莱对她丈夫说的一句话:"没完没了的一切——毫无希望的——计划和梦想——可你到底实现了什么……难道一首诗歌的代价——就是我们孩子的生命吗?"[2]在剧中,诗人雪莱的形象像一把在绝望中燃尽的火焰——他逃避婚姻,逃避债务,逃避政治和文坛体制对他没完没了的迫害,直到死亡。和雪莱一样,拜伦以近乎疯狂的热情去拥抱希腊的自由之战和死亡。该剧打动观众的并非诗人们的理想主义,而是他们在追逐乌托邦理想时一次次"跌倒在生活的荆棘上"、遍体鳞伤的悲壮。关于该剧,布伦顿曾说:"剧中的雪莱带有明显的 60 年代后期激进主义者的特征……如果雪莱没有死去,世界一定会因他而不同。他也许会成为另一个但丁,也许会以激进的态度挑战狄更斯,让后者变得更加进步,他也许还会见到卡尔·马克思。"[3]作为个体,理想主义者也许在现实中会像雪莱那样注定失败,但通过创作这样的政治戏剧,

① Howard Brenton. In interview with Tony Mitchell, "The Red Theatre under the Bed". *New Theatre Quarterly*, 11 Aug. 1987, p.196.

② Howard Brenton, *Bloody Poetry*. London & New York: Methuen, 1985, p.74.

③ Howard Brenton, "Brenton's Erehwon". In interview with Robert Gore-Langton. *Plays and Players*, Apr. 1988, p.10.

布伦顿希望像剧中的诗人一样,用异托邦般的现实,来点亮未来的乌托邦梦想。这也解释了为什么布伦顿会说:"他们是失败了,他们彼此之间是有些残忍,但我仍旧要写这部剧来歌颂他们,向他们敬礼!"因为"他们属于我们"[①]。

虽然布伦顿的这类作品很有深度,但就其在当代英国戏剧史上的成就而言,他主要以另一类剧作经典而著称。《丘吉尔的戏剧》《罗马人在英国》《第十三夜》(*Thirteenth Night*,1981)等作品集中反映了布伦顿那一代英国社会主义者在经历了20世纪六七十年代政治理想的幻灭之后对英国历史和文化传统的反思,体现了他们对西方政治神话的再写。其中,1981年的《第十三夜》在布伦顿的戏剧作品中具有特殊的位置:这是一部介于《罗马人在英国》和"乌托邦三部曲"之间的过渡性作品,既有前者的再写风格,又兼具后者的乌托邦主题。在该剧中,布伦顿从文化唯物主义的角度再写莎剧《麦克白》,通过主人公杰克异托邦式的梦境叙述,构建了一个从充满理想主义的英国工党领袖,堕落为麦克白式独裁人物的政治寓言,表达了那一代青年在历经了精神破灭之后对未来社会的乌托邦情怀。

进入21世纪后,布伦顿一直笔耕不辍,其中具有代表性的作品是《保罗》(*Paul*,2005)和《从没这么好过》(*Never So Good*,2008),前者以极具争议和影响力的基督教"创始者"保罗为对象,后者则是以20世纪保守党领袖哈罗德·麦克米伦(Harold Macmillan)为对象进行创作。两部作品均引起了很大的轰动。

二、《罗马人在英国》[②]介绍

《罗马人在英国》是布伦顿最负盛名的代表之作,也是其改写英国历史神话的一部力作。在该剧中,布伦顿以后现代的叙事,将古今三段历史互文拼贴,讲述了公元前55年罗马人的入侵、515年撒克逊人的到来、1980年英国对爱尔兰的占领这三次征服和冲突。

从情节上讲,该剧共分为两部分。第一部分展现的是罗马人对英国的入侵。本剧开始时,两名爱尔兰逃犯走出森林,寻找去大海的路,却遭遇了三个凯尔特兄弟的攻击,其中一个叫马班,是部落的祭司。尽管爱尔兰人一再声称他们是误入部落领地,无意伤害任何人,但三个年轻人还是对他们进行了追杀,一个爱尔兰人被杀死,另一个人逃入森林。很快,真正的入侵者罗马人到来了。当心满意足的三兄弟在河边晒着太阳时,三个罗马士兵突然出现,杀死了其中的两个年轻人。关键时刻,马班一口拉丁文救了他的命。他们把这个会说拉丁语的"怪物"带到了凯撒面前。凯撒虽然下令释放了这个会说拉丁语的祭司,却将一个象征着罗马宗教的维纳斯女神像挂在了他的脖子上,然后任由士兵强奸了马班。在第一部分的最后,侥幸逃走的爱尔兰人遇到了一个女奴,将其强奸后带她一同去寻找那个传说中的乐土。女奴却趁他不备,用石头砸死了他。在下一个瞬间,舞台画面突然切换到了20世纪80年代在爱尔兰的英国军队,一架直升机里的士兵用机枪射死了手握石头的女奴。

① Howard Brenton, "On Writing the Utopian Plays". *Greenland*. London:Methuen, 1988, p.3.
② Howard Brenton, *The Romans in Britain*. London:Methuen Drama, 1989. 以下出自该剧本的引文页码随文注出,不单列脚注。

本剧的第二部分更为复杂,两条情节线时而平行,时而交错。一条是 20 世纪英国军队在爱尔兰故事的延续;另一条则是罗马人离开英国之后撒克逊人到来的故事。在前一个故事里,英国军官奇切斯特装扮成爱尔兰农民在一片田地里干活,他的任务是寻找机会暗杀爱尔兰反抗领导人奥鲁尔克。尽管奇切斯特宣称自己是为国家利益而战,但心里却渴望和平。当暗杀的对象出现时,奇切斯特却被内心和平的愿望征服,他说自己是爱尔兰的朋友,不想再有杀戮。奥鲁尔克本想放了他,但他的爱尔兰母亲却愤怒地说道:"谁给他的权力让他站在爱尔兰的土地上,大谈战争的恐怖?"(98)于是,奥鲁尔克命令手下杀死了奇切斯特。在这个 20 世纪故事的中间,不时还穿插着 6 世纪的另一段历史。当时,基督教虽已传入,但岛上的凯尔特人却面临着新的威胁:撒克逊人来了。这段故事围绕着一位父亲和两个女儿进行。在这段故事中,女儿不仅杀死了一个掉队的撒克逊伤兵,还杀死了那个曾撩过她裙子的异教徒父亲。此外,故事中还有另外一行四人,即两个厨子、一位罗马贵妇和她的情人兼管家——此时,罗马人已离开英国一个世纪,身染瘟疫的罗马贵妇却还念念不忘她的帝国之梦,最终,她的情人用她手里的鞭子杀死了她。最后,两批挣脱了奴役的自由人——两个女儿和两个厨子——相遇并汇聚在一起。一个厨子说,他想做一个诗人,书写那个充满传奇色彩的亚瑟王,该剧在"亚瑟? 亚瑟?"的回声中拉上了帷幕。

在这部作品中,布伦顿以新历史主义的目光,从反传统的角度超越传统"史实"的束缚,重新解读历史和神话,将批判的矛头直指英国的民族性。布伦顿说过,他之所以写凯撒入侵英国的那段历史,是因为世人都知道那段历史,认为是罗马人在岛上修建了道路,给岛国的荒蛮部落带来了文明和法律。[①] 布伦顿创作此剧就是为了打破这种固化的历史观,揭露传统历史"神话"背后隐藏的真相:所谓历史神话,不过是政治、历史、文化等意识形态误导下的认知。就像布伦顿在《丘吉尔的戏剧》里对丘吉尔这位近代神话人物的颠覆一样,《罗马人在英国》重构了那个远古的神话:罗马人的出现彻底摧毁了岛上的部落文化,这对生活在岛上的凯尔特人来说无疑是灭顶之灾,是世界的末日。如部落祭司马班所说,就算罗马人走了,被他们撒过盐巴的田地在未来的数年里都将会寸草不生。即便是他的族人能从森林里的藏身之地走出来,罗马人用奇异的外来武器置入其体内的恐惧,也会永远笼罩在他们的内心深处。当然,布伦顿在本剧中所关心的焦点并非遥远的部落,而是当代英国社会本身。通过追溯英国人的祖先凯尔特人被征服和奴役的历史,布伦顿影射了 20 世纪英国人对爱尔兰的征服。众所周知,11 世纪之前的英国历史可以说是一个被外族入侵和征服的历史,但自文艺复兴以后,英国历史进入了征服他国的新篇章。虽然在剧中的古今两段历史中,英国人的角色已是天壤之别——从被征服者一跃变成了征服者——但两段历史所折射出来的政治内涵却是一样的。不论是凯撒,还是 20 世纪的英国士兵,当他们站在别人的土地上,并坚信自己是在播种文明和进步时,他们所做的都是屠杀和对当地民族的毁灭。穿梭于过去与现在的历史碎片中,该剧不仅推翻了由传统神话组成的历史思维定式,更使我们听到了传统历史话语下的异样喧哗。

本书节选的是《罗马人在英国》中的第一幕第一场、第五场、第六场以及第二幕的第七场。

① Howard Brenton, *Hot Irons: Diaries*, *Essays*, *Journalism*. London: Nick Hern Book, 1995, p.28.

三、《罗马人在英国》选读①

The Romans in Britain

Part One

Caesar's Tooth

On the run—A family and its fields—Two worlds touch—Fugitives and refugees—Caesar's tooth—The gods grow small—Two murders

The action takes place north of the River Thames on 27th August，54BC and the following dawn.

Scene One

Darkness. Dogs bark in the distance. Silence.

CONLAG： Where the fuck are we?

By the sea?

Daui?

DAUI： Day in，day out. Lying in a boat with salt round the back of my eyeballs. In a river up to my neck. Marshes with leeches. Moors with birds of prey. Rocks with wild cats. In sun，in rain，in snow—I have heard you ask where the fuck are we.

CONLAG： Well.

Where are we?

DAUI： How the fuck do I know?

All I do know is，three days of forest. Then that. Farms.

Stockades. Fields.

A silence.

CONLAG： You can smell their food. Smell how their teeth went into it. The little squirts of fat in the meat. The spit that washed it down. Yeah，you come out of the trees. You smell the meal，the fire，the family. All that you've lost.

DAUI: All that we've shat upon. And has shat upon us.

CONLAG： The criminal life. It's the boils that get you. Yeah，when you go on the run，you don't think about getting boils.

He sniffs.

Do you smell fish?

They both sniff.

① Howard Brenton，*The Romans in Britain*. London：Methuen Drama，1989，pp.11－14，pp.47－61，pp.96－99.

DAUI：No fish.

CONLAG：Could be near the sea，though. Maybe they don't eat fish for religious reasons.

DAUI：Do you hear the sea?

　　They listen.

CONLAG：Dogs.

DAUI：Dogs.

CONLAG：Dogfish?

DAUI：Just dogs.

CONLAG：Could be a strange sea，this side of Britain. Sea of dogs! Waves of tails! Rabid surf，all froth and teeth! Dogshit beaches!

DAUI：I'd put nothing past this country.

CONLAG：Better get back in the trees. Come dawn，see where we are.

DAUI：Three nights of trees. I'll not sleep under trees again.

CONLAG：Better，Daui. If men make you live like an animal—

DAUI：
CONLAG： } Be an animal.

CONLAG：True! It's true!

DAUI：Creepy crawlies. Things that are there and not there. Ghosts. Mantraps. Wild animals. Gods. All that rubbish. I'll not take that again.

CONLAG：But maybe these bastards aren't asleep. [...] Makes your hearing sharp. Makes you see in the dark too. They'll hear us! Run out and see us! With hard-ons! And kill us—or worse!

　　A silence. They burst out laughing.

DAUI：I never know when your brain's running out your nose or not.

　　The sound of DAUI *scuttling about.*

　　Not too wet here.

CONLAG：All right，all right. It's wrong. But I'm not the leader of this robber band.

　　Robber band of two poor fuckers.

DAUI：Brambles here. Do for the sleeper's wall. You got the bag?

CONLAG：Yes I've got the bag.

DAUI：Let me feel it.

CONLAG：I've got the bag.

DAUI：What have you done with the bag?

CONLAG：There is the bag! Dear oh dear.

DAUI：Is it the bag?

CONLAG：What bag do you think it is?

DAUI：You could have changed it for another.

CONLAG：Look—

DAUI：Back in the trees! Someone you're in league with! Some corpse，ghost，thing! That's following us all the time! That you're winking at，behind my back! When people go as low as you，down in the filth like you，I don't know what you do!

CONLAG：You call me low—

DAUI：I don't know what you do!

CONLAG：Feel the iron in the bag. Feel it.

A silence.

DAUI：The wine—

CONLAG：The wineskin's in the bag. Squishy. Feel it.

DAUI*'s voice heavy with exhaustion.*

DAUI：Iron and wine.

CONLAG：I'm glad we killed that man we met. And took his iron and his wine. Didn't he squeal! Didn't he squeal!

He laughs.

You sleep first. I'll watch.

DAUI：I could sleep.

But don't drink the wine.

CONLAG：Me? Drink our wine?

DAUI：And don't go talking to yourself. And screaming.

CONLAG：Right.

DAUI：And leave my arse alone.

CONLAG：Right.

DAUI：And don't sell me to 'em.

The things in the trees.

While I'm asleep.

CONLAG *sighs.*

CONLAG：Right.

A silence.

Daui?

A silence.

You don't think—that's what we're going to find?

A silence.

After all our sorrows.

A silence.

And heartbreak. And boils. And my pusy ear. And the thing at the bottom of my spine.

A silence.

Find a dogshit beach?

DAUI: A boat. We'll find a boat. Or people are going to die.

CONLAG: Right.

A silence.

Right.

Scene Five

River bank and woods. The bodies of BRAC *and* VIRIDIO *on the ground.*

Upstage a group of ROMAN SOLDIERS *stand very still—a* STANDARD BEARER, *holding a legion standard, two fully armed* SOLDIERS *and a* BUGLER.

A silence.

Two SOLDIERS, *in tunics, run on with a stretcher, on it the bodies of the* MOTHER *and the* SECOND VILLAGE MAN, *her husband. The* SOLDIERS *tip the bodies onto the ground and run off with the stretcher.*

A silence.

A punishment squad of three SOLDIERS, *in tunics, and a* GUARD *come on. They are laden with piles of wooden lavatory seats and spades.*

GUARD: Field lavatory detail!

FIRST SOLDIER: All right all right we're behind you.

SECOND SOLDIER: I am sick of digging lavatories.

GUARD: Then don't end up in a punishment squad.

THIRD SOLDIER: Something to tell your kiddies, when you get back home.

SECOND SOLDIER: Oh yeah. I dug a shit hole on the edge of the world.

They throw the seats down in a heap.

GUARD: A good fathom down, lads.

They begin to dig.

JULIUS CAESAR *wanders forward from the back looking at the ground. He is followed at a distance, though closely observed, by members of his staff-ASINUS, a historian in civilian clothes, a legionary LEGATE, a legionary PREFECT, and a PRIMUS PILUS —a centurion of the highest rank, a man in his early sixties.*

CAESAR *stops. His staff stops. The punishment squad stop working and stare.*

A silence, all still.

CAESAR *stoops and picks up* MARBAN's *knife. He walks on. The punishment squad return to work.*

Dangling the knife casually at his side between finger and thumb CAESAR *walks by the*

MOTHER's *body, ignoring it*.

CAESAR：Prefect of the Legion.

The PREFECT *runs forward*.

Set the standards.

PREFECT：Yes General.

CAESAR：Don't pitch camp yet. Wait for the order.

PREFECT：Yes General.

CAESAR：Be careful with their bodies. Consecrate the ground. Set up an altar.

PREFECT：General.

The PREFECT *goes back to the staff*.

CAESAR：My bugler.

The BUGLER *runs forward*.

Let them know I'm here.

BUGLER：Yes General.

PREFECT (*to the* PRIMUS PILUS)：Set the standards. The order to pitch camp has not been given.

PRIMUS PILUS：Yes Sir. (*He shouts*:) First Standard Bearer!

The STANDARD BEARER *runs forward*. *The* BUGLER *blows a call*.

A runner down the lines. The order is set the standards. Wait for the bugle to pitch camp.

STANDARD BEARER：Yes Sir.

The STANDARD BEARER *digs his standard into the ground*，*then begins to run off*. *The* SOLDIERS *take up guard of the standard*.

CAESAR：Wait.

PRIMUS PILUS：Stop where you are.

The STANDARD BEARER *stops*.

LEGATE：Gaius Julius Caesar. This is my command. It is my privelege to receive your orders—

CAESAR (*ignoring the* LEGATE)：Primus Pilus. (*The* PRIMUS PILUS *runs to* CAESAR. *Privately*.) What did we do here?

PRIMUS PILUS：A couple of cohorts got jumbled up in the trees. The runners lost contact. Then they came on this lot—

CAESAR：And had some fun.

PRIMUS PILUS：Without orders, one thing led to another.

(*Carefully*.) What with—

CAESAR：What with an invasion that's deteriorated into a squalid little raid，eh Centurion?

Nothing from the PRIMUS PILUS.

I'm not angry with the men. Let that out，down the lines.

PRIMUS PILUS：General.

CAESAR: Stay. (*Calls out:*) Prefect. (*The* PREFECT *runs to* CAESAR.) Any sign of them regrouping?

PREFECT: Nothing. We came on them suddenly and dispersed them.

CAESAR: Prisoners?

PREFECT: Some.

CAESAR: Dead?

PREFECT: No Romans. Of them—(*He shrugs.*)

CAESAR: Think they're getting together in the trees, Centurion?

PRIMUS: What w∗gs① do in the trees, General—

CAESAR: Quite. I want to give the men a rest. What do you think?

> *The* PREFECT *and the* PRIMUS PILUS *uncertain.*

> *Quite.* (*A silence.*)

> Divided watch. An hour's recreation for the men stood down. Then change round. No alcohol. For every man swimming a man in battle readiness, watching the trees.

PREFECT: Yes General.

> CAESAR *waves them away.*

> (*To the* PRIMUS PILUS:) That order down the lines.

PRIMUS PILUS: Sir.

> *The* PRIMUS PILUS *walks quickly to the* STANDARD BEARER. *They talk privately for a few moments, then the* STANDARD BEARER *runs off.*

> *The* LEGATE, *near tears, walks towards* CAESAR.

LEGATE: This is my command. You are humiliating me, before the Legion—

> CAESAR *walks away.*

CAESAR: Asinus, my friend.

> ASINUS *walks to* CAESAR, *who leads him away from the* LEGATE.

> What tribe was it we've just cut to pieces?

ASINUS: As far as I can see, not Trinovante. But a loose grouping, a handful of families—

CAESAR: In the federation of the Trinovantes?

ASINUS: Probably sympathizers.

CAESAR: Sympathizers of sympathizers with us.

ASINUS: Yes.

CAESAR: Wonderful. Is their chieftan killed, or what?

ASINUS: The body of a woman was bitterly fought over. That body.

> *He points to the body of the* MOTHER. CAESAR *doesn't look.*

① 原文为对有色人种的蔑称,以下蔑称处理方式相同。

CAESAR：A woman?

ASINUS：They are not belgaic, they do not originate from the mainland. They are of the ancient stock of Britain. Traces of matriarchy are to be found among them. The Iceni—

CAESAR：All right all right! (*A silence*.) Forgive me. Your scholarship is invaluable. But I've got toothache.

ASINUS：I'll call a surgeon—

CAESAR：No no. (*He calls out:*) The Legate of this legion. (*The* LEGATE *comes forward quickly*.) (*To* ASINUS:) Stand back. But overhear us. Conspicuously.

ASINUS *steps back. A silence*.

LEGATE：Protector of my family—

CAESAR (*angrily*)：You what?

A silence. Then CAESAR *holds the knife up by its tip, looking at the handle*.

See, I would like to know how they lay the bronze into the iron. Curling patterns. Like marketry, but with metal. Very fine and on a simple hand weapon. I could have you stoned by your own soldiers for what happened here. (*A silence*.) Stoned. (*A silence*.) Do these n * * gers have steel? The Celts Of Northern Italy had steel, eh?

(*Over the* LEGATE*'s shoulder:*) Asinus, when we come to a smithy, look to see if there are steel tools.

The LEGATE *looks at* ASINUS *and back to* CAESAR.

Or did they just trade it from abroad, eh? For a dog, eh?

CAESAR *tosses the knife and catches it by the handle*.

I am not the protector of your family, Aurelius Drusius. I just seduced your sister.

LEGATE：I know you are angry with me, I learn from your anger, it is justified, I—

CAESAR：Don't. (*A silence*.) Don't begin to speak like that. Don't go down that path. Ten sentences and you will be promising to kill yourself. Then you will have to kill yourself. And you will never forgive me. Nor will your family.

LEGATE：I speak from the heart.

CAESAR：A disgusting, fashionable habit.

LEGATE：I have no cynicism—

CAESAR：Nor have I! (*He stares at the* LEGATE.) I take rhetoric very, very seriously. In war, what is done is done. In speech, what is meant is meant. You're a young man, learn how a Roman must speak. Of his life, in public, at moments like this. When you are being reprimanded, for having lost control of your command, during a minor mopping up exercise, against a wretched bunch of w * g farmers, women and children, in a filthy backwater of humanity, somewhere near the edge of the world.

A silence.

There. I've spoken of your tiny stupidity—and ended with the world. Textbook rhetoric, little to big? Eh? (*He grimaces, tonguing his bad tooth. He massages his face. He stops.*)

A silence.

It's an affliction.

A silence. He sniggers.

I think I am going to make a remark for the Official Biography, Asinus.

ASINUS, *notes at the ready.* CAESAR *sniggers again.*

I was going to say it's an affliction, to see in any one act, its consequence. To see a man—(*He gestures at the* LEGATE.) and see his future. At once. Bang, like that.

In any predicament, its opposite. To build a tower, knowing brick by brick, how it can be destroyed. Even in the victory of an enemy, I see his defeat.

Once I was captured by pirates. Island fishermen really. I told them—when my ransom is paid, I will return and kill you.

My ransom was paid, I raised a fleet. I stormed their islands.

I crucified them all, all their communities, twenty thousand of them, men women and children! Wooded islands. The crosses took all the trees. The islands will be rock and turf for ever. A logic. I walked in forests as a captive. Free, the same ground had to be a barren plain. One extreme the mother of the opposite extreme.

After all, my ancestral mother is Venus, Goddess of love, and I am a man of war.

He sniggers. A silence.

LEGATE: What—

CAESAR: What's your future? You—(*He puts his arm round the* LEGATE's *shoulders.*) will die, a little before me, a very old man, very rich, very happy and very senile. You are relieved of your command in all but name and show. The Prefect of your legion will take his orders directly from me. You will stay on my staff. Your humiliation as a military man will be politely obscured. If you protest, you will be stoned by your soldiers, with relish. The political consequences of maltreating so favourite a son would be tiresome, but easily overcome by my party.

LEGATE: I—

CAESAR: No no no. Put it like this, are you my friend, or aren't you, eh? (*Hugging the* LEGATE.) What d'you say?

LEGATE: I'm your friend.

CAESAR: What a fucking island, eh? What a wretched bunch of w * gs, eh? Go and have a swim.

LEGATE: Yes, General.

CAESAR: Look, send this knife to your sister, as a present from me. Tell her—(*He toys with the knife.*) to guard with this knife, what I would enter as a knife.

LEGATE: I—

CAESAR *gives the knife to the* LEGATE.

CAESAR: She reads Terence, she'll understand. (CAESAR *takes the knife back*.) I'll have it cleaned up. A box made. Maybe a human pelt to wrap it in, eh?

LEGATE: Thank you, Gaius Julius.

The LEGATE *hesitates, then walks away and off the stage*. CAESAR *watches him for a while then turns away*.

CAESAR: The politics of the Roman dinner table are with us, even on the filthy marshes of the edge of the world, eh Asinus?

ASINUS: Yes.

CAESAR: I want him killed. An auxiliary, pissed. A slave with the grievance. Anything—(*An angry gesture*.) trivial. Arrange it.

ASINUS: Yes. Do you want to see something odd?

CAESAR: Odd?

ASINUS *makes a sign*. Two SOLDIERS *come on with* MARBAN, *still naked, bound*. CAESAR *looks at him*.

Well?

ASINUS: This Celt talks Latin.

CAESAR (*to* MARBAN): Do you? (*Nothing from* MARBAN.) Soldier, go and cut the head off the body of that woman.

The SOLDIER *moves*.

MARBAN: No!

CAESAR *stills the* SOLDIER *with a sign*.

CAESAR: Why not?

Because then I would own her soul?

MARBAN (*low*): Fitness of things.

CAESAR: What?

SOLDIER: Speak up to the General rubbish!

MARBAN: It would be against the fitness of things!

A silence.

CAESAR: How clumsy your obscene superstitions sound in my language, Druid.

Which is what you are. No?

Nothing from MARBAN.

SOLDIER: Speak up rubbish!

CAESAR (*to the* SOLDIER): No no. (*To* ASINUS:) We know Druids on the mainland speak Greek. Even write it. It's no surprise to find a little Druid in Britain, talking Latin.

ASINUS: All the tools of civilisation. And they keep their people in ignorance.

CAESAR: Hunh. Let him go.

The SOLDIERS *push* MARBAN *forward. He stands, still bound, shivering.* CAESAR, *with disgust.*

Look at the way they live.

A silence.

I'm going to let you run back into the woods, little Druid.

CAESAR *takes a pendant from his neck.*

Tie that round his neck. Tight.

The SOLDIER *does so,* MARBAN *writhing.*

Let him go in the woods. Still bound. His fellow priests will find Venus around his neck. (*Suddenly fierce.*) Listen listen to me! On the mainland I burn your temples. Your priests that will not serve the Roman Gods—I kill. I desecrate their bodies. Desecration according to your beliefs. The head off and burnt, et cetera. Because there are new Gods now. Do you understand? The old Gods are dead.

Nothing from MARBAN.

Yes, you understand. We are both religious men. (*To the* SOLDIERS:) Give him fifty lashes before you let him go. To make the point.

SOLDIER: Yes General.

CAESAR *waves them away. The* SOLDIERS *take* MARBAN *off.*

CAESAR: What did we come to this island for, Asinus?

ASINUS: Fresh water pearls—

CAESAR: So we did. Leave me.

ASINUS: Gaius Julius.

ASINUS *walks away then, at a discreet distance, turns and watches* CAESAR.

CAESAR: Primus Pilus. You and two men.

PRIMUS PILUS (*to the* SOLDIERS *guarding the standard*): You and you.

They go to CAESAR.

CAESAR: Stand with your backs to me.

PRIMUS PILUS: General.

The PRIMUS PILUS *nods to the* SOLDIERS. *They stand with their backs to* CAESAR. CAESAR *stoops forward, feeling his tooth with his fingers. Then he holds his lips back and loosens the tooth with the point of the knife. The punishment squad stop work and look.*

FIRST SOLDIER: What is our General doing?

SECOND SOLDIER: The moody sod wants to be alone.

THIRD SOLDIER: Sometimes a man has got to be alone.

（*They laugh*.）

GUARD：Get on get on.

With a grunt CAESAR *pulls his tooth out*. *Blood on his fingers*. *He looks at the tooth*.

ASINUS（*aside*）：He is a man waiting on the edge of the world. For what? In a sense, he does nothing. He only reacts. And finds himself master of continents. It is not surprising that he pays historians to find omens of great things at the time of his birth.

CAESAR *throws his tooth away*.

CAESAR：Vinegar.

The PRIMUS PILUS *gives* CAESAR *a flat bottle*. *He sluices his mouth out and spits*.

Stones begin to fly over the stage, *landing amongst the Romans*.

FIRST SOLDIER（*this is*, *of the* SOLDIERS *guarding* CAESAR）：W * gs. Throwing stones.

SECOND SOLDIER：Slings.

PRIMUS：General—

CAESAR：Yes. Quickly.

SOLDIERS *running*, *shields over their heads*. *The* SOLDIERS *guarding* CAESAR *hold their shields* above him.

PRIMUS PILUS：Bugler! Standard Bearer!

CAESAR：Prefect of the legion.

The STANDARD BEARER *and* BUGLER *run to the* PRIMUS PILUS. *The* PREFECT *runs to* CAESAR.

PRIMUS PILUS：Men out of the water. First and second centuries of the fourth cohort, up to the trees with missiles—they are not, not to enter the forest. Bugler, defensive formations.

The BUGLER *blows a call*. *The* STANDARD BEARER *runs off*.

CAESAR：Yes?

PREFECT：Can only be a handful. With slings. Even children. Dying down now.

CAESAR：We will not pitch camp. We go south, now.

PREFECT：General. Primus Pilus!

PRIMUS PILUS：Sir.

PREFECT：Strike the standards.

PRIMUS：Sir. Bugler! Marching order!

The BUGLER *makes another call*.

CAESAR：Asinus, record this order.

ASINUS：Yes General.

CAESAR（*to the* PREFECT）：Take their animals. Salt the fields. Kill the prisoners. Do what you can in the time.

PREFECT：Yes General. Primus Pilus, with me.

They hurry away.

CAESAR (*to* ASINUS): Even a little massacre must look like policy. They'll take it as a warning. Or that we knew these people were traitors. Probably leave a little local war behind us—no bad thing.

(*To the* SOLDIERS *shielding him:*) Join your squads.

The SOLDIERS *run off.* CAESAR *walks away upstage, followed by* ASINUS.

The SOLDIERS *of the punishment squad.*

FIRST SOLDIER: Not making camp? What about our lavatories?

GUARD: Leave 'em for the Britons. Teach 'em an healthy habit.

SECOND SOLDIER: I am always digging lavatories on this campaign which are never used.

GUARD: That's the speed of modern warfare.

Scene Six

Moonlight. The fields.

MARBAN *is sitting on the ground, legs skewed beneath him, still naked and bound, the Venus Pendant round his neck.*

A silence.

The FIRST *and* SECOND VILLAGE WOMEN *and* FIRST, THIRD *and* FOURTH VILLAGE MEN *come on. They have weapons at the ready, and dart about searching, stopping, listening, looking.*

Then they are all still.

A silence.

FIRST VILLAGE MAN: They've gone. (*A silence.*) Into the ground?

SECOND VILLAGE WOMAN: There.

She points to MARBAN. *The* FIRST VILLAGE MAN *approaches him cautiously.*

FIRST VILLAGE MAN: Where are your brothers?

FOURTH VILLAGE MAN: Salt! Salt on the fields! (*He weeps.*) They'll put salt on the fields.

FIRST VILLAGE MAN: Where is our Mother?

FOURTH VILLAGE MAN: They've poisoned us.

FIRST VILLAGE MAN: Your brothers and your mother—

THIRD VILLAGE MAN (*nursing his wound*): Maybe they're defeated. Maybe—it's peace.

FOURTH VILLAGE MAN: Maybe they tortured him, put him here as a decoy, ambush, while we weep with him for our fields—

THIRD VILLAGE MAN: No. It's peace.

FOURTH VILLAGE MAN: And poison.

FIRST VILLAGE MAN: Boy—

SECOND VILLAGE WOMAN: He's tied up. Cut him free.

The FIRST VILLAGE MAN *hesitates.*

Go on!

The FIRST VILLAGE MAN *cuts* MARBAN *free and steps away quickly.*

At once MARBAN *tugs at the Venus round his neck, gets it off and throws it away.*

MARBAN: Give me a knife.

A silence.

When they let me go I stayed in the trees, near them.

I knew I was—filthy! Filthy! Defiled! With one of their Gods round my neck! Give me a knife!

FIRST VILLAGE WOMAN (*quietly, to the* FIRST VILLAGE MAN): Don't.

A silence.

MARBAN: They're marching to the coast. To cross to the mainland. Give me a knife.

A silence.

FOURTH VILLAGE MAN: Gone.

MARBAN: No.

THIRD VILLAGE MAN: Defeated?

MARBAN: No.

THIRD VILLAGE MAN: But—

They look at each other. A silence.

FIRST VILLAGE WOMAN: Make clearings in the forest, before the cold weather. New fields, hidden—

SECOND VILLAGE WOMAN: Get through the winter, to plant them—

FIRST VILLAGE WOMAN: We'll see in the morning, how much they've burnt—

MARBAN: Give me a knife! (*He laughs.*) I am a priest. A seer. I see. (*He laughs.*)

Three years, the salt will drain out of the fields. And in the fourth year? Will you dare creep out of the hidden fields in the forests, to plant another harvest? To watch the nightmare of another raid, ripening through the year?

Oh the life of the farms will go on.

But you'll never dig out the fear they've struck in you. With their strange, foreign weapons.

Generation after generation, cataracts of terror in the eyes of your children. And in the eyes of husband for wife and wife for husband, hatred of the suffering that is bound to come again.

They've struck a spring in the ground beneath your feet, it will never stop, it will flood everything. The filthy water of Roman ways.

He laughs.

They'll even take away death as you know it. No sweet fields, rich woods beyond the

grave. You'll go to a Roman under-world of torture, a black river, rocks of fire.

We must have nothing to do with them. Nothing.

Abandon the life we know.

Change ourselves into animals. The cat. No, an animal not yet heard of. Deadly, watching, ready in the forest. Something not human.

FIRST VILLAGE MAN: And live off what, priest?

MARBAN: Visions. Visions. Stones. Visions. (*A silence. Then, dead voiced:*) The ghosts of our ancestors, slink away. The fabulous beasts, their claws crumble. The Gods grow small as flies.

He weeps quietly.

FIRST VILLAGE WOMAN: Give him a knife.

The THIRD VILLAGE MAN *puts a knife before* MARBAN. *He looks up from weeping, at the knife. He holds it upwards in his fist, on the ground, his arm extended. He raises himself up and is falling on the knife—*

Part Two

Scene Seven

The light changes. A sunset. Golden yellow light, O'ROURKE *walks out of the trees.* CHICHESTER *opens his eyes, sees him and sits up.*

O'ROURKE: Good evening to you.

Two MEN *with automatic weapons come out of the trees. The* WOMAN *walks quickly across.*

So you're a friend of the Republican cause, Mr Henwick.

CHICHESTER *stands. A silence.*

You're a strange and puzzling man to us, Mr. Henwick. Here you are on an Irish farm, out of the goodness of your heart helping a bedridden old woman, her sons being scattered by British economic imperialism. You are heard singing in the pubs. Spreading it about that you are no friend of the British Government. Then sending us messages that you are a gunrunner, with communist weapons for sale.

Now as I see it, you're either a madman, or an intelligence officer with the Special Air Services Regiment.

One way or the other.

So you'd better convince me quick that you're stone crazy. See if he's armed.

The two armed MEN *advance on* CHICHESTER.

CHICHESTER: I am—

I am a British Officer.

The two MEN *stop dead still.*

A long silence.

My name is Thomas Edward Chichester.

Henwick was my cover.

I come from an old English Army family. My father was killed by a landmine in Cyprus, when I was a baby.

My mission was to assassinate you, O'Rourke.

A silence, then:

O'ROURKE (*slowly*): Now why, in God's name, do you tell me that?

A silence.

FIRST MAN: Kill the bastard.

O'ROURKE: Be quiet.

SECOND MAN: This could be a set-up—

O'ROURKE: I don't think so. What is your rank?

CHICHESTER: Captain.

O'ROURKE: You have just spoken your death warrant, Captain Chichester.

Why?

CHICHESTER: I keep on seeing the dead. A field in Ireland, a field in England. And faces like wood. Charred wood, set in the ground! Staring at me.

The faces of our forefathers.

Their eyes are sockets of rain-water, flickering with gnats. They stare at me in terror.

Because in my hand there's a Roman spear. A Saxon axe.

A British Army machine-gun.

The weapons of Rome, invaders, Empire.

O'ROURKE: This is one hell of a way to deny your Imperial heritage. That what you're trying to do. Captain?

CHICHESTER, *gripping the wrist of his right band, shaking it.*

CHICHESTER: The weapons. I want to throw them down.

And reach down. To the faces. Hold the burnt heads in my hands and pull them up. The bodies out of the earth. Hold them against me.

Their bones of peat and water and mud. And work them back to life.

Like King Arthur—

FIRST MAN: Christ Almighty! He's raving mad.

He laughs.

SECOND MAN: Let's have done with him.

O'ROURKE: I think he may just be an honourable man, having a hard time of it. The assassin,

humanised by his trade.

O'ROURKE *laughs*.

Is that it Captain? The horrors of war?

WOMAN：What right does he have to stand in a field in Ireland and talk of the horrors of war? What nation ever learnt from the sufferings it inflicted on others? What did the Roman Empire give to the people it enslaved? Concrete. What did the British Empire give to its colonies? Tribal wars. I don't want to hear of this British soldier's humanity. And how he comes to be howling in the middle of my country. And how he thinks Ireland is a tragedy. Ireland's troubles are not a tragedy. They are the crimes his country has done mine. That he does to me，by standing there.

O'ROURKE（*to the two* MEN）：When you've disarmed him，shoot him.

A silence. CHICHESTER *begins to tremble*.

CHICHESTER：You murdering bastards—

The SECOND MAN *shoots him*.

CHICHESTER *fumbles for his gun*.

When will peace come? When will peace come? When will peace come?

The SECOND MAN *shoots him again*.

O'ROURKE：Ah Moraed. What will we do when we have peace?

WOMAN：Peace will take care of itself. War will not.

The THREE MEN，O'ROURKE *and the* WOMAN *walk away*.

A moon shines，the light goes as—

四、思考题

1. 本剧开始时，剧作家向观众和读者呈现出怎样的一个故事背景？

2. 森林里逃出的两个爱尔兰人的形象反映了怎样残酷的生存环境？

3. 剧作家刻画出罗马人到来之前英伦岛上怎样的部族生活？

4. 剧中呈现的三个历史情节之间有什么共同特征？其深刻意义何在？

5. 暴力无疑是本剧的核心主题，整个故事弥漫着血腥，其中共有 12 次屠杀和 4 次性暴力，但在剧中，大多数暴力——不论是两个爱尔兰人在林中对陌生人的宰杀和对女奴的强暴，还是罗马人割去部落女首领的头颅——都发生在舞台之下，即便是那些出现在舞台上的杀人画面，如马班兄弟之死、英国军官奇切斯特被杀等场面，也是一晃而过。只有罗马士兵对马班的性暴力被赤裸裸地呈现在观众的面前，其残暴程度令人发指。这也是该剧上演后遭到猛烈抨击的主要原因。但毫无疑问，布伦顿在本剧中要表现的远非表面的暴力，而是更深刻的含义。你如何理解这一暴力意象的深刻含义？

6. 如何理解凯撒挂在马班脖子上的维纳斯神像？对于这位凯尔特人的祭司来说，它意味着什么？他为什么最终选择自杀？

7. 虽然本剧的一个核心主题是暴力和侵略,但贯穿作品的另一个主题则是对梦想的追求:罗马人为追求帝国梦想跨越海峡来到英伦岛国,两个爱尔兰人穿过森林要到海上去寻找乐土,神话背景中的亚瑟王为自由而战斗,现实画面中的奇切斯特为和平而死。立足本剧,思考一个问题:在人类的文明史中,暴力和梦想之间有着怎样的内在关系?

五、本节推荐阅读

[1] Boon,Richard. *Brenton: The Playwright*. London:Methuen,1991.

[2] Boon,Richard. "Writers with Dirty Hands:Howard Brenton's *A Sky Blue Life: Scenes after Maxim Gorki*". *Modern Drama*,32(1989):183 - 191.

[3] King,Kimball,ed. *Modern Dramatists: A Casebook of Major British*,*Irish*,*and American Playwrights*. New York:Routledge,2001.

[4] Mitchell,Tony,ed. *File on Brenton*. London:Methuen,1988.

[5] Wu,Duncan. *Six Contemporary Dramatists: Bennett*,*Potter*,*Gray*,*Brenton*,*Hare*,*Ayckbourn*. Hampshire:Palgrave Macmillan,1996.

第二章
当代英国女性戏剧

第一节　当代英国女性戏剧概论

当代英国女性戏剧的崛起与女性主义运动密切相关，女性主义运动的一个重要方面就是女性作家在包括戏剧在内的不同领域的出现。战后英国戏剧舞台上，女性剧作家是不可小觑的力量，她们在当代英国戏剧发展史中扮演着重要的角色。她们伴随着战后英国戏剧的发展而发展：她们于20世纪50年代末开始出现，于七八十年代后期在英国舞台上崭露头角，最终在90年代形成了当代英国戏剧中独特的女性剧场景观。

几乎在奥斯本新戏剧出现的同时，女性剧作家也开始亮相英国剧坛。1958年，安·杰利科（Ann Jellicoe）的《疯妈妈的游戏》（*The Sport of My Mad Mother*）和希拉·德莱尼（Shelagh Delaney）的《感受甜蜜》（*A Taste of Honey*）先后在皇家宫廷剧院上演，她们的作品虽然没有像奥斯本的作品那样产生巨大的影响，但也被视为"愤怒的青年"戏剧的一部分。

70年代，随着战后英国戏剧第二次浪潮的发展，女性戏剧也开始活跃起来。其中，影响最大的女性剧作家是帕姆·杰姆斯和卡里尔·丘吉尔，她们与皇家宫廷剧院、皇家莎士比亚剧院等主流剧院频繁合作，为提高女性戏剧的地位做出了突出贡献。其中，杰姆斯出生于1925年，比大部分第一次浪潮中的男性剧作家都年长，但与后者不同的是，她直到70年代初才开始创作戏剧并得到认可。杰姆斯共创作了20多部作品，包括早期的《克里斯蒂娜女王》（*Queen Christina*，1977）、《皮亚夫》（*Piaf*，1978）和后期的《蓝色天使》（*The Blue Angel*，1991）、《斯坦利》（*Stanley*，1996）等。在创作中，杰姆斯擅长以女性历史名人，如克里斯蒂娜女王、伊迪丝·比阿夫、玛琳·黛德丽等为原型来刻画人物，通过再述她们的经历，揭示这些历史女性真实、脆弱，甚至病态的内心世界。为此，杰姆斯的戏剧又被视为"修正性的传记体戏剧"（revisionist style of biographical theatre）。①

在70年代的英国剧坛上，更加引人注目的女性剧作家是卡里尔·丘吉尔，她不仅是20世纪英国最著名的女性剧作家之一，也是当代欧洲最伟大的女性剧作家之一。她的戏剧生涯几乎是英国女性戏剧发展的一个缩影。

① Elaine Aston，"Pam Gems：Body Politics and Biography". In Elaine Aston and Janeue Reinelt，eds.，*The Cambridge Companion to Modern British Women Playwrights*. Cambridge：Cambridge University Press，2000，p.157.

　　1972年，随着其首部作品《业主》(Owners)在皇家宫廷剧院的成功上演，丘吉尔一举成名。在这部剧中，女房地产商玛丽恩一改传统女性的形象，是一个认同男性价值观的女性。她生活的目的就是赚钱，这使她在追求成功的道路上自私而强大。在剧中，不能生育的玛丽恩想用欺骗的手段夺取丽萨和亚力克的孩子，在对孩子的争夺战中，她说："你们都认为我是个女人，就会让步，是不是？认为我应该善良，应该理解一个女人想要拥有自己孩子的心情，但你们错了，我是不会那样做的。"①剧中的玛丽恩无疑是现代资本主义社会价值观的产物，如她所说："我像狗一样拼命地工作，因为我所受到的教育就是这样的，要干净、利索，任何时候都要做到最优秀、最好，否则就不会成功。"(30)该剧彻底颠覆了传统英国舞台上的性别关系，剧中的玛丽恩是丘吉尔后期代表作《顶尖女子》中马琳的原型。事实上，从《业主》到《顶尖女子》，丘吉尔反复探讨的一个问题就是如何界定成功女性，以及资产阶级价值观所倡导的富有侵略性的个性和成功价值观对性别关系和女性角色的影响。

　　这一时期丘吉尔的另外三部代表作是《老猫》(Vinegar Tom，1976)、《白金汉郡上空的光芒》(Light Shining in Buckinghamshire，1976)、《极乐的心境》(Cloud Nine，1979，又译《九重天》)。其中，《老猫》是丘吉尔与"怪兽剧团"(Monstrous Regiment)集体创作的作品。它以17世纪英国"猎巫"历史为背景，讲述了下层女性被判定为"女巫"而成为替罪羊的故事。标题中的Vinegar Tom源自女主人公艾丽斯的母亲琼养的一只猫，琼后来在剧中被当作女巫绞死。关于这部剧，丘吉尔曾说："这是一部关于女巫但却没有女巫的戏剧，这部戏剧讲述的不是邪恶、歇斯底里和魔鬼附身，而是贫穷、屈辱和偏见。"(130)17世纪是英国历史上大规模搜捕"女巫"的最后一段时期，当时的人们如果做了错事，往往会把责任推到黑衣魔鬼身上，但剧中的女主人公艾丽斯却不信魔鬼："如果穿黑衣服的人是魔鬼，那么教士和绅士们也都是魔鬼了。"(135)在剧中，佃农杰克没有同情心，为霸占更多的土地，总在和妻子盘算着如何挤走其他佃农；他虽然曾与艾丽斯有过性关系，并希望继续得到她，但在人前却摆出一副卫道士的模样。当他家小牛病死、牛奶搅不出黄油、他失去性能力时，他认为是琼和艾丽斯这对"女巫"母女捣的鬼，发誓要把她们送上断头台。在剧中，琼和精通传统医术的女人埃伦最终被当作女巫处死，艾丽斯和她的好友苏珊则被当作女巫关押。这部剧不仅揭示了西方历史上"猎巫"事件的本质，也将男性的迷信、猥琐、自私与女性的宽容、忍耐、智慧进行了对比，从而颠覆了传统的性别认知。剧中的艾丽斯是一个觉醒的女性，在第20场，当她目睹琼和埃伦被处以绞刑的一幕时，她说："如果我能侥幸活下来，我一定要成为一个女巫，我会杀死他们的牲畜……如果现在能见到魔鬼，我愿意给它一切，只要它能给我权力和力量。"(175)

　　《极乐的心境》是给丘吉尔带来国际声誉的首部剧作。该作品以"换装"(cross-dressing)的戏剧手法，探讨了殖民背景下的身份和性别界定，并对维多利亚时期和当代妇女的地位和自我意识进行了对比。在女性主义思想家朱迪斯·巴特勒(Judith Butler)看来，"换装"作为一种性别戏仿，揭示了性别政治的本质，即本体论的性别(gender)概念并不存在，因为这个所谓的本质化性别身份不过是性别规范制造的一种幻象。人们模仿所谓的本质化性别身份不过是在模仿性别规范而已。②这一观点同样适用于文化身份。在丘吉尔等剧作家的作品中，"换装"这一舞台策略揭示了性别和文化界限的人为性，从而使性别和文化越界成为可能。《极乐的心境》分为两幕，两幕均采用了"换装"的戏剧手法。第一幕的时间

①　Caryl Churchill, *Plays One: Owners, Traps, Vinegar Tom, Light Shining in Buckinghamshire, Cloud Nine*. London: Methuen, 1985, p.63.以下出自该剧本的引文页码随文注出，不单列脚注。
②　Judith Butler, *Gender Trouble*. New York: Routledge, 1990, p.138.

是19世纪后期,场景是维多利亚时期的英属殖民地非洲,故事围绕殖民地行政长官克莱夫一家展开,主要人物是克莱夫、妻子贝蒂、儿子爱德华、女儿维多利亚和岳母莫德,此外还有贴身黑奴乔舒亚、家庭教师埃伦。该幕的"换装"手法尤其突出,在人物表中,丘吉尔明确指出,第一幕中克莱夫的妻子贝蒂要由男演员扮演,他的黑人仆人乔舒亚要由白人演员扮演,而他的儿子爱德华则由一名成年女子扮演。第二幕的故事设定在1979年,场景是现代的伦敦,故事围绕克莱夫的孩子们展开,家庭成员由多元性取向者组成。这一幕中只有一人"换装",即女同性恋者琳5岁的女儿卡西,她由一名成年男子扮演。虽然第二幕与第一幕实际相差大约百年,但作者设定剧中的时间只是过了25年。这一设定的目的在于使我们看到,假如第一幕中的人物活到当代,其性格、生活态度、生活方式等会发生怎样的变化。

进入80年代后,英国女性戏剧得到稳步的发展。撒切尔夫人执政后英国剧坛整体上变得沉闷和保守,女性剧作家的作品为80年代的英国剧坛带来了不少活力。除了丘吉尔,80年代女性剧作家中的佼佼者还有萨拉·丹尼尔斯(Sarah Daniels)和汀布莱克·韦藤贝克。其中,丹尼尔斯是一个眼光敏锐、富有创新精神的剧作家。她在戏剧中用现实主义的手法来展现男性对女性的压迫和妇女所受到的伤害。她的代表作是《杰作》(*Masterpieces*,1983)。该剧的核心主题是探讨淫秽作品对人们生活的影响,剧中的男性几乎都看过淫秽作品,有把女性当作性工具的倾向。本剧的中心事件是女主人公罗威娜在接触淫秽作品之后开始憎恨所有男性,最终将一名尾随她的男子推下地铁。

与丹尼尔斯不同,韦藤贝克是一位具有全球多元文化视野的剧作家,她出生在美国,后来却成了英国公民,此外,她还拥有在法国、希腊和其他国家生活旅居的经历。她的成长经历使她对国家、身份、种族概念有着与众不同的见解,这对她的戏剧创作产生了重要的影响。韦藤贝克的早期代表作是《新意阐释》(*New Anatomies*,1981),剧中的主人公是一位名叫伊莎贝拉的女冒险家,即丘吉尔在《顶尖女子》第一场中提到的维多利亚时期的英国传奇女旅行家。该剧虽然对当代社会问题、乌托邦理想等问题展开了讨论,但它关注的核心则是女性身份。剧中角色均由女演员扮演,除了饰演伊莎贝拉的女演员外,其他女演员分别饰演西方男子、西方女子和阿拉伯男子。通过女饰男角的"换装"表演,韦藤贝克意在揭示性别身份的建构、选择和妥协过程,从而打破传统哲学对性别概念的界定,改变传统意义上的女性主体形象。①

韦藤贝克80年代后期最著名的剧作是《夜莺之爱》。与前期作品不同,这部戏剧取材于希腊神话,而非历史。该剧通过对多个希腊神话的再写,揭示了传统神话叙述之下被隐藏了无数个世纪的"她者"(herself)故事,改写了希腊神话中关于人类认知的宏大主题。在剧中,女歌队提出的一系列问题发人深思:"为什么美狄亚要杀死她的子女?为什么国家之间要打仗?为什么有些种族会灭绝?"②女歌队的"天问"充满了对社会政治的指涉和对神话中关于人类世界观和认识论的质疑。韦藤贝克曾说过,她之所以重述希腊神话,是因为希腊人是最早的人文主义者,他们思考的是关于人类的大问题,而重述神话,就是再次回到这些大问题上。③她进行神话改写创作的目的是借助神话话语,将当代观众重新带回到古希腊哲学思维中,回到人类早期对各种宏大主题的哲学思考上。韦藤贝克一直活跃于英国剧坛,新作

①　陈琛,《越界:丁布莱克·韦藤贝克戏剧中的性别、阶级和国族》,博士论文,2018年,第62页。
②　Timberlake Wertenbaker,*Plays One: New Anatomies*,*The Grace of Mary Traverse*,*Our Country's Good*,*The Love of the Nightingale*,*Three Birds Alighting on a Field*. London:Faber and Faber,1996,p.349.
③　Elaine Aston and Janelle Reinelt,*Modern British Women Playwrights*. Cambridge:Cambridge University Press,2000,p.135.

不断，已成为在当代英国戏剧舞台上可与卡里尔·丘吉尔比肩的女性剧作家。

20 世纪 90 年代，当代英国女性戏剧进入新的阶段。著名剧评家克里斯托弗·英尼斯在《现代英国戏剧，1890—1990》(*Modern British Drama*，*1890－1990*，1992)一书的最后一章中以"现在时：女性主义戏剧"为标题来凸显女性戏剧的活力和存在。[①]

而在 90 年代这批剧作家中，萨拉·凯恩无疑是最优秀也是最有争议的剧作家。1995 年，凯恩的首部剧作《摧毁》被搬上皇家宫廷剧院的舞台，凯恩一夜成名。在该剧中，凯恩以 90 年代波黑战争为主线，通过发生在利兹酒店房间里的一个故事，以简约的笔触和一系列深刻而犀利的舞台形象，向世人展示了爆炸、痛苦、折磨、饥饿、性暴力、屠杀等灾难性的战争场景和当代暴力社会的可怕现实。在剧中，凯恩不仅展现了性暴力、人食人等野蛮画面，还再现了《李尔王》中那种挖去双目的极端暴力场景。为此，不少剧评者又将凯恩视为 90 年代英国"直面戏剧"(In-Yer-Face Theatre，又译"扑面戏剧""无法回避的戏剧")的代表者。

在此后的数年中，她先后又创作了《菲德拉的爱》(*Phaedra's Love*，1996)、《清洗》(*Cleansed*，1998)、《渴求》(*Crave*，1998)和《4.48 精神崩溃》(*4.48 Psychosis*，1999)四部剧作。这里的每一部作品都可谓是凯恩一次与众不同的艺术旅程。在这些作品中，她为世人绘制了一幅黑暗、恐怖但却又充满了人性的精神景观。所以，不同于此前的所有女性剧作家，她在戏剧中表现的重点不是女性的社会地位或者对历史的关注，而是近乎失去理性的暴力，她要展现的是年轻一代剧作家对生活意义的痛苦探索。凯恩对社会洞察和哲学思考之深使她超越了她的性别和年龄，得以跻身品特、邦德等战后英国戏剧的大家之列。用剧评家伊恩·里克森(Ian Rickson)的话说："凯恩是一个真正的剧场诗人，她以少见的勇气、令人震撼的语言带领观众走进了人类最深层、最幽暗的现实之中。"[②]但这位敢于直面人类黑暗、集争议和才华于一身的戏剧奇才却在 1999 年 2 月的一个夜里自杀身亡，永远消失在凌晨最黑暗的寂静之中。

除了凯恩，80 年代后期崛起的韦滕贝克在 90 年代也非常活跃，先后创作了一批优秀的剧作，如《田间飞落三只鸟》(*Three Birds Alighting on a Field*，1992)、《破晓》(*The Break of Day*，1995)、《达尔文之后》(*After Darwin*，1998)等。

总的说来，虽然当代英国女性剧作家在英国剧坛的地位和影响仍不如品特、邦德、斯托帕德等男性剧作家，但丘吉尔、韦滕贝克、凯恩等人的戏剧已是公认的当代西方戏剧的经典之作，这使她们在英国戏剧史上占据了举足轻重的地位。

本章重点介绍当代英国女性剧场中的两部经典作品：卡里尔·丘吉尔的《顶尖女子》、伊莱恩·范思坦(Elaine Feinstein)和英国女性戏剧组(Women's Theatre Group)集体创作的《李尔的女儿们》。

① Christopher Innes，*Modern British Drama*，*1890－1990*. Cambridge：Cambridge University Press，1992，p.7.
② Claire Armitstead，"No pain，No Kane". *The Guardian*，29 Apr. 1998，p.12.

第二节　卡里尔·丘吉尔及其《顶尖女子》

一、卡里尔·丘吉尔简介

卡里尔·丘吉尔是当代英国戏剧舞台上最优秀的女性戏剧家之一，也是最具创新精神的西方剧作家之一。[①] 1938 年，丘吉尔出生在英国的一个中产阶级家庭，父亲是一名政治漫画家，母亲是一名模特。丘吉尔童年生活在伦敦，1949 年至 1956 年生活在加拿大的蒙特利尔，1957 年进入牛津大学学习英国文学。在此期间，她开始对英国的资产阶级价值观及等级制度感到厌恶，并对马克思主义理论产生了兴趣。而此时正值西方英国戏剧的繁荣时期，贝克特的荒诞派戏剧、贝托尔特·布莱希特（Bertolt Brecht）的史诗剧、奥斯本的《愤怒的回顾》等对她产生了极大的影响。

1972 年，丘吉尔的首部剧作《业主》在皇家宫廷剧院上演。1974 年，她成为皇家宫廷剧院首位女性常驻剧作家。自此，丘吉尔便一直活跃在英国戏剧舞台之上，创作了大量优秀作品。其中，她在 70 年代至 90 年代的主要作品是《白金汉郡上空的光芒》《老猫》《极乐的心境》《顶尖女子》《令人担心的钱财》（*Serious Money*，1987）。

在很长一段时间里，丘吉尔的戏剧都被贴上"社会主义女性主义"（socialist feminist）的标签。[②] 在这里，社会主义戏剧通常指的是 20 世纪六七十年代工人阶级剧作家的社会性戏剧（socially-committed drama），如奥斯本、威斯克等人的作品，这些作品具有高度的政治意识，丘吉尔的创作受他们的影响很大。虽然她作品中的主人公通常是女性，但她并非只狭隘地描写女性所受到的压迫。事实上，在 20 世纪七八十年代，她对自己的定位一直是剧作家，而不是一位女性主义剧作家。[③] 虽然在其后期创作中，她逐渐承认了自己的女性主义创作倾向，但她在戏剧创作中关注的不是个体女性在心理或生活中所受到的压迫，而是社会大背景中的两性关系、现代女性所面对的家庭生活与事业上的冲突等问题。事实上，我们很难用"弱者"来定义她所刻画出来的女性人物，因为她们当中虽然有些是生活在社会底层、备受压迫的劳动妇女，但也不乏贪婪成性、不择手段的"成功女士"。

丘吉尔是一位勇于创新的剧作家。在艺术技巧上，她不仅借鉴了乔·奥顿（Joe Orton）的"黑色"闹剧手法，用荒诞不经的形式表达严肃的主题，而且还经常打破时空界限，用超现实的策略来表现人物的潜意识。在戏剧创作上，她受琼·利特尔伍德（Joan Littlewood）和革新派导演马克斯·斯塔福德-克拉克（Max Stafford-Clark）的影响，多次与怪兽剧团、联合股份剧团公司（Joint Stock Company）等戏剧公司合作，参与即兴戏剧工作坊的集体创作活动，与导演和演员们一起实地调查、收集资料、共同创作。她还与音乐家和舞者合作，探索舞台表演艺术和技巧。她的几部戏剧如《白金汉郡上空的光芒》《老猫》《极乐的心境》《令人担心的钱财》等都是这种艺术实践的成果。其作品风格上的大胆、机智和幽默使她备受

① Elaine Aston，*Caryl Churchill*．Plymouth：Northcote House Publishers，1997，p.3.
② Elaine Aston and Janelle Reinelt，*The Cambridge Companion to Modern British Women Playwrights*．Cambridge：Cambridge University Press，2000，p.174.
③ Caryl Churchill，"Geraldine Cousin Interview"．*New Theatre Quarterly*，Feb. 1988，p.3.

观众和评论家的青睐。

从《食鸟》(*A Mouthful of Birds*，1986)开始，丘吉尔在戏剧创作中不断地从神话、民间传说和其他艺术形式中汲取灵感，其戏剧在形式上表现出更加强烈的实验性。《妖女》(*The Skriker*，1994)一剧大量使用了舞蹈、音乐、哑剧等艺术形式，而剧名中的 skriker 一词则是源于北欧的一种变形精灵或地精的名称。在剧中，通过"妖女"对爱、复仇和人类思想的追求，以及其黑暗力量对两个年轻女性生活的影响，丘吉尔探讨了由性别、故事叙事、扭曲的语言和城市生活构成的现代社会生态。丘吉尔戏剧涉及的社会题材非常广泛，但她通常不会直接给出她的答案或解决办法，而是通过开放性的结局引导观众自我思考以寻找自己的答案。

丘吉尔是一位高产的剧作家。20 世纪 90 年代后，她先后创作了《疯狂的森林》(*Mad Forest*，1990)、《妖女》《旅馆：在一个任何事情都可能发生的房间》(*Hotel: In a Room Anything Can Happen*，1997)、《蓝色的心》(*Blue Heart*，1997)、《克隆人生》(*A Number*，2002，又译《基因数字》)、《独自逃跑》(*Escaped Alone*，2016)等。作为一位与时俱进的剧作家，丘吉尔在戏剧创作中积极思考当代社会问题，如在《克隆人生》中，她引入了克隆人这一极具伦理争议的话题，探讨了人类在人工智能时代面临的关于"人"的大问题。

二、《顶尖女子》①介绍

《顶尖女子》是当代女性主义戏剧的经典之作。著名评论家迈克尔·比林顿（Michael Billington)称它为 20 世纪英国十部最佳戏剧之一。② 丘吉尔的不少戏剧都涉及女性主义问题，《顶尖女子》是丘吉尔唯一一部所有角色均为女性的戏剧，也是与当代生活结合最紧密的一部剧作。

丘吉尔曾说："在英国，女性主义思想更多的是与社会主义相关，而不是关注妇女是否能在资本主义的等级阶梯上获得成功。"③她觉得有必要纠正人们以资产阶级的个人主义、个人奋斗价值观为标准来判断女性成功与否的传统思维。关于获得高薪和权力是否代表成功这个问题，丘吉尔通过《顶尖女子》中的马琳这位来自乡下、靠个人奋斗实现自我理想的成功女性，给出了自己的答案。该剧深刻探讨了资产阶级女性主义的复杂性，以及当女性按照男性标准获取成功时要付出的代价。与社会主义女性主义所强调的女性独立和反抗压迫的观点不同，资产阶级女性主义主张："顶尖女性要争取更多的权力，以享受与男性同样的平等。"④在 20 世纪 80 年代，这种成功女性的典范就是英国第一位女首相撒切尔夫人。作为一名社会主义女性主义剧作家，丘吉尔透过《顶尖女子》亮明了自己的性别政治立场。

本剧开场时，主人公马琳设宴庆贺自己荣升为"顶尖女子职业介绍公司"总经理，邀请了五位历史、文学和艺术作品中的传奇女子：9 世纪女扮男装成为教皇的琼，维多利亚时期的女旅行家伊莎贝拉，13 世纪日本天皇的妃子(后成为尼姑)二条，勃鲁盖尔油画作品中那个率领村妇们攻打地狱的格雷，薄伽丘和乔叟讲述过的中世纪传说中以温顺和忍耐著称的格丽塞尔达。这五位女性有一个共同特征：她们都曾经历过辉煌，也都为显赫的名声或地位付出了沉重的代价。她们要么由于生孩子暴露女性身份

① Caryl Churchill，*Top Girls*. London：Methuen Drama，1991.以下出自该剧本的引文页码随文注出，不单列脚注。
② Elaine Aston，*Feminist Views on the English Stage*. Cambridge：Cambridge University Press，2003，p.20.
③ Lynne Tuss，"A Fair Cop". In interview with Caryl Churchill. *Plays and Players*，Jan. 1984，pp.8－10.
④ Michelene Wandor，*Post-War British Drama: Looking Back in Gender*. London：Routledge，2001，p.118.

而被乱石砸死,要么享受不到家庭的温暖或是因各种原因失去丈夫、情人或孩子。在宴席上女人们欢庆的气氛逐渐被酒后的宣泄所代替,她们不断打断彼此的话,插入自己的叙述,讲述各自成功背后的痛苦和牺牲。在这里,丘吉尔使用的技巧是重叠式戏剧对白,即一个人物的话还没说完,另一个人物已经开始插入自己的话。通过跨时空的想象,五位来自不同时代的"成功"女子在对白的重叠交错中实现了思想和话语的碰撞。这段对白成为该剧最精彩的部分,整个画面妙趣横生,呈现出强烈的喜剧效果,而且五位女子的话语内容对全剧主题起到了画龙点睛的作用。在这几位传奇女子中,执着是她们的共同特点。通过她们的酒后真言——失去丈夫、情人和孩子的痛苦经历,我们不仅对她们的"成功"产生怀疑,也不由得反思当代女性马琳所谓的"成功"。当琼问她到底得到了什么职位时,马琳回答说:"嗯,虽说不是教皇,但也是总经理。"(13)马琳显然高估了自己的成就,而且她也为这个职位付出了巨大的代价。

接下来的故事主要围绕马琳、其私生女安吉和马琳的姐姐乔伊斯展开。在剧中,展现马琳工作场景的时间虽然很短,但这些场景也足够表现出她的强势性格。通过她与求职者的对话,我们可以看出马琳工作的风格——虽然精明能干,但却对身边的人缺乏理解和同情。剧中的她拒绝接受投奔她的女儿,冷酷地将她们的关系定位成姨妈和外甥女的关系。从马琳和乔伊斯的谈话中,我们得知马琳的性格与她的经历有着紧密的关系:由于家境贫寒,她们从小就目睹母亲挨饿、挨打,为改变命运,马琳在17岁时抛下私生女离开乡下跑到伦敦,当时已结婚3年而尚未有孩子的姐姐乔伊斯则收养了安吉,而且像对自己的亲生女儿一样爱她。最后一场显示,姐妹俩在生活态度和政治观点上存在着极大的分歧,她们发生了激烈的争吵,争吵的内容包括孩子的抚养问题、乔伊斯对马琳成功的看法、老人的赡养问题、对父母当年生活的评价等。其中,她们对政治立场的争吵最为激烈:马琳的偶像是"铁娘子"撒切尔夫人,因为撒切尔夫人是英国历史上第一位女首相,是个人奋斗的典范,她高度赞扬撒切尔夫人的新自由主义国家政策;而身为底层阶级女性的代表,乔伊斯所持的则是社会主义立场,她称撒切尔夫人是一个"女希特勒",并抨击撒切尔夫人的"劫贫济富"政策,认为其私有化政策使少数有钱人获益,而让绝大多数人的生活更苦。

在剧中,姐妹俩虽然性格迥异、立场不同,但却有一个共同之处——她们在生活上都找不到幸福和满足感。乔伊斯的丈夫不仅外遇不断,而且还不承担养家的义务;马琳虽在职场中获得了令人羡慕的地位,且不乏追求者,但这些追求者都不会娶她为妻,因为他们想要的还是乖巧听话的女人。在最后一场中,姐妹俩一边喝着威士忌、一边争吵和痛哭的画面与第一场形成了一种呼应——虽然时代已发展到20世纪,但她们与历史上的女性一样,心里很苦,渴望得到幸福和满足。

在这部剧中,丘吉尔笔下的女性既有历史上的伟人,也有现代社会中的成功人士,既有生活艰辛的乡村妇女,也有事业有成却泯灭了亲情的城市白领。通过她们,丘吉尔力图引导世人思考女性主义时代的社会性问题:到底什么是成功女性?女性在追求成功的过程中应该如何安排自我?剧中所有的女性,不论是当代两姐妹,还是第一场中那些来自历史、文学和艺术中的女子,她们都不幸福,都有着各自的缺陷和遗憾。剧末时,安吉被噩梦惊醒,说出了本剧最后一句台词:"太可怕了。"(87)此句看似梦话,实则寓意深刻——等待安吉的将是怎样一个没有希望的未来!

本书节选的是《顶尖女子》中第一幕(本幕不分场)的前半部分。

三、《顶尖女子》选读①

Top Girls

Note on characters

ISABELLA BIRD（1831－1904）lived in Edinburgh，travelled extensively between the ages of forty and seventy.

LADY NIJO（b. 1258）Japanese，was an Emperor's courtesan and later a Buddhist nun who travelled on foot through Japan.

DULL GRET is the subject of the Brueghel painting，*Dulle Griet*，in which a woman in an apron and armour leads a crowd of women charging through hell and fighting the devils.

POPE JOAN，disguised as a man，is thought to have been Pope between 854－856.

PATIENT GRISELDA is the obedient wife whose story is told by Chaucer in The Clerk's Tale of *The Canterbury Tales*.

Act One

Restaurant. Table set for dinner with white tablecloth. Six places. **MARLENE** *and* **WAITRESS.**

MARLENE：Excellent，yes，table for six. One of them's going to be late but we won't wait. I'd like a bottle of Frascati straight away if you've got one really cold.

The WAITRESS *goes*.

ISABELLA BIRD *arrives*.

Here we are. ISABELLA.

ISABELLA：Congratulations，my dear.

MARLENE：Well，it's a step. It makes for a party. I haven't time for a holiday. I'd like to go somewhere exotic like you but I can't get away. I don't know how you could bear to leave Hawaii./I'd like to lie in the sun forever，except of course I

ISABELLA：I did think of settling.

MARLENE：can't bear sitting still.

ISABELLA：I sent for my sister Hennie to come and join me. I said，Hennie we'll live here forever and help the natives. You can buy two sirloins of beef for what a pound of chops costs in Edinburgh. And Hennie wrote back，the dear，that yes，she would come to Hawaii if I wished，but I said she had far better stay where she was. Hennie was suited to life in Tobermory.

① Caryl Churchill，*Top Girls*. London：Methuen Drama，1991，pp.1－14.

MARLENE：Poor Hennie.

ISABELLA：Do you have a sister?

MARLENE：Yes in fact.

ISABELLA：Hennie was happy. She was good. I did miss its face，my own pet. But I couldn't stay in Scotland. I loathed the constant murk.

MARLENE：Ah! Nijo!

 She sees LADY NIJO *arrive*.

 The WAITRESS *enters with wine*.

NIJO：Marlene!

MARLENE：I think a drink while we wait for the others. I think a drink anyway. What a week.

 The WAITRESS *pours wine*.

NIJO：It was always the men who used to get so drunk. I'd be one of the maidens，passing the sake.

ISABELLA：I've had sake. Small hot drink. Quite fortifying after a day in the wet.

NIJO：One night my father proposed three rounds of three cups，which was normal，and then the Emperor should have said three rounds of three cups，but he said three rounds of nine cups，so you can imagine. Then the Emperor passed his sake cup to my father and said，'Let the wild goose come to me this spring.'

MARLENE：Let the what?

NIJO：It's a literary allusion to a tenth-century epic，/His Majesty was very cultured.

ISABELLA：This is the Emperor of Japan? /I once met the Emperor of Morocco.

NIJO：In fact he was the ex-Emperor.

MARLENE：But he wasn't old? /Did you，Isabella?

NIJO：Twenty-nine.

ISABELLA：Oh it's a long story.

MARLENE：Twenty-nine's an excellent age.

NIJO：Well I was only fourteen and I knew he meant something but I didn't know what. He sent me an eight-layered gown and I sent it back. So when the time came I did nothing but cry. My thin gowns were badly ripped. But even that morning when he left/—he'd a green robe with a scarlet lining and

MARLENE：Are you saying he raped you?

NIJO：very heavily embroidered trousers，I already felt different about him. It made me uneasy. No，of course not，Marlene，I belonged to him，it was what I was brought up for from a baby. I soon found I was sad if he stayed away. It was depressing day after day not knowing when he would come. I never enjoyed taking other women to him.

ISABELLA：I certainly never saw my father drunk. He was a clergyman./And I didn't get married till I was fifty.

The WAITRESS *brings menus.*

NIJO: Oh, my father was a very religious man. Just before he died he said to me, 'Serve His Majesty, be respectful, if you lose his favour enter holy orders.'

MARLENE: But he meant stay in a convent, not go wandering round the country.

NIJO: Priests were often vagrants, so why not a nun? You think I shouldn't? /I still did what my father wanted.

MARLENE: No no, I think you should./I think it was wonderful.

DULL GRET *arrives.*

ISABELLA: I tried to do what my father wanted.

MARLENE: Gret, good. Nijo. Gret./I know Griselda's going to be late, but should we wait for Joan? /Let's get you a drink.

ISABELLA: Hello Gret! (*Continues to* NIJO.) I tried to be a clergyman's daughter. Needlework, music, charitable schemes. I had a tumour removed from my spine and spent a great deal of time on the sofa. I studied the metaphysical poets and hymnology./I thought I enjoyed intellectual pursuits.

NIJO: Ah, you like poetry. I come of a line of eight generations of poets. Father had a poem/in the anthology.

ISABELLA: My father taught me Latin although I was a girl./But

MARLENE: They didn't have Latin at my school.

ISABELLA: really I was more suited to manual work. Cooking, washing, mending, riding horses./ Better than reading books,

NIJO: Oh but I'm sure you're very clever.

ISABELLA: eh Gret? A rough life in the open air.

NIJO: I can't say I enjoyed my rough life. What I enjoyed most was being the Emperor's favourite/ and wearing thin silk.

ISABELLA: Did you have any horses, Gret?

GRET: Pig.

POPE JOAN *arrives.*

MARLENE: Oh Joan, thank God, we can order. Do you know everyone? We were just talking about learning Latin and being clever girls. Joan was by way of an infant prodigy. Of course you were. What excited you when you were ten?

JOAN: Because angels are without matter they are not individuals. Every angel is a species.

MARLENE: There you are.

They laugh. They look at menus.

ISABELLA: Yes, I forgot all my Latin. But my father was the mainspring of my life and when he died I was so grieved. I'll have the chicken, please,/and the soup.

NIJO: Of course you were grieved. My father was saying his prayers and he dozed off in the sun. So I

touched his knee to rouse him. 'I wonder what will happen,' he said, and then he was dead before he finished the sentence./If he'd died saying

MARLENE：What a shock.

NIJO：his prayers he would have gone straight to heaven./Waldorf salad.

JOAN：Death is the return of all creatures to God.

NIJO：I shouldn't have woken him.

JOAN：Damnation only means ignorance of the truth. I was always attracted by the teachings of John the Scot, though he was inclined to confuse/God and the world.

ISABELLA：Grief always overwhelmed me at the time.

MARLENE：What I fancy is a rare steak. Gret?

ISABELLA：I am of course a member of the/Church of England.

GRET：Potatoes.

MARLENE：I haven't been to church for years./I like Christmas carols.

ISABELLA：Good works matter more than church attendance.

MARLENE：Make that two steaks and a lot of potatoes. Rare. But I don't do good works either.

JOAN：Canelloni, please,/and a salad.

ISABELLA：Well, I tried, but oh dear. Hennie did good works.

NIJO：The first half of my life was all sin and the second/all repentance.

MARLENE：Oh what about starters?

GRET：Soup.

JOAN：And which did you like best?

MARLENE：Were your travels just a penance? Avocado vinaigrette. Didn't you/enjoy yourself?

JOAN：Nothing to start with for me, thank you.

NIJO：Yes, but I was very unhappy./It hurt to remember

MARLENE：And the wine list.

NIJO：the past. I think that was repentance.

MARLENE：Well I wonder.

NIJO：I might have just been homesick.

MARLENE：Or angry.

NIJO：Not angry, no,/why angry?

GRET：Can we have some more bread?

MARLENE：Don't you get angry? I get angry.

NIJO：But what about?

MARLENE：Yes let's have two more Frascati. And some more bread, please.

　　The WAITRESS *exits*.

ISABELLA：I tried to understand Buddhism when I was in Japan but all this birth and death

succeeding each other through eternities just filled me with the most profound melancholy. I do like something more active.

NIJO: You couldn't say I was inactive. I walked every day for twenty years.

ISABELLA: I don't mean walking./I mean in the head.

NIJO: I vowed to copy five Mahayana sutras./Do you know how

MARLENE: I don't think religious beliefs are something we have in common. Activity yes.

NIJO: long they are? My head was active./My head ached.

JOAN: It's no good being active in heresy.

ISABELLA: What heresy? She's calling the Church of England/a heresy.

JOAN: There are some very attractive/heresies.

NIJO: I had never heard of Christianity. Never/heard of it. Barbarians.

MARLENE: Well I'm not a Christian./And I'm not a Buddhist.

ISABELLA: You have heard of it?

MARLENE: We don't all have to believe the same.

ISABELLA: I knew coming to dinner with a pope we should keep off religion.

JOAN: I always enjoy a theological argument. But I won't try to convert you, I'm not a missionary. Anyway I'm a heresy myself.

ISABELLA: There are some barbaric practices in the east.

NIJO: Barbaric?

ISABELLA: Among the lower classes.

NIJO: I wouldn't know.

ISABELLA: Well theology always made my head ache.

MARLENE: Oh good, some food. Waitress is bringing the first course.

NIJO: How else could I have left the court if I wasn't a nun? When Father died I had only His Majesty. So when I fell out of favour I had nothing. Religion is a kind of nothing/and I dedicated what was left of me to nothing.

ISABELLA: That's what I mean about Buddhism. It doesn't brace.

MARLENE: Come on, Nijo, have some wine.

NIJO: Haven't you ever felt like that? Nothing will ever happen again. I am dead already. You've all felt/like that.

ISABELLA: You thought your life was over but it wasn't.

JOAN: You wish it was over.

GRET: Sad.

MARLENE: Yes, when I first came to London I sometimes...and when I got back from America I did. But only for a few hours. Not twenty years.

ISABELLA: When I was forty I thought my life was over./Oh I

NIJO：I didn't say I felt it for twenty years. Not every minute.

ISABELLA：was pitiful. I was sent on a cruise for my health and I felt even worse. Pains in my bones, pins and needles in my hands, swelling behind the ears, and—oh, stupidity. I shook all over, indefinable terror. And Australia seemed to me a hideous country, the acacias stank like drains./I had a

NIJO：You were homesick.

ISABELLA：photograph for Hennie but I told her I wouldn't send it, my hair had fallen out and my clothes were crooked, I looked completely insane and suicidal.

NIJO：So did I, exactly, dressed as a nun. I was wearing walking shoes for the first time.

ISABELLA：I longed to go home,/but home to what? Houses

NIJO：I longed to go back ten years. Isabella are so perfectly dismal.

MARLENE：I thought travelling cheered you both up.

ISABELLA：Oh it did/of course. It was on the trip from

NIJO：I'm not a cheerful person, Marlene. I just laugh a lot.

ISABELLA：Australia to the Sandwich Isles, I fell in love with the sea. There were rats in the cabin and ants in the food but suddenly it was like a new world. I woke up every morning happy, knowing there would be nothing to annoy me. No nervousness. No dressing.

NIJO：Don't you like getting dressed? I adored my clothes./When I was chosen to give sake to His Majesty's brother,

MARLENE：You had prettier colours than Isabella.

NIJO：the Emperor Kameyana, on his formal visit, I wore raw silk pleated trousers and a seven-layered gown in shades of red, and two outer garments,/yellow lined with green and a light

MARLENE：Yes, all that silk must have been very...

The WAITRESS *starts to clear the first course.*

JOAN：I dressed as a boy when I left home.

NIJO：green jacket. Lady Betto had a five-layered gown in shades of green and purple.

ISABELLA：You dressed as a boy?

MARLENE：Of course,/for safety.

JOAN：It was easy, I was only twelve. Also women weren't/allowed in the library. We wanted to study in Athens.

MARLENE：You ran away alone?

JOAN：No, not alone, I went with my friend./He was sixteen

NIJO：Ah, an elopement.

JOAN：but I thought I knew more science than he did and almost as much philosophy.

ISABELLA：Well I always travelled as a lady and I repudiated strongly any suggestion in the press that I was other than feminine.

MARLENE：I don't wear trousers in the office./I could but I don't.

ISABELLA：There was no great danger to a woman of my age and appearance.

MARLENE：And you got away with it, Joan?

JOAN：I did then.

The WAITRESS *starts to bring the main course*.

MARLENE：And nobody noticed anything?

JOAN：They noticed I was a very clever boy./And when I

MARLENE：I couldn't have kept pretending for so long.

JOAN：shared a bed with my friend, that was ordinary—two poor students in a lodging house. I think I forgot I was pretending.

ISABELLA：Rocky Mountain Jim, Mr Nugent, showed me no disrespect. He found it interesting, I think, that I could make scones and also lasso cattle. Indeed he declared his love for me, which was most distressing.

NIJO：What did he say? /We always sent poems first.

MARLENE：What did you say?

ISABELLA：I urged him to give up whisky,/but he said it was too late.

MARLENE：Oh Isabella.

ISABELLA：He had lived alone in the mountains for many years.

MARLENE：But did you—?

The WAITRESS *goes*.

ISABELLA：Mr Nugent was a man that any woman might love but none could marry. I came back to England.

NIJO：Did you write him a poem when you left? /Snow on the

MARLENE：Did you never see him again?

ISABELLA：No, never.

NIJO：mountains. My sleeves are wet with tears. In England no tears, no snow.

ISABELLA：Well, I say never. One morning very early in Switzerland, it was a year later, I had a vision of him as I last saw him/in his trapper's clothes with his hair round his face,

NIJO：A ghost!

ISABELLA：and that was the day,/I learnt later, he died with a

NIJO：Ah!

ISABELLA：bullet in his brain./He just bowed to me and vanished.

MARLENE：Oh Isabella.

NIJO：When your lover dies—One of my lovers died./The priest Ariake.

JOAN：My friend died. Have we all got dead lovers?

MARLENE：Not me, sorry.

NIJO (*to* ISABELLA)：I wasn't a nun, I was still at court, but he was a priest, and when he came to me he dedicated his whole life to hell./He knew that when he died he would fall into one of the three lower realms. And he died, he did die.

JOAN (*to* MARLENE)：I'd quarrelled with him over the teachings of John the Scot, who held that our ignorance of God is the same as his ignorance of himself. He only knows what he creates because he creates everything he knows but he himself is above being—do you follow?

MARLENE：No, but go on.

NIJO：I couldn't bear to think/in what shape would he be reborn.

JOAN：St Augustine maintained that the Neo-Platonic Ideas are indivisible from God, but I agreed with John that the created

ISABELLA：Buddhism is really most uncomfortable.

JOAN：world is essences derived from Ideas which derived from God. As Denys the Areopagite said—the pseudo-Denys—first we give God a name, then deny it/then reconcile the

NIJO：In what shape would he return?

JOAN：contradiction by looking beyond/those terms.

MARLENE：Sorry, what? Denys said what?

JOAN：Well we disagreed about it, we quarrelled. And next day he was ill,/I was so annoyed with him, all the time I was

NIJO：Misery in this life and worse in the next, all because of me.

JOAN：nursing him I kept going over the arguments in my mind. Matter is not a means of knowing the essence. The source of the species is the Idea. But then I realised he'd never understand my arguments again, and that night he died. John the Scot held that the individual disintegrates/and there is no personal immortality.

ISABELLA：I wouldn't have you think I was in love with Jim Nugent. It was yearning to save him that I felt.

MARLENE (*to* JOAN)：So what did you do?

JOAN：First I decided to stay a man. I was used to it. And I wanted to devote my life to learning. Do you know why I went to Rome? Italian men didn't have beards.

ISABELLA：The loves of my life were Hennie, my own pet, and my dear husband the doctor, who nursed Hennie in her last illness. I knew it would be terrible when Hennie died but I didn't know how terrible. I felt half of myself had gone. How could I go on my travels without that sweet soul waiting at home for my letters? It was Doctor Bishop's devotion to her in her last illness that made me decide to marry him. He and Hennie had the same sweet character. I had not.

NIJO：I thought His Majesty had a sweet character because when he found out about Ariake he was so kind. But really it was because he no longer cared for me. One night he even sent me out to a man who had been pursuing me./He lay awake on the other side of the screens and listened.

ISABELLA: I did wish marriage had seemed more of a step. I tried very hard to cope with the ordinary drudgery of life. I was ill again with carbuncles on the spine and nervous prostration. I ordered a tricycle, that was my idea of adventure then. And John himself fell ill, with erysipelas and anaemia. I began to love him with my whole heart but it was too late. He was a skeleton with transparent white hands. I wheeled him on various seafronts in a bathchair. And he faded and left me. There was nothing in my life. The doctors said I had gout/and my heart was much affected.

NIJO: There was nothing in my life, nothing, without the Emperor's favour. The Empress had always been my enemy, Marlene, she said I had no right to wear three-layered gowns./But I was the adopted daughter of my grandfather the Prime Minister. I had been publicly granted permission to wear thin silk.

JOAN: There was nothing in my life except my studies. I was obsessed with pursuit of the truth. I taught at the Greek School in Rome, which St Augustine had made famous. I was poor, I worked hard. I spoke apparently brilliantly, I was still very young, I was a stranger; suddenly I was quite famous, I was everyone's favourite. Huge crowds came to hear me. The day after they made me cardinal I fell ill and lay two weeks without speaking, full of terror and regret./But then I got up

MARLENE: Yes, success is very...

JOAN: determined to go on. I was seized again/with a desperate longing for the absolute.

ISABELLA: Yes, yes, to go on. I sat in Tobermory among Hennie's flowers and sewed a complete outfit in Jaeger flannel./I was fifty-six years old.

NIJO: Out of favour but I didn't die. I left on foot, nobody saw me go. For the next twenty years I walked through Japan.

GRET: Walking is good.

The WAITRESS *enters.*

JOAN: Pope Leo died and I was chosen. All right then. I would be Pope. I would know God. I would know everything.

ISABELLA: I determined to leave my grief behind and set off for Tibet.

MARLENE: Magnificent all of you. We need some more wine, please, two bottles I think, Griselda isn't even here yet, and I want to drink a toast to you all.

ISABELLA: To yourself surely,/we're here to celebrate your success.

NIJO: Yes, Marlene.

JOAN: Yes, what is it exactly, Marlene?

MARLENE: Well it's not Pope but it is managing director.

JOAN: And you find work for people.

MARLENE: Yes, an employment agency.

NIJO：Over all the women you work with. And the men.

ISABELLA：And very well deserved too. I'm sure it's just the beginning of something extraordinary.

MARLENE：Well it's worth a party.

ISABELLA：To Marlene.

MARLENE：And all of us.

JOAN：Marlene.

NIJO：Marlene.

GRET：Marlene.

MARLENE：We've all come a long way. To our courage and the way we changed our lives and our extraordinary achievements.

They laugh and drink a toast.

ISABELLA：Such adventures. We were crossing a mountain pass at seven thousand feet, the cook was all to pieces, the muleteers suffered fever and snow blindness. But even though my spine was agony I managed very well.

MARLENE：Wonderful.

NIJO：Once I was ill for four months lying alone at an inn. Nobody to offer a horse to Buddha. I had to live for myself, and I did live.

ISABELLA：Of course you did. It was far worse returning to Tobermory. I always felt dull when I was stationary./That's why I could never stay anywhere.

NIJO：Yes, that's it exactly. New sights. The shrine by the beach, the moon shining on the sea. The goddess had vowed to save all living things./She would even save the fishes. I was full of hope.

JOAN：I had thought the Pope would know everything. I thought God would speak to me directly. But of course he knew I was a woman.

MARLENE：But nobody else even suspected?

The WAITRESS *brings more wine.*

JOAN：In the end I did take a lover again.

ISABELLA：In the Vatican?

GRET：Keep you warm.

NIJO：Ah, lover.

MARLENE：Good for you.

JOAN：He was one of my chamberlains. There are such a lot of servants when you're a Pope. The food's very good. And I realised I did know the truth. Because whatever the Pope says, that's true.

NIJO：What was he like, the chamberlain?

GRET：Big cock.

ISABELLA：Oh Gret.

MARLENE：Did he fancy you when he thought you were a fella?

NIJO：What was he like?

JOAN：He could keep a secret.

MARLENE：So you did know everything.

JOAN：Yes，I enjoyed being Pope. I consecrated bishops and let people kiss my feet. I received the King of England when he came to submit to the church. Unfortunately there were earthquakes，and some village reported it had rained blood，and in France there was a plague of giant grasshoppers，but I don't think that can have been my fault，do you?

Laughter.

The grasshoppers fell on the English Channel and were washed up on shore and their bodies rotted and poisoned the air and everyone in those parts died.

Laughter.

...

四、思考题

1. 我们该如何理解丘吉尔的女性主义思想？

2. 丘吉尔跨越时空，将相隔几个世纪、来自不同文化和宗教背景的五位奇女子与现代成功女性马琳放在一起，从而使观众和马琳的现代观念与其他人物的信念之间产生了强烈的时代错位感，这种戏剧策略对本剧的主题产生了怎样的作用？

3. 该剧最精彩的部分无疑是重叠式戏剧对白，五位成功女子在对白的重叠交错中实现了思想和话语的碰撞，这种重叠式戏剧对白呈现了怎样的戏剧效果？

4. 在本剧的最后一场，马琳和乔伊斯姐妹俩喝着威士忌交谈、痛哭，该画面与本剧开头第一场产生了怎样的呼应？从开头的庆功酒会到剧末时两姐妹的交谈，整个戏剧在结构上仿佛构成了一个主题和形式上的闭环。通过这样的戏剧叙事，剧作家在表达着什么？

五、本节推荐阅读

[1] Aston，Elaine. *Caryl Churchill*. Plymouth：Northcote House Publishers，1997.

[2] Butler，Judith. *Gender Trouble*. New York：Routledge，1990.

[3] Cousin，Geraldine. *Churchill the Playwright*. London：Methuen，1989.

[4] Fitzsimmons，Linda. *File on Churchill*. London：Methuen，1989.

[5] Gobert，R. Darren. *The Theatre of Caryl Churchill*. London：Bloomsbury Methuen Drama，2014.

[6] Innes，Christopher. *Modern British Drama: The Twentieth Century*. Cambridge：Cambridge University Press，2002.

[7] Kritzer，Amelia Howe. *The Plays of Caryl Churchill: Theatre of Empowerment*. London：Palgrave Macmillan，1991.

[8] Randall，Phyllis R. *Caryl Churchill: A Casebook*. New York：Garland Publishing Inc.，1988.

第三节　伊莱恩·范思坦和英国女性
戏剧组及其《李尔的女儿们》

一、英国女性戏剧组和集体创作

由伊莱恩·范思坦和英国女性戏剧组共同创作的《李尔的女儿们》不仅是女性莎剧改写的代表之作,更是当代英国戏剧集体创作的典范。

1968 年之后,一大批边缘小剧场涌现出来,它们使戏剧成为最自由的艺术形式之一。在此背景下,各种女性剧团纷纷成立,如女子街头剧团(Women's Street Theatre Group,1970)、英国女性戏剧组、怪兽剧团等,这些剧团为女性剧作家们提供了展示自己才华的舞台。

事实上,在 20 世纪 70 年代英国女性戏剧崛起的过程中,大部分女性剧作家都有过与小剧团合作的经历。如丘吉尔的《老猫》《白金汉郡上空的光芒》《极乐的心境》等剧均是与怪兽剧团等集体合作的产物。除了怪兽剧团,另一个以集体创作著称的女性剧团便是英国女性戏剧组。自成立之始,为了避免陷入剧场竞争和权力等级关系,英国女性戏剧组便选定了集体创作为其创作的基本模式。她们推出了长达半年之久的周日开放活动,将剧场对所有喜爱戏剧的女性开放,邀请她们参与试演、剧本讨论和创作。这一活动吸引了众多女性,其中不乏有过主流剧场创作经历的职业女性。活动结束时,一批剧本脱颖而出,其中就包括帕姆·杰姆斯、米歇尔莱纳·旺达(Michelene Wandor)等剧作家的作品。[①] 这些活动奠定了英国女性戏剧组开放式的剧场格调。而由伊莱恩·范思坦和英国女性戏剧组共同创作的《李尔的女儿们》便是英国女性戏剧组集体创作理念的一部代表作,该剧不论在风格上还是内容上均可称为当代女性戏剧集体创作的典范。

1987 年,英国女性戏剧组决定推出一部莎士比亚戏剧的改写作品,为此她们邀请诗人伊莱恩·范思坦并向她提供资助,请她与剧组成员一起创作。范思坦是 20 世纪 80 年代后期在英国文坛上崛起的一位犹太诗人、小说家和剧作家,在参与《李尔的女儿们》创作之前,她以诗歌和小说著称,其戏剧创作并不多。在《李尔的女儿们》之后,她又独立创作了两部戏剧作品:《外国女孩》(*Foreign Girls*,1993)和《冬天里的相遇》(*Winter Meeting*,1994)。根据剧评家莉兹贝思·古德曼(Lizbeth Goodman)的记载,范思坦在和剧组探讨了剧本的基本思路之后,写了一个初稿。随后,创作组便开始以工作坊的形式对剧本进行了一系列的讨论和排练式修改,最终形成了 1987 年首演时的舞台剧本。[②] 所以,这部剧作是由范思坦、导演、五个演员共同完成的。鉴于这种集体创作模式,学界很难对《李尔的女儿们》的作者属性做出界定,多数著述称该剧由伊莱恩·范思坦和英国女性戏剧组共同创作。

《李尔的女儿们》不仅是集体创作的典范,也是女性改写剧场的经典作品。如阿德里安娜·里奇

①　Catherine Itzin,*Stages in the Revolution: Political Theatre in Britain since 1968*. London:Eyre Methuen Ltd,1980,pp.230-231.

②　转引自 Marianne Novy,*Cross-Cultural Performance: Differences in Women's Re-vision of Shakespeare*. Urbana:University of Illinois Press,1993,p.55.

(Adrienne Rich)所说,改写不只是文化历史中的一个篇章,更是一种文化生存的行为,作家改写的目的是通过改写性创作,走进一个被解放的属于"她者"的创作空间。① 通过改写经典,女性剧场重新找到了对被魔化的女性人物的再述权,从而打破女性作为"客体、符号或她者"的僵硬概念,让世人看到传统文本强加于她们的形象。

作为后现代创作的一种形式,集体创作不仅解构了传统作者的概念,更将戏剧推向了剧场的本质。多少世纪以来,世人在圣化莎士比亚的过程中将莎剧视为《圣经》一般的文字。女性主义剧场对莎剧改写的目的之一,就是要解构莎士比亚所代表的元作者的神话。用彼得·埃里克森(Peter Erickson)的话说,女性改写者所解构的并非莎士比亚的伟大艺术,而是他书写人类"崇高、神圣经验"时不可动摇的终极权威性。② 就女性主义改写创作而言,集体创作本身对其意义的发生非常重要。如改写理论家丹尼尔·费什林(Daniel Fischlin)所说,通过集体创作,女性改写剧场不仅凸显了戏剧创作的合作本质,更挑战了多个世纪以来围绕着"作者"这一概念的某些根深蒂固的观念——这些观念不仅决定了一个作家进入文学传统的资格,也决定了其地位的构建和持续性。作为被圣化的文学存在,莎士比亚身上早已聚集了被视为文学正典的标准性和文化价值观,这也是英国女子剧团选择从女性主义的角度、以集体创作的形式再写莎剧的原因。③ 传统上,一个作家在文学历史中的位置几乎完全取决于其作者属性,莎士比亚更是因其作者身份而获得了文化权威的地位。而《李尔的女儿们》的创作过程则告诉人们,戏剧和剧场本就是集体创作的聚集地,而非个体作者的独奏,任何作者,包括莎士比亚在内,都不过是剧场众多声部中的一个。在此意义上,该剧是对戏剧本质的回归。

二、《李尔的女儿们》④介绍

《李尔的女儿们》以《李尔王》为起源文本,从女性政治的角度,书写了一个关于李尔女儿们的"她者"故事,实现了当代女性主义剧场与莎剧的批判性对话。

《李尔的女儿们》共有十四场,五个人物:三个女儿、弄人(Fool)和保姆(Nurse/Nanny)。从剧情上讲,该剧属于莎剧改写,即以"前写本"的形式,讲述了高纳里尔、里根、考狄利娅、弄人和保姆之间以及三个女儿与李尔的关系。本剧开始时,三个未成年的公主生活在一个童话般的城堡里,由保姆照顾。她们有着不同的兴趣:高纳里尔喜欢绘画,里根热爱雕刻,考狄利娅钟情于文字。本剧结束时,她们却都失去了各自的兴趣:高纳里尔放弃了绘画,不惜一切代价追求权力;里根流产,彻底看穿了父权社会;考狄利娅失去天真,学会了沉默和权衡话语。

几个世纪以来,观众们一直对《李尔王》中三个女儿的形象感到困惑:为什么她们会如此残酷地对待李尔?她们是否应为李尔的悲剧负责?剧中为什么没有她们母亲的身影?基于莎剧中的这些裂缝,《李尔的女儿们》以"前写式"的叙事,将李尔女儿们的故事追溯到了莎剧《李尔王》发生之前。"前写"一

① Adrienne Rich, "When We Dead Awaken: Writing as Re-vision". In Maggie Humm, ed., *Feminisms: A Reader*. Hemel Hempstead: Harvester Wheatsheaf, 1992, p.369.
② 转引自 Lynne Bradley, *Adapting King Lear for the Stage*. Farnham: Ashgate Publishing Limited, 2010, p.193.
③ Daniel Fischlin and Mark Fortier, *Adaptations of Shakespeare*. London and New York: Routledge, 2000, p.215.
④ Elaine Feinstein and The Women's Theatre Group, *Lear's Daughters*. In Daniel Fischlin and Mark Fortier, eds., *Adaptations of Shakespeare*. London and New York: Routledge, 2000. 以下出自该剧本的引文页码随文注出,不单列脚注。

词来自英文 prequel，指根据现存文学经典的情节，凭着想象而创作的前篇。在《李尔的女儿们》中，故事以莎剧第一幕（年迈的李尔以女儿们所表达的爱来分封国土）为起点，逆时而上，进入《李尔王》之前的历史阶段——那时，李尔尚未年老，疆土尚未分裂，女儿们尚未成年。通过对女儿们从童年到成人的那段前史的叙述，该剧从当代女性主义的视角，向世人揭示了封存于那段沉默历史中的故事。

该剧的独特之处在于，集体创作不仅存在于剧本的创作过程，集体创作的概念更以"集体作者叙述"的形式被引入了剧情的构建之中：剧中的人物不是被动的客体，而是故事构建的主体，是自我历史的叙述者，她们以故事性话语，凭借各自的记忆，共同书写了一个属于"她们"的故事。

在《李尔的女儿们》中，故事性话语构成了剧情发展的基本框架。本剧开始时，弄人以半童话的口气说："在一个城堡里，住着三个公主，她们在育婴室里听着保姆讲童话故事。"（218）以此为开端，整个剧情的发展成为一个由故事和记忆编织的叙事。如在第二场中，保姆讲述了三个公主出生时的故事："当你（高纳里尔）出生时……一颗彗星拖着火红的尾巴在天上划过，照亮了黑色的天穹……"（218）在第三场中，三个公主讲述了第一次爬下楼去的故事，里根说："天很黑……透过一扇门，我听见一个男人在吼叫。门开着，一眼望去，我看见了父亲。"（220）在第九场中，保姆讲了一个耗子的故事：王国里耗子猖獗，国王重金请了一个捉耗子的吹笛手，后者吹着笛子把耗子领进了河里，但国王却食言背信，故事结束时，耗子占领了城堡，吃掉了国王和王后。在第十二场和第十三场中，故事事件与现实事件交错在一起：高纳里尔和里根准备出嫁，弄人谈论着金钱、投资和公主的身价；里根怀孕了，但为了国家不得不堕胎，她和姐姐一起嫁给了帮助李尔平叛的公爵。在第十四场中，保姆被告知，她已被辞退。她悲愤地讲述了她最后一个故事：当年为了哺乳李尔的孩子，她不得不丢弃了自己的孩子。她最后预言："李尔，耗子在啃噬你的王位。我会远远地站着，笑看此壮举的发生……"（231）此后，她走下了舞台，穿过观众席而离去。随着门被"砰"地一声关上，舞台上的灯光都聚焦在弄人身上。她说道："一个结束，一个开始。时间到！"（232）

在整个剧作中，人物们用故事、童谣和记忆讲述剧情和对白，形成一种不同于正史叙事的戏剧策略。事实上，不论是对于该剧的女性集体创作者，还是剧中五个来自莎剧的人物而言，以故事性话语叙述事件和历史本身都具有特殊的意义，因为故事不只是故事，还是书写历史及身份的载体。

在莎剧《李尔王》中，弄人是李尔身边的小丑，但也是李尔人性、良心和理性的化身，代表着世间普遍的常识。但在《李尔的女儿们》一剧中，弄人却是一个复杂而难以界定的人物。她既是男，也是女；既是弄人，又会客串王后，甚至李尔。弄人是剧中最为独特的叙述者：她既是叙述者，又是评论者；她既讲述故事，又盘点剧情。本剧以她的开场白开始，又以她的话语结束，她在参与叙述的同时，还扮演着剧内导演的角色——她以特有的概括性独白推动着剧情，她那看似荒诞的语句却带有极强的评论性色彩，揭示着剧中人物的命运和戏剧主题。

事实上，对李尔女儿的历史书写是五个人物集体叙述的共同结果。在此过程中，如果说弄人像是剧内导演，那么保姆则是剧中最重要的故事讲述者。在剧中，保姆几乎讲述了所有的故事：三个女儿的出生、三个女儿第一次爬下楼去、李尔两次胜利归来、笛手和耗子的故事、王后的故事以及保姆自己的故事。但这位故事叙述者也是谜一样的人物。她同时扮演着母亲和佣人的双重角色，被称为 Nurse，又被称为 Nanny。她的故事叙述中似乎隐藏着如蒙娜丽莎的微笑一般神秘的知识。

同样参与集体叙述的还有三个女儿，她们既是被讲述的对象，又是故事的讲述者和参与者。她们在参与和叙述中走完了从天真到成熟、从童话主人公到莎剧中李尔女儿原型的精神之旅。在剧中，三个女

儿的故事在一定程度上也是她们与李尔关系的故事,是她们在父权社会中自我认知的故事。所以,在故事的叙述顺序上,她们出生故事之后的第一个故事便是"爬下楼去,学着认识一个父亲和一个国王"(219)。尽管三个女儿的经历不同,但她们的故事在结构上却如出一辙:跨出育儿室的门槛,便进入了一个由父亲和王者主宰的世界——在这个世界中,对李尔的印象构成了她们对世界的第一认知。剧中不时会出现这样的画面:高纳里尔站在窗边,或是考狄利娅走到镜子前。由女儿、窗口和镜子构成的画面似乎暗示着对于三个女儿而言,她们听到的、参与的和叙述的故事既是她们认知世界的窗口,也是她们认识自我的镜子。在剧中,透过一个个故事,女儿们走完了她们的成长之路——从童话公主最终变成父权社会中以钱估价的商品。

因此,在本剧中,集体作者叙述不仅仅是一种叙事策略,也是本剧政治主题的一部分:其集体创作性使它成为对一切正典历史叙述的挑战。透过人物的故事性话语和集体作者式记忆,本剧强调了历史叙述的文本性、虚构性、话语性和政治性本质,呈现出一种新历史主义的叙事观。剧中的细节一再暗示,历史书写在本质上是一种带有文本和虚构色彩的主观记录。随着对故事叙述的参与,李尔的女儿们越来越发现,那些构成她们自我和对李尔认知的成长故事,竟充满了谎言。而这也正是女性改写者对历史叙述真相的发现——历史叙述并非史实性的、客观的,相反它和所有叙述一样具有文本的虚构性和主观性。这也是为什么随着更多故事的展开,三个女儿不仅开始质疑那些她们听到的故事,而且渐渐地从被动的故事角色中走出来,主动地参与故事的叙述和建构。因此,在一定程度上,剧中人物对故事叙述参与的冲动与现实中女性剧作家们对莎剧改写的冲动形成了一种平行:不论剧内,还是剧外,她们都在以自己的角度讲述或再述"她们"的故事。因为她们都发现了叙述传统对她们身份的扭曲性界定,因此她们选择了跳出"被写",转而成为历史叙述的作者和改写者。

本书节选的是《李尔的女儿们》(单幕剧)中的第二场、第三场、第八场、第十二场、第十三场、第十四场。

三、《李尔的女儿们》选读[①]

Lear's Daughters

Scene Two

Three Sisters, the Nurse together

NURSE(*to* GONERIL):When you were born, the Queen wore nothing but her crown.

CORDELIA:What, nothing?

NURSE:Lear was not there. He was in the library looking at something. You came out like a dart, head first, then body, all over scarlet, covered in blood. The crown fell off and over you, encircling you, your whole body.

GONERIL:What then?

① Elaine Feinstein and The Women's Theatre Group, *Lear's Daughters*. In Daniel Fischlin and Mark Fortier, eds., *Adaptations of Shakespeare*. London and New York: Routledge, 2000, pp.218 - 220, pp.224 - 225, pp.229 - 232.

NURSE：And then a comet rushed through the sky，leaving a red trail in the black. (*whispers*) And it was twelve o'clock midday.

GONERIL：I remember it. I remember it quite clearly. I remember being born quite clearly. I heard music.

REGAN：What about me?

NURSE：When you were born，the Queen was sitting on her throne. At midnight you dropped out onto the velvet plush like a ruby.

CORDELIA：Where was Daddy this time?

NURSE：Still in the library.

REGAN：And then what happened?

NURSE：A volcano erupted.

REGAN：A volcano?

NURSE：Yes，the lava got everywhere. We were cleaning for days.

REGAN：I remember it. I heard music too.

NURSE：And was it beautiful?

REGAN：Yes，oh yes.

CORDELIA：Now me. What happened when I was born?

NURSE：When you were born...

　　(NURSE *looks at her. She draws* CORDELIA *to her，whispers in her ear*.)

GONERIL：What?

REGAN：What?

GONERIL：What did she say?

REGAN：What did she say?

　　(CORDELIA *and* NURSE *look at each other*.)

GONERIL：Nothing. Nothing happened did it? Nothing.

NURSE：And afterwards we had cake. Victoria sponge on a doily in the parlour with the clock ticking. The cake was cut into three.

REGAN：A piece for each of us.

NURSE：A piece for Lear. A piece for the Queen.

　　And a piece for me.

REGAN：Did it taste nice?

NURSE：Ask Lear.

　　(*The* NURSE *moves away*.)

REGAN：What did she say?

GONERIL：What did she say?

REGAN：Come on，Cordelia!

CORDELIA (*slowly*)：She said that the Queen was outdoors. And I grew like a red rose out of her

legs. And there was a hurricane.

REGAN: It's the same, it's the same.

CORDELIA: And Lear was there.

(*Lights down. Light up on* FOOL *down right*.)

FOOL: When she came, there was just a note. It said, 'I'm coming soon. Nanny.' So I went about my business. If the note had any significance it was wasted on me. Two weeks later there was another note, pinned under my cereal bowl. 'There's been a set-back, but wait for me there. Nanny.' I was seven or maybe twelve, I can't be certain, but Goneril was definitely two. The Queen, their mother then, had taken to spooning honey over the flowerbeds. She wore a peg on each finger and had ordered the hair to be removed from all over her body. Everyone said there was something wrong. She'd tipped the scales. She needed a friend or a nurse or 'at least something to cheer her up a bit', everyone said. A third note came. 'Sorry it's taken so long but I shall be with you by midday tomorrow. Can I bring my ducks?' Signed Nanny or Nurse.

By eleven o'clock next day I was at the city walls watching for a new face. At middy she came, riding sideways on a donkey. I knew it must be her.

(NURSE *moves into space as if entering for the first time*.)

NURSE: Sorry I'm late.

FOOL: She said.

NURSE: But these things take time.

FOOL: 'Oh, don't worry, no matter', I said and I helped her carry her things to her room. 'Will you be stopping long?' I asked.

NURSE: That's not really up to me.

FOOL: She said.

NURSE: I do as I'm told.

FOOL: I don't know if you're expected, that's the trouble.

NURSE: I'll make myself indispensable. Soon they'll come to rely. You know how these folks are, always make the same mistakes.

(FOOL *holds out hand for money*. NURSE *places gloves in* FOOL's *hand*. FOOL *throws bag to* NURSE.)

FOOL: Three daughters. With two mothers—one buying, one selling. One paying, one paid.

(FOOL *picks up the* QUEEN's *veil*.)

Scene Three

The Fool is the Queen

(FOOL *sits on box upstage. Arranges veil as the* QUEEN. *During this scene* FOOL *speaks as*

FOOL *and* QUEEN.)

FOOL (QUEEN)：Nurse! Nurse!

NURSE：Yes，your majesty.

FOOL (QUEEN)：Is it nearly morning?

NURSE：The birds are just beginning.

FOOL (QUEEN)：Don't talk to me about birds. The doctor was putting live pigeons on my feet all day yesterday.

FOOL：To help her conceive.

NURSE：What is this? (*picks up cup*)

FOOL (QUEEN)：The doctor gave it to me.

NURSE：What for?

FOOL (QUEEN)：To help me sleep.

NURSE：He's a fake. What are you doing with these? (*picks up ledgers*)

FOOL (QUEEN)：Keeping the accounts/

FOOL：The budget is in chaos. Taxes aren't being paid，and there's no income from the fields.

NURSE：You should leave all that business to him.

FOOL (QUEEN)：He is very distressed by reading documents like these/

FOOL：so by and large he doesn't read them.

NURSE：About your children.

FOOL (QUEEN)：I want them taken away.

NURSE：You don't see them enough.

FOOL (QUEEN)：South.

NURSE：He won't like that.

FOOL (QUEEN)：I could go with them. For a holiday.

BOTH：He won't like that.

FOOL (QUEEN)：No，he won't，he likes to have me near him.

NURSE：I'll bring them in to see you then，shall I?

FOOL (QUEEN)：I'm too tired.

NURSE：Later on this afternoon.

FOOL (QUEEN)：They wear me out.

NURSE：That's settled then. I'll go and arrange it. Good.

　　(NURSE *crosses down left，pauses at exit. Curtsies.* FOOL *dumps* QUEEN *and moves down centre.*)

FOOL：Lear's daughters. Three princesses creeping down the stairs，learning about a father，who is also a king.

　　(*Going downstairs.*)

(GONERIL，REGAN，CORDELIA *centre stage*. FOOL *circles the sisters and as each one speaks mirrors actions and words*. FOOL *first looks at* GONERIL *and turns suddenly and points to* CORDELIA.)

CORDELIA：The first time I go downstairs，I run bare foot cold on the stone steps. Careful I tell myself. Slow down：Don't slip. But I have to run because of the shadows. In my new white shirt，satin rustling as I go downstairs. Looking up，there is a huge oak door，with a handle high above my head. I reach up，wanting to be let in，banging my hands on the door until it opens. There are too many lights and too many faces. And then the one face，clear and sharp，stooping right down and swinging me high above the floor，up to the ceiling，up to the rafters. In a giant's arms，my feet are touching the sky，and then...down. The smell of a breath，warm and sweet，soft lips wet on my cheek，bristles scratching my chin and neck，and down on to the table，and I turn，holding my skirt，round and round. Look，Daddy，look，Daddy，look，look，look.

(FOOL *touches* REGAN.)

REGAN：I'm not scared going downstairs. It's dark and very late. Goneril is asleep，lying across her bed，with one hand and foot hanging over the side，frowning and talking in her sleep，like she always does. Cordelia is sleeping curled up tight in a ball. Sheets and blankets wrapped tight around her. And I am on my own. Downstairs I go，breathing shallow and seeing nobody. The stairs are rough on my feet. Passing a door I hear men's voices shouting and calling. The door is open and looking in，I can see my Father. He is singing，banging his fist on the Table，not quite in tune，not quite in time. And his arm is around Mother's neck. I think it's Mother. He has a hand inside her dress，holding her breast. Not tender，he's just holding her. And Mother's face. It is Mother. I'm certain it is. Her face is blank，without expression，like a figure made of wax. I'm scared now. (*turns back to mirror*)

(FOOL *touches* GONERIL.)

GONERIL：The first time I go downstairs，I sit on his throne to see what it is like. It has a high back，carved and uncomfortable. He likes that，likes to feel its weight behind his back. It is so big my feet cannot reach the edge. I stay on a long time，sitting quietly，looking about me. When he comes in，I am smiling，and he is angry because he knows what I am thinking and I smile on—because I want him to know.

(FOOL *addresses audience*.)

FOOL：The first time I went downstairs I was pushed. And it bloody hurt. I broke my finger (*holds up little finger—it is straight*) and it's never been straight since. Look. (*bends little finger*)

(FOOL *moves downstage. Looks at notes—the running order*.)

The Guided Tour. (FOOL *walks round centre stage*) The nursery. Books，paints，a knife—for carving—and a Nanny. Down the stairs the parlour—lace，cake，a knife—for slicing—

medicines, honey, account books—to keep things in order.

NURSE(*interjects*): And the Nurse.

FOOL: Down the stairs. The dining room. The kitchen. The storeroom. The Counting House—for the king! A knife—for the guard. And (*points*) the Fool's room. (*moves to its spot*) And underneath, the sewers, full of Rats. Now. (*gets comfy*) The Fool.

　　When I was born, nothing happened. There was no bright star, no hurricane, no visitors came from afar. Obviously my parents hadn't read the right books so my arrival was completely overlooked.

<div align="center">

Scene Eight

</div>

Funeral preparations

FOOL (*putting veil down in bundle*): The Queen is dead! Long live the Queen! But who will take her place at the King's right hand? Cordelia the favourite, Goneril the eldest, or Regan the outsider?

　　(CORDELIA *leaves centre stage*. GONERIL *goes to trunk and puts head on hands*. REGAN *picks up hair brush from floor*.)

REGAN: We'd better get changed. We can't go downstairs dressed like this. (GONERIL *is shaking*. REGAN *crosses to her*) Don't cry. (REGAN *comforts her*) Don't cry...you're laughing! Stop it! Why are you laughing?

　　(GONERIL *Stops. Shakes head*.)

GONERIL: He'll be very upset. He'll have to manage on his own now.

　　(*They both start to laugh*. FOOL *laughs quietly with them offstage. They stop laughing*.)

REGAN: How will we manage without her?

GONERIL: Don't worry. I'll take care of everything now.

REGAN: We should change.

GONERIL: No. He'll be down there all in black. Dressed for sorrow. We'll be fine as we are.

　　(*They smile*, REGAN *turns away*) Regan. I feel sick.

　　(GONERIL *holds her stomach. Cries*.)

REGAN: You'll be fine. You'll be fine.

GONERIL: Will it take long?

REGAN: No, I don't think so.

　　(CORDELIA *enters*.)

CORDELIA: He said I'm his special girl and I've got to look after him. I'm not going with you, I've got to hold his hand. (GONERIL *goes to trunk*. REGAN *slumps on bench*) Nanny! (NURSE *enters*) Daddy says Mummy's gone to live with God and I can wear a long black dress with gloves. Get me ready.

NURSE: Turn around.

CORDELIA: He said Mummy would be pleased to know she'd left everything in such good hands. Do you think she can see us now?

NURSE: Keep your head still.

CORDELIA: He said when we come out of the church all the people will cheer when I stand next to him because I will be so brave. Do you think they will?

NURSE: There you are. You'll do.

CORDELIA (*turns to look in mirror*): Oh. Look, Nanny, look, I look really grown up. Just like a Queen.

REGAN (*sharply*): Goneril. Look.

(GONERIL *crosses to window. Looks at* NURSE. NURSE *goes to window.*)

CORDELIA: What is it?

(GONERIL *indicates to* NANNY *to take* CORDELIA *away quickly.* NANNY *looks out of the window.*)

NURSE: Come with me.

(*When* NURSE *and* CORDELIA *have gone,* REGAN *and* GONERIL *look to the window again, after a while* REGAN *turns away.*)

GONERIL: How can he? Today.

REGAN: He's disgusting.

GONERIL: He's got his hand right up her skirt.

REGAN: Anyone can see him. Not just us. Doesn't he care?

GONERIL: He's unbuttoning himself.

REGAN: Come away.

GONERIL: He's so... How dare he?

REGAN: Who is she?

GONERIL: I don't know.

REGAN: Doesn't she mind him pawing her like that?

(*They turn away from window.*)

GONERIL: What will happen now? Do you think he will marry her?

REGAN: I don't know.

GONERIL: If he does he'll have a son. I know it. He'll try until he does. I'll never be Queen.

(FOOL *enters from left, whistling* 'Sing a song of sixpence'. *Circles centre stage and then looks out of window over shoulders of* GONERIL *and* REGAN.)

FOOL (*laughing. Sings*): Wasn't that a dainty dish to set before the King? (FOOL *returns to its spot. Whistles*) Time passes. (*whistles*) It rains. And every spring the river outside the castle overflows, flooding the sewers and disturbing the rats. (*pause*) One morning a stone is

thrown through the window，breaking the glass and cracking the mirror. It lands in the middle of the floor. (*makes popping sound. Sisters centre stage look at spot and then turn away in boredom*) Lear takes to riding in his carriage with the shutters down and going the long way round to avoid the crowds. And the Fool amuses the Nanny，and the Nanny amuses the Fool，as they wait for the rain to stop.

Scene Twelve

Sisters discuss getting married

(GONERIL *and* REGAN *on stage*. GONERIL *is reading ledger*.)

REGAN：Are you getting changed?

GONERIL：No.

REGAN：Aren't you coming down?

GONERIL：No.

REGAN：Why not?

GONERIL：I'm too busy.

REGAN：You have to come. It's our celebration.

GONERIL：I must finish this.

REGAN：Come down with me.

GONERIL：No.

(*Silence.*)

REGAN：Goneril.

GONERIL：What?

REGAN：This wedding. (*there is silence*) What do you feel about it?

GONERIL：Nothing.

REGAN：I don't understand.

GONERIL：I feel nothing about it.

REGAN：Do you want this marriage?

GONERIL：Wanting doesn't come into it.

REGAN：When I lie in bed at night，I can feel my heart beating so fast，it's like I'm living at twice the pace. I'm running out of life. How can you feel nothing about it?

GONERIL：It's our job. It's what we're here for. To marry and breed.

REGAN：Like dogs?

GONERIL：Like dogs. Valuable merchandise. I can show you the figures here if you like.

REGAN：I'm scared.

GONERIL：It's what we're here for.

REGAN：I'm going to have a baby. Seven months' time. Nurse says.

GONERIL: How could you be so stupid?

REGAN: Oh, Goneril? I'm not stupid, but I'm not stone, not dead. You, you've always been the first, the cleverest, the best, and Cordelia, she's the, the pretty, the lovable, Lear's darling. Then there's me, in the middle, neither fish nor fowl, do you see? I've had nothing that's, that's for me, just for me. I've been number two, between one and three, but nothing. So I've taken everything, everything that I can feel or touch or smell or do or be, everything to try and find something, to find me, do you see?

GONERIL: Come here, Regan. You see these ledgers? What do they say to you?

REGAN: Listen to me?

GONERIL: You see these figures! (REGAN *turns away, goes to mirror*. GONERIL *pulls her back to trunk. Forces her to look at ledger*)

REGAN: Let go of my arm. (*struggling*)

GONERIL: They say Regan, Second Daughter of Lear, is worth this much, and these figures here...(REGAN *tries to look away*) Look at them? These figures say My Lord Duke of Cornwall, owns this much. These figures say Regan will marry Cornwall and then Cornwall will own more and Lear will get a grandson, a legitimate heir and they will all be contented men. However, Regan, Second Daughter of Lear, with bastard child, is worth *this* much! (GONERIL *rips out page from ledger, crumbles it and throws it on floor*. REGAN *pulls away to mirror, staring hard into it*) Get rid of it!

REGAN (*looking in mirror*): I can't see your features. Your expression in the mirror. Your face is blank.

GONERIL: You're imagining things.

REGAN: It's him. You've got his face.

(GONERIL *exits. Lighting change*. REGAN *pacing floor*. NURSE *enters carrying cup and cloth*.)

REGAN: Will it take long?

NURSE: No, I don't think so. It will hurt.

(REGAN *nods. It is hurting already*.)

REGAN: What was it?

NURSE: Rue and pennyroyal. (*there is pain*. REGAN *groans aloud*) You mustn't scream. Bite on this.

(NURSE *hands* REGAN *cloth. There is pain*. NURSE *goes to* REGAN *and holds her*.)

REGAN: I'm going to die. You've poisoned me.

NURSE: You're not going to die yet.

REGAN (*in pain*): Please let it be over. (*pain*) Please.

(NURSE *puts rag in* REGAN's *mouth*. REGAN *groans*. NURSE *Stands behind* REGAN. *Holds her*.)

NURSE：Breathe. Breathe. You have to push.

REGAN：Oh，Jesus.

NURSE：You have to.

REGAN：I'm frightened.

NURSE：Push. Push.

　　（*There is a pause.*）

REGAN：What do I look like?

NURSE：You look as if you're laughing. （*There is no more pushing.* REGAN *collapses to floor.*
　　NURSE *looks down.*）

　　It would have been a boy.

REGAN：I'll get out of here soon.

NURSE：You will.

　　（*Lights down. Lights up on* FOOL.）

<div align="center">

Scene Thirteen

</div>

The weddings

FOOL：Two bridegrooms waiting downstairs. Two brides waiting to be swept off their feet.

　　（FOOL *walks to window*，*humming the Wedding March.* GONERIL *and* REGAN *kneeling at*
　　altar. FOOL *stands on window seat.* NURSE *and* CORDELIA *watch.*）

FOOL：Who gives this woman?

　　（*When answering questions* REGAN，CORDELIA，GONERIL *and* NURSE *all speak together*
　　and take different poses.）

CORDELIA：So beautiful.

GONERIL/REGAN：I promise，I do，I will. （*spoken happily with big smiles*）

NANNY：Lear triumphant.

FOOL：To love，honour and obey.

NANNY：That is my place. That is my place. （*spoken happily with big smiles*）

GONERIL/REGAN：I promise，I do，I will. （*spoken happily with big smiles*）

CORDELIA：Spin for Daddy. （*spoken happily with big smiles*）

FOOL：Just cause or impediment?

NANNY：And you mustn't tell. And you mustn't tell.

GONERIL/REGAN：I promise，I do，I will. （*spoken as above*）

CORDELIA：Just the two of us. （*spoken as above*）

FOOL：Who gives this woman? （*menacing*）

NANNY：Lear triumphant. （*loud*）

CORDELIA：So beautiful. （*whispered*）

GONERIL/REGAN：I swear to. (*whispered*)

FOOL：Love，honour and obey?

NANNY：That is my place，that is my place. (*whispered*)

GONERIL/REGAN：I promise. I do，I will. (*whispered*)

CORDELIA：Spin for Daddy. (*loud*)

FOOL：Just cause or impediment?

NANNY：And you mustn't tell. (*loud*)

CORDELIA：Just the two of us. (*whispered*)

GONERIL/REGAN：Triumphant. (*whispered*)

FOOL：Kiss the bride. (*happily*)

CORDELIA：She means the world to him. (*spoken loud and happy*)

NANNY：She brings a large dowry. (*spoken loud and happy*)

GONERIL/REGAN：To love and cherish. (*spoken loud and happy*)

FOOL：Catch the flowers.

CORDELIA：Daddy's girl. (*spoken loud and happy*)

NANNY：Cordelia the favourite. (*spoken loud and happy*)

GONERIL/REGAN：To love and cherish. (*spoken loud and happy*)

FOOL：Cut the cake.

CORDELIA：Together again. (*spoken loud and happy*)

NANNY：A knife for slicing. (*spoken loud and happy*)

GONERIL/REGAN：To love and cherish. (*spoken loud and happy*)

GONERIL/REGAN：To love and cherish.

FOOL：Kiss the bride. (*menacing*)

NANNY：She brings a large dowry. (*loud*)

CORDELIA：She means the world to him. (*whispered*)

GONERIL/REGAN：To love and cherish. (*whispered*)

FOOL：Catch the flowers.

CORDELIA：Daddy's girl. (*loud*)

NANNY：Cordelia the favourite. (*whispered*)

GONERIL/REGAN：To love and cherish. (*whispered*)

FOOL：Cut the cake.

CORDELIA：Together again.

NANNY：A knife for slicing. (*loud*)

GONERIL/REGAN：Cherish.

[GONERIL *goes for* LEAR's (FOOL's) *eyes with knife. Action freezes. All turn to audience，*

begin to walk down stage. Chattering，repeating sections of above plus.]

GONERIL：Thank you for coming. Yes，he is handsome，isn't he?

NANNY：With his light shining all around her，like a net.

CORDELIA：As they came out of the church the people cheered and cried so I did as well.

FOOL：One day this will all be yours.

(*pushing way to front*) And the King said, 'I have decided I cannot part with you both yet. Live here a while longer.'

(*Silence. Then all begin to speak again.* GONERIL *holding knife moves upstage.* GONERIL *drops knife.*)

REGAN：Goneril!

(*Chatter starts again.* GONERIL *slowly moves to window. In the chatter we hear the name* 'GONERIL' *emerging until it turns into a collective cry.*)

ALL Goneril!

GONERIL (*on window seat，as though to throw herself out*)：Nanny! I can't see! The lace is scoring into my eyes. I can't see anything. Nanny! Nanny!

(NANNY *catches* GONERIL. FOOL *runs away. Lights out.* GONERIL *and* REGAN *move off-centre.* NANNY *returns to her spot.* FOOL *walks from its spot across stage to* NANNY.)

Scene Fourteen

The Nurse reveals all.

(FOOL *scuttles across to* NURSE's *spot. Has letter behind its back.*)

FOOL：Knock，knock.

NURSE：Who's there?

FOOL：Letters.

NURSE：Letters who?

FOOL：Let us in，I've got a note for you.

(*Hands letter to* NURSE. *Hurries back to* FOOL's *spot.*)

NURSE (*opening letter，finds money inside*)：My services are no longer required. Who does he think he is? Who is he to throw me aside when he no longer wants me to do the job he chose for me in the first place! Oh no，I didn't choose it；I was poor. Just like the Queen when she didn't make the right sort of boy-child for him—finished. Well，she died，didn't she? (*mimics*) Yes，but... Yes but what? Why did she die? How? You don't know. I do. I was there. And now me. How many more? How many more of us will he throw away when we no longer suit? Goneril? Regan? Cordelia even? (*mimics*) Oh-no-not-Cordelia-she'll-always-fit. Will she though? could have dropped her on the castle steps and her head would have cracked open like an egg. I could have taught them bad things. Have I? I've nearly bitten my tongue in two. And sometimes I haven't bothered. Well，they've learnt. From-me-wit-me-without-

me. All but her. Cordelia. Well，we'll see. Money he gives me. Pieces of silver. What do I want with his gold? I had a baby once. Did you know? I had to give my baby away so that I had milk for his. Milk. When his Queen died I looked at my shrunken breasts in the bit of mirror I had and then I put it in the coffin. What to do? Eat farewell cake in the parlour? Stab it to crumbs! Leave him a note, 'Cordelia's mine—I swapped her at birth for your son. Love Nanny.' That would rock his little world. But is it true? You'll never know. I do. Walk down the stairs，out of the castle，through the city，out of the city，beyond into the countryside，back to where I belong，people I know. Lear! There are rats gnawing at your throne and I'll not be in it but I'll watch the spectacle from afar，smiling，knowing it is what I've always wanted to happen.

（NURSE *gathers her belongings*. *Takes off apron*. *Walks to centre stage*. CORDELIA *is looking through window*.）

CORDELIA：They've gone. I saw Goneril stop on the skyline and I thought for a moment they were turning and coming back. But they didn't. (*walks round room*) She's left her paints behind. I suppose I can give her them when they visit. She can get some more. Just us now. Nanny.

NURSE：I'm leaving.

CORDELIA：Leaving?

NURSE：They've gone...you're to be married soon—when he's decided on your husband. I'm not needed anymore. He says.

（NURSE *goes to exit*.）

CORDELIA：Nanny! （NANNY *turns*） You never liked me，did you? （NURSE *doesn't answer*） No. No-one does but him. （NURSE *turns to go*） Nanny，listen. I've got two voices. Ever since going downstairs and Daddy lifting me onto the table，I've talked like a child，used the words of a child. No-one likes it but him. But I do have another voice. In my head I have words I never say to anyone—never have said to anyone. Till now. I can do it，you see. (*goes up to* NANNY) Nanny，don't go. I could go and see him，he listens to me，I'm his little girl... (*trails off*. *Realizes the difficulty*. *Starts again*) I could speak to him as a woman，as one adult to another，he'd listen，he'd...(*stops*. *Knows*)

NANNY：It doesn't matter，Cordelia. (*turns*. *Whispers something to* CORDELIA. NURSE *exits*，*walks to* FOOL) Money he gives me! Pieces of silver? What do I want with his gold? Here，Fool. Grovel for it，Fool，for that I shall never do!

（NANNY *tempts* FOOL *with money*. *Throws it up in the air and hits the* FOOL *around the face with fist*，*flattening* FOOL *to ground*. NANNY *exits through audience*. *Banging doors*. FOOL *gets up*.）

CORDELIA：Fool!

（FOOL *gathers money*. *Goes to* CORDELIA *who is sitting at window seat*，*crying*. FOOL *tosses*

coin in air. Decides. Sits next to CORDELIA *and starts to cry, aping it badly. A caricature of* CORDELIA. CORDELIA *looks at* FOOL *and stops crying.*)

(FOOL *moves quickly to front stage. Lights up on* FOOL.)

FOOL: That very night the Fool went downstairs, stood on the table and began its turn.

How many kisses does it take to keep a king happy?

One to kiss his tears away.

One to kiss his fevered brow.

One to kiss him deep in passion and 100 to kiss his arse!

(*mimes being hit in face*)

And the King doesn't laugh.

Who's the biggest stinker in the world?

King Pong!

(*laughs again and mimes being hit in face*)

And the King doesn't laugh.

A man goes up to a woman in the street. 'How much?' he says. She is outraged. 'What do you think I am?' and the man says, 'We know what you are, love, we're just discussing the price.' And the King laughs—and he laughs. He laughs as though he would burst. Taking the Fool's ear he twists it to open its mouth. He places a coin on the edge of its tongue and the Fool. (*mimes swallowing coin, gulps*) Three, two, one and the Fool—standing on the table looking after number one. A Father waiting outside. Two mothers, one dead or gone missing, the other leaving. Three daughters, paying the price.

(*Lights up centre stage.* GONERIL, REGAN, CORDELIA *stand in line,* GONERIL *in middle.*)

GONERIL: Looking up, I can't see the sky. There's too much red. Red in my eyes. Red on my hands. They touched and felt but I cannot recognize them. My father's daughter, and still he gives me stop and start. Controlling by my hatred, the order of my life. Lear's daughter. Blood in my eyes and lost to heaven.

REGAN: I used to carve with my knife, create beauty from distortion, soft curves from the knottiest, most gnarled woods. When life was at its dullest, most suffocating, I would be full of energy, curiosity. And then 'Get rid of it', she said, 'Get rid of it', and that was all. The veil was pulled away from my eyes and I could see what he had done to her, had done to me. And so I shall set my face to a new game which will not be beautiful, but there'll be a passion still and I'll be there with it till the end, my end, carved out at her hands—and I would not have it any other way.

CORDELIA: Words are like stones, heavy and solid and every one different. I hold two in my hands, testing their weight. 'Yes', to please, 'no', to please myself, 'yes', I shall and

'no', I will not. 'Yes' for you and 'no' for me. I love words. I like their roughness and their smoothness，and when I'm silent I'm trying to get them right. I shall be silent now，weighing these words，and when I choose to speak，I shall choose the right one.

（*Lights on* FOOL *on its spot*. *Bows to audience*.）

FOOL：An ending. A beginning.（*throws crown into circle*，*the sisters all reach up and catch it*. *Freeze*.）Time's up.

（*Holds out hand for money*.）

（*Blackout*.）

四、思考题

1. 什么是文化唯物主义？什么是女性文化唯物主义？

2. 虽然本剧中的弄人和莎剧中的小丑弄人形象不同，但他/她们却有着一定的共通性：虽然他/她们均是小人物，但作为清醒的知情者，他/她们看到了剧作家希望观众能看到的真相。你如何理解这一观点？他/她们在各自剧中看到的真相是什么？

3. 本剧是对莎剧《李尔王》的"前写式"书写，我们该如何从互文性的视角来解读当代女性主义剧场与莎剧的批判性对话？就改写理论而言，"前写本"重述过去的事件是为了影响和断裂"现在"，《李尔的女儿们》对李尔女儿们前史的构建，不可避免地会冲击到观众对《李尔王》的理解，从而对莎剧的意义产生影响。你怎么理解这一观点？

4. 如何理解该剧中王后这一形象？母亲的缺失与三个女儿的悲剧结局有何关联？

5. 剧作家在该剧中运用故事、童谣和记忆这样的非主流话语来重述三个女儿的故事，其寓意何在？

6.《李尔的女儿们》不仅表现出对"女性经历"的极大关注，更表现出对女性人物如何从"父权式社会结构"的羁绊中解脱的关注。你如何理解这一评论？

五、本节推荐阅读

[1] Bradley，Lynne. *Adapting King Lear for the Stage*. Farnham：Ashgate Publishing Limited，2010.

[2] Fischlin，Daniel and Fortier，Mark，eds. *Adaptations of Shakespeare*. London and New York：Routledge，2000.

[3] Friedman，Sharon，ed. *Feminist Theatrical Revisions of Classic Works*. North Carolina：McFarland & Company，2009.

[4] Hutcheon，Linda. *A Theory of Adaptation*. New York：Routledge，2006.

[5] Humm，Maggie，ed. *Feminisms：A Reader*. Hemel Hempstead：Harvester Wheatsheaf，1992.

第三章
当代英国直面戏剧

第一节　当代英国直面戏剧概论

　　1995 年 1 月 12 日,萨拉·凯恩的《摧毁》在伦敦皇家宫廷剧院上演,剧中对暴力、性虐、屠杀等社会现象的描写给沉寂的英国剧场带来了巨大的冲击,成为英国剧坛的又一颗"炸弹"。该剧以最真实的暴力场景直面社会现实,呈现当今社会面临的威胁,强有力地反映了 20 世纪 90 年代处于英国社会边缘的一代年轻人的叛逆和愤怒。在他们看来,"正常人"的生活虚假、空洞、无聊,所以他们宁愿选择主流社会所不齿的另类生活方式,如吸毒、偷窃、放纵和暴力,因为他们认为这种刺激性的生活才是真实的。

　　在很大程度上,凯恩的《摧毁》对当代英国剧坛的影响不亚于《愤怒的回顾》在第一次浪潮中的影响——它直接催化了 20 世纪末英国戏剧的转向,成为英国"直面戏剧"兴起的标志。继《摧毁》上演后,一大批具有类似特征的剧作先后出现,如马丁·麦克多纳的《丽南山的美人》、马克·雷文希尔的《购物与纵欲》(*Shopping and Fucking*,1996)、安东尼·尼尔森的《审查者》(*The Censor*,1997)等。这些戏剧以暴力美学的方式,大胆描写处于当代社会边缘的下层年轻人中的暴力、非传统性生活等,形成了当代英国戏剧发展的第三次转折,并被贴上"直面戏剧",即 In-Yer-Face 的文类标签。这些作品被频繁地搬上伦敦主流剧场的舞台,其中也不乏获得托尼奖(Tony Award)、普利策奖(Pulitzer Prize)、劳伦斯·奥利弗戏剧奖(Laurence Olivier Award)等重要戏剧奖项的作品,它们不仅成为英国戏剧的当代经典,在国际剧坛也享有盛誉。

　　事实上,In-Yer-Face 一词并非专业文学术语。它最早出现在美国 20 世纪 70 年代的体育新闻中,是一种表示嘲讽和耻笑的叹词,后来发展为俚语,意为"个体的空间遭受侵犯"或"正常的界限被逾越"。[1] 该词作为戏剧术语最早出现在英国戏剧评论家亚历克斯·希尔兹(Aleks Sierz)的文章中,用来描述 1994 年至 1999 年间出现在英国剧坛的由《摧毁》所代表的戏剧创作范式:这种戏剧中的人物不仅语言粗俗肮脏,而且谈论着各种禁忌话题,脱衣行不耻之事,甚至互相谩骂羞辱,处于时而不悦、时而暴力的癫狂状态。但这种戏剧却能强有力地迫使观众做出发自内心的反省,他们要么急切地逃离此处,要么被深深震撼,认为这是他们所见过的最好作品,并希望所有朋友都能看到。[2]

① Aleks Sierz, *In-Yer-Face Theatre: British Drama Today*. London：Faber and Faber，2001，p.4.
② Aleks Sierz, *In-Yer-Face Theatre: British Drama Today*. London：Faber and Faber，2001，p.5.

在戏剧内容上,"直面戏剧"主要诉诸暴力、禁忌等主题,其目的是最大限度地增强观众的情绪体验。暴力主题最早可追溯到古希腊悲剧时期,在邦德、布伦顿等当代英国剧作家的作品中也非常普遍,但"直面戏剧"中的"暴力"与此前的暴力政治不同,它要探索的是个体的痛苦而非公共政治,这一点与邦德的暴力主题形成了鲜明对比:直面戏剧不仅避免将政治问题和道德说教显性化,而且也不寻求公开的社会剖析,是一种去政治化的表达。除了暴力主题,直面戏剧的另一个特征是在内容上经常涉及性、裸体、毒瘾、欲望等私密性禁忌话题,以探索人性的弱点和挑战人性的边界。总之,在这种新写作范式中,现实与戏剧的界限被打破,社会禁忌遭到挑衅,人类的欲望被一览无余。剧中人物虽然有强者(恐怖分子和罪犯)和弱者(病人和残疾人)两种类型,但并无真正的好坏之分,他们常常处于孤独绝望、性情冷漠、精神麻木、责任和信念缺失的窘态中,既不会使用政治词汇来表达心中所想,也不会呼吁政府改变大众的生活。但这些人物却并非全然是被动的受害者,他们在用去政治化的方式为所处时代中的苦难与不公发声。①

在创作艺术上,直面戏剧家通常采用具有亵渎性质的语言,将暴力、毒品、虐待、性交、食人、呕吐、裸体等一系列具有冒犯和忌讳特点的内容以显性化的方式,直接暴露在观众面前,以达到震慑性、冲击性、激怒性和挑衅性的戏剧效果,其目的是"让观众做出反应,使其要么想要逃离剧场,要么惊叹这是他们看过的最好的剧作"②。另外,这些直面剧作家们一般在小型工作室内上演自己的作品。充满挑衅的语言,简短、直接和快速的人物对话,情绪激烈的演员,相对狭窄的空间,所有这一切无疑能加剧气氛的紧张和观众的不安,形成一种典型的激烈型直面戏剧风格的悖论式体验:观众虽身处安全的物理空间,其精神空间却尽是惊恐不安。

在舞台艺术上,直面戏剧对极端舞台的呈现和粗俗语言的使用使该剧成为主动引导在场观众深层融入的一种方式,其目的是更好地探索后现代社会和后消费主义社会中人类的情感和社会问题。用萨拉·凯恩的话说:"重要的是要记住那些从未发生过的事情——这样它们就不会发生。我宁愿在戏剧里加大剂量开猛药,也不愿在生活中冒险。"③所以,直面戏剧家对极端场景的舞台展演实际上是通过剧场艺术来强化观众的剧场体验感,从而将其带入一场令人震撼的情感和精神之旅的,这样做的最终目的是激发他们对自我内心的审视,增强他们在现实生活中面对极端事件时的免疫性和自控力。

但需要指出的是,直面戏剧的艺术性在于,它在颠覆戏剧传统的同时,也在传承传统。通过借鉴自然主义、存在主义的艺术理念和古希腊悲剧的净化功能,直面戏剧将残酷的现实不加修饰地搬上舞台,迫使观众去直面他们通常逃避的场面和感觉。此外,直面戏剧还继承了翁托南·阿铎(Antonin Artaud)的残酷戏剧(Theatre of Cruelty)的传统,不仅主张直面和暴露丑恶的一面,还致力于呈现"全面人"(l'homme total),而非被规训的"社会人"(l'homme sociale)。"全面人"与"社会人"代表着两种截然相反的群体,在阿铎看来,"全面人"忠于本我,不受律法、宗教和道德教条的限制。④ 在这一点上,直面戏剧同残酷戏剧一样,通过展示真实的"全面人"来逼人类丢掉虚伪的面具,正视真实的自我和我们所

① Andrea Peghinelli, "Polly Stenham and Mark Ravenhill: Astonishing Debuts and Court Scandals". *Status Quaestionis*, 2(2012), p.30.
② Aleks Sierz, *In-Yer-Face Theatre: British Drama Today*. London: Faber and Faber, 2001, p.5.
③ Sarah Kane, quoted in Heidi Stephenson and Natasha Langridge, *Rage and Reason: Women Playwrights on Playwriting*. London: Methuen, 1997, p.133.
④ Antonin Artaud, *The Theatre and Its Double*. Trans. Victor Corti. London: Alma Classics Ltd, 2013, p.88.

处的动荡不安的时代环境。

从严格意义上讲，直面戏剧既不是一种运动，也不是一种流派。它更多的是一种建立在实验戏剧基础上的美学风格，具有强烈的体验性和一定的政治性。综观直面戏剧 10 多年的发展态势，它在风格上可粗分为两种：激烈型（hot version）和冷酷型（cool version）。①

一、激烈型直面戏剧

激烈型直面戏剧多在小型剧场上演，观众数量一般控制在 50 人至 200 人之间。该类型的直面戏剧大多采用极端主义的美学风格，以粗俗直接的语言，将残酷暴力外显化，营造出具有冲击力的舞台效果，从而给观众带来强烈的感官体验，最终震撼和净化观众的内心。凯恩的《摧毁》、雷文希尔的《购物与纵欲》、尼尔森的《审查者》等皆是激烈型直面戏剧的例证。

作为直面戏剧的先驱人物，凯恩从一开始便在戏剧创作理念上带有很强的体验性。1992 年，凯恩在爱丁堡观看杰里米·韦勒（Jeremy Wellers）的《发狂》（Mad）一剧。这是一部非传统性戏剧演出：演员由有一定精神疾病史的人员和没有精神疾病史的人员组成，观众在观剧过程中会时不时面对极度不适的场景，这部戏剧以其挑衅性的美学风格给观众带来很强烈的体验感受。观剧后，凯恩深受触动，直言"这正是我想要创作的戏剧"②。基于这种体验性戏剧理念，凯恩在此后的数年中完成了五部戏剧作品：《摧毁》《菲德拉的爱》《清洗》《渴求》和《4.48 精神崩溃》。凯恩的创作大致可分为两个阶段。前期作品《摧毁》《菲德拉的爱》《清洗》充斥着血腥与暴力、挑衅与激进，崇尚将不可言说之物显性化。相比之下，后期作品《渴求》和《4.48 精神崩溃》的直面特征逐渐呈现淡化的趋势，开始由"直面"转向"回首"，语言和情节都相对平和。可以肯定的一点是，其作品不论以何种形式出现，核心都是描绘 90 年代西方公众的精神绝望和社会的暗淡图景。综观这些作品，它们涉及大量虐待、强奸、食人、挖眼、折磨、残害、毁灭、阉割、成瘾、疯狂、创伤、抑郁等场景。虽然这些内容并不新颖，可追溯到古希腊悲剧的创作时期，但在直面戏剧的表现形式下，它们焕发出不同于此前戏剧传统、带有 20 世纪 90 年代特殊烙印的时代特征。

在凯恩的戏剧中，《摧毁》不仅是她的成名作，也是激烈型直面戏剧的开山之作。《摧毁》③是继 1965 年邦德的《被拯救》和 1987 年布伦顿的《罗马人在英国》之后，当代英国舞台上最受争议的一部剧作。在本剧中，通过发生在利兹酒店房间里的一系列事件，凯恩以简约的笔触和深刻而犀利的舞台形象，向世人展示了当代暴力社会的可怕现实。

该剧共分为两个部分，包括三位人物：伊恩、凯特和一名士兵。其中，45 岁的伊恩是一名地方记者，也是一位来自右翼派别的特工，其工作内容包括窃听谈话、处理尸体、接收指令等。故事开始时，伊恩已是肺癌晚期，心中充满了对死亡的恐惧，他说他恨这个城市，恨周围的人，恨自己那片发黑的烂肺。他一直拨弄着手里的手枪，紧张地向窗外张望，显得焦虑不安。在此过程中，他不停地喝酒，抽烟，和凯特聊天。凯特是伊恩的前女友，情绪紧张时有口吃和昏厥的毛病，但她身上却有着当代人少有的单纯和爱

① 此处对直面戏剧的分类借鉴了希尔兹的《直面戏剧：当今的英国戏剧》中的观点。
② Aleks Sierz, *In-Yer-Face Theatre: British Drama Today*. London：Faber and Faber，2001，pp.92 - 93.
③ Sarah Kane, *Blasted*. London：Methuen Drama，2001.以下出自该剧本的引文页码随文注出，不单列脚注。

心。她在剧中所表现出的仁爱与伊恩的冷漠形成了极大的反差。来自中产阶层的伊恩对一切都是玩世不恭的态度，充满了英国式的傲慢，他似乎不爱任何人，包括他的妻子和孩子，即便是对他在感情上极度依赖的凯特，他也毫不在意，他甚至趁凯特昏厥之时对她实施了强暴。在第二幕结束时，一个士兵闯入了他们的房间，凯特从窗户逃走，随后是一声爆炸声——酒店遭到炸弹袭击，舞台陷入黑暗。

接下来的故事为本剧的第二部分。爆炸过后，士兵和伊恩从昏厥中醒来。士兵端着枪吃完了桌上的残食，然后坐下来与伊恩聊天。他告诉伊恩，自己不想杀他，因为杀了伊恩会让自己孤独；而后，他开始向伊恩讲述自己如何在战争中杀死一个12岁的女孩和她家人，以及他的女友蔻尔的故事：一群士兵强奸了她，割断了她的喉咙，割去了她的耳朵和鼻子。听着他的故事，观众也恍惚了，不知道眼前的一切到底发生在英国的利兹，还是世界的另一个地方。但伊恩对士兵的故事并不感兴趣，他们之间的故事最后以士兵对伊恩的性暴力和挖其双目后开枪自杀而告终。这时，凯特手抱一个婴儿从外面回来，婴儿不久之后死去，被就地掩埋。而外面的战事一直不断。凯特不得不再次出去觅食，房间里仅留下伊恩一人，饥饿中的伊恩竟挖出了婴儿的尸体，吞噬残尸，然后自己躺进了挖开的婴儿墓坑里。该剧结束时，满腿血迹的凯特带着面包、香肠回来，她在伊恩身边坐下，开始给失去双目的伊恩喂食。此时，外面下着雨，一片黑暗，该剧的最后一句话来自伊恩，他对凯特说："谢谢你！"

在这部剧中，通过发生在伊恩、凯特和士兵之间的剧情，凯恩用当代实验剧场的理念，以一种莎士比亚式的戏剧诗学，构建了一个西方暴力社会中"人人"的故事，创造了一部既基于当下主题又与传统西方暴力剧场一脉相承的当代经典。

事实上，当1992年凯恩对该剧进行初步构思时，其情节非常简单：场景设定在一个封闭的房间中，故事人物是一个男人和一个女人，故事的高潮是女人遭到男人的强暴。在这个剧情构思中，凯恩关注的是当代社会中的性暴力和性虐待。最终引发该剧在立意上发生巨大变化的是一个偶然事件——更确切地说，是凯恩在写作过程中看到的一则关于斯雷布雷尼察事件的新闻——这一新闻报道使凯恩十分震惊，她开始重新思考手中正在创作的剧本。凯恩后来回忆说：

> 那天晚上，在写作的间歇，我打开电视新闻频道，一张波黑老妇人的脸出现在屏幕上，她在对着镜头哭诉："谁来帮帮我们？我们需要联合国的人来这儿帮助我们。"那一瞬间，我坐在那儿，眼睛盯着画面，心里在想，为什么没人做点什么？……我突然觉得，这样可怕的事情在发生着，而我，却在这里写着这么一个发生在房间里的两个人的荒诞故事，这有什么意义？这些文字有什么意义？那一刻，我突然明白了自己该写些什么，但那个关于一个男人和一个女人的构思却留在了我的脑中。我当时想到的问题是："发生在利兹酒店里的强奸事件与发生在波黑的战争之间，是否存在着某种内在的关联性？"这一问题使我豁然开朗，很显然，它们之间存在关联——一个是因，一个是果，人类战争的种子隐含在和平时期文明社会的暴力之中。所谓的文明与发生在中欧的战争之间的那堵墙其实很薄，随时都能被拆掉。[①]

这段话显示出，凯恩的重心聚焦在当代社会中的暴力问题上——暴力在现实社会中无处不在，发生在利

① Sarah Kane, quoted in Graham Saunders, "'Out Vile Jelly': Sarah Kane's 'Blasted' and Shakespeare's 'King Lear'". *New Theatre Quarterly*, 20(2004), p.71.

兹酒店房间中的暴力事件与远在波黑的战争之间存在着内在的逻辑关联。

《摧毁》是一部典型的激烈型直面戏剧作品。它将性暴力与战争暴力并置在一起,阐明了个体的强奸行为与战争屠杀计划之间的联系。剧中,士兵不仅野蛮地性侵了伊恩,还吞食了他的眼珠。在现实层面上,吞食眼珠是一种食人行为,可以被看作一种特别可怕但"合乎逻辑"的战争后果。在心理层面上,士兵暴行的背后隐藏着他严重的心理创伤,尤其是在女友蔻尔的不幸遭遇一事上。士兵回忆说:"他们强奸了她,割断了她的喉咙,切下了她的耳朵和鼻子,然后把它们钉在前门上。"(45)这些惨烈的场面成为士兵日后实施暴行的导火索,所以在性侵伊恩时,士兵反复强调蔻尔的悲惨遭遇。这些惨不忍睹的行为举止实则是社会现实的真实写照:"成千上万的人像猪一样挤进卡车,试图离开小镇。女人们把婴儿扔到车上……人们拼命挤压践踏,直至死亡……饥饿的男人在啃食死去妻子的大腿。"(47)

《摧毁》不是对单个特定冲突的叙述,因为战争并非仅出现在新闻报道中,而是无处不在的。凯恩希望借助文学载体,在戏剧文本中"加大剂量",用暴力表现暴力,淡化戏剧与现实之间的"隔阂",并用强烈的视觉冲击来刺激人们已经麻木的神经。

1999 年,凯恩离世,世人终于意识到她非凡的戏剧天赋和深刻的社会思想,不少评论者开始为凯恩正名,称她为英国"继莎士比亚和品特之后最伟大的剧作家"。事实上,凯恩虽为直面戏剧的代表,但她的戏剧却表现出在 20 世纪 90 年代的剧作中少见的对传统戏剧诗学的传承。首先,在剧场理念上,她继承了法国戏剧家翁托南·阿铎所倡导的残酷戏剧理念,强调舞台对暴力的赤裸呈现和对观众感官的冲击:"观众是最先通过感官来思考的,而大部分的剧场却要先诉诸观众的理解力,这是十分荒诞可笑的。"[①]其次,在剧场艺术上,凯恩受荒诞派戏剧的影响很大,在她的戏剧中到处可见品特戏剧中所特有的空白、沉默、停顿、重复、破折号等艺术手法,她像品特那样,借助极简的语言和舞台策略把人类的恐惧和生存窘境呈现在观众面前。最后,在主题上,凯特对暴力的理解使人们在想到邦德、布伦顿的同时,也想到伊丽莎白时代的悲剧。正如格雷厄姆·桑德斯(Graham Saunders)所说,凯恩与 90 年代新生派剧作家的最大不同之处在于她对社会重大问题的深切关注——她描写暴力是因为她深刻地意识到暴力无处不在,是当下最重要的社会问题;她在剧中以极端剧场的形式展示暴力,目的是唤醒人们麻木的感知,也唤醒他们失去的人性。

紧跟凯恩的步伐,英国舞台上出现了第二个激烈型直面戏剧作家:马克·雷文希尔。1996 年,凭借备受争议的《购物与纵欲》,雷文希尔成为"直面戏剧"潮流中具有影响力的代表人物之一。《购物与纵欲》将凯恩作品中的暴力描写往前推进了一步。因其醒目的标题和大胆的内容,该剧也引发了戏剧界的大讨论。根据 1981 年英国的《不雅展示控制法案》(Indecent Displays Control Act),fuck 一词被禁止在公共场合出现。为解决这一困境,《购物与纵欲》的海报分别采用了两种策略,一是使用叉子碎片的图像来模糊词语的冒犯性;二是增添星号,将标题改为 Shopping and F * * *ing。[②] 这个禁用语比任何广告都更有效地宣传了这部戏剧。然而,《购物与纵欲》的惊人亮相并非完全源于海报的设计,最重要的是,这个标题准确把握了 20 世纪末的时代背景,反映了当时 30 岁以下的一代人在经历了价值体系崩溃后盛行的物质主义和道德空虚感。就其内容而言,剧中的五位年轻人(露露、罗比、马克、加里和布莱恩)是一群被推到极端情境下的极端人物。他们身处一个没有政治、没有宗教、没有历史、没有父母引导

①　翁托南·阿铎:《剧场及其复象》,刘俐译注。杭州:浙江大学出版社,2010 年,第 99 页。

②　Aleks Sierz, *In-Yer-Face Theatre: British Drama Today*. London: Faber and Faber, 2001, p.125.

的晚期资本主义社会中。在这里，毒品、自残等场面无处不在。当谈到这部剧的创作时，雷文希尔说道："我最初对这部剧的情节和主题没有太多的想法，但是将购物和性作为剧本的立足点时，一个清晰的想法突然浮现在我的脑海中。"①可以说，《购物与纵欲》是雷文希尔激烈型直面戏剧创作的典型代表，饱含着他对社会常规的公然挑衅。

激烈型直面戏剧作家除了凯恩和雷文希尔，还有后起之秀安东尼·尼尔森。1967年，尼尔森出生在一个"戏剧之家"，母亲是一名演员，父亲是一位导演。浓厚的家庭表演氛围对尼尔森产生了潜移默化的影响。在尼尔森的眼中，戏剧应是一种情感体验，和摇滚乐很像，观众可身临其境，感受舞台巨大的冲击力。② 1991年，尼尔森为爱丁堡戏剧节创作剧作《正常人：杜塞尔多夫的开膛手》（*Normal：The Düsseldorf Ripper*），之后又创作了20多部作品，如《穿透者》（*Penetrator*，1993）、《家庭之年》（*Year of the Family*，1994）、《圣诞前夜》（*The Night Before Christmas*，1995）、《审查者》等。其中《审查者》是尼尔森的代表作。该剧以审查色情影片为立足点，描述了与性相关的主题。在审查影片的间隙，舞台场景还穿插着审查者的日常生活——这位主人公患有窥阴癖、性无能等疾病，妻子有婚外情，他与同事方丹发生了性关系，这意外治愈了他的性无能。最后，方丹被人杀害，审查者痛哭流涕，妻子却误以为丈夫与她产生了心灵共鸣。比起社会政治话题（审查制度），尼尔森更多地关注主体体验和人性问题。在尼尔森看来，性爱与罪疚合为一体的心理定式是极为有害的，因为性不仅是一种行为，更是一种表达、一种语言。

《摧毁》《购物与纵欲》《审查者》的侧重点虽各有不同，但这些剧本均有一个共同之处，即敢于探索禁忌题材和直面各种暴力，且都采用极端的方式去诠释孤独的个体和病态的社会，以求为观众的内心带来强大的震撼。

二、冷酷型直面戏剧

相比之下，冷酷型直面戏剧主张采用自然主义的风格和传统的结构去调节极端情绪。其中，最为常见的便是对喜剧形式的应用，因为喜剧是一种最佳的间离策略，可以有效减弱剧场内的恐慌氛围并缓解观众紧张不安的情绪。据此特点，马丁·麦克多纳无疑是冷酷型直面戏剧的代表人物。不同于凯恩、雷文希尔和尼尔森，麦克多纳在戏剧创作上的成就主要归功于他的表述行为和喜剧技巧。

作为当今最有影响力的剧作家之一，麦克多纳从成名伊始便备受争议。这位来自英国伦敦南部的剧作家出生在一个爱尔兰家庭，特殊的成长背景在赋予麦克多纳双重身份和双重视角的同时，也引发了不少学者的争论。事实上，身份界定和剧作真实性是众多争论议题中的焦点。关于身份界定，学术界可谓众说纷纭，莫衷一是。自2008年麦克多纳的作品首次进入中国以来，国内人士就对其各抒己见，而其身份始终处于一个含糊不清的状态，有爱尔兰作家、英国剧作家、英国爱尔兰作家等说法。这些界定虽有一定的合理性，但仍存在不足之处。在一次采访中，麦克多纳就此问题明确了自己的态度，他直言："我总觉得自己介于两者之间……一半爱尔兰人，一半英国人，或者两者都不是。"③可以看到，麦克多纳

① Mark Ravenhill，"Me，My Book，and Writing in America"．*Contemporary Theatre Review*，16（2006），p.134.
② Aleks Sierz，*In-Yer-Face Theatre：British Drama Today*．London：Faber and Faber，2001，p.66.
③ Fintan O'Toole，"A Mind in Connemara：The Savage World of Martin McDonagh"．*The New Yorker*，6（2006），p.42.

本人拒绝固定的身份归属，而是倾向于一种模糊化的状态，以便同时拥有局内人和局外人的双重视角，以更好地审视戏剧创作的内容和对象。在麦克多纳的所有剧作中，"丽南三部曲"和"阿伦岛三部曲"（又称"黑色喜剧三部曲"系列）是戏剧学者热议的对象。

"丽南三部曲"由《丽南山的美人》《康尼马拉的骷髅》（*A Skull in Connemara*，1997）和《荒凉的西部》（*The Lonesome West*，1997）组成；"阿伦岛三部曲"则由《伊尼什曼岛的瘸子》（*The Cripple of Inishmann*，1996）、《伊尼什莫尔岛的上尉》（*The Lieutenant of Inishmore*，2001）和《伊尼什尔岛的女鬼》（*The Banshees of Inisheer*，2004）组成。这些作品都聚焦于对爱尔兰西部方言和风土人情的描绘，反映了作者对爱尔兰现实的深切思考。虽是如此，爱尔兰在麦克多纳的笔下却常被刻画为一个荒凉阴郁、暴力横行、停滞落后的地方，这与传统的浪漫田园式描写形成了鲜明对照。

麦克多纳与爱尔兰之间的情感记忆纽带主要源于早期家庭氛围的熏陶和短暂的暑期生活经历。在麦克多纳的少年时代，父母因生活习惯问题移居爱尔兰，自己则和哥哥继续留在伦敦。在高中阶段，每年夏天的访亲之行成为他接触爱尔兰西部方言和人文风情的最佳时机。这些经历为麦克多纳日后的创作提供了丰富的素材，但我们还应注意到，这位长期旅居伦敦的剧作家对爱尔兰的整体风貌并非全然皆知，其剧作中不乏对爱尔兰的扭曲化描写，如夸张的口音、滑稽的人物场面等，这也引发了不少学者的质疑和指责。然而，在麦克多纳本人看来，"对爱尔兰西部社会问题（家庭暴力、社会不公、信任丧失）的描写虽存在夸大的成分，但这种描写也是戏剧创作的一种手段，其目的是在痛苦中激发笑声，让这种痛苦在戏剧中变得能够让人忍受"[1]。

在《丽南山的美人》《康尼马拉的骷髅》《荒凉的西部》等剧作中，麦克多纳运用荒诞的手法将愤怒、暴力、偏见等人性的黑暗面直接展现于众，以暴反暴，形成了独特的直面戏剧创作观：黑色喜剧。黑色喜剧能够让人在痛苦、磨难和死亡面前依旧保持欢笑，这不仅是对正统文化的挑战，也是对社会现实的讽刺针砭。[2]

《丽南山的美人》是一部描述母女暴力的戏剧。故事发生在爱尔兰的一座小镇里，40岁的女儿莫琳曾被视为"丽南山的美人"，但为了照顾母亲一直保持单身，母亲玛格性格专横，对莫琳有着极强的控制欲。在剧中，莫琳与男友佩托相爱，但玛格担心女儿出嫁后无人照看自己，便使出浑身解数拆散两人，故意将尿液倒入洗碗池中，向佩托泄露莫琳的精神病史，甚至偷看二人的信件并随即销毁。最后，佩托与别人订婚并移民美国，绝望的莫琳丧失理智，用残酷的手段杀死了母亲。本剧结束时，莫琳精神崩溃，她坐在母亲坐过的摇椅上，像母亲之前那样痛苦度日。该剧所描写的家庭破裂和伴随而来的身体与精神上的暴力无疑是当代普遍存在的社会现象和问题。剧中的生活用具，如洗碗池、食用油、火钳等，都成为羞辱、虐待、施暴和谋杀的工具。该剧于1996年在英国皇家国家剧院首演后获得很大成功，先后获得奥利弗最佳戏剧奖、托尼奖等。

作为"丽南三部曲"中的第二部，《康尼马拉的骷髅》以扭曲的夫妻关系为主线展开论述。和《丽南山的美人》一样，剧中的家庭同样是破碎的。该剧讲述的是米克·多德的杀妻案，标题出自贝克特的名剧《等待戈多》中幸运儿呓语般的独白。剧中人物米克以掘坟为生，负责清理教堂墓地的陈年尸骨，为新丧

[1] M. Isabel Seguro Gómez，"Disabling Mainstreamised Representations of Irishness in Martin McDonagh's Leenane Trilogy". *Nordic Irish Studies*，15(2016)，p.150.

[2] Marion Castlebery，"Comedy and Violence in *The Beauty Queen of Leenane*". In Richard Rankin Russell，ed.，*Martin McDonagh: A Casebook*. London and New York：Routledge，2007，p.44.

之人腾出位置。有传言说,米克在七年前谋杀了妻子奥娜,但他声称自己是因为醉酒驾驶才导致奥娜死于车祸的,用他的话说:"我喝了一杯酒,喝了一杯好酒,她没有系安全带,事情就是这样。"①由于缺乏目击证人和现场证据,米克被无罪释放。然而,当地社群对此并不认同,他们认为米克犯有蓄意谋杀罪。这究竟是意外还是谋杀,我们无从知晓。丈夫对妻子的暴力是该剧的中心议题。妻子去世后,米克频频抱怨妻子乱放物品和她糟糕的厨艺:"她做的炒鸡蛋让人难以下咽,不知为什么,每次炒的鸡蛋要么呈灰色,要么是糊了。"②在整部剧中,妻子奥娜没有一句台词——她无疑是父权制压迫下家庭暴力的受害者,面对强权的米克,奥娜一直处于失语的状态。除了暴力,麦克多纳还在剧中探讨了历史、创伤、记忆、正义等主题。

如果说《丽南山的美人》聚焦的是母女间的虐杀,《康尼马拉的骷髅》讲述的是夫妻间的谋杀,那么《荒凉的西部》呈现的则是一个荒唐的弑父事件。在剧中,科尔曼与瓦伦是兄弟俩,他们整日为圣像、威士忌、炉子、色情杂志争吵不休。对他们而言,争吵不仅是唯一的相处方式,还是一种相互折磨的乐趣。在剧中,父亲仅仅因为嘲笑科尔曼的发型"像个喝醉酒的小孩",就被科尔曼开枪打死。在科尔曼的眼中,弑父确实违背上帝之法的核心教义——信、望、爱,但父亲对其发型的嘲笑却是一种不可原谅的侮辱。对于父亲的离世,兄弟二人不以为意,他们更加关心的是财产、土地和保险金。父亲死后,两兄弟之间更加相互猜忌,矛盾日益激化。为了阻止手足相残,神父威尔士试图用自戕的方式来感化他们,结果证明他的牺牲是一种徒劳。剧中的父亲形象有双重所指:一是指血缘上的父亲(father),二是指天主教神父(Father)。弑父和手足之争暗示的是爱尔兰天主教神话的崩塌和现代爱尔兰社会道德的沦丧。

不难发现,以上三部作品中都充斥着各种暴力。需要指出的是,虽然这些暴力行为触目惊心,但麦克多纳剧本中的暴力却不像凯恩、雷文希尔和尼尔森剧本中的暴力那样血腥和残酷。不论是剧中病态的母女关系、扭曲的夫妻关系,还是异化的父子关系和兄弟关系,麦克多纳皆以相对隐晦的语言和婉转的方式将其呈现出来。2003 年,其新作《枕头人》(*The Pillowman*)问世。剧中的虐童事件则是通过讲故事的形式展现在公众面前的,这在很大程度上缓解了观众直面暴力时的冲击力。另外,麦克多纳剧中的性用语和性场面也较少,常以隐喻和暗示的形式出现。

但不论是激烈型还是冷酷型,直面戏剧的艺术独特性在于它总是通过舞台上的极端事件给观众带来极大的情感冲击和困扰,以此引发他们对自我存在与现实处境的哲学性和社会性思考。所以,在直面戏剧中,观众看不到传统上舒适的郊区生活和乡土情怀,这些新生派剧作家们借用异化性的人物和场景来重新定义社会和世界,为观众呈现了一幅黑暗的当代景观。

1999 年,随着凯恩的去世,直面戏剧日渐进入退潮期。但英国直面戏剧的影响力仍不容小觑,其作品迄今已被译成 30 多种语言,在世界各地广为流传。2004 年,随着胡开奇先生的《萨拉·凯恩与她的直面戏剧》一文在《戏剧艺术》上的发表,直面戏剧也被引入了中国戏剧舞台。

本章将以麦克多纳的《丽南山的美人》为例,分析当代英国直面戏剧的特点。

① Martin McDonagh, *The Beauty Queen of Leenane and Other Plays*. New York：Vintage Books，1998，p.106.
② Martin McDonagh, *The Beauty Queen of Leenane and Other Plays*. New York：Vintage Books，1998，p.63.

第二节　马丁·麦克多纳及其《丽南山的美人》

一、马丁·麦克多纳简介

1996 年,随着《丽南山的美人》在爱尔兰戈尔韦郡的市政剧院首演成功,26 岁的马丁·麦克多纳一夜成名,成为 20 世纪 90 年代以来最受瞩目的当代剧作家之一。1997 年,《时代周刊》在文章中更是盛赞麦克多纳是"除莎士比亚以外,唯一一位在同一个演出季有四部作品同时在伦敦西区上演的剧作家"①。

麦克多纳出生于伦敦南部坎伯韦尔,是爱尔兰移民的后裔,共创作了 9 部戏剧。麦克多纳的黑色喜剧将怪诞的暴力、悬疑的剧情与黑色幽默融合在一起,具有很强的时代特征。在主题上,他不仅沿袭了约翰·米林顿·辛格(John Millington Synge)的农民剧、贝克特的荒诞剧、英国直面戏剧等的创作传统,还在作品中结合了朋克音乐、流行电影的暴力书写;在风格上,他大量使用拼贴、互文、戏仿等创作手法,因此其作品具有显著的后现代美学特征。麦克多纳的戏剧在全球各地上演,多次荣获奥利弗戏剧奖、托尼奖等。除了戏剧创作,麦克多纳还涉足影坛,由他执导的《六响枪》(*Six Shooter*,2004)、《杀手没有假期》(*In Bruges*,2008)、《七个变态人格》(*Seven Psychopaths*,2012)和《三块广告牌》(*Three Billboards Outside Ebbing*,*Missouri*,2017)荣获奥斯卡金像奖、金球奖、英国电影学院奖等奖项。

从内容上看,麦克多纳的戏剧创作大致分为两个阶段。在早期阶段,他创作了"丽南三部曲"和"阿伦岛三部曲",这些剧作以爱尔兰西部的戈尔韦为创作背景,从后现代的视角走进西部神话,为世人刻画了一幅家庭空间破碎、深受殖民阴影困扰和信仰坍塌的当代爱尔兰西部图景,以一种病态、阴暗和暴力的黑色田园意象消解了传统西部神话的浪漫叙事。在后期阶段,麦克多纳创作了《枕头人》《断手斯城》(*A Behanding in Spokane*,2010)、《刽子手》(*Hangmen*,2015)、《一件非常非常非常黑暗的事》(*A Very Very Very Dark Matter*,2018)等剧,这些剧作不同于其早期阶段聚焦于爱尔兰西部的作品,而是放眼世界,将戏剧的背景延伸到东欧小国、美国小镇、英国监狱、丹麦的哥本哈根等地。

与同时代的其他剧作家相比,麦克多纳以当代西方社会底层人物的不幸、苦难、犯罪、死亡为题材创作了一系列黑色喜剧。在这些剧作中,暴力是麦克多纳反复呈现的主题,而一直以来,评论者关注最多、争议最多的也是麦克多纳在戏剧中的暴力书写。在他的剧中,暴力场景随处可见:弑父、杀母、杀妻、兄弟相残、活埋、自杀、肢解、致残、亵渎尸体等。除了人与人之间的暴力,剧中还描写了人类对动物的虐待和杀害:打瞎奶牛的眼睛、割掉狗的耳朵、微波炉活烹仓鼠、开枪打猫等。正是因为剧中充斥的大量惨绝人寰的暴力书写,英国剧评人亚历克斯·希尔兹将麦克多纳与尼尔森、凯恩、雷文希尔的戏剧创作归为一类,称之为"直面戏剧"。

① 　Mimi Kramer,"Three for the Show". *Time Magazine*,4 Aug. 1997,p.71.

值得注意的是,与凯恩、雷文希尔等激烈型直面剧作家不同,麦克多纳对暴力的描写经常通过滑稽、荒诞的手法来实现。《伊尼什莫尔岛的上尉》便是一部典型的麦克多纳式直面戏剧。该剧讲述的是狂热的帕德里克上尉为自己的宠物猫复仇的故事,融滑稽、荒诞、暴力、血腥为一体:帕德里克接到父亲唐尼的电话,得知猫咪托马斯病危,即刻动身从北爱尔兰赶回阿伦岛,不料遭到同组织成员的跟踪和埋伏,幸得梅雷亚德相救。两人坠入爱河,并策划退出军队,自建派别。当梅雷亚德发现自己的猫被帕德里克开枪打死时,她无情地击毙了情人。此时剧情突转,猫咪活蹦乱跳地出现在舞台上,由它引起的大屠杀变得毫无意义。幸存者唐尼准备朝它开枪,却下不了手,于是开始抚摸猫,给它喂食。这部剧的特色是直面戏剧对朋克音乐的跨媒介效仿。在剧中,麦克多纳使用"戏剧音乐化"的叙事策略,不仅把碎片化的音乐歌词镶嵌到戏剧文本中,而且吸取朋克音乐中暴力美学、虚无主义和性别混乱的思想内涵以呈现音乐化主题,从而使该剧具有音乐化特征,实现了对朋克音乐的跨媒介效仿。通过对朋克音乐元素的越界性运用,麦克多纳以暴力隐喻的方式戏谑地再现了"北爱尔兰冲突"这一历史事件,表达了其作为一个和平主义者以反暴力为旨的政治诉求。

作为一个直面戏剧的代表者,麦克多纳和凯恩等剧作家一样对戏剧的目的表现出同样的立场,即通过各种舞台艺术来展现黑暗、暴力,促使人们对暴力和碎片化的社会做出反思。

二、《丽南山的美人》①介绍

《丽南山的美人》是麦克多纳的代表作,于 1996 年在爱尔兰首演后被搬上英国皇家宫廷剧院的舞台,并荣获奥利弗最佳戏剧奖。该剧使麦克多纳一举成名,曾在全球各地上演,被译为 30 多种语言,2015 年首次登上中国舞台,并成为北京鼓楼西剧场常年演出的剧目。

该剧故事发生在爱尔兰西部戈尔韦郡的一个名叫丽南的小镇。在剧中,40 岁的老处女莫琳负责照顾 70 岁的母亲玛格,自私冷酷的玛格一心把女儿拴在自己身边。该剧共分为两部分:第一部分通过现实主义的写作手法,呈现了爱尔兰戏剧传统中最熟悉的一个意象,即在乡村起居室和厨房里,壁炉上方的墙上挂着十字架,十字架旁边是约翰·肯尼迪兄弟的照片,火炉边放着一把漆黑沉重的火钳,窗外是田野。本剧开始时,外面瓢泼大雨,坐在摇椅上的玛格询问莫琳天气,莫琳没好气地回答,她们的生活一如阴雨连绵的天气,沉闷、灰暗、绝望。接着母女开始说起爱尔兰语的衰落以及英国对爱尔兰长达数个世纪的殖民统治。对她们而言,前后不搭的对话只是为了打发无聊的时间。第二部分是第五场到第九场,母亲因担心将来无人照看自己,不断阻挠女儿恋爱,莫琳渴望逃离房子和母亲的束缚,和她的爱人在一起。随着情节的发展,戏剧风格逐渐转变为自然主义,母女卷入一场激烈的控制权争夺战,最终绝望的莫琳用火钳杀死了母亲,自己也精神崩溃、陷入疯狂。

麦克多纳通过发生在爱尔兰西部一个原生家庭里弑母的故事,向世人展示了一个当代家庭暴力的寓言。在剧中,传统的家庭破裂,母女关系失调,表现出一种病态、扭曲和异化的特征:玛格自私而专制,以"尿液感染""背部不好"等健康问题为由,命令莫琳做各种家务;莫琳则认为自己在母亲眼里像是一名仆人,愤怒使她对母亲充满恶意。莫琳曾在 20 多岁时去过英国打工,在那里她能找到的唯一一份

① Martin McDonagh, *The Beauty Queen of Leenane*. London: Bloomsbury Publishing, 1996.以下出自该剧本的引文页码随文注出,不单列脚注。

工作就是打扫厕所，但这种卑微的工作使她饱受英国人的歧视和谩骂，这段经历最终使她精神崩溃，后来玛格将莫琳从英国的一家疯人院接回。从此莫琳便落入母亲的控制，后来疾病缠身的母亲需要女儿的照顾，她们相互残害，又彼此依存，母女之间的关系畸形病态。

家庭暴力是该剧的重要主题，稳定的家庭关系因暴力而被打破。剧中暴力从语言暴力、精神摧残逐渐升级到身体暴力。挑衅和煽动性的语言是莫琳用来反抗专制的老母亲的重要武器。在第一场，玛格干涉女儿的人身自由，阻止莫琳和陌生人搭讪，这招来莫琳的强烈反抗，她说道："如果他喜欢谋杀老女人的话，我会把他带来见你，如果他用把大斧头或别的家什，砍下你的脑袋，朝你的脖子里吐唾沫，我也绝不介意……我还会十分享受。"（10）面对莫琳的语言反抗，玛格则是力图从精神上打压和摧残莫琳。为了拆散莫琳和佩托，玛格向佩托披露了莫琳早年曾被关进英国精神病院的隐私，致使莫琳备受打击而精神恍惚，她甚至亲手烧掉佩托写给莫琳的信件，毁掉了女儿与佩托结婚的唯一希望。为了逼问信中内容，失去理智的莫琳开始从身体上折磨玛格，最终导致玛格死亡。摆脱母亲令人窒息的控制之后，莫琳拎起满是灰尘的行李箱离开，走向一个不确定、没有希望的未来，她失去的是再也找不到的幸福。在某种意义上，玛格是爱尔兰民族传统中母亲的象征，麦克多纳通过莫琳的弑母行为，揭示了爱尔兰民族神话的破灭。

"家"原本是欢乐和亲密的空间。但在剧中，家失去了爱、温暖和安全的象征意涵。对于莫琳来说，她感觉不到"家"，没有归属感，因此她无法定义自己是谁，但同时又无法断绝与母亲的血缘关系。而导致这一"问题的症结"（the crux of the matter）则是爱尔兰被英国殖民的历史。"问题的症结"一词在剧本中多次出现，以强调英国殖民历史给爱尔兰留下的创伤后果："如果不是英国人偷走了我们的语言、土地和上帝给予我们的一切，我们就不会沦落到去他们那里乞讨工作和救济的境地。"（9）在剧中，爱尔兰西部地区仍未从后殖民主义的阴影中挣脱出来，到处都是闭塞、落后、贫穷的景象，人们做梦都想要逃离"这个鬼地方"，摆脱停滞不变的生活，见识外面的世界。剧中的人物贫穷、悲惨、病态，整日吃着垃圾食品，观看无聊的肥皂剧，毫不了解自己国家的历史，他们不仅无知和愚昧，而且自恋、粗俗和可笑。偷窃、骚乱和谋杀成为他们生活的常态，对他们而言，要么通过移民逃离此地，要么屈从现实，麻木地活着。

事实上，麦克多纳在本剧中揭露的是20世纪90年代爱尔兰经济繁荣背后不为人知的另一面：贫富差距巨大，1/3的人口生活在贫困线以下，多达4万人口移民海外。正如麦克多纳在访谈中所言："不管人们怎么为凯尔特之虎唱颂歌，我本能地看到了它背后被人们遗漏和疏忽的那一面。"[①]通过对西部乡村物质贫乏和精神贫瘠的书写，麦克多纳以"局外人"的视角展现了爱尔兰不为人知、黑暗的一面，从而打破了爱尔兰文化中对西部田园神话的幻想。

本书节选的是《丽南山的美人》的第一场、第七场的片段和第八场。第一场交代了故事发生的时间、背景、人物，刻画了莫琳和玛格爱恨交织的母女关系。第七场的片段是莫琳对母亲玛格的严刑逼问。第八场是莫琳弑母后的独白。

① Liz Hoggard，"Martin McDonagh: Playboy of the West End World". *Independent Magazine*，15 Jun. 2002, p.12.

三、《丽南山的美人》选读①

The Beauty Queen of Leenane

Scene One

The living room / kitchen of a rural cottage in the west of Ireland. Front door stage left, a long black range along the back wall with a box of turf beside it and a rocking chair on its right. On the kitchen side of the set is a door in the back wall leading off to an unseen hallway, and a newer oven, a sink and some cupboards curving around the right wall. There is a window with an inner ledge above the sink in the right wall looking out onto fields, a dinner table with two chairs just right of centre, a small TV down left, an electric kettle and a radio on one of the kitchen cupboards, a crucifix and a framed picture of John and Robert Kennedy on the wall above the range, a heavy black poker beside the range, and a touristy-looking embroidered tea towel hanging further along the back wall, bearing the inscription 'May you be half an hour in Heaven afore the Devil knows you're dead'. As the play begins, it is raining quite heavily. MAG FOLAN, a stoutish woman in her early seventies with short, tightly permed grey hair and a mouth that gapes slightly, is sitting in the rocking chair, staring off into space. Her left hand is somewhat more shrivelled and red than her right. The front door opens and her daughter, MAUREEN, a plain, slim woman of about forty, enters carrying shopping and goes through to the kitchen.

MAG: Wet, Maureen?

MAUREEN: Of course wet.

MAG: Oh-h.

 MAUREEN *takes her coat off, sighing, and starts putting the shopping away.*

MAG: I did take me Complan.

MAUREEN: So you *can* get it yourself so.

MAG: I can. (*Pause.*) Although lumpy it was, Maureen.

MAUREEN: Well, can I help lumpy?

MAG: No.

MAUREEN: Write to the Complan people so, if it's lumpy.

MAG (*pause*): You do make me Complan nice and smooth. (*Pause.*) Not a lump at all, nor the comrade of a lump.

MAUREEN: You don't give it a good enough stir is what you don't do.

① Martin McDonagh, *The Beauty Queen of Leenane*. London: Bloomsbury Publishing, 1996, pp.5 – 11, pp.52 – 56.

MAG：I gave it a good enough stir and there was still lumps.

MAUREEN：You probably pour the water in too fast so. What it says on the box，you're supposed to ease it in.

MAG：Mm.

MAUREEN：That's where you do go wrong. Have another go tonight for yourself and you'll see.

MAG：Mm. (*Pause*.) And the hot water too I do be scared of. Scared I may scould meself.

　　MAUREEN *gives her a slight look*.

MAG：I *do* be scared，Maureen. I be scared what if me hand shook and I was to pour it over me hand. And with you at Mary Pender's，then where would I be?

MAUREEN：You're just a hypochondriac is what you are.

MAG：I'd be lying on the floor and I'm not a hypochondriac.

MAUREEN：You are too and everybody knows that you are. Full well.

MAG：Don't I have a urine infection if I'm such a hypochondriac?

MAUREEN：I can't see how a urine infection prevents you pouring a mug of Complan or tidying up the house a bit when I'm away. It wouldn't kill you.

MAG (*pause*)：Me bad back.

MAUREEN：Your bad back.

MAG：And me bad hand. (MAG *holds up her shrivelled hand for a second*.)

MAUREEN (*quietly*)：Feck…(*Irritated*.) I'll get your Complan so if it's such a big job! From now and 'til doomsday! The one thing I ask you to do. Do you see Annette or Margo coming pouring your Complan or buying your oul cod in butter sauce for the week?

MAG：No.

MAUREEN：No is right，you don't. And carrying it up that hill. And still I'm not appreciated.

MAG：You *are* appreciated，Maureen.

MAUREEN：I'm not appreciated.

MAG：I'll give me Complan another go so，and give it a good stir for meself.

MAUREEN：Ah，forget your Complan. I'm expected to do everything else，I suppose that one on top of it won't hurt. Just a…just a blessed fecking skivvy is all I'm thought of!

MAG：You're not，Maureen.

　　MAUREEN *slams a couple of cupboard doors after finishing with the shopping and sits at the table，after dragging its chair back loudly. Pause*.

MAG：Me porridge，Maureen，I haven't had，will you be getting? No，in a minute，Maureen，have a rest for yourself…

　　But MAUREEN *has already jumped up，stomped angrily back to the kitchen and started preparing the porridge as noisily as she can. Pause*.

MAG：Will we have the radio on for ourselves?

MAUREEN *bangs an angry finger at the radio's 'on' switch. It takes a couple of swipes before it comes on loudly, through static—a nasally male voice singing in Gaelic. Pause.*

MAG: The dedication Annette and Margo sent we still haven't heard. I wonder what's keeping it?

MAUREEN: If they sent a dedication at all. They only said they did. (*She sniffs the sink a little, then turns to* MAG.) Is there a smell off this sink now, I'm wondering.

MAG (*defensively*): No.

MAUREEN: I hope there's not, now.

MAG: No smell at all is there, Maureen. I do promise, now.

MAUREEN *returns to the porridge. Pause.*

MAG: Is the radio a biteen loud there, Maureen?

MAUREEN: A biteen loud, is it?

MAUREEN *swipes angrily at the radio again, turning it off. Pause.*

MAG: Nothing on it, anyways. An oul fella singing nonsense.

MAUREEN: Isn't it you wanted it set for that oul station?

MAG: Only for *Ceilidh Time* and for whatyoucall.

MAUREEN: It's too late to go complaining now.

MAG: Not for nonsense did I want it set.

MAUREEN (*pause*): It isn't nonsense anyways. Isn't it Irish?

MAG: It sounds like nonsense to me. Why can't they just speak English like everybody?

MAUREEN: Why should they speak English?

MAG: To know what they're saying.

MAUREEN: What country are you living in?

MAG: Eh?

MAUREEN: What country are you living in?

MAG: Galway.

MAUREEN: Not what county!

MAG: Oh-h...

MAUREEN: Ireland you're living in!

MAG: *Ireland.*

MAUREEN: So why should you be speaking English in Ireland?

MAG: I don't know why.

MAUREEN: It's Irish you should be speaking in Ireland.

MAG: It is.

MAUREEN: Eh?

MAG: Eh?

MAUREEN: 'Speaking English in Ireland.'

MAG (*pause*): Except where would Irish get you going for a job in England? Nowhere.

MAUREEN: Well, isn't that the crux of the matter?

MAG: Is it, Maureen?

MAUREEN: If it wasn't for the English stealing our language, and our land, and our God-knows-what, wouldn't it be we wouldn't need to go over there begging for jobs and for handouts?

MAG: I suppose that's the crux of the matter.

MAUREEN: It *is* the crux of the matter.

MAG (*pause*): Except America, too.

MAUREEN: What except America too?

MAG: If it was to America you had to go begging for handouts, it isn't Irish would be any good to you. It would be English!

MAUREEN: Isn't that the same crux of the same matter?

MAG: I don't know if it is or it isn't.

MAUREEN: Bringing up kids to think all they'll ever be good for is begging handouts from the English and the Y * * ks. That's the selfsame crux.

MAG: I suppose.

MAUREEN: Of course you suppose, because it's true.

MAG (*pause*): If I had to go begging for handouts anywhere, I'd rather beg for them in America than in England, because in America it does be more sunny anyways. (*Pause.*) Or is that just something they say, that the weather is more sunny, Maureen? Or is that a lie, now?

MAUREEN *slops the porridge out and hands it to* MAG, *speaking as she does so*.

MAUREEN: You're oul and you're stupid and you don't know what you're talking about. Now shut up and eat your oul porridge.

MAUREEN *goes back to wash the pan in the sink*. MAG *glances at the porridge, then turns back to her*.

MAG: Me mug of tea you forgot!

MAUREEN *clutches the edges of the sink and lowers her head, exasperated, then quietly, with visible self-control, fills the kettle to make her mother's tea. Pause*. MAG *speaks while slowly eating*.

MAG: Did you meet anybody on your travels, Maureen? (*No response.*) Ah no, not on a day like today. (*Pause.*) Although you don't say hello to people is your trouble, Maureen. (*Pause.*) Although some people it would be better not to say hello to. The fella up and murdered the poor oul woman in Dublin and he didn't even know her. The news that story was on, did you hear of it? (*Pause.*) Strangled, and didn't even know her. That's a fella it would be better not to talk to. That's a fella it would be better to avoid outright.

MAUREEN *brings* MAG *her tea, then sits at the table*.

MAUREEN: Sure, that sounds exactly the type of fella I would *like* to meet, and then bring him home to meet you, if he likes murdering oul women.

MAG: That's not a nice thing to say, Maureen.

MAUREEN: Is it not, now?

MAG (*pause*): Sure why would he be coming all this way out from Dublin? He'd just be going out of his way.

MAUREEN: For the pleasure of me company he'd come. Killing you, it'd just be a bonus for him.

MAG: Killing *you* I bet he first would be.

MAUREEN: I could live with that so long as I was sure he'd be clobbering you soon after. If he clobbered you with a big axe or something and took your oul head off and spat in your neck, I wouldn't mind at all, going first. Oh no, I'd enjoy it, I would. No more oul Complan to get, and no more oul porridge to get, and no more—

MAG (*interrupting, holding her tea out*): No sugar in this, Maureen, you forgot, go and get me some.

MAUREEN *stares at her a moment, then takes the tea, brings it to the sink and pours it away, goes back to* MAG, *grabs her half-eaten porridge, returns to the kitchen, scrapes it out into the bin, leaves the bowl in the sink and exits into the hallway; giving* MAG *a dirty look on the way and closing the door behind her.* MAG *stares grumpily out into space.*

Blackout.

Scene Seven

...

She suddenly realises what she's said. MAUREEN *stares at her in dumb shock and hate, then walks to the kitchen, dazed, puts a chip pan on the stove, turns it on high and pours a half-bottle of cooking oil into it, takes down the rubber gloves that are hanging on the back wall and puts them on.* MAG *puts her hands on the arms of the rocking chair to drag herself up, but* MAUREEN *shoves a foot against her stomach and groin, ushering her back.* MAG *leans back into the chair, frightened, staring at* MAUREEN, *who sits at the table, waiting for the oil to boil. She speaks quietly, staring straight ahead.*

MAUREEN: How do you know?

MAG: Nothing do I know, Maureen.

MAUREEN: Uh-huh?

MAG (*pause*): Or was it Ray did mention something? Aye, I think it was Ray...

MAUREEN: Nothing to Ray would Pato've said about that subject.

MAG (*tearfully*): Just to stop you bragging like an oul peahen, was I saying, Maureen. Sure what does an oul woman like me know? Just guessing, I was.

MAUREEN：You know sure enough, and guessing me arse, and not on me face was it written. For the second time and for the last time I'll be asking, now. How do you know?

MAG：On your face it *was* written, Maureen. Sure that's the only way I knew. You still do have the look of a virgin about you you always have had. (*Without malice.*) You always will.

Pause. The oil has started boiling. MAUREEN *rises, turns the radio up, stares at* MAG *as she passes her, takes the pan off the boil and turns the gas off, and returns to* MAG *with it.*

MAG（*terrified*）：A letter he did send you I read!

MAUREEN *slowly and deliberately takes her mother's shrivelled hand, holds it down on the burning range, and starts slowly pouring some of the hot oil over it, as* MAG *screams in pain and terror.*

MAUREEN：Where is the letter?

MAG（*through screams*）：I did burn it! I'm sorry, Maureen!

MAUREEN：What did the letter say?

MAG *is screaming so much that she can't answer.* MAUREEN *stops pouring the oil and releases the hand, which* MAG *clutches to herself, doubled up, still screaming, crying and whimpering.*

MAUREEN：What did the letter say?

MAG：Said he did have too much to drink, it did! Is why, and not your fault at all.

MAUREEN：And what else did it say?

MAG：He won't be putting me into no home!

MAUREEN：What are you talking about, no home? What else did it say?!

MAG：I can't remember, now, Maureen. I *can't...*!

MAUREEN *grabs* MAG's *hand, holds it down again and repeats the torture.*

MAG：No...!

MAUREEN：What else did it say?! Eh?!

MAG（*through screams*）：Asked you to go to America with him, it did!

Stunned, MAUREEN *releases* MAG's *hand and stops pouring the oil.*

MAG *clutches her hand to herself again, whimpering.*

MAUREEN：What?

MAG：But how could you go with him? You do still have me to look after.

MAUREEN（*in a happy daze*）：He asked me to go to America with him? Pato asked me to go to America with him?

MAG（*looking up at her*）：But what about me, Maureen?

A slight pause before MAUREEN, *in a single and almost lazy motion, throws the considerable remainder of the oil into* MAG's *midriff, some of it splashing up into her face.* MAG *doubles*

up, screaming, falls to the floor, trying to pat the oil off her, and lies there convulsing, screaming and whimpering. MAUREEN steps out of her way to avoid her fall, still in a daze, barely noticing her.

MAUREEN (*dreamily, to herself*): He asked me to go to America with him...? (*Recovering herself.*) What time is it? Oh feck, he'll be leaving! I've got to see him. Oh God... What will I wear? Uh... Me black dress! Me little black dress! It'll be a remembrance to him...

She darts off through the hall.

MAG (*quietly, sobbing*): Maureen...help me...

MAUREEN returns a moment later, pulling her black dress on.

MAUREEN (*to herself*): How do I look? Ah, I'll have to do. What time is it? Oh God...

MAG: Help me, Maureen—

MAUREEN (*brushing her hair*): Help you, is it? After what you've done? Help you, she says. No, I won't help you, and I'll tell you another thing. If you've made me miss Pato before he goes, then you'll *really* be for it, so you will, and no messing this time. Out of me fecking way, now...

She steps over MAG, who is still shaking on the floor, and exits through the front door. Pause. MAG is still crawling around slightly. The front door bangs open and MAG looks up at MAUREEN as she breezes back in.

MAUREEN: Me car keys I forgot...

She grabs her keys from the table, goes to the door, turns back to the table and switches the radio off.

Electricity.

She exits again, slamming the door. Pause. Sound of her car starting and pulling off. Pause.

MAG (*quietly*): But who'll look after me, so?

Still shaking, she looks down at her scalded hand. Blackout.

Scene Eight

Same night. The only light in the room emanates from the orange coals through the grill of the range just illuminating the dark shapes of MAG, sitting in her rocking chair, which rocks back and forth of its own volition, her body unmoving, and MAUREEN, still in her black dress, who idles very slowly around the room, poker in hand.

MAUREEN: To Boston. To Boston I'll be going. Isn't that where them two were from, the Kennedys, or was that somewhere else, now? Robert Kennedy I did prefer over Jack Kennedy. He seemed to be nicer to women. Although I haven't read up on it. (*Pause.*) Boston. It does have a nice ring to it. Better than England it'll be, I'm sure. Although where wouldn't be better than England? No shite I'll be cleaning there, anyways, and no names

called, and Pato'll be there to have a say-so anyways if there was to be names called, but I'm sure there won't be. The Y**ks do love the Irish. (*Pause*.) Almost begged me, Pato did. Almost on his hands and knees, he was, near enough crying. At the station I caught him, not five minutes to spare, thanks to you. Thanks to your oul interfering. But too late to be interfering you are now. Oh aye. Be far too late, although you did give it a good go, I'll say that for you. Another five minutes and you'd have had it. Poor you. Poor selfish oul bitch oul you. (*Pause*.) Kissed the face off me, he did, when he saw me there. Them blue eyes of his. Them muscles. Them arms wrapping me. 'Why did you not answer me letter?' And all for coming over and giving you a good kick he was when I told him, but 'Ah no,' I said, 'isn't she just a feeble-minded oul feck, not worth dirtying your boots on?' I was defending you there. (*Pause*.) 'You will come to Boston with me so, me love, when you get up the money.' 'I will, Pato. Be it married or be it living in sin, what do I care? What do I care if tongues'd be wagging? Tongues have wagged about me before, let them wag again. Let them never stop wagging, so long as I'm with you, Pato, what do I care about tongues? So long as it's you and me, and the warmth of us cuddled up, and the skins of us asleep, is all I ever really wanted anyway.' (*Pause*.) 'Except we do still have a problem, what to do with your oul mam, there,' he said. 'Would an oul folks' home be too harsh?' 'It wouldn't be too harsh but it would be too expensive.' 'What about your sisters so?' 'Me sisters wouldn't have the bitch. Not even a half-day at Christmas to be with her can them two stand. They clear forgot her birthday this year as well as that.' 'How do you stick her without going off your rocker?' they do say to me. Behind her back, like. (*Pause*.) 'I'll leave it up to yourself,' Pato says. He was on the train be this time, we was kissing out the window, like they do in films. 'I'll leave it up to yourself so, whatever you decide. If it takes a month, let it take a month. And if it's finally you decide you can't bear to be parted from her and have to stay behind, well, I can't say I would like it, but I'd understand. But if even a year it has to take for you to decide, it is a year I will be waiting, and won't be minding the wait.' 'It won't be a year it is you'll be waiting, Pato,' I called out then, the train was pulling away. 'It won't be a year nor yet nearly a year. It won't be a week!'

The rocking chair has stopped its motions. MAG *starts to slowly lean forward at the waist until she finally topples over and falls heavily to the floor, dead. A red chunk of skull hangs from a string of skin at the side of her head.* MAUREEN *looks down at her, somewhat bored, taps her on the side with the toe of her shoe, then steps onto her back and stands there in thoughtful contemplation.*

MAUREEN: 'Twas over the stile she did trip. Aye. And down the hill she did fall. Aye. (*Pause*.) Aye.

Pause. Blackout.

四、思考题

1. 如何解读剧中的母女关系？如何理解这种畸形病态、爱恨交织的母女关系？以剧中第一场为例进行分析。

2. 如何理解剧中的家庭暴力主题？请将暴力主题置于爱尔兰20世纪戏剧的整体语境中进行文本细读，并挖掘其中蕴含的深层意义。

3. 在第八场中，莫琳弑母之后的大段独白呈现出莫琳怎样的心理世界和内在现实？

4. 如何理解莫琳的疯狂？她的精神疾病与在英国打工的经历有何联系？

5. 如何理解全球化、移民、流散对剧中人物的影响，他们对爱尔兰以及对其他国家有着何种不同的看法？

五、本节推荐阅读

［1］Chambers，Lilian and Jordan，Eamonn，eds. *The Theatre of Martin McDonagh: A World of Savage Stories*. Dublin：Carysfort，2006.

［2］Jordan，Eamonn. *Justice in the Plays and Films of Martin McDonagh*. Gewerbestrasse：Palgrave Pivot，2019.

［3］Lonergan，Patrick. *The Theatre and Films of Martin McDonagh*. London：Methuen Drama，2012.

［4］McDonagh，Martin. *Plays: 1: The Beauty Queen of Leenane；A Skull in Connemara；The Lonesome West*. London and New York：Bloomsbury Publishing，1999.

［5］Russell，Richard Rankin，ed. *Martin McDonagh: A Casebook*. London and New York：Routledge，2007.

第四章
当代英国莎士比亚改写戏剧

第一节 当代英国莎士比亚改写戏剧概论

自莎士比亚戏剧(以下简称"莎剧")出现以来,剧作家们以数不清的形式在舞台上重述和改写莎剧。从 1660 年到 1777 年,50 多部莎剧改写作品问世,它们均在不同程度上对莎剧原文进行了删减、添加或全文的再写,莎剧改写出现了第一次高峰。[①] 在他们当中,最著名的例子莫过于 1681 年内厄姆·泰特(Nahum Tate)对莎剧《李尔王》的喜剧性改写。泰特版的剧名为《李尔王传》(*The History of King Lear*),该剧以李尔复位、情人团圆(考狄利娅和埃德加)为结局,在英国舞台上上演了 150 多年,直至 1838 年才最终恢复到莎氏悲剧的原貌。进入 19 世纪之后,莎士比亚备受推崇,被圣化为诗人、哲人和预言家。但即便是在这种背景下,莎剧改写也并未停止,诗人约翰·济慈(John Keats)就曾著有《王者史蒂芬:一部戏剧片段》(*King Stephen: A Dramatic Fragment*,1819)。对莎剧的改写潮流一直延续到了 20 世纪。现代戏剧大师萧伯纳就曾热衷于莎剧改写,著有《凯撒和克莉奥佩特拉》(*Caesar and Cleopatra*,1899)《莎氏与萧夫》(*Shakes versus Shav*,1949)等作品。

进入 20 世纪 60 年代之后,西方文学和文化进入了一个改写的时代,这一现象尤其表现在以莎剧为代表的经典剧作改写中。受后现代主义文化思潮的影响,莎士比亚及其作品成为无数当代人改写/再写的对象,莎剧改写由此成为莎士比亚在当下存在的独特形式。大量西方戏剧家投身于这一文学/文化实践中,以莎剧为起源文本创作了一大批当代经典剧作。

随着查尔斯·马洛维奇(Charles Marowitz)的《拼贴,哈姆雷特》(*Collage Hamlet*,1965)在伦敦的上演,英国舞台上也掀起了旷日持久的改写热潮。1966 年,汤姆·斯托帕德的剧作《罗森格兰兹和吉尔登斯敦已死》(*Rosencrantz and Guildenstern Are Dead*)隆重问世,这部带有荒诞派特色的莎剧改写作品不仅成就了斯托帕德在当代英国戏剧中的地位,也代表着莎剧改写被主流戏剧所接受。此后,斯托帕德还创作了《多格的〈哈姆雷特〉,卡胡的〈麦克白〉》等作品。与此同时,更多的英国剧作家加入了改写莎剧的行列:爱德华·邦德凭借《李尔》《赢了》《大海》(*The Sea*,1973)等剧作成为与马洛维奇和斯托帕德齐名的改写大家;大卫·埃德加以《罗密欧与朱丽叶》为素材创作了《死亡故事》(*Death Story*,1972);奥

① Jean I. Marsden, *The Re-imagined Text: Shakespeare,Adaptation,and Eighteenth-Century Literary Theory*. Lexington:University Press of Kentucky,1995, p.15.

斯本以莎剧《科利奥兰纳斯》为起源文本创作了《有个地方叫罗马》（*A Place Calling Itself Rome*，1973）。此外还有威斯克的《商人》、布伦顿的《第十三夜》、伊莱恩·范思坦和英国女性戏剧组集体创作的《李尔的女儿们》、霍华德·巴克的《七个李尔》（*Seven Lears*，1989)等莎剧改写作品。

这种改写实践一直延续到了 21 世纪的今天。《纽约时报》（*The New York Times*）剧评家本·布兰特利(Ben Brantley)在 2007 年的一篇文章中指出，在当今的伦敦舞台上，跨越文学类别和文本时空的改写创作仍异常活跃，在当前这个文化时代，对经典的再构正在考验并延伸着传统戏剧的最大极限。[①]

一、“后”文化语境下的当代莎剧改写

正如后现代批评家琳达·哈琴(Linda Hutcheon)所言，20 世纪 60 年代后出现的当代莎剧改写作品是一种不同于传统改写的“后”理论思潮下的“再写”(rewriting)文学：随着后现代主义、解构主义、后结构主义、后殖民主义、女性主义等诸多“后”理论思潮的出现，“改写”(adaptation)像众多处于劣势的对立项一样，获得了翻身的机会，得以从“前文本”(hypotexts，又译“潜文本”“先文本”)的阴影下解放出来，获得了独立的存在。这些理论思潮对莎剧改写实践产生了巨大的影响——它不仅改变了莎剧“改写”的基本内涵，也为其创作提供了新的主题驱动、叙述策略和话语模式，从而使当代改写成为一种独立的创作实践，一种不同于传统改编/改写的文学存在。

首先，从创作性质上看，后现代思潮中关于创作与文学性的理论极大地影响了改写创作的性质和地位。没有哪个时代像过去半个世纪那样对创作的文学性及原创性提出质疑。围绕着“艺术如何创造艺术？文学如何源于文学？”这一宏大主题，当代理论家们提出了完全不同于以往的看法。如罗兰·巴特(Roland Barthes)明确指出，一切写作无不是互文范畴中一个文本与诸多其他文本的关联。[②] 既然一切写作皆为互文和再写，那么“原创”又为何是原创？这种对文学性和创作的后现代主义思考方式为“改写”成为文学和文化主流奠定了理论基础，也为莎剧改写进入西方主流文化营造了适时的文化语境。

在这种文化氛围中，各种理论，如互文性理论(intertextuality theory)、作者理论(author theory)、叙事学理论(narratology theory)、读者反应理论(reader-response theory)、接受理论(reception theory)、多重语境理论(recontextuality theory)、引用理论(quotation theory)、修正理论(revisionism theory)等，为重新界定“改写”的性质及存在提供了前所未有的新视野。在这里，尤其重要的是互文性理论的出现。根据朱丽娅·克里斯蒂娃(Julia Kristeva)的定义，互文性是“一种(或多种)符号系统向另一种符号系统的移植——它是一个意义实践的过程，也是多个意义系统移植的过程”[③]。根据此理论体系，一切创作都是文本间的穿行，在文本生成时承载着全部文化语境。除了互文性，还有多重语境理论，在雅克·德里达(Jacques Derrida)等批评家看来，多重语境性是一切文本存在的前提。[④] 根据这一理论，任何形式的写作既不可能有传统意义上的原始语境，也不可能拥有终结性的闭合语境。写作的意义在于通过无穷尽的新语境，永远地延伸自己——通过一次次写作上的叠加以及一次次地演绎和扩展作

① Ben Brantley，“When Adaptation Is Bold Innovation”. *The New York Times*，18 Feb. 2000，p.89.
② Roland Barthes，“Theory of the Text”. In R. Yong, ed.，*Untying the Text: A Post-Structuralist Reader*. London：Routledge，1981，p.39.
③ Michael Scott，*Shakespeare and the Modern Dramatist*. New York：St. Martin's Press，1989，p.7.
④ Daniel Fischlin and Mark Fortier，eds.，*Adaptations of Shakespeare*. London and New York：Routledge，p.5.

品的意义来实现。而叙事学家热拉尔·热奈特（Gérard Genette）对这一观点的阐释更是精辟："一切文本都是将自身刻于先文本之上的后文本。"①在此理论语境下，改写成为"一种语义的移置，从一种符号系统向另一种符号系统的移码和嬗变"②。

其次，从主题驱动上看，当代理论思潮中的文化政治性理论以其特有的批判性视角，为莎剧改写提供了创作上的主题动力。虽然 17 世纪已出现过在艺术层面上极具颠覆性的莎剧改写作品，但不论那时的改写表现出何种激进的特征，它们在改写思想上无不是立意维护剧场在意识形态上的稳定性。相比之下，当代莎剧改写则表现出强劲的批判性：在女性主义、文化唯物主义、性政治、后殖民主义等各种政治思潮的驱动下，剧作家们将莎剧置于种族、阶级、性别、族裔等当代政治主题的坐标系中，从不同的角度挖掘莎剧作品的"潜意识"，给予那些曾经是沉默、边缘、丑陋、劣势者的一方一个"发声"的机会，最终使改写作品成为不同政治声音和思想意识较量的聚集地，例如邦德的《李尔》成为邦德式暴力政治的载体，《李尔的女儿们》成为女性剧场中性别政治的经典之作等。

因此，这些作品的一个共同特征就是，改写者强烈的当代政治意识成为他们创作的内动力。当谈到为什么选择莎士比亚作为其戏剧创作的源头时，邦德认为几百年来莎士比亚在西方人们的眼中一直都是真言者的化身，他说："人们总觉得，是有两个人到了那座神圣的山巅，接受了刻在石板上的文字：一个是摩西，另一个便是莎士比亚。在西方人文主义者眼中，莎士比亚简直是一个受人崇拜的神，一个指引我们行为和思想的人。"③但邦德认为，尽管莎士比亚是继希腊戏剧巨匠之后最有影响力的剧作家，但他却从未真正给人类指出过一条解决社会问题的出路——即便他的确为他那个特定的时代找到过某种答案，但答案也只是顺从，即接受发生的一切、接受人性的善恶。对于邦德这样的剧作家来说，这种顺从的态度正是暴力政治数千年来得以在世间延存的根本原因，这也是莎士比亚哲学和价值观的反动之处。当谈及《李尔》一剧的创作时，邦德指出，他之所以选《李尔王》为起源文本，是因为李尔在世人心中早已被神化为一种传统悲剧的原型，一个集个人悲剧、政治悲剧和国家悲剧为一体的元悲剧的化身。④　在剧中，邦德立意要做的是打破这种悲剧原型，重新塑造李尔这面"社会的镜子"，使之成为阐释"邦德式"（Bondian）暴力政治主题的载体。

最后，从叙事模式上看，后现代思潮为当代改写创作提供了后现代性的叙事形态和话语策略。在这种创作理念下，以莎剧经典为代表的元叙事被彻底地颠覆和解构，取而代之的是互文、拼贴、戏仿、嵌入、沉默、置换，甚至是白页。各种不同而零散的文本混合在一起，不同作家作品中的词语、句子、段落被掺杂在一块，写作不再是封闭的、同质的、统一的，文学作品变成了文字碎片的集合物，显示出开放、异质、破碎、多声部的特质，成为犹如马赛克一般的拼盘杂烩。在这种后现代文化背景下，当代剧作家们大胆地穿梭于莎氏文本和思想中，打碎其原型，然后在其瓦砾上进行狂欢式的"重构"和"再构"，人们熟知的莎剧形象、对白、场景被置于各种陌生化的戏剧语境中，观众的脑中也被激发起无数意义的联想。在这种由拼贴、戏仿等构成的后现代叙述范式的影响下，当代莎剧改写一改传统改写在意义上的闭合性，呈

① Gérard Genette, *Palimpsests: Literature in the Second Degree*. Trans., Channa Newman and Claude Doubinsky. Lincoln：University of Nebraska Press，1997，p.ix.
② Linda Hutcheon，*A Theory of Adaptation*. New York：Routledge，2006，p.15.
③ Malcom Hay and Philip Roberts，eds.，*Edward Bond: A Companion to the Plays*. London：Theatre Quarterly Publications，1978，p.4.
④ Philip Roberts，ed.，*Bond on File*. London：Methuen，1985，p.24.

现出与起源文本强烈的互涉性和超链接性。在此过程中，当代改写者将观众引入了一个神奇的意义变化和生成过程，文学创作变成了一种毫无顾忌的文本穿行和再码的经历。[1]

二、当代改写是莎士比亚戏剧在"后"时代中的一种特有存在

当代莎剧改写的后现代性使改写成为莎士比亚戏剧在当下的一种特有存在。虽然在20世纪60年代后莎剧的存在受到了前所未有的解构，但也正是在这个被改写者颠覆和解构的过程中，莎剧获得了一种新的、鲜活的生命力和精神内核的传承——它被"误写"和再写的过程，也是其彰显自我的过程。

其一，虽然就本质而言，自古到今的所有改写创作均属于叠刻性（palimpsestuous）创作，但没有哪个时代的剧作家像今天这样强烈地意识到莎士比亚作为作家的存在。事实上，莎士比亚本人在创作时同样吸纳了各种先前文化，也就是说，莎士比亚与当代改写者在创作实践上并无本质不同，他们的作品都表现出多重文本的叠刻性特征。但最终使他们不同的是当代改写者在改写莎剧时对起源文本及莎士比亚作者身份的强烈意识。在伊丽莎白时代，作为改写者的莎士比亚无须在意所用素材的源头，因为在那个时代，先前文本并未打上某位作者的烙印。但莎剧却不同。自18世纪以后，随着"作者身份"（authorship）的凸显，尤其是经历了19世纪的"封圣"之后，莎士比亚成为西方文化中最为强大的文学符号之一，他被赋予了其作品的绝对所有权，在很长一段时间里，莎剧文字如《圣经》一般不可更改，莎剧成为原型文学的化身。因此，当当代改写者面对这位被经典化的作者，要在他的"羊皮纸稿本"上拭去其签名，以留下自己的印迹时，却发现作为起源文本作者的莎士比亚早已在"羊皮纸稿本"上留下太深的烙印和太厚重的积淀，以至于难以抹去其痕迹。

其二，20世纪后半期的莎剧改写是一种"后"文化理论语境下的创作，一种有意识的颠覆性创作行为。也就是说，在创作时，莎士比亚及其作品作为一种被解构的目标、被挑战的对象和被作用的存在体，一直萦绕在改写者的意识中。因为所谓"后现代"，不过是西方思想家对传统人文思想的重构和整合。用马洛维奇的话说："我再思故我在"。[2] 事实上，所有当代莎剧改写无不是始于剧作家对莎剧的质疑，而所谓改写，就是这些剧作家从当代人的角度带领观众对各种经典问题所进行的反思。也就是说，当代改写者在进行莎剧再写时既是剧作家，也是批评家——莎剧改写的过程在本质上是改写者与莎士比亚就诸多文化和政治问题进行对话和商榷的过程。不论当代改写者从何种文化和政治的角度出发进行改写，他们均能在莎士比亚身上找到某种参照：在邦德这样的社会性剧作家眼中，莎士比亚是西方反动人性价值观的代表；在女性剧作家眼中，他是父权政治的化身；在后殖民主义者眼中，他是一个服务于全球文化霸权的欧洲殖民文化的符号。[3] 而改写实践，就是将莎剧置于各种新的社会和历史语境中，对其文化符号进行拨乱反正。就像后现代莎剧影片《威廉·莎士比亚的罗密欧＋朱丽叶》（*William Shakespeare's Romeo ＋ Juliet*，1996）片名中的数字符号"＋"所显示的那样，在一定意义上，所有改写都不过是以添加的形式在"引用"着莎剧文本。作为一个关键指令词，"＋"不仅提醒着我们改写作品的非终结性，也提醒着我们改写作品与起源文本之间的关联，暗示着后现代改写文化中的作者概念最终是

① Katherine E. Kelly, ed., *The Cambridge Companion to Tom Stoppard*. Cambridge: Cambridge University Press, 2001, p.10.
② Daniel Fischlin and Mark Fortier, eds., *Adaptations of Shakespeare*. London and New York: Routledge, 2000, p.188.
③ Susan Bennett, *Performing Nostalgia: Shifting Shakespeare and the Contemporary Past*. London: Routledge, 1996, p.25.

一个值得商榷之处。所以,当剧作家们在改写莎剧时,他们与莎士比亚的关系既是对抗,也是对话,既是解构,也是合谋,这便是当代莎剧改写问题中存在的悖论性内核。但不论改写者与莎士比亚的关系是合谋还是对话,抑或是解构性的再构,它们无不显示出莎士比亚在整个改写过程中幽影般的存在。

其三,莎士比亚不仅存在于改写者的创作过程中,也存在于当代改写作品意义的实现阶段。在17世纪,当莎士比亚借用先前文本进行戏剧创作时,他无须在意那些起源文本的出处,因为他无须依靠观众对源头的记忆来实现其作品的意义。但20世纪的莎士比亚后人却不同。他们在改写莎剧时不仅在消费着观众对莎剧文本的记忆,也在消费着人们对莎剧演出的文化记忆。马洛维奇曾问过自己这么一个问题:"是不是所有人,包括那些没有读过和看过《哈姆雷特》的人都知道这部剧? 我们的集体无意识中是否已沉淀着哈姆雷特的痕迹,从而使我们感觉他似曾相识?"[①]从文本创作到舞台意义的实现,当代莎剧改写的诞生注定是互文性的,也必定是互文性的。走过400多年的文本传承和演出历史,尤其是进入20世纪后期,世人熟知的莎剧早已蒙上了一层厚厚的互文尘埃。一个剧本的解码在很大程度上取决于观众对那些先前文本的了解。事实上,当代剧作家进行改写创作时使用的核心策略就是互文性策略:当代改写作品之所以能实现其深刻的意义,在一定程度上是因为它成功地唤起了观众的脑中对莎剧文化的全部记忆,从而使不同时间和空间的经验和实践通过观众的思想平台,在新的作品中聚集在一起并发生碰撞。

本章将以威斯克的《商人》和斯托帕德的《多格的〈哈姆雷特〉,卡胡的〈麦克白〉》中的《卡胡的麦克白》为例,分析不同风格的当代英国莎剧改写作品。

① Michael Scott,*Shakespeare and the Modern Dramatist*. New York:St. Martin's Press, 1989, p.105.

第二节　阿诺德·威斯克及其《商人》

一、阿诺德·威斯克简介

阿诺德·威斯克出生在伦敦东区的一个犹太家庭,父亲是一个俄裔犹太裁缝,母亲是匈牙利裔犹太人。所以,从出身上来讲,威斯克来自一个典型的工人家庭。像奥斯本等同时期的剧作家一样,威斯克接受正规教育的时间很短,16 岁便离开了学校,做过几种零工,1950 年开始在皇家空军服役。服役结束后,他又开启了一段漂泊的生涯,在农场做过帮工,在厨房里当过搬运工,最后,经过培训,他在巴黎的一家餐馆里做了一名糕点师傅,但他讨厌厨师的工作,因为在那里,人来人往,人们停留的时间是那么短暂,彼此间无法互相了解。1955 年至 1956 年间,他在伦敦电影技术学校就读半年,同年参加了一次新剧本的选拔赛,从中脱颖而出。

1957 年,威斯克完成了他的首部剧作《厨房》,在 1958 年至 1960 年间完成了他的代表作《威斯克三部曲》,即《掺麦粒的鸡汤》《根》《我在谈论耶路撒冷》,从而达到了戏剧事业的巅峰。1959 年他被评为英国最有希望的剧作家。

《威斯克三部曲》开辟了 20 世纪 60 年代英国流行的“激进现实主义”的先河,将奥斯本代表的当代现实主义戏剧往前推进了一步。对于威斯克来说,戏剧是他所看到和经历的社会生活的延伸,他曾说:“对于莎士比亚来说,世界可能是一个舞台,但对我来说,世界则像是一个厨房。”[1]威斯克指出:“我的人物在舞台上做的是展示某种思想,然后按照它去生活、去行动……所以,在我的第一部剧作《厨房》里,没有长篇大论,没有高深的言语。整个剧就是为了表现一个观点而再现厨房的气氛。”[2]

在这一阶段,他发起并推动了名为“第四十二中心”的工程,该工程的宗旨是提高工人阶级的文化修养。这是威斯克将他的社会主义理想付诸行动的一个重大举措,但正是这个工程成了威斯克戏剧事业的一个转折点。在此后的几年里,他在这个项目上投入了大量的精力。1970 年,这一理想主义的工程由于经费危机而被迫终止。与此同时,他的剧作在英国也开始遭受冷落。事实上,他 70 年代的剧作中也不乏优秀作品,如《记者》(*The Journalists*,1977)、《商人》(*Shylock*,1976,又名《夏洛克》)。其中,《商人》更是成为当代莎剧改写的经典,与《威斯克三部曲》一起代表着威斯克戏剧的最高成就。

作为战后英国戏剧第一次浪潮中的主流作家,有着犹太身份的威斯克在改写莎剧时呈现出与众不同的文化构建方式。在《商人》中,威斯克从文化唯物主义的角度,将积满厚重文化尘埃的莎剧《威尼斯商人》置于动态的历史坐标系中,审视并拷问被给予了复杂社会印记的夏洛克文化现象和话语符号,从而在政治历史的层面上实现了对文化记忆的再签名。

①　参见何其莘,《英国戏剧史》,南京:译林出版社,1999 年,第 388 页。
②　Arnold Wesker, "Question and Answer". *New Theatre Magazine*, 3 Apr. 1960, p.7.

二、《商人》^①介绍

作为后现代时期的戏剧创作,威斯克的改写旨在实现对莎剧历史性意义的反拨、修正和再写。在威斯克的笔下,夏洛克不再是莎剧中那个喊着"难道犹太人不会流血吗?"的原型形象,而是一位文艺复兴时期的犹太人文主义者,一个在其悲剧中埋藏着 20 世纪"大屠杀因子"的理想主义者。

在剧情上,《商人》保留了《威尼斯商人》的情节要素——三只匣子、一磅肉、杰西卡的私奔,但威斯克的故事聚焦的是夏洛克在威尼斯犹太区的生活。本剧开始时,年近六旬的夏洛克正在书房里向好友安东尼奥展示他收藏的手稿。透过他们的对白,大量鲜为人知的犹太历史(如犹太焚书事件、犹太社区入夜被上锁的可怕史实)涌入剧情。安东尼奥的教子巴塞尼奥的来访引出了莎剧故事中的借贷情节:为了帮助教子巴塞尼奥,安东尼奥向夏洛克借三千块钱,夏洛克慷慨应允,且不取利息。安东尼奥提醒夏洛克,根据威尼斯的法律,与犹太人的任何交易必须立有契约,否则后者将受到严惩。为嘲笑这一法律,夏洛克提议订立一个"一磅肉"的契约,以疯狂对疯狂。在接下来的一幕中,故事快速推进,安东尼奥的晚宴、货船海难、杰西卡私奔、法庭裁决等情节一一展现。在法庭上,"一磅肉"的契约引发了犹太民族与基督社会的全面冲突。一方面,诗人洛伦佐从基督道德的角度将犹太人与高利贷等同起来;另一方面,夏洛克则代表犹太人向反犹主义发出愤怒的控诉:"犹太人! 犹太人! ……我们来时是陌生人,走时又成为叛徒;若忍受迫害,我们就会遭人鄙视,若拿起武器,我们又成为劫世的罪犯。无论我们怎么做,都不能让你们满意。"(255)最终,法庭仍像在莎剧中那样剥夺了夏洛克的藏书与财产,该剧在夏洛克的绝望声中拉上帷幕:"也许该是踏上耶路撒冷之旅的时候了。"(264)

任何一种言说的背后都潜伏着言说者的政治冲动,《商人》更是如此。400 多年来,除了《暴风雨》中的凯列班,没有哪位莎剧人物像夏洛克一样被赋予如此强烈的符号特征和如此沉重的文化记忆。在 20 世纪,奥斯维辛大屠杀永远地改变了世人对《威尼斯商人》的接受度。在本剧中,威斯克从文化唯物主义的角度将莎剧置于"后大屠杀"视角下的动态历史坐标之中,从当下的角度实现了对莎剧意义的反拨与再写。

与原莎剧不同,威斯克在剧中将故事置于 1563 年的威尼斯,那个时代是一个在历史坐标系中文艺复兴与犹太迫害并存的时代:一方面,1563 年的威尼斯是犹太文化最鲜活的时期,大量犹太书籍面世,一批犹太教的律法大师和诗人在此阶段云集威尼斯,在剧中,威斯克不仅向世人指出了犹太文明的辉煌,更强调了它是西方文明源头之一的事实;但另一方面,1563 年也是犹太迫害史上的一个重要时间,10 年犹太文化浩劫刚刚过去,1553 年,就在圣马克广场上,大量犹太法典和希伯来经典被作为亵渎上帝的禁书烧毁,在接下来的 10 年间被禁止收藏。在剧中,诗人乌斯库就曾提到 1562 年葡萄牙科英布拉地区宗教法庭将 35 名犹太人施以火刑的事件。同样的迫害也发生在英国:那里几乎没有了犹太人,即便有,也大多转入了地下。

作为一名犹太剧作家,威斯克无疑意识到了莎剧在塑造夏洛克这一人物时的文化霸权。因此他在重写夏洛克的故事时,立意去除传统夏洛克的符号特征,凸显其"人"的一面:"我的夏洛克代表的是一种

① Arnold Wesker. *Arnold Wesker: Volume 4*. Harmondsworth: Penguin, 1990.以下出自该剧本的引文页码随文注出,不单列脚注。

自由精神,自由不仅是他的实质所在,也是我的实质所在,是存在于我们意识深处的重要犹太精神的本质所在。"①在剧中,威斯克将夏洛克和安东尼奥刻画为一对挚友,他们都热爱知识和书籍。所以,威斯克的夏洛克不再是莎剧中那个视钱如命的高利贷者,而是一位学者型银行家,一个视知识为生命的犹太藏书家和精神上的理想主义者。他收藏了大量稀世手稿,其中不乏12世纪和13世纪的犹太典籍。他本人还效法犹太先知,在手稿的夹缝处留下思想的痕迹:"借贷生意从不是我生活的全部,犹太区中一直回响着思想的争鸣。"(193)他不仅收集藏书,还在家中接待来自世界各地的文化名流。

在剧中,夏洛克对理想主义的追求集中体现在"让我们像自由人一样阐释法律"这一愿望上。根据威尼斯法律,任何公民与犹太人交易都必须签订契约,但夏洛克却坚持要像朋友那样无偿借钱给安东尼奥:"我只听从我自己的法律,那就是我的心……安东尼奥,我们不能改变法律,但就此一次,让我们既不从基督徒的角度,也不从犹太人的角度,而是从'人'的角度来阐释法律。"(215)对此,安东尼奥提醒夏洛克,他是一个犹太人,他和他的族人在威尼斯的存在本身就是一种奢侈,而不是权利,所以他们更要倚仗契约和法律而存在。在这种背景中,夏洛克提出,他们索性签一个"一磅肉"的契约,来嘲弄这个荒诞的法律。在夏洛克看来,不管面前是何种种族仇视和迫害,自己对人性都有着不可剥夺的权利。

在这部剧中,夏洛克和在莎剧中一样是一位悲剧性人物,但此剧中的悲剧却不同于莎剧,它更多的是一种自欺的悲剧。在剧中,尽管夏洛克在追求知识时不得不戴着标示他犹太身份的黄帽子,在从事生意时不得不接受法律的歧视,他仍旧坚信,威尼斯是文明的中心,他可以在隔离区的家里收藏文化,并让自己的家成为被迫害犹太人的避难地。该剧立意表现的正是这种犹太人文主义理想被现实击碎的过程。在安东尼奥的晚会上,即便被巴塞尼奥等人一次次侮辱戏弄,夏洛克仍像学者一般畅谈威尼斯的文明进程。但极具讽刺的是,正当他慷慨激昂地畅谈文明复兴时,远处传来的钟声却将其飞扬的精神拽回了现实——那是犹太人必须返回隔离区的信号。所以,法庭一幕之后,这位坚信自己在所有宗教仇恨和迫害面前拥有不可剥夺的人权的犹太人决定离开:"去加入那些在码头上等候的老人,开始朝圣的历程,然后长眠于此。"(264)

这部剧作的意义在于,它揭示出夏洛克的悲剧中隐藏着20世纪大屠杀的种子。在剧中,文化灭绝、宗教迫害、犹太屠杀等意象贯穿故事的始末,剧末时,面对无数个世纪以来强加于其民族身上的"替罪羊"角色,夏洛克悲愤地对着法庭说道:"你们战争打输了,是犹太人的错;经济崩溃了,也是犹太人的错……一切都是犹太人的错……你们的仇恨何时才会枯竭?"(259)以色列学者伊弗莱姆·斯克(Efraim Sicher)指出,20世纪的大屠杀是西方文明的"二次堕落"——西方社会之所以想出一套完美的道德和精神标准对犹太人进行惨绝人寰的杀戮,是因为其想将欠犹太文明的债一笔勾销,卸去他们对犹太民族的愧疚,实现一种内疚转移。②

在剧中,通过对莎剧的再写,威斯克成功颠覆了西方夏洛克文化传统的内涵,将强加于其民族身份之上的罪恶标签推回到了源头之处。如此改写莎剧的人性和犹太主题,说明威斯克在创作中达到了一种新的政治意境,从"后大屠杀"历史观的角度,实现了对夏洛克在犹太文化记忆坐标中的重新界定。

本书节选的是该剧第一幕中的第四场和第二幕中的第五场。

① Arnold Wesker. *Distinction*. London:Jonathan Cape,1985,p.259.
② Martha Tuck Rozett. *Talking Back to Shakespeare*. Newark:University of Delaware Press,1994,p.44.

三、《商人》选读①

The Merchant

Act One

Scene Four

...

ANTONIO (*finally making himself known*)：Gentlemen，allow me to introduce my godson，Bassanio Visconti.

SHYLOCK：Ah，Antonio. You found him. Welcome，young man，welcome. You'll stay to eat with us，won't you? Do you know anything about architecture? We're building a new synagogue，look. We don't have a Palladio to build us a San Giorgio Maggiore，but with our modest funds...

ANTONIO：I don't think Bassanio plans to stay，but we would like to talk together，and if—

SHYLOCK：But of course. Friend Rodrigues is leaving.

RODERIGUES：To be bolder!

TUBAL：And I have sights to show Signor Usque.

SHYLOCK：The first time godfather and son meet is a special and private time. (*To* TUBAL *as he and* SHYLOCK *prepare to leave*) Tubal，you *should* look at these plans for the new synagogue before they're folded away. It's your money too，you know.

TUBAL：I'm plan blind，Shylock. They mean nothing to me. *You* spend my money.

(*They leave*.)

BASSANIO：And that is a Jew?

ANTONIO (*reprimanding*)：He is a Jew.

BASSANIO：I don't think I know what to say.

ANTONIO：Have you never met one before?

BASSANIO：Talked of，described，imagined，but—

ANTONIO：Shylock is my special friend.

BASSANIO：Then，sir，he must be a special man.

ANTONIO (*suspicions and changing the subject*)：Your father speaks highly of you and begs me to help where I can.

BASSANIO：My lord Antonio—

ANTONIO：I'm not a lord，I'm a patrician—lapsed and indifferent to their politicking but，a patrician nonetheless.

① Arnold Wesker，*The Merchant*. In *Arnold Wesker: Volume 4*. Harmondsworth：Penguin，1990，pp.209 – 216，pp.253 – 264.

BASSANIO: Lord, patrician—you are my godfather.

ANTONIO: I'd forgotten.

BASSANIO: Oh, understandably, understandably! The early years were so full of my father's talk of you and your goodness and your good time together, but—he made no effort to make us known to one another. It was a cause of distress between us.

ANTONIO: There were good times together, were there?

BASSANIO: He spoke of little else. What he shared with you, I shared. What happened between you, I saw happen. If I did wrong he'd say, your godfather would not approve of that. And as I grew I did what I did, thought what I thought, saying to myself—what would the good Antonio do now, how would the wise Antonio decide?

ANTONIO: Ah, wisdom! I feared it.

BASSANIO: You must surely have experienced this yourself, sir, that in your mind there is always one person, a vivid critic, whose tone of voice and special use of words is there in your brain, constantly.

ANTONIO: They call him God, Bassanio.

BASSANIO: I think you're mocking me. Have I come at a wrong time? Perhaps I shouldn't have come at all. To be honest, I hate arriving behind letters of recommendation, it's so undignified and besides, what can the poor host do but be courteous, obliging. Forgive me, sir. You know nothing of me. I'll go. But I'll find ways of making myself known to you, and useful, and in the coming months I'll try to earn your trust. Goodbye, sir.

ANTONIO: No, no, no. Don't go, young man. I've been rude and discourteous, forgive me. Bachelors have special dreads. Old age, loneliness, too much noise, too many requests; we fear opportunists and women. Senile fears. Forgive me. Sit and talk about yourself and what you want of me. Of course I remember your father. We were good for one another in lean years. Talk. I'll help his son. Without question. Trade? Tricks of the trade? Contracts? To represent me? Tell me what you want.

BASSANIO: In Belmont, sir, there is a lady.

ANTONIO: Ah, love!

BASSANIO: Her father's family goes back to the time when Venetians were fishermen, and—

ANTONIO: And would now prefer to forget it!

BASSANIO: —And, like all of those ancient families, became wealthy. These, the Contarinis, added to their wealth with—what shall I call it?—not madness, but—unorthodoxy. The father of my lady, whose name is Portia, was—well—odd! A philosopher.

ANTONIO: Oh, very odd.

BASSANIO: He evolved, it seems, a strange theory that men's character could be learned by tests, and to this end he devised a huge chart divided into the most important aspects of a man's

character. Honour, common sense, loyalty, stamina and so on. And for each virtue and its opposite he devised their tests. His entire estates became manned by men he'd chosen based upon these philosophically evolved examinations. All, with one exception, fell into ruin.

ANTONIO: What an incredibly sad story.

BASSANIO: There is a happy side. The daughter—

ANTONIO: Beautiful?

BASSANIO: Well, not beautiful perhaps, but—striking, vivid. Compelling. Intelligent eyes, mobile features—handsome. In fact, if I must be blunt, determination and strength of will give her face a masculine aspect. She's feminine to the extent that she doesn't deny her sex, yet misleading because she doesn't cultivate, exploit, abuse it.

ANTONIO: Just such a woman I'd like to have met in my youth.

BASSANIO: You'll understand, then, the reason for my agitation.

ANTONIO: But not yet how it concerns me.

BASSANIO: Three caskets rest at Belmont. One gold, one silver, one lead. Who chooses the correct casket wins the daughter.

ANTONIO: Aha! The final test. And my role in this?

BASSANIO: I've lived a stupid, wasting life, Signor Antonio. I possess nothing and can lay my hands on nothing. I had hoped to marry wealth but now I've fallen in love with ruins. I mean to choose the right casket, marry that extraordinary woman and work to restore her property to profit. But I'm without means either to dress myself or reach her.

ANTONIO: It will cost?

BASSANIO: To present myself without insult? Three thousand ducats.

ANTONIO: Three thousand ducats!

BASSANIO: I believe no claim was ever made on your godfathership before.

ANTONIO: None.

BASSANIO: And none will be again.

ANTONIO: Bassanio, you come at a bad time. I've ships to sea but no cash to hand. More, I plan retirement, and all my wealth lies in their cargoes. The small change I need for daily living is easily got on credit from friendly traders, but the eyes of the Rialto are on me and I know no one who'll lend me so large a sum except—

BASSANIO: Who?

ANTONIO: Shylock.

BASSANIO: The Jew?

ANTONIO (*defying his contempt*): Shylock.

BASSANIO: But the interest rate, the conditions.

ANTONIO: Whatever the conditions! It's more than I've ever borrowed in my life, but for the good

years of my youth with your father, done!

BASSANIO: With a Jew!

ANTONIO: I've told you, young man, the Jew is my special friend.

BASSANIO: Of course. Forgive me, sir. And now, I'll go. If there's anything I can do for you in the city?

ANTONIO: Yes, take a message to my assistant, Graziano Sanudo. Tell him I won't be in today, but to arrange for dinner on Wednesday. I'm entertaining my friend, Shylock, so no pork. Join us, Bassanio, I keep a good wine cellar.

BASSANIO: With the greatest of pleasure, and honoured. May I bring with me an old friend I've recently met with again? A sort of philosopher.

ANTONIO: 'Sort of'?

BASSANIO: Writes poetry occasionally.

ANTONIO: A 'sort of philosopher' who 'writes poetry occasionally!' Good! Old Shylock might enjoy that. What's his name?

BASSANIO: Lorenzo Pisani.

ANTONIO: Ah! The silk manufacturers.

BASSANIO: You know them?

ANTONIO: The fabric, not the family.

BASSANIO: You won't regret this trust, Signor.

ANTONIO: I hope to God I do not, Bassanio.

　　(BASSANIO, *leaving*, *meets* SHYLOCK *on the way out*. SHYLOCK *bows but is ignored*.)

　　I hope to God.

SHYLOCK: And what was that like?

ANTONIO: I'm not certain. He'd not met a Jew before.

　　(SHYLOCK *goes into fits of laughter*.)

ANTONIO: What is so funny?

SHYLOCK: That's not a sin. There are a hundred million people in China who've not met a Jew before!

ANTONIO: Still he worries me for other reasons. There was too much calculation in him. You'll be meeting him on Wednesday and can judge for yourself. I've invited him for dinner. With a friend of his, Lorenzo Pisani.

SHYLOCK: Pisani?

ANTONIO: You know him?

SHYLOCK: I know him. He wrote a poem once, too long, 'The Ruin of the Nation's Heart'. A murky thing, full of other people's philosophy. Jessica showed it to me. She seemed very impressed because it called for a return to simplicity...

ANTONIO: Of course! My assistant Graziano showed it to *me*. Seems it set our youth on fire, full of disgust with the great wretchedness of the world and the sins of men. It had a sense of doom

which the poet seemed to enjoy rather more than he was anxious to warn of.

SHYLOCK: That's the one! Ah, children, children! (*which reminds him, so he calls*) Children! Children! Let's eat. (*To* ANTONIO) You must be starving, and the Portuguese must be bored to death with my books by now, and we must be finished eating in time for a sitting. (*Calling again*) Jessica. (*To* ANTONIO) I'm having our portrait painted. It's the day for a sitting. A great painter, an old man now, but exquisite, Moses of Castelazzo. Renowned!

ANTONIO: Shylock?

SHYLOCR: My friend?

ANTONIO: I have a great favour to ask of you.

SHYLOCK: At last! A favour! Antonio of Shylock!

ANTONIO: To borrow three thousand ducats.

SHYLOCK: Not four? Five? Ten?

ANTONIO: I'm not making jokes, Shylock.

SHYLOCK: And why do you think I do?

ANTONIO: For three months?

SHYLOCK: Your city borrows forever, why not three months for you?

ANTONIO: You know my position?

SHYLOCK: I know your position. Your fortune in one voyage, I know. Insane. Still.

ANTONIO: You're a good man, old man.

SHYLOCK: Old man—forever! Good—not always. I'm a friend.

ANTONIO: What shall you want as a surety in the contract?

SHYLOCK: The *what*?

ANTONIO: The contract, Shylock. We must draw up a bond.

SHYLOCK: A bond? Between friends? What nonsense are you talking, Antonio?

ANTONIO: Collateral must be arranged.

SHYLOCK: Between you and me?

ANTONIO: The law demands it.

SHYLOCK: Then we'll ignore the law.

ANTONIO: The law demands: no dealings may be made with Jews unless covered by a legal bond.

SHYLOCK: That law was made for enemies, not friends.

ANTONIO: I don't want it for myself, Shylock, but for you. If word gets out we've made no bond then you'll be penalized, not I.

SHYLOCK: And who will tell?

ANTONIO: It's known already. The money is not for me. My godson. No, don't tell me I'm a fool. The boy's father was a good friend. I told him you were the only man I know could raise that sum at once.

SHYLOCK: Good! Then lie to him. Tell him, if you must tell him anything, that a contract exists and it's in my possession.

ANTONIO: Shylock! The law says, in these very words, 'It is forbidden to enter into dealings with a Jew without sign and sealing of a bond, which bond must name the sums borrowed, specify the collateral, name the day, the hour to be paid, and—

TOGETHER: —and be witnessed by three Venetians, two patricians and one citizen, and *then* registered!

ANTONIO: Be sensible! The law of Venice is a jealous one, no man may bend it. The city's reputation rests on respect for its laws.

SAYLOCK: Sensible! Sensible! I follow my heart, my laws. What could be more sensible? The Deuteronic Code says 'Thou shalt not lend upon usury to thy brother. Unto a foreigner thou mayest lend upon usury, but unto thy brother not.' Your papacy, however, turns your laws against us. But for once, Antonio, let us not quite bend the law but interpret it as men, neither Christian nor Jew. I love you, therefore you are my brother. And since you are my brother, my laws say I may not lend upon usury to you, but must uphold you. Take the ducats.

ANTONIO: But the laws of Venice are something else, dear Shylock, dear brother. They say we cannot be brothers.

SAYLOCK: I will not have soiled a friendship with my fellow man.

ANTONIO (*pressing*): And if Venice represents anything any longer to anyone in the world it's through its laws, more important even than its constitution.

SHYLOCK: The laws must leave me to conduct my loves as I please.

ANTONIO: Especially now when the economy is so vulnerable.

SHYLOCK: My dealings with you are sacrosanct.

ANTONIO: The French markets are gone, the English are building faster and better ships and there are fools talking about dangerous protectionist policies. We are a nervous Empire.

SHYLOCK: I will have trust.

ANTONIO: Shylock listen!

SHYLOCK: My heart needs to know I can trust and be trusted.

ANTONIO: You must not, cannot, bend the law.

SHYLOCK: You can have three thousand ducats but there will be no bond, for no collateral, and for no time limit whatsoever.

ANTONIO: I understand. And it brings me closer to you than ever. But the deeper I feel our friendship the more compelled I feel to press my point, and protect you. You are a Jew, Shylock. Not only is your race a minority, it is despised. Your existence here in Venice, your pleasures, your very freedom to be sardonic or bitter is a privilege, not a right. Your life, the lives of your people depend upon contract and respect for the laws behind contract. What is in your contract with the city councillors they *must* respect. Therefore you, of all peoples, have

need of that respect for the law. The law, Shylock, the law! For you and your people, the bond-in-law must be honoured.

SHYLOCK: Oh, you have really brought me down. That's earth I feel now. Solid. (*Pause, not losing his good humour*.) We'll cheat them yet.

ANTONIO: You mean you're still not persuaded?

SHYLOCK: I'm persuaded, oh yes, I'm very, very persuaded. We'll have a bond.

ANTONIO: Good!

SHYLOCK: A nonsense bond.

ANTONIO: A nonsense bond?

SHYLOCK: A lovely, loving nonsense bond. To mock the law.

ANTONIO: To mock?

SHYLOCK: Barbaric laws? Barbaric bonds! Three thousand ducats against a pound of your flesh.

ANTONIO: My flesh?

SHYLOCK: You're like an idiot child suddenly. (*Mocking*) 'A nonsense bond? My flesh?' Yes. If I am not repaid by you, upon the day, the hour, I'll have a pound of your old flesh, Antonio, from near that part of your body which pleases me most—your heart. Your heart, dearheart, and I'd take that, too, if I could, I'm so fond of it.

(*Pause as SHYLOCK waits to see if ANTONIO accepts*.)

ANTONIO: Barbaric laws, barbaric bonds?

SHYLOCK: Madness for the mad.

ANTONIO: Idiocies for idiots.

SHYLOCK: Contempt for the contemptible.

ANTONIO: They mock our friendship—

SHYLOCK: —We mock their laws.

ANTONIO (*pinching himself*): Do I have a pound of flesh? I don't even have a pound of flesh.

SHYLOCK (*pinching him*): Here, and here, and here, one, two, three pounds of flesh!

(*He's tickling him; ANTONIO responds. Like children they're goosing each other and giggling, upon which note JESSICA and RIVKA enter with food, RODERIGUES also.*

TUBAL, REBECCA and USQUE enter deep in animated conversation. A meal is to be eaten, the sounds and pleasures of hospitality are in the air.)

Act Two

Scene Five

[*The women turn and sweep into the Courtroom of the Doge's Palace, Venice.*

PORTIA *and* NERISSA *walk straight up to ask the Doge permission to enter. He grants it. JESSICA*

is embraced by RIVKA *and* TUBAL，NERISSA *moves to the Christian side．Present are* USQUE，REBECCA，RODERIGUES *and* SENATORS．

（NOTE：*If the set can hide* PORTIA *from the proceedings，good．If not，she must leave the court and reappear on her line．*）

The YOUNG MEN *are surprised．*]

BASSANIO：Portia！

LORENZO：Jessica！

BASSANIO：Did the women say they were coming？

LORENZO：On the contrary，Portia felt there was nothing to be done．

BASSANIO：Nor is there．Silence！For two hours this court of inquiry has had nothing but silence from him．Shylock！Will you speak！

（*No response．*）

He says nothing，offers no explanations，simply claims the bond．

JESSICA：Explain it to them，father，explain！

（SHYLOCK *growls and turns away．He hates scorning her，but can't help himself．She retires in distress to the Christian side．*）

BASSANIO：Look at that scowl．Have you ever seen such meanness in a face before？（*To* SHYLOCK）He was your friend！You boasted a gentile for a friend！

GRAZIANO：When a man says nothing you can be sure he hides evil and guilt，you can be sure．

BASSANIO：But why hasn't Antonio said something？

GRAZIANO：Well，of course，he wouldn't．Bewitched wasn't he？Forced into the bond．（*Calling out*）What did you say，old Jew？Not only would I be your friend，but I have to be your friend．Friendship？Ha！

BASSANIO：Shylock，will you speak！

LORENZO：Perhaps it's not Shylock who should speak but some of our own city councillors．Why were they silent？What Jewish money do they owe？It must be huge if they're prepared to let a fellow citizen be skinned alive．（*Calling out*）Fellow Venetians，is this city so far gone in its quest for profit and trade that there's no morality left？Usury is a sin against charity．When God had finished his creation he said unto man and unto beasts，and unto fishes：increase and multiply，but did he ever say increase and multiply unto money？

ANTONIO：Profit is the fruit of skill，young man！

JESSICA：And this bond was the fruit of friendship，Lorenzo，not usury，you know it！

TUBAL：Besides，most people at some moments in their life become short of money—illness...

USQUE：... A bad harvest...

RODERIGUES：... Domestic misfortune...

TUBAL：What shall they? I mean it's a problem!

LORENZO：I promise you that when the young patricians take their seats there'll be more God than Mammon on our statute books. Usury is a sin against charity. The—

TUBAL：And to deprive the people of an opportunity to obtain help is a sin against humanity!

LORENZO (*ignoring him*)：Usury is a sin against charity. The—

TUBAL：Listen to me!

LORENZO：The people suffer from it!

ANTONIO：The people suffer from ignorance, Lorenzo, believe me. To deprive them of knowledge is the sin.

LORENZO：Knowledge! Knowledge! How Shylock's books have muddied your mind. A man can be strong and happy with no knowledge, no art. Turn to the shepherd and the tiller and the sailor who know of the evils of usury, without books, without art. Real knowledge, simple knowledge is in the wind and seasons and the labouring men do.

ANTONIO：You say a man is happy with no knowledge or art? There is wisdom in the wind, you say? The seasons tell all there is to know of living and dying? I wonder? Is it really understanding we see in the shepherd's eye? Is the tiller told more than the thinker? I used to think so, sitting with sailors roughened by salt, listening to their intelligence. They perceive much, I'd say to myself. But as I sat a day here, a day there, through the years, their intelligence wearied me. It repeated itself, spent itself upon the same complaints, but with no real curiosity. Only one thing was observed again and again: that there is much to know. But to know that there is much to know and yet not ask—I can't respect that man. How alive can he be with muscles but no curiosity? You wonder why I bind my fate to Shylock, what I see in him? Curiosity! There is a driven man. Exhilarating! I thank the shepherd for my clothes and the tiller for my food, good men. Blessed. Let them be paid well and honoured. But they know, I, we know: there is a variousness to be had in life richer than laying seeds in the narrow troughs of a turned and turned hungry earth. Why else does the labourer send his sons to schools when he can? He knows what self-respect knowledge commands. All men do, wanting for their children what fate denied them, living without meat and keeping warm with mere sticks to do it. I'd have died before now if no man had kindled my soul with his music or wasn't there with his bright thoughts keeping me turning and taught about myself. Yes. Even at such an hour, I remember these things. Don't talk to me about the simple wisdom of the people, Lorenzo. Their simple wisdom is no more than the ignorance we choose to keep them in.

(*Silence.*)

GRAZIANO：As I thought. Bewitched. A knife hangs over him and he defends the man who holds it.

LORENZO：Be quiet，Graziano.

GRAZIANO：Lorenzo!

LORENZO：Stop meddling. You're a fool! The situation is too complex for you and I've not time for your tavern-tattle.

BASSANIO：Quiet now. The Doge is ready.

（*The* DOGE *returns to the official proceeding leaving* PORTIA *to continue perusing papers*.）

DOGE：Antonio Querini?

ANTONIO（*stepping forward*）：Most serene Prince.

DOGE：Shylock Kolner?

SHYLOCK：Most serene Prince.

DOGE：This court has never had before it such a case. The issue's clear，the resolution not. We must retrace and nag at it again. Signor Shylock，are you fully aware that the court is prepared to release both parties from the need to see this contract through?

SHYLOCK：I am，excellency.

DOGE：Yet you refuse，and state no reason?

SHYLOCK：I refuse and state no reason. Yes.

DOGE：And do you know this man may bleed to death?

SHYLOCK：I have our greatest doctors standing by.

DOGE：To do what? What can even Jewish doctors do to stem such awful draining of a man's life-blood? A strange perverted charity your silence，or does this man have some hold over you? We've noticed your absence from the council's meetings. You once enjoyed the affairs of running our city，tell the court. Don't be afraid. What has happened?

ANTONIO（*impatiently*）：Nothing has happened，excellency，more than I've lost my appetite for the intrigues and boredom of administration. I can't pretend this is a city of holiness and light. These are empty boasts，wind fit for the lungs of impatient youth but they have nothing to do with our humiliation in this court. Please，may we proceed.

DOGE：Then you say why we're here humiliated in this court. Say why you shared the madness of a bond which twice endangers you：from a man insisting that you pay a forfeiture of flesh，and from the law which must punish you for mocking it.

（*No response*.）

Your silence does not help.

GRAZIANO：I knew it! I told it! I warned it!

ANTONIO：Graziano，be quiet!

GRAZIANO：A plot! A plot! A Jewish plot!

ANTONIO：Be quiet，I say.

GRAZIANO：I can't be quiet，I love you.

ANTONIO：You love no one and nothing but a safe place with the multitude. Now be quiet.

DOGE：Why do you attack your friends, Antonio? These men who've come to speak for you? And why are you not speaking for yourself?

（*Pause*.）

LORENZO：Incredible! The man has even chained his victim to silence. Most serene Prince, I beg you—

DOGE：Be careful!

LORENZO：—the reason for humiliation in this court is linked with principles which go beyond this case.

DOGE：Do not attempt to make capital!

LORENZO：We should not be inquiring into silence but questioning if Jews and usury, no matter what the bond, should be permitted to pollute the fabric of our city's life. The real question is—

TUBAL：Do you think we enjoy the indignity of lending to your poor at twelve percent...?

LORENZO：...the real question is...

RODERIGUES：Collect for your poor among yourselves!

LORENZO：...the real question is...

USQUE：You have pious fraternities, collect from them for your poor!

TUBAL：Or use taxes!

LORENZO：...THE REAL QUESTION IS...

DOGE：The question of the city's contracts with the Jews is a matter for the Council. The laws of Venice are very clear and precise and cannot be twisted this way and that for political significance or gain, nor denied to foreigners, otherwise justice will not obtain. And the principal foundation of our city, is justice. The people of Venice must have justice.

ANTONIO (*finally angry*)：Justice? For the people of Venice? The people? You pride yourselves you mirror Rome! But one benefit that great empire had and we lack is: equal political citizenship. Here, in Venice, political power rests quite firmly in the hands of two hundred families and those only. That, though he talks of principle, is what Lorenzo cannot wait for, to share that power, take it over, perhaps, but not eradicate its sure corrosiveness. You use the people's name, for through their grievances, you'll come to power. One of their grievances is what you call usury. The usurer's a Jew, and the Jew the people's favourite villain. Convenient! Easy! But the Jew pursues what he hates to pursue in order to relieve us of the sin. Usury must exist in our city, for we have many poor and our economy can't turn without it. Do we condemn the Jew for doing what our system has required him to do? Then if we do, let's swear, upon the cross, that among us we know of no Christian, no patrician, no duke, bishop or merchant who, in his secret chambers, does not lend at interest, for that

is what usury is. Swear it! On the cross! No one, we know no one! (*Pause*.) Who's silent now? (*Pause*.) You will inflame the people's grievances in order to achieve power, Lorenzo, but will you ever question its necessity? I doubt it, for once there you'll sing such different songs I think.

DOGE: You do not make inquiry easy for this court, Signor.

BASSANTO: How can you make inquiries into silence, most serene Prince, the inhuman silence of an arrogant chosen people. Heretical! They still refuse to acknowledge that they are no longer the chosen people.

SHYLOCK: Oh horror of horrors! Oh heresy of heresies! Oh sweat! Oh futter! Oh butterflies, gooseflesh, hair-on-end! Oh windbag of windbags! And *you* I suppose, have been chosen instead?

LORENZO (*flooding the proceedings with conciliatory warmth and charm*): Most serene Prince. If my friend misapplies the word inhuman, we can perhaps understand. But I must pursue my original plea and ask the court to remember this: the Signor Shylock is not here because he is a Jew. The patricians of Venice are good men and justly fear being accused of such prejudice. No! What is on trial in this court is, I insist, the principle of usury whose evil this bond so tragically exemplifies, and from whose consideration we should not be detracted. The *bond* is inhuman, not the man. *No* one doubts the Tew is human. After all, has not a Jew eyes?

SHYLOCK: What is *that* fool attempting now?

LORENZO: Has not a Jew hands?

SHYLOCK: Is he presuming explanations on *my* behalf?

LORENZO: Has not a Jew organs, dimensions, senses, affections, passions?

SHYLOCK (*enraged*): Oh no!

LORENZO: Is not the Jew fed with the same food, hurt with the same weapons, subject to the same diseases, healed by the same means, warmed and cooled by the same winter and summer as a Christian is?

SHYLOCK: No, no!

LORENZO: If you prick him, does he not bleed?

SHYLOCK: No, no, NO! I will rot have it. (*Outraged but controlled*) I do not want apologies for my humanity. Plead for me no special pleas. I will not have my humanity mocked and apologized for. If I am unexceptionally like any man then I need no exceptional portraiture. I merit no special pleas, no special cautions, no special gratitudes. My humanity is my right, not your bestowed and gracious privilege.

GRAZIANO: See how ungrateful the Jew is? I knew it! I told it! I warned it! The Jew was silent because he knew that the moment he opened his mouth he'd hang himself with his

arrogance. The Jew...

SHYLOCK (*furious but low and dangerous, building*): Jew! Jew, Jew, Jew! I hear the name around and everywhere. Your wars go wrong, the Jew must be the cause of it; your economic systems crumble there the Jew must be; your wives get sick of you—a Jew will be an easy target for your sour frustrations. Failed university, professional blundering, self-loathing—the Jew, the Jew, the cause the Jew. And when will you cease? When, when, when will your hatreds dry up? Dear God of Abraham, will your mindless hungerings for *our* flesh ever be satisfied? There's nothing we can do is right. Admit it! You will have us all ways won't you? For our prophecies, our belief in universal morality, our scholarship, our command of trade, even our ability to survive. If we are silent we must be scheming, if we talk we are insolent. When we come we are strangers, when we go we are traitors. In tolerating persecution we are despised, but were we to take up arms we'd be the world's marauders, for sure. Nothing will please you. Well, damn you then! (*Drawing knife.*) I'll have my pound of flesh and not feel obliged to explain my whys and wherefores. Think what you will think that in any case. I'll say it is my bond, The law is the law. You need no other reason, nor shall you get it—from me.

(*He turns to the* DOGE, *justice must be done.* ANTONIO *joins him on the other side of the* DOGE. *They turn to face one another—doomed friends. Though-no Jew must take another's life yet* SHYLOCK *has made the decision to damn his soul for the community which he feels is threatened.*)

PORTIA: Most serene Prince, I have read the documents. (*Pause.*) Your Excellency, forgive my presumption, I know nothing of the law, but I cannot see that there is sufficient detail in this contract to make it legally valid.

(*Murmurs in court.*)

And if not valid, then not binding.

(*Excitement grows.*)

But I'm anxious in case my intelligence is merely foolish faith in little more than a hair of the law.

DOGE: The courts of Venice are open to justice no matter how tenuous a hair binds it to the law.

PORTIA: Then it seems to me this contract contains nothing but contradictions.

(*Tense silence.*)

There is in this bond a call for flesh but none for blood.

(*Noise in court.*)

There is in this bond a call for a precise pound weight but none for more or less.

(*Growing noise.*)

It cannot be executed because torn flesh draws blood.

(*Still growing noise*.)

It cannot be executed because precise weight cannot be achieved.

(*Yet more noise*.)

This contract is not binding because—impossible.

(*A swift silence in court*.)

SHYLOCK (*stunned, moves first to embrace* ANTONIO): Thank God! Thank God! Of course! Idiots! Cut flesh draw blood. No blood no flesh. Oh, Antonio, how could such a simple fact escape us? Pedants of the law! Shame on you, a disgrace to your tribe. Go down Shylock, to the bottom of the class. Oh, Tubal, what a fool you've had for a partner. No wonder we never owned the really big warehouses. (*Offering knife to the three men*) There! For you! You need it. You've no wit to draw blood with your brains or tongue, take this. Cruder, but guaranteed. Ha ha! No blood, no flesh. I love the lady. Young lady I love you. You have a future, I see it, a great future.

PORTIA (*with sadness*): But not you, old Shylock.

SHYLOCK: Not I? Are you mad? I've been delivered of murder—I've got a clean and honest life to continue. Oh, not for a hundred years, I know, and it's a pity because today, TODAY I feel I want to go on living for ever and ever. There's such wisdom in the world, such beauty in this life. Ha! Not I, young lady? Oh yes, I! I, I, I! A great future, also. Back to my books.

DOGE: No Shylock, no books.

SHYLOCK: No books? Will you take my books?

ANTONIO: You take his life when you take his books.

SHYLOCK: What nonsense now?

DOGE: No nonsense, I'm afraid, Shylock. An old Venetian law condemns to death and confiscation of his goods the alien who plots against the life of a citizen of Venice.

SHYLOCK: I? Plot? Against a citizen of Venice? Who? Antonio?

DOGE: You pursued that which would end a man's life.

SHYLOCK: But was 'that' which I pursued 'plot'? Plot? Malice aforethought.

DOGE: Malice forethought or not, the end was a citizen's death.

ANTONIO: However—

SHYLOCK: But there's no perception, no wisdom there.

ANTONIO: However—

SHYLOCK: As I warned, as I knew, no pity there.

GRAZIANO: Pity's called for now!

ANTONIO: HOWEVER! The law also says the offender's life is at the mercy of the Doge—

DOGE: Which mercy I make no delay in offering you. But the State must take your goods. The

people of Venice would not understand it if—

SHYLOCK: Oh! The people of Venice, of course.

LORENZO: See what contempt he has.

SHYLOCK: The people again. What strange things happen behind the poor people's name.

DOGE: —The people of Venice would not understand it if the law exacted no punishment at all for such a bond.

SHYLOCK: Of course.

ANTONIO: And I? What punishment do the people of Venice exact of me?

DOGE: Your foolishness, Signor, was punished by the pain of threatened death. Enough!

ANTONIO: The wisdom of patrician privilege, of course.

DOGE: But do not strain it, friend. Do not.

ANTONIO (*bowing*): I thank you.

　　(*The* DOGE *and all leave, except* SHYLOCK, ANTONIO, PORTIA JESSICA.)

SHYLOCK (*turning to* PORTIA): And the lady, where is the lovely lady, what does she say to all this?

PORTIA (*with sad apology*): The lovely lady can say nothing more to merit the name.

SHYLOCK (*tenderly, as to a daughter*): All that intelligence? Gone?

PORTIA: Not gone, but limited in power. Your lovely lady used her common sense to read a bond. That is the best not only she could do, but can be done. The law takes over now.

SHYLOCK (*sardonically*): Oh! I forgot! The law. Yes. Impartial justice. Is that to be applied now?

PORTIA (*poignantly*): Oh, Signor Shylock, please don't look to me for help.

SHYLOCK: There, there! I'm sorry. Shuh, shuh.

PORTIA (*raging at the departed* DOGE): I would not carry a sword in one hand and scales in the other. That image always seemed to me ambiguous. Is my sword held high to defend the justice my left hand weighs? Or is it poised threateningly to enforce my left hand's obduracy?

SHYLOCK: Impartial justice, lovely lady, impartial justice.

PORTIA: Impartial! How? I am not a thing of the wind, but an intelligence informed by other men informed by other men informed! I grow. Why can't they? What I thought yesterday might be wrong today. What should I do? Stand by my yesterdays because I have made them? I made today as well! And tomorrow, that I'll make too, and all my days, as my intelligence demands. I was born in a city built upon the Wisdom of Solon, Numa Pompilius, Moses!

SHYLOCK: You waste your breath, young lady, there was never any such city in the world.

PORTIA (*returning tenderly to* SHYLOCK): I can't console you, Signor Shylock, forgive me. Rage against the slowness of the law is all I can do for you. Not much help, though, is it?

　　(*They exchange sad smiles.*)

SHYLOCK: In all law part is diseased. A diseased law inspired the mad bond, another now demands

a price to be paid.（*Shrugs*.）What can one do?

PORTIA：Wisdom，inconsiderately，does not translate in a moment.

（*They exchange another smile*.）

SHYLOCK（*with sad pleasure，taking her hand，still as to a daughter*）：You have a future，young lady，I tell you，a great future.

（JESSICA *finds this tender moment between her father and another young woman unbearable and flees*.）

ANTONIO：Shylock! Don't be a stubborn old man. Explain to the court you did not want to set a precedent in law. You'll save your books.

SHYLOCK（*sardonically and with finality*）：No. Take my books. The law must be observed. We have need of the law，what need do we have of books? Distressing，disturbing things，besides. Why，dear friend，they'd even make us question laws. Ha! And who in his right mind would want to do that? Certainly not old Shylock. Take my books. Take everything. I do not want the law departed from，not one letter departed from.

（*Sound of song*.）

Perhaps now is the time to make that journey to Jerusalem. Join those other old men on the quayside，waiting to make a pilgrimage，to be buried there—ach! What do I care! My heart will not follow me wherever it is. My appetites are dying，dear friend，for anything in this world. I am so tired of men.

（SHYLOCK *moves away a bitter man*. *Everyone has left except* PORTIA. *The scene has changed to Belmont*. *We hear the distant sad singing of a woman*. *The song is* 'Adio querida'，*a Sephardic song*.）

四、思考题

1. 如何理解威斯克在主题、情节和人物塑造上对莎剧《威尼斯商人》的改写?

2. 如何理解本剧中夏洛克和安东尼奥对法律的不同理解? 在他们的对话中,夏洛克话语中的"我的法律"无疑是以人性的名义与社会法律的对抗,是以大写的"人"对由法律所代表的基督社会权力话语的挑战。对此你怎么理解?

3. 在剧中,夏洛克的朋友安东尼奥、姐姐瑞弗卡等都清醒地看到了夏洛克精神追求上的虚幻性。在第一幕中,面对夏洛克对威尼斯的热情,安东尼奥说道:"你的感激已使威尼斯变得扭曲,夏洛克,你忘记了自己头上的黄帽子。"在第二幕中,姐姐瑞弗卡一针见血地说道:"我看着你一直游离在犹太人的圈外,把鼻子伸到外人的家里。我看着你不安分地徘徊,假装自己可以走到任何人的街上······你一辈子都在装! 你究其一生,不过是想要成为不是自己的你,想把世界看成你渴望的样子。"对于这些话,你怎么理解?

4. 在本剧中,威斯克是怎样将原本意义模糊的莎士比亚喜剧改写为一部犹太理想主义者的精神悲

剧的?

5.在第二幕的法庭一场上,当巴塞尼奥将"一磅肉"的契约曲解为异教徒的嗜血时,诗人洛伦佐以貌似基督式的宽容,恩赐般地对夏洛克说:"野蛮的是这个契约,而不是你。没有谁怀疑犹太人的人性。难道犹太人没有眼睛吗?"对此,夏洛克愤怒地回答道:"我并不需要谁为我的人性辩护。我不需要特别的恳求,更不容许谁来为我的人性辩护⋯⋯我的人性是我的权利,不是你们赐予的特权。"你如何理解这段著名的对白?

6.在威斯克的剧中,那个曾在莎剧中偷走了夏洛克女儿的人物洛伦佐被赋予了诗人的身份,也正是其诗人的才华使洛伦佐成为一个极具破坏力的人物。在法庭上,他用诗人的辩才将夏洛克与高利贷的邪恶等同起来:"威尼斯人,难道因为这个城市在追求利润和贸易的路上走得远,所以它完全丧失了道德的观念吗?高利贷是违背基督仁慈精神的罪恶。"莎剧中那些为夏洛克辩护的词句,如何在洛伦佐的口中成为对夏洛克人性的最大攻击?

五、本节推荐阅读

〔1〕Massai，Sonia，ed. *World-wide Shakespeares: Local Appropriations in Film and Performance*. London：Routledge，2005.

〔2〕Rozett，Martha Tuck. *Talking Back to Shakespeare*. Newark：University of Delaware Press，1994.

〔3〕Scolnicov，Hanna and Holland，Peter，eds. *The Play out of Context: Transferring Plays from Culture to Culture*. Cambridge：Cambridge University Press，1989.

〔4〕Wesker，Arnold. *Arnold Wesker: Volume 4*. Harmondsworth：Penguin，1990.

〔5〕Wilcher，Robert. *Understanding Arnold Wesker*. Columbia：University of South Carolina Press，1991.

第三节 汤姆·斯托帕德及其《多格的〈哈姆雷特〉,卡胡的〈麦克白〉》

一、汤姆·斯托帕德简介

汤姆·斯托帕德是战后英国戏剧第二次浪潮的代表人物。1937 年,斯托帕德出生在捷克的一个犹太家庭,二战时随父母到新加坡避难,其父在战争中丧生,母亲改嫁英国军官肯尼思·斯托帕德,此后全家随继父回英国定居。斯托帕德受这一身世经历的影响,形成了其戏剧创作中中心与边缘的双重性视角。

1967 年,斯托帕德的首部剧作《罗森格兰兹和吉尔登斯敦已死》在英国国家剧院上演,斯托帕德一夜成名,成为在该剧院上演剧作的最年轻的剧作家。同年 11 月,该剧登上百老汇的舞台,成为从英国国家剧院进入美国主流剧场的首部作品。该剧以《哈姆雷特》中的两个小人物为主人公,是一部以生存主义哲学为主题的后现代改写戏剧。在莎剧中,哈姆雷特的同学罗森格兰兹和吉尔登斯敦受命陪王子去英国,却糊里糊涂地送了性命。在斯托帕德的剧中,这两位小人物却成了主角,他们像悲剧王子哈姆雷特那样思考一个同等重大的存在问题——为什么他们注定要死亡? 在整个剧中,他们时时觉得有一双无形的手在牵引着他们走向一条不归之路,直到最后才明白,那只命运之手竟是莎剧文本中的"既定情节"。

在接下来的半个多世纪里,斯托帕德创作了大量剧作,但最负盛名的仍是其早期经典作品,除了《罗森格兰兹和吉尔登斯敦已死》,还有《跳跃者》(*Jumpers*,1972)、《怪诞的效仿》(*Travesties*,1975)等。在这一阶段,斯托帕德形成了他戏剧创作的最大特点,即在传统与经典中寻找突破口,对传统上的中心与边缘进行角度的转换,从而带给观众崭新的视野。在他的剧中,中心有时是文学经典,有时是哲学、历史等概念,它们在剧中无一例外地被某种边缘的力量推翻或被狂欢式地"误用"。在《跳跃者》中,斯托帕德围绕着人类登月引发的宗教哲学危机,以喜剧的形式书写了一个关于道德哲学的政治寓言。在《怪诞的效仿》中,他以后现代记忆式话语,演绎了一个发生在俄国革命家列宁、现代派小说家乔伊斯和达达派画家查拉之间的荒诞故事。

在 20 世纪 70 年代后期,斯托帕德以自己的母国捷克为背景,创作了一系列关于东欧政治的剧作,如《蓄意犯规》(*Professional Foul*,1977)、《多格的〈哈姆雷特〉,卡胡的〈麦克白〉》等。80 年代上半期是斯托帕德戏剧创作的一个过渡阶段,其主要作品是《夜与昼》(*Night and Day*,1978)和《真相》(*The Real Thing*,1982),它们在创作上展现了斯托帕德戏剧中少有的现实主义风格。

1988 年以后,斯托帕德再次回到早期戏剧中的后现代风格,并在 90 年代进入一个新的创作高峰期。在《汉普古德》(*Hapgood*,1988)和《阿卡狄亚》(*Arcadia*,1993)中,他将量子力学、混沌数学等科学主题演绎为表现人性世界和人文思想、证明理性知识虚假性的意象载体,从而成为英国科学戏剧的代表者之一。在《印度深蓝》(*Indian Ink*,1995)和《爱的创造》(*The Invention of Love*,1997)中,他借用记忆话

语对历史进行了后现代式的书写,历史不再是对过去事件的记载,而成为可以被记忆虚构的文本叙事。

进入 21 世纪后,斯托帕德最著名的作品是《乌托邦彼岸》(*The Coast of Utopia*,2002),这是一部由《远航》(*Voyage*)、《海难》(*Shipwreck*)、《救援》(*Salvage*)组成的三部曲。该剧以 1833 年至 1865 年间俄国的社会变迁为背景,讲述了几位俄国知识分子的思想历程,探讨了浪漫无政府主义、乌托邦理想主义与现实政治改革之间的矛盾和联系。斯托帕德近年来的最新作品是《难题》(*The Hard Problem*,2015)、《利奥波德城》(*Leopoldstadt*,2020)等,后者获得了奥利弗奖。

二、《多格的〈哈姆雷特〉,卡胡的〈麦克白〉》①介绍

《多格的〈哈姆雷特〉,卡胡的〈麦克白〉》聚集了两部姊妹作品。用斯托帕德的话说,它们之间之所以用",",分开,是为了表明它们是不可分割的一体:如果说前者设定了剧作家"重写"莎剧的"游戏"规则,那么后者则是对此规则的实践和彰显。

在《多格的〈哈姆雷特〉》中,斯托帕德创作的中心意义是:一切文本(包括莎剧)如果被赋予不同的语境,都会变成新的话语通道。本剧开始时,三个男孩一边说着多格(校长之名)的语言,一边玩着球,调试着麦克风。这时,一辆装有木板的卡车到来,男孩们便运用路德维希·维特根斯坦(Ludwig Wittgenstein)的语言游戏,喊着 planks、slabs、blocks 和 cubes,开始建造平台。这四个词像密码一样,在不同的语言游戏规则中代表着不同的含义。男孩们知道游戏的规则,但卡车司机伊西却不知。不久麦克风调试完毕,平台也建成完工,于是,他们开始在平台上演《哈姆雷特》。首先,由校长多格扮演的莎士比亚走上台去,说了一段由《哈姆雷特》中多个名段改编而成的开场白,然后他们演的便是被荒诞拼贴后的《哈姆雷特》。十五分钟之后,演出结束,司机伊西拆去平台上的木板。

虽然整个剧看上去像是一部荒诞闹剧,但事实上,斯托帕德是在用独特的方式告诉人们语言在戏剧创作中的使用。就像剧中"多格的语言游戏"所显示的那样,语句在不同规则下会呈现出不同的语义。通过剧中的木板"游戏",斯托帕德向人们展现了作为语料的莎剧文本被重新"编码"而生成新的意义的过程。在这里,如果说用不同木块搭建的"平台"象征着莎剧"再编码"后的新语境,那么剧中的"麦克风"则代表着新语义通过再语境得以向观众传递的途径。

虽为姊妹作品,《卡胡的〈麦克白〉》和《多格的〈哈姆雷特〉》在情节上并没有多少关联,使他们血脉相连的是戏剧意义的生成主题。《卡胡的〈麦克白〉》在剧情上是莎剧《麦克白》与 20 世纪 70 年代后期东欧政治主题的"拼贴"。虽然斯托帕德两岁时就离开了捷克,但东欧却从未离开过他的记忆。1977 年,他首次重返布拉格,结识了几个受迫害的捷克艺术家,他们被迫离开热爱的舞台之后,在自家的客厅里上演自编的《麦克白》。斯托帕德创作《多格的〈哈姆雷特〉,卡胡的〈麦克白〉》的灵感便来源于此。

在本剧中,斯托帕德将故事设定在布拉格艺术家卡胡的家中。本剧开始时,客厅里在上演莎剧《麦克白》——麦克白与三个女巫相遇,然后谋杀国王邓肯。麦克白握着血淋淋的匕首上场说:"我已经把事办好,你没有听见一个声音吗?"(52)这时客厅外警笛响起,一个稽查官进来,径直坐入观众席中。通过人物对白,我们得知,扮演麦克白的莱多夫斯基是捷克著名的演员,因政治原因被剥夺了表演权,他现在

① Tom Stoppard,*Dogg's Hamlet*,*Cahoot's Macbeth*. London:Faber and Faber,1980. 以下出自该剧本的引文页码随文注出,不单列脚注。

的职业是卖报员,其他演出者也多是如此。短暂的混乱之后,演出继续进行,但接下来,《麦克白》的演出不时会被稽查官的说教和恐吓打断。随着《麦克白》剧情的进展——麦克白篡位,内战恶化——客厅中的镇压也越来越野蛮。稽查官手拿名单,在观众席中来回走动,用手电筒照着观众的脸说:"让我看看今晚谁在这里。"(59)此后,稽查官大段大段的政治威胁越来越频繁地切入《麦克白》的独白,他甚至喊道:"你们问法律?那我就告诉你们,法律就是刻在我警哨上的文字。"(61)

随着《麦克白》剧中的大臣班柯被杀和其幽灵出现在麦克白面前,现实事件也发生了戏剧性的突变。《多格的〈哈姆雷特〉》中的卡车司机伊西突然走进屋来,说着一口"多格语言"。于是,舞台上便出现了荒诞的一幕:一边是《麦克白》的演出,一边则是伊西和班柯的幽灵在观众席间来回穿梭。终于,伊西的"多格语言"与演出中的莎剧英文对白交错在一起,并通过女主人的翻译连成一体,最后,所有演员都开始说起了"多格语言",《麦克白》的台词完全变成了"多格式话语"。面对演员们密码式的"多格对白",一头雾水的稽查官将搜查变成了一场逮捕,他命令大家用伊西的木块在演区前筑起一堵墙,试图将演员与观众隔开。但还没等墙建成,舞台上麦克白就已被麦克德夫杀害,后者登上了平台,将王冠戴到了头上。至此,伊西突然用正常的英语喊了一声"莎士比亚完了",随后舞台上一片寂静。

毫无疑问,这是一部典型的政治寓言,其主题是东欧政治对文化的压制。就像稽查官说的那样:"别以为我不在时你们就可以有一个自己的《麦克白》,我在时的《麦克白》就不值得入眼。你们给我记着,只能有一个《麦克白》,因为举办'晚会'的人是我,而不是你们。"(56)

但该剧与其他政治寓言的最大不同在于,它对东欧政治的表现完全是通过一条语言的平行主题实现的:莎剧情节和对白被斯托帕德置于当代东欧政治的语境中,从而变成了再码后的一种新话语。客厅里上演的莎剧与现实中发生的政治暴力场面相互交错,形成意义上的互文性:麦克白对老国王的谋杀与现实中政治对艺术的"谋杀"相呼应,从而构建出一个奇特的戏剧话语模式。在此语境中,《麦克白》的剧情和对白便散发出不同于莎剧的新意义,莎剧对白仿佛成为对客厅政治镇压事件的"旁白"。比如,稽查官一边和演员们侃侃而谈,一边用政治的语言一步步操控房里的"电话"("言路"),直至给艺术家们贴上了"反动"的标签。这时,就听莎剧人物麦克德夫喊道:"可怕!可怕!混乱已经完成了他的杰作!大逆不道的凶手打开了王上的圣殿,把它的生命偷了去。"(56)在这里,麦克德夫的话仿佛成了双关语,恰好地评述了客厅里正在发生的一切,当麦克德夫喊出"我们的主人给人谋杀了"时,莎剧对白完全变成了评述时事的双重话语,其真实的意义回荡在莎剧对白的弦外之音中。

在本剧中,卡车司机伊西和他的"木板"再次成为展现维特根斯坦"语言游戏"的视觉象征:一切文本语言,包括莎剧在内,就像卡车上的"木板"一样,当落入不同书写者的手中时便会"再码"出不同的话语。一方面,稽查官要用"木板"来筑起政治的"平台"和"围墙";另一方面,艺术却要使"木板"(莎剧语言)构建表达自我思想的"另类"话语。直到最后,伊西的"多格语言"和莎剧彻底接轨,成为一种稽查官无法"解码"的新话语,从而与后者的政治话语形成了对立。

虽然从表面上看,这部作品是一部政治寓言,但事实上,在政治主题的表面之下,一股更加巨大的暗流则是对莎剧的"再码"和对莎士比亚创作神话的狂欢式颠覆。

本书节选的是《多格的〈哈姆雷特〉,卡胡的〈麦克白〉》中的《卡胡的〈麦克白〉》(独幕剧,没有场次之分)中间的一部分。

三、《多格的〈哈姆雷特〉,卡胡的〈麦克白〉》选读[①]

Cahoot's Macbeth

...

MACBETH: I have done the deed. Didst thou not hear a noise?

LADY MACBETH: I heard the owl scream and the crickets cry.

(*A police siren is heard approaching the house. During the following dialogue the car arrives and the car doors are heard to slam.*)

MACBETH: There's one did laugh in 's sleep, and one cried 'Murder!'

One cried 'God bless us!' and 'Amen' the other,

(*Siren stops.*)

As they had seen me with these hangman's hands.

LADY MACBETH: Consider it not so deeply.

These deeds must not be thought

After these ways; so, it will make us mad.

MACBETH: Methought I heard a voice cry, 'Sleep no more! Macbeth does murder sleep'—

(*Sharp rapping.*)

Whence is that knocking?

(*Sharp rapping.*)

How is't with me when every noise appals me?

LADY MACBETH: My hands are of your colour; but I shame

To wear a heart so white.

Retire we to our chamber.

MACBETH: Wake Duncan with thy knocking! (*Sharp rapping.*)

I would thou couldst!

(*They leave. The knocking off-stage continues. A door, off-stage, opens and closes. The door into the room opens and the INSPECTOR enters an empty room. He seems surprised to find himself where he is. He affects a sarcastic politeness.*)

INSPECTOR: Oh—I'm sorry—is this the National Theatre?

(*A woman, the HOSTESS, approaches through the audience.*)

HOSTESS: No.

INSPECTOR: It isn't? Wait a minute—I could have made a mistake...is it the National

Academy of Dramatic Art, or, as we say down Mexico way, NADA?... No? I'm utterly

① Tom Stoppard, *Dogg's Hamlet*, *Cahoot's Macbeth*. London: Faber and Faber, 1980, pp.52 - 61.

nonplussed. I must have got my wires crossed somewhere.

(*He is wandering around the room, looking at the walls and ceiling.*)

Testing, testing—one, two, three...

(*To the ceiling. In other words the room is bugged for sound.*)

Is it the home of the Bohemian Light Opera?

HOSTESS: It's my home.

INSPECTOR (*Surprised*): You live here?

HOSTESS: Yes.

INSPECTOR: Don't you find it rather inconvenient, having a lot of preening exhibitionists projecting their voices around the place?—and that's just the audience. I mean, who wants to be packed out night after night by a crowd of fashionable bronchitics saying 'I don't think it's as good as his last one,' and expecting to use your lavatory at will? Not to mention putting yourself at the mercy of any Tom, Dick or Bertolt who can't universalize our predicament without playing ducks and drakes with your furniture arrangements. I don't know why you put up with it. You've got your rights.

(*Nosing around he picks up a tea-cosy to reveal a telephone.*)

You've even got a telephone. I can see you're not at the bottom of the social heap. What do you do?

HOSTESS: I'm an artist.

INSPECTOR (*Cheerfully*): Well it's not the first time I've been wrong. Is this 'phone practical?

(*To ceiling again.*) Six seven eight one double one.

(*He replaces the receiver.*)

Yes, if you had any pride in your home you wouldn't take standing-room only in your sitting-room lying down.

(*The telephone rings in his hand. He lifts it up.*)

Six seven eight one double one? Clear as a bell. Who do you want?

(*He looks round.*)

Is Roger here?

(*Into the 'phone.*)

Roger who? Roger and out?

(*He removes the 'phone from his ear and frowns at it.*)

Didn't even say goodbye. Whatever happened to the tradition of old-world courtesy in this country?

(*He puts the 'phone down just as* 'MACBETH' *and* 'LADY MACBETH' *re-enter the room.*)

Who are you, pig-face?

'MACBETH': Landovsky.

INSPECTOR：The actor?

'MACBETH'：The floor-cleaner in a boiler factory.

INSPECTOR：That's him. I'm a great admirer of yours, you know.

I've followed your career for years.

'MACBETH'：I haven't worked for years.

INSPECTOR：What are you talking about?—I saw you last season—my wife was with me...

'MACBETH'：It couldn't have been me.

INSPECTOR：It *was* you—you looked great—sounded great—where were you last year?

'MACBETH'：I was selling papers in—

INSPECTOR（*Triumphantly*）：—the newspaper kiosk at the tram terminus, and you were wonderful! I said to my wife, that's Landovsky—the actor—isn't he great?! What a character! Wonderful voice! "Getcha paper!"—up from here（*He thumps his chest.*）—no strain, every syllable given its value... Well, well, well, so now you're sweeping floors, eh? I remember you from way back. I remember you when you were a night-watchman in the builder's yard, and before that when you were the trolley porter at the mortuary, and before that when you were the button-moulder in *Peer Gynt*... Actually, Pavel, you've had a funny sort of career—it's not my business, of course, but...do you know *what you want*? It's my opinion that the public is utterly confused about your intentions. Is this where you saw it all leading to when you started off so bravely all those years ago? I remember you in your first job. You were a messenger—post office, was it...?

'MACBETH'：*Antony and Cleopatra*.

INSPECTOR：Right!—You see—I'm utterly confused myself. Tell me Pavel, why did you give it all up? You were a star! I saw your Hamlet, your Stanley Kowolski—I saw your Romeo with what's her name—wonderful girl, whatever happened to *her*? Oh my God, don't tell me!—could I have your autograph, it's not for me, it's for my daughter—

'LADY MACBETH'：I'd rather not—the last time I signed something I didn't work for two years.

INSPECTOR：Now, look, don't blame us if the parts just stopped coming. Maybe you got over-exposed.

'LADY MACBETH'：I was working in a restaurant at the time.

INSPECTOR（*Imperturbably*）：There you are, you see. The public's very funny about that sort of thing. They don't want to get dressed up and arrange a baby-sitter only to find that they've paid good money to see *Hedda Gabler* done by a waitress. I'm beginning to understand why your audience is confined to your circle of acquaintances.（*To audience.*）Don't move. I mean, it gives one pause, doesn't it? 'Tonight Macbeth will be played by Mr Landovsky who last season scored a personal success in the newspaper kiosk at the tram terminus and has recently been seen washing the floors in number three boiler factory. The role of Lady

Macbeth is in the capable hands of Vera from The Dirty Spoon'... It sounds like a rough night.

(*The words 'rough night' operate as a cue for the entrance of the actor playing* MACDUFF. *Enter* MACDUFF.)

MACDUFF: O horror, horror, horror!

Confusion now hath made his masterpiece!

INSPECTOR: What's *your* problem, sunshine? Don't tell me you've found a corpse—I come here to be taken out of myself, not to be shown a reflection of the banality of my own life. Why don't you go out and come in again. I'll get out of the way. Is this seat taken?

HOSTESS: I'm afraid the performance is not open to the public. (*Enter* 'ROSS', 'BANQUO', 'MALCOLM', *but not acting*.)

INSPECTOR: I should hope not indeed. That would be acting without authority!—acting without authority!—you'd never believe I make it up as I go along... Right!—sorry to have interrupted.

(*He sits down. Pause.*)

Any time you're ready.

(*The* HOSTESS *retires. The* ACTORS *remain standing on the stage, unco-operative, taking their lead from* 'MACBETH'. *The* INSPECTOR *leaves his seat and approaches* 'MACBETH'.)

INSPECTOR (*To* 'MACBETH'.): Now listen, you stupid bastard, you'd better get rid of the idea that there's a special *Macbeth* which you do when I'm not around, and some other *Macbeth* for when I *am* around which isn't worth doing. You've only got one *Macbeth*. Because I'm giving this party and there ain't no other. It's what we call a one-party system. I'm the cream in your coffee, the sugar in your tank, and the breeze blowing down your neck. So let's have a little of the old trouper spirit, because if I walk out of this show I take it with me.

(*He goes back to his seat and says genially to audience.*)

So sorry to interrupt.

(*He sits down.* 'MACBETH' *is still unco-operative.* 'ROSS' *takes the initiative. He talks quietly to* 'BANQUO', *who leaves to make his entrance again.* 'LADY MACBETH' *goes behind screen stage left.*)

ROSS: Goes the King hence today?

(*Pause.*)

MACBETH: He does; he did appoint so.

(*The acting is quick and casual.*)

ROSS: The night has been unruly.

MACBETH: 'Twas a rough night.

(MACDUFF *enters as before.*)

MACDUFF：O horror，horror，horror！

Confusion now hath made his masterpiece.

Most sacrilegious murder hath broke ope

The Lord's anointed temple and stole thence

The life of the building.

MACBETH：What is't you say? The life? Mean you His Majesty?

BANQUO：Ring the alarum bell. Murder and treason.

LADY MACBETH：What's the business，

Speak，speak！

MACDUFF：O gentle lady，

'Tis not for you to hear what I can speak.

(*Alarum bell sounds*.)

Our royal master's murdered.

LADY MACBETH：Woe，alas！What，in our house！

ROSS：Too cruel，anywhere.

MACBETH (*Enters with bloody daggers*.)：Had I but died an hour before this chance

I had lived a blessed time；far from this instant

There's nothing serious in mortality.

All is but toys；renown and grace is dead，

The wine of life is drawn，and the mere lees

Is left this vault to brag of.

(*Enter* MALCOLM.)

MALCOLM：What is amiss?

MACBETH：You are，and do not know't.

MACDUFF：Your royal father's murdered.

MALCOLM：By whom?

MACBETH：Those of his chamber，as it seemed，had done't：

Their hands and faces were all badged with blood；

So were these daggers which unwip't we found upon their pillows；

Oh yet I do repent me of my fury

That I did kill them.

MALCOLM：Wherefore did you so?

LADY MACBETH (*Swooning*)：Help me hence，ho！

MACBETH：Look to the lady！

MACDUFF：Look to the lady！

(LADY MACBETH *is being taken out*.)

MACBETH: Let us briefly put on manly readiness

And meet in the hall together.

(*All，except* MALCOLM *exeunt* .)

MALCOLM（*Aside*）: To show an unfelt sorrow is an office

Which the false man does easy. I'll to England.

This murderous shaft that's shot

Hath not yet lighted; and our safest way

Is to avoid the aim. Therefore to horse.

(*Exit* .)

MACDUFF: Malcolm and Donalbain，the King's two sons，

Are stolen away and fled，which puts upon them

Suspicion of the deed.

ROSS: Then 'tis most like

The sovereignty will fall upon Macbeth?

MACDUFF: He is already named and gone to Scone

To be invested.

(*Fanfare* .

They leave the stage . MACBETH *in cloak crowns himself standing above screen* .

The INSPECTOR *applauds and steps forward into the light* .)

INSPECTOR: Very good. Very good! And so nice to have a play with a happy ending for a change.

(*Other* ACTORS *come on-stage in general light* .)

(*To* LADY MACBETH.) Darling，you were marvellous.

'LADY MACBETH': I'm not your darling.

INSPECTOR: I know，and you weren't marvellous either，but when in Rome *parlezvous* as the natives do. Actually，I thought you were better on the radio.

'LADY MACBETH': I haven't been on radio.

INSPECTOR: You've been on mine.

(*To the general audience the* INSPECTOR *says* .)

Please don't leave the building. You may use the lavatory but leave the door open.

(*To* MACBETH.)

Stunning! Incredible! Absolutely fair to middling.

'MACBETH': You were rubbish!

INSPECTOR: Look，just because I didn't laugh out loud it doesn't mean I wasn't enjoying it. (*To* HOSTESS.) Which one were you?

HOSTESS: I'm not in it.

INSPECTOR: You're in it, up to here. It's pretty clear to me that this flat is being used for entertaining men. There is a law about that, you know.

HOSTESS: I don't think Macbeth is what was meant.

INSPECTOR: Who's to say what-was meant? Words can be your friend or your enemy, depending on who's throwing the book, so watch your language. (*He passes a finger over the furniture.*) Look at this! Filthy! If this isn't a disorderly house I've never seen one, and I have seen one. I've had this place watched you know.

HOSTESS: I know.

INSPECTOR: Gave themselves away, did they?

HOSTESS: It was the uniforms mainly, and standing each side of the door.

INSPECTOR: My little team. Boris and Maurice.

HOSTESS: One of them examined everyone's papers and the other one took down the names.

INSPECTOR: Yes, one of them can read and the other one can write. That's why we go around in threes—I have to keep an eye on those bloody intellectuals.

'MACDUFF': Look, what the hell do you want?

INSPECTOR: I want to know who's in tonight.

(*He looks at a list of names in his notebook and glances over the audience.*)

HOSTESS: They are all personal friends of mine.

INSPECTOR: Now let's see who we've got here. (*Looking at the list.*) Three stokers, two labourers, a van-driver's mate, janitors, street cleaners, a jobbing gardener, painter and decorator, chambermaid, two waiters, farmhand... You seem to have cracked the problem of the working-class audience. If there isn't a catch I'll put you up as a heroine of the revolution. I mean, the counter-revolution. No, I tell a lie, I mean the normalization—Yes, I know. Who is that horny-handed son of the soil?

(*The* INSPECTOR *points his torch at different people in the audience.*)

HOSTESS: (*Looking into the audience.*) Medieval historian...professor of philosophy...painter...

INSPECTOR: And decorator?

HOSTESS: No...lecturer...student...student...defence lawyer... Minister of Health in the caretaker government...

INSPECTOR: What's he doing now?

HOSTESS: He's a caretaker.

INSPECTOR: Yes, well, I must say a column of tanks is a great leveller. How about the defence lawyer?

HOSTESS: He's sweeping the streets now.

INSPECTOR: You see, some went down, but some went up. Fair do's. Well, I'll tell you what. I don't want to spend all day taking statements. It's frankly not worth the candle for three

years' maximum and I know you've been having a run of bad luck all round—jobs lost，children failing exams，letters undelivered，driving licences withdrawn，passports indefinitely postponed—and nothing on paper. It's as if the system had a mind of its own；so why don't you give it a chance，and I'll give you one. I'm really glad I caught you before you closed. If I can make just one tiny criticism... Shakespeare—or the Old Bill，as we call him in the force—is not a popular choice with my chief，owing to his popularity with the public，or，as we call it in the force，the filth. The fact is，when you get a universal and timeless writer like Shakespeare，there's a strong feeling that he could be spitting in the eyes of the beholder when he should be keeping his mind on Verona—hanging around the 'gents'. You know what I mean？ Unwittingly，of course. He didn't know he was doing it，at least you couldn't prove he did，which is what makes the chief so prejudiced against him. The chief says he'd rather you stood up and said，'There is no freedom in this country'，then there's nothing underhand and we all know where we stand. You get your lads together and we get our lads together and when it's all over，one of us is in power and you're in gaol. That's freedom in action. But what we don't like is a lot of people being cheeky and saying they are only Julius Caesar or Coriolanus or Macbeth. Otherwise we are going to start treating them the same as the ones who say they are Napoleon. Got it？

'MACBETH'：We obey the law and we ask no more of you.

INSPECTOR：The law？ I've got the Penal Code tattooed on my whistle，Landovsky，and there's a lot about you in it. Section 98，subversion—anyone acting out of hostility to the state... Section 100，incitement—anyone acting out of hostility to the state... I could nick you just for acting—and the sentence is double for an organized group，which I can make stick on Robinson Crusoe and his man any day of the week. So don't tell me about the laws.

四、思考题

1. 斯托帕德戏剧艺术的一个重要特点就是在传统和经典中寻找一个落脚点,然后反其道而行之。一方面,这种后现代式的视角转换带给观众一个崭新的戏剧视野；另一方面,斯托帕德对经典的改写实践也是一个生动的布鲁姆修正理论的个案。在斯托帕德的戏剧创作中,莎士比亚、王尔德、贝克特等经典作家均成为他自我移植的土壤。对此你怎么理解？

2. 很少有哪个作家像斯托帕德这样热衷于从经典中汲取写作灵感,他是怎样的一个拿来主义者？分析在《罗森格兰兹和吉尔登斯敦已死》和《多格的〈哈姆雷特〉,卡胡的〈麦克白〉》中,他是如何从《哈姆雷特》《麦克白》等经典戏剧的框架中衍生出崭新的情节的？

3. 在本剧中,莎剧情节和对白是如何被置于当代东欧政治的语境中,变成再编码后的新话语的？

4. 我们该如何理解剧中的"木板""多格语言""电话""平台"等象征性的意象？

5. 在本剧的政治主题之下,一股暗流是对莎剧的"再编码"和对莎氏创作神话的狂欢式颠覆。在《卡

胡的〈麦克白〉》中,剧作家是如何将《麦克白》的剧情与现实中发生在捷克的故事交织在一起,从而构成一种独特的"斯托帕德-莎士比亚"叙述话语的?

五、本节推荐阅读

〔1〕Billington,Michael. *Stoppard: The Playwright*. London:Methuen,1987.

〔2〕Delaney,Paul,ed. *Tom Stoppard in Conversation*. Ann Arbor:University of Michigan Press,1994.

〔3〕Gussow,Mel. *Conversation with Tom Stoppard*. New York:Grove Press,1996.

〔4〕Hunter,Jim. *About Stoppard: The Playwright and the Work*. London:Faber and Faber,2005.

〔5〕Kelly,Katherine. *The Cambridge Companion to Tom Stoppard*. Cambridge:Cambridge University Press,2001.

〔6〕Nadel,Ira. *Double Act: A Life of Tom Stoppard*. London:Methuen Publishing Ltd,2002.

〔7〕Tynan,Kenneth. *Show People: Profiles in Entertainment*. London:Weidenfeld and Nicolson,1980.

第五章
当代英国神话改写戏剧

第一节　当代英国神话改写戏剧概论

约瑟夫·坎贝尔(Jaseph Campbell)曾说过,神话是一扇秘密的门,宇宙通过它将无尽的能量倾注到人类文化中。[①] 作为一种古老的叙事,神话是人类最强大的想象力,它隐含着人类最古老的形而上的思考,它和所有主流叙事一样,是一种具有伦理内涵的社会话语。

在后现代批评家眼中,神话具有双层政治含义:一方面,神话是属于某个文化群体的故事,对于创造出这个神话故事的母体文化而言,它是一种传统和神圣的故事叙述,承载着这个文化群体某些牢不可破的信仰,因为它的叙述带有属于其文化源头的潜文本意义;但另一方面,同样的神话对于另一个文化群体来说,却可能是一种浸润着社会意识形态的伪真理。[②] 因此,作为一种传递意识形态及文化信仰的故事叙述,神话在人类的发展过程中对人类意识的形成有着巨大的影响。如在《夜莺之爱》中,韦滕贝克借助于男合唱者之口说:"神话是话语,是公众的话语,它口口相传,直到其意义从公众话语蜕变为教导和指引后人的遥远的故事。"[③]

如神话学家鲁刚所说,神话变化的历史,不是神话的历史,而是神话创造者的历史。[④] 改写神话,就是改写神话中的政治意义,当代剧作家通过对神话的改写和重构,以表达当下时代的社会关注和精神诉求。

在《那些我们听到的声音》("The Voices We Hear")一文中,韦滕贝克详细地阐述了她的神话观,以解释选择希腊神话为题材进行戏剧创作的原因。归其要义,有以下三点:

其一,她提出,希腊神话中隐含着人类认知的大问题:"虽然我不知道是否是希腊人创造了'认识自己'这一概念,但毫无疑问,是希腊人开启了认识论的大门,他们是哲学的源头。"[⑤]自希腊文明以后,西

①　约瑟夫·坎贝尔:《千面英雄》,黄珏苹译。杭州:浙江人民出版社,2016年,第1页。

②　Frances Babbage, *Re-visioning Myth: Feminist Strategies in Contemporary Theatre*, A Thesis Submitted for the Degree of PhD at the University of Warwick, 2000, pp.5 - 9.

③　Timberlake Wertenbaker, *The Love of the Nightingale*. In *Timberlake Wertenbaker: Plays 1*. London: Faber and Faber, 1996, p.315. 以下出自本剧的引文和参考页码随文注出,不单列脚注。

④　鲁刚:《文化神话学》,北京:社会科学文献出版社,2009年,第15页。

⑤　Timberlake Wertenbaker, "The Voices We Hear". In Edith Hall, et al., eds., *Dionysus Since 69: Greek Tragedy at the Dawn of the Third Millennium*. Oxford: Oxford University Press, 2004, p.361.

方思想者一直坚信,自我认知是人类获得理性行为、创造美好社会的途径。从这个意义上讲,大多数的希腊悲剧均属于"自觉性悲剧"(tragedy of self-knowledge),俄狄浦斯、克瑞翁、阿伽门农等无不是因为"缺乏自我认知"而堕入毁灭。所以韦滕贝克认为,我们之所以不停地回到神话,是因为人类走过了几千年的路之后,越来越意识到希腊剧作家一度怀疑却不敢道出的真相——人类也许是不可知的,不仅不可知,而且是非理性的。她提出,20世纪的事件证明,人类文明虽然已经发展了数千年,但在道德上却似乎一直裹足不前,甚至在认知上日渐退步——我们知道的越来越多,但对自身的理解却越来越少。

其二,她提出,虽然神话悲剧中充满了自觉性英雄,但"如果我们细读这些神话悲剧,就会发现,神话中感情最为激烈的人物总是女人,克吕泰涅斯特拉、伊莱卡、赫卡柏、美狄亚、菲德拉、安提戈涅,无不是如此"。(362)对于此现象,韦滕贝克不禁产生疑问,这些女人与人类自我的认知有何关系?与理性又有何关系?在她看来,他们之间显然没有任何关系,因为希腊诗人在书写这些女人时,并没有把她们当作女人来描写,而是把她们视为某种恐惧之物的隐喻——人类非理性和神秘性的化身。(362)所以,韦滕贝克指出,希腊悲剧家笔下的神话女性与亚里士多德式的人物程式截然不同:亚氏神话英雄总是沿着"傲慢—堕落—顿悟—接受命运"的叙述范式展开,而神话女性却相反——她们是一种让理性思考感到困惑的生命存在,一种非理性的、不可知的、无法解决却又挥之不去的迷思。(362)

其三,在她看来,人类与神秘力量的关系决定着宇宙的运转,而女神所代表的不可知性与男神所代表的理性认知共同存在,构成了希腊悲剧家所探讨的人类问题的核心张力。在这种认知张力之中,一方面是公共主流话语及其政治权力,另一方面则是挑战社会权威和道德秩序的越界者,其中最为典型的就是酒神和古希腊戏剧之神狄俄尼索斯。这位带有一定女性特质的酒神是一个典型的越界者,他洞悉一切自然秘密,却放纵神性,打破了所有被希腊人视为神圣的秩序、禁忌和界限,成为痛苦与狂喜交织的癫狂人性的象征。他与伴随其左右的女祭司或酒神伴侣成为希腊神话政治话语中的文化"他者"和"杂音"。从这个意义上讲,希腊神话中的众神世界与后结构主义时代有着很大的相似性——神话中的酒神节其实就是一个"他者"的狂欢节,酒神节上的合唱就是异乡人的唱语。[①]对韦滕贝克和所有当代剧作家而言,再写神话,就是倾听神话中被埋藏了无数个世纪的"杂音"。

20世纪60年代,神话改写成为西方主流剧场的普遍现象。希腊神话悲剧吸引了大量当代作家和导演,他们在埃斯库罗斯、索福克勒斯和欧里庇得斯描绘的充满矛盾的神话世界中找到了反映当下社会问题的文化和美学棱镜。1969年,美国先锋戏剧大师理查·谢克纳(Richard Schechner)推出了《狄俄尼索斯在69年》(*Dionysus in 69*),这是一部以《酒神的伴侣》(*Bacchae*)为前文本的改写作品。同一时段,西方舞台上涌现出大量神话改写作品,如德国剧作家海纳·米勒(Heiner Müller)的《索福克勒斯:俄狄浦斯王》(*Sophocles: Oedipus the King*,1967)、《菲洛克忒忒斯》(*Philoctetes*,1968),英国导演彼得·布鲁克(Peter Brook)的《欧尔盖斯特》(*Orghast*,1971),英国诗人、剧作家托尼·哈里森(Tony Harrison)的《普罗米修斯》(*Prometheus*,1998),以及约翰·杰塞伦(John Jesurun)、海纳·米勒、安德烈·纪德(André Gide)三人共同创作的《菲洛克忒忒斯变奏曲》(*Philoktetes-Variations*,1994)。

进入21世纪以来,西方戏剧舞台上的神话改写创作势头不减。澳大利亚女性剧作家克里斯汀·伊万斯(Christine Evans)以特洛伊战争和现代战争为背景,创作了《特洛伊芭比:与欧里庇得斯的〈特洛

① Edith Hall,"Introduction". In Edith Hall,et al.,eds.,*Dionysus Since 69: Greek Tragedy at the Dawn of the Third Millennium*. Oxford: Oxford University Press,2004,p.3.

伊女人〉相撞》(*Trojan Barbie: A Car-Crash Encounter with Euripides' Trojan Women*，2007)；美国戏剧家玛丽·齐默尔曼(Mary Zimmerman)以奥维德(Ovid)的《变形记》(*Metamorphoses*)为题材创作了改写新剧《变形记》(*Metamorphoses*，2002)，该剧获得了托尼奖。此外，五位西方女性剧作家塔尼娅·巴菲尔德(Tanya Barfield)、卡伦·哈特曼(Karen Hartman)、基奥里·米娅嘉华(Chiori Miyagawa)、林恩·诺蒂奇(Lynn Nottage)、卡里达·斯维奇(Carida Svich)以索福克勒斯的《安提戈涅》(*Antigone*)为起源文本，用集体创作的形式创作了神话作品《安提戈涅创作工程》(*Antigone Project*，2004)。在这部剧作中，五位剧作家从各自的角度重新创作了一个以安提戈涅为主人公的单幕剧，分别将安提戈涅的故事置于海滩上、一战时的美国、档案中、非洲村庄和地下世界，从而讲述了一个关于安提戈涅的多维立体故事。通过将安提戈涅的故事置于21世纪的社会政治中，五位女性剧作家表达了政治最终是人性的这一思想。还有德国剧作家克里斯托弗·间平(Christopher Rüping)，他创作了《狄俄尼索斯之城》(*Dionysos Stadt*，2018)，在长达10小时的戏剧中，间平讲述了普罗米修斯将象征科学、文明、创造的火种赠予人类，而人类却将其用于抢夺劫掠的故事，该剧成为2019年柏林戏剧节"十部最值得关注的剧目之一"。

在战后英国剧场中，一批剧作家以神话为载体进行政治剧的创作。这类戏剧起步于邦德在20世纪70年代的神话改写戏剧《女人》，发展于丘吉尔在20世纪80年代的实验戏剧《食鸟》，最终在20世纪90年代的凯恩、韦滕贝克等新生代剧作家的手中发扬光大。

作为第一次浪潮中政治戏剧的代表者，邦德提出，传统神话的目的是服务于不公正的社会，当代剧场的责任就是要揭示这些神话的本质，并修正这些神话。"剧作家的作品应该是斗争的一部分……我们不仅要写问题剧，还要创作含有问题答案的作品……我们应该用自己的思想来实现这一点，这样，我们就可以挣脱过去神话对我们的束缚……"[1]在《女人》中，邦德遵循他的理性剧场理念，从社会政治的角度穿越神话，以揭示当代暴力政治的本质。与邦德不同，韦滕贝克则从女性主义神话学的角度重述希腊神话，从而揭示了传统神话书写之下的"她者"故事。在其代表作《夜莺之爱》的故事开始之前，她曾在该剧"前言"中引用了三段话。在第一段引文中，有这样一句话："听！这就是神话中的杂音，它像影子，悄无声息，你听见了吗?"(285)通过这段引文，韦滕贝克意在指出，作为古希腊官方主流文化的聚集地，神话叙事被赋予了社会道德的声音，但在其主流声音之下，却一直存在着无数"他(她)者"话语的潜流和暗涌，虽然这些暗涌几乎静默得难以察觉，但它却真实地存在着。

在本章，我们将以邦德的《女人》、韦滕贝克的《夜莺之爱》为例来分析不同风格的神话改写戏剧。

[1] Malcolm Hay and Philip Roberts, *Edward Bond: A Companion to the Plays*. London：Theatre Quarterly Publications，1978，p.74.

第二节　爱德华·邦德及其《女人》

一、爱德华·邦德简介

邦德是一个诗人,也是一个思想家。他力图通过戏剧对西方社会中的暴力政治做出全新的解释,以揭示权力、暴力与公正之间的内在关系。他指出:"政治是戏剧的核心,戏剧要解决的是自我和社会的关系……政治戏剧的要务就是弄清传统人性中最深刻的悖谬现象。"[①]关于"人性中的悖谬现象",邦德这样阐述:"圣奥古斯丁说:'爱,就要做你要做之事。'希姆莱也声称:'我是为了爱才用毒气杀死犹太人的。'这里隐含着人类种族观念中一个本质性的悖谬现象。"[②]在邦德看来,正是这些错误的道德观和政治观形成了人类历史的暴力链条。

这种思想在他 20 世纪 70 年代的作品中得到集中的体现。70 年代是邦德戏剧创作的高峰期,他最著名的几部作品——《李尔》《大海》《赢了》《女人》等均创作于该阶段。

《李尔》是邦德的经典作品。在剧中,为防御北部宿敌的入侵,国王李尔在修筑一座城墙,不料两个女儿却与敌人私下里结为了夫妻。他们推翻了李尔的政权,李尔和忠臣沃林顿被俘,两姐妹割去了沃林顿的舌头。李尔逃到了一个村庄里,被掘墓之子收留。随后,士兵到来,他们打死了掘墓之子,强暴了他的妻子考狄利娅,抓走了李尔。随后,考狄利娅和情人木匠开始报仇,他们推翻了两个女儿的政权,下令继续修建城墙。在狱中,李尔目睹大女儿被解剖和二女儿被刺死的惨状,而后自己也被挖去了双目。受尽苦难的李尔这时终于意识到自己和所有执政者围绕着"城墙"所犯下的错误和罪行:城墙就像是社会政权的象征,它使当权者以冠冕堂皇的理由实施暴力。剧末时,李尔爬上这个曾经寄托了他所有政治梦想的城墙,想用铁锹拆除它,最后被士兵打死。通过改写,邦德笔下的李尔被塑造成了承载当代暴力政治主题的一面镜子——"李尔王既代表了西方文化中的至善,也代表了西方文化中的至恶,是一个集社会极权与博大人性为一体的矛盾存在。"[③]

《赢了》是邦德继《李尔》之后的另一部力作。在这部剧中,莎士比亚本人成为故事的主人公。本剧开始时,年老的莎士比亚坐在故乡的花园里,手里握着一份地契。而在花园的深处,一个无家可归的女子为了生存被园丁奸污;在篱笆之外,英国正经历着从封建社会向资本主义的过渡——圈地运动和清教徒运动在轰轰烈烈地逼近。下午,羊毛商库姆来访,他是来说服莎士比亚支持圈地运动的,那份地契将保护他的利益不受影响,但前提是他以"不参与"的态度默许圈地事件的发生。随后,库姆发现了藏在树丛里的流浪女子,并以维护公众道德的名义将她绞死。绞刑架上的女人仿佛是一幅被放大的现实画卷,撞碎了莎士比亚紧闭的良知天窗。这时,剧作家本·琼森来访,带来了伦敦剧院被烧、清教徒来了的消息,但莎士比亚却无动于衷地埋头喝酒和酣睡。下雪了,站在白茫茫的田野之上,莎士比亚仿佛成了在

① Edward Bond,"Four Short Essays on Drama by Edward Bond". 15 Jun. 2017. http://www.edwardbond.org/Theory/theory.html.
② Michael Mangan,*Edward Bond*. Plymouth:NorthCote House Publishers,1998,p.69.
③ James C. Bulman,"Bond,Shakespeare,and the Absurd". *Modern Drama*,19.1(1986),p.60.

暴风雨中流浪荒野的李尔,心头涌起了诗人的顿悟:白茫茫的大地像是自己耕耘一生的戏剧世界,它看似在揭示人类的灾难和痛苦,事实上却空无一物。邦德认为艺术的价值就在于永远清醒地知道真相,他在该剧的前言写道:"莎士比亚写过《李尔王》,李尔在荒野向上苍索求的就是人类行为的道德和天理……莎士比亚一定是知道这些的,否则他就不会写出那部剧作。"①在《赢了》中,莎士比亚清楚地知道发生在身边的一切,但却关闭了良知的天窗,这种"不参与"的态度使他成了社会暴力的帮凶。

如果说20世纪70年代是邦德戏剧创作的第一个黄金时期,那么在20世纪80年代后半期,邦德就进入了他创作的第二个高峰期。以1985年的《战争三部曲》为分界线,邦德在戏剧创作上从前期的经典戏剧创作转向后期的后现代暴力戏剧创作。以《战争三部曲》为起点,他先后创作了《咖啡》《21世纪的罪恶》《假如一无所有》《平衡行动》《破碎的碗》等。在这一时期,邦德的戏剧在英国备受冷落,但在欧洲大陆却大受欢迎。80年代之后,邦德成为很多欧洲戏剧导演心目中继布莱希特之后最有影响力的戏剧理论家,其作品在德国、法国的主流剧场受到追捧。90年代之后,邦德与法国导演阿兰·弗朗松(Alain Françon)、巴黎城市剧院(Théâtre de la Ville)、柯林国家剧院(Théâtre national de la Colline)建立了紧密的合作关系。邦德不仅在欧洲大陆找到了新的观众和灵感,也开启了后现代"事件剧场"的艺术探索,从而将前期的"理性剧场"推向了新的哲学高度。

从《被拯救》到《咖啡》,从理性剧场到事件剧场,从成名于英国到成就于法国,邦德用波澜壮阔的戏剧人生重新明确了当代剧场的责任。邦德的戏剧让人想到英国诗人威廉·布莱克(William Blake),虽然他一生追求的暴力政治主题显得有些激进,但正是这种坚定的政治思想给予邦德戏剧一种强烈的道德冲击力。

二、《女人》②介绍

《女人》是对《特洛伊女人》《俄狄浦斯王》《安提戈涅》等多部古希腊神话悲剧的改写。

该剧共分两部分。第一幕以片段式的画面讲述了特洛伊战争。背景是特洛伊在衰落,雅典城邦在崛起。在剧中,希腊神话中的英雄奥德修斯、墨涅拉俄斯、阿伽门农等合并为一个人物赫洛斯(英文是Heros),一尊女神像代替海伦成为引发特洛伊战争和灾难的主线——这尊女神像是雅典王从被征服的东方获取的一尊幸运女神像,但它却被特洛伊人偷走了。本剧开始时,战争已进行数年,特洛伊国王普里阿摩斯已病死,王后赫库巴在主持残局。赫洛斯派他的妻子伊斯墨涅作为特使与赫库巴谈判,假意承诺只要特洛伊交出神像,希腊人即可和平退兵。伊斯墨涅却为了使特洛伊免遭毁灭而与赫库巴联手,赫库巴答应交出神像,条件却是将伊斯墨涅留作人质。但她们的计划最终失败,城池被攻破,希腊大军屠城,王孙被摔死。第一幕结束时,赫库巴像俄狄浦斯那样刺瞎了自己的一只眼睛,伊斯墨涅则被希腊人视为叛徒,像安提戈涅那样被砌入墙中。

第二幕讲的是后特洛伊时代的故事:伊斯墨涅从墙穴中被放出,她与王后逃到了一个海上小岛,神像在海难中落入水中。12年后,赫洛斯为寻找神像率军追至小岛。虽然他对赫库巴说,他们已建起一个新雅典:"我们以理性代替恐惧,以法律代替暴力,以秩序代替混乱,以劳动代替掠夺。"(79)但他仍担

① Edward Bond, *Bingo. In Edward Bond Plays: Three*. London: Methuen, 1987, p.41.
② Edward Bond, *The Woman*. New York: Methuen, 1979. 以下出自该剧本的引文页码随文注出,不单列脚注。

心,没有神像,他的统治将无法稳定,这种对失去权力的恐惧驱使他来到小岛,他发誓像当年征服特洛伊一样夺回神像,如果得不到,将杀死所有岛民。面对灾难,赫库巴说道:"如果我是一个女祭司,神祇会降临来告诉我怎么做,但现在来的却是我的敌人——我不得不再次让自己被愤怒燃烧,就像特洛伊城上的大火一样。"(82-83)最后,赫库巴与一位外来的奴隶联手杀死了赫洛斯,希腊人离去。

在邦德看来,特洛伊战争是资本主义文化中邪恶价值观的象征。他曾说:"第一幕是一个历史瞬间,第二幕则是一个关于历史的故事——这样设置的目的是借助时间距离来重新审视历史……在希腊将军的心中,存在着一个由神像代表的伪理想,每一个法西斯社会都曾为自己构建过一种美好的神话。"①这种历史观在剧中通过赫洛斯得到集中体现。作为历史上所有英雄、王者的化身,赫洛斯曾在洗劫特洛伊之前发誓,他必须维护社会价值,因为这是他的使命,他也必须洗劫特洛伊,因为那是雅典的期待。在这里,他的暴力政治的逻辑是,既然神像能利国兴邦,那么为了城邦的利益,一切杀戮皆合理,他说:"如果我不能找回石像,我也必须向雅典民众证明,我已尽了我所有之力,哪怕这意味着必须在痛苦中杀死那些岛民,摧毁他们的村落……我看重对雅典的责任,那是一个自由的王国。"(90)在这里,赫洛斯身上所体现出的暴力哲学与李尔的"城墙政治"可谓如出一辙:它使暴力道德化,使当权者以冠冕堂皇的理由实施暴政。在邦德看来,政权最可怕的一面就是这种政治理想下所掩盖的血腥。更加可怕的是,这种政治暴力的观念已浸入社会意识的肌肤深处,成为一种惯性思维:一代代统治者无不在沿着各种所谓的"正义"之路,走向一轮轮新的暴力。

邦德一再强调,自己戏剧创作的内动力是理性而非人性。作为一个当代人,他拒绝接受莎士比亚悲剧人物的人性独白,他让剧中人物构建的是一个社会性的独白:"哈姆雷特发现的只是自己的'灵魂',我的人物发现的却是社会的灵魂。"②在邦德看来,暴力是当代西方社会的核心问题,其可怕性在于它是传统道德、社会观念和政治结构的产物。因此,除去暴力的关键是打破这一观念,而赫洛斯和李尔就是这种观念的代表。

本书节选的是《女人》中第一幕的第一场至第二场、第四场至第六场。

三、《女人》选读③

The Woman

Part One

One

Greek camp. Headquarters.

NESTOR *asleep on a stool.*

SOLDIERS（*off*）：Dead. Dead.

① Philip Roberts, ed., *Bond on File*. London: Methuen, 1985, p.41.
② Hilde Klein, "Edward Bond: An Interview". *Modern Drama*, 38(1995), p.408.
③ Edward Bond, *The Woman*. New Tork: Methuen, 1979, pp.13-21, pp.26-39.

THERSITES (*off*): Priam dead!

A moment later THERSITES runs on shouting.

Hurrah! (*To* NESTOR.) Priam dead!

SOLDIERS (*off*): Dead. Hurrah.

THERSITES (*running out*): Priam dead!

THERSITES runs off.

SOLDIERS (*off*): Priam dead.

AJAX runs on.

AJAX (*to* NESTOR): Priam's dead!

AJAX runs off.

SOLDIERS (*off*): Dead. Dead.

NESTOR (*waking*): What?

SOLDIERS (*off*): Hurrah.

THERSITES *and* AJAX *run back. They embrace. Off, cheers and cries of 'Dead' are heard throughout the scene.*

THERSITES: The bastard's dead!

AJAX: Rotting!

NESTOR: Who is?

THERSITES: Priam!

SOLDIERS (*off*): Dead. Dead. Dead.

NESTOR: Dead?

AJAX: Yes yes yes !

HEROS *comes on.*

THERSITES (*to* HEROS): That's why the city was quiet. He's been dying for weeks.

NESTOR: Priam's dead?

AJAX: The fight'll go out of them now!

THERSITES: Give them a month!

AJAX: They'll all be dead.

NESTOR (*embracing* AJAX *and* THERSITES): My boys! I shall see Greece again!

HEROS: We must hold a council. If we miss this chance we could be here for years.

NESTOR: Stools! Stools!

An ORDERLY *brings on the officers' stools.*

HEROS: Do we know what he died of?

AJAX: Old age!

NESTOR: Not killed?

THERSITES: Some children came up on the wall playing funerals. We shouted up and they said: the

king's dead. Then their guards came back and called them down from inside.

NESTOR: I'm sorry he wasn't killed.

AJAX: We heard priests chanting.

HEROS: Let's sit.

They sit.

AJAX: Hecuba will run Troy now. He chose Hecuba—not his son.

HEROS: We've sat outside Troy for five years. This is our first chance.

NESTOR: I'm surprised he lasted so long. He was old when he married Hecuba. Older than I am now. (*Laughter.*) It's true—long thin man with a white beard and little piggy eyes. Even on a calm day he looked doubled up in the wind.

HEROS: He'd have compromised in the end—Hecuba won't.

THERSITES: Her son might make her.

HEROS: When her husband couldn't?

AJAX: You think they'll—

ISMENE *comes in.*

ISMENE: Is Priam dead?

HEROS: Yes thank God!

NESTOR: No women in council. Bad luck.

THERSITES: Ismene might be able to advise us.

NESTOR: Advise us?

THERSITES: Now Troy's run by a woman.

NESTOR: Well...

HEROS: Let Ismene stay. What Thersites says is true.

THERSITES *gives his stool to* ISMENE.

Well.

AJAX: You think they'll fight on?

THERSITES: Won't they just—

HEROS: Let's review the situation. Twenty-five years ago Troy was already a falling city and Athens in the ascent. My father'd won his war for the Eastern mines. He'd captured the statue of the Goddess of Good Fortune and was bringing it to Athens. Hecuba told Priam that if he owned the statue Troy would be saved. He took it—and since then Troy's had nothing but disasters. Why? The statue brings good fortune only to those destined to own her. But how can we win the war and capture the statue of Good Fortune when we haven't got the statue to give us the good fortune to win the war?

AJAX: That's the problem.

HEROS: Well, no man's hand can be more impious than the Trojans': to hold what all men call the

supreme goddess against her will! On such men the greatest misfortune must fall. What is their greatest misfortune? That we should win the war. This proves that we must.

NESTOR: In a nutshell.

HEROS: But for that very reason Troy must fight. They fight but can't win—the goddess of Good Fortune will punish them by giving us the victory. I know what's happening in Troy. It's so clear in my head. Listen!—I'll tell you.

A scene inside Troy

PRIAM on a bier. HECUBA, CASSANDRA *and the* SON.

HECUBA *wears ceremonial mourning. She is made up like an old aristocratic whore. She looks tragic but doesn't cry.*

CASSANDRA *has a round face, long fair hair, and is pale and has been crying. The* SON *is a little short and thickset, but he moves simply and is dressed heroically. The scene has an air of theatricality.*

Note: in the first production HECUBA *was played by* NESTOR, CASSANDRA *by* THERSITES *and the* SON *by* AJAX. PRIAM*'s body was invisible. There were no* PRIESTS. *The scene is to be imagined as occurring in* HEROS*'s head.*

HECUBA: Burn Priam before the war temple and scatter his ashes—(*She turns to the* SON.)—on the battlefield yourself.

SON: Mother! Even my father's funeral—she uses that to put my life in danger.

CASSANDRA: Yes, mother—that's dangerous!

SON: It's only done for heroes who died in battle.

HECUBA: If he was your age he'd have gone on the battlefield and sent the Greeks packing—we'd have celebrated victory long ago!

SON: If you'd let him he'd have given the Greeks everything at the start—lock stock and barrel!

HECUBA: Cover his ears! They say the dead still hear voices from this world for a time. He lies there and can't strike his son while he insults his mother!

SON: You bully people by acting! She treats this city as if it was on a stage.

CASSANDRA (*wearily*): Please.

SON: You worry what he hears when he's dead! She shouted at him every day when he was alive!

HECUBA (*turns away and talks almost to herself*): Who will help me? What can I lean on? —not even this wall. My enemies sit out there and wait for it to crumble. If it was iron they'd wait for it to rust. They have the patience of the damned. I'm shut up with the spiders that will build webs on my tomb.

CASSANDRA: Mother.

HECUBA: No, I won't be comforted. (*She takes the ring from* PRIAM's *finger and holds it over her head between finger and thumb*.) Your father made me head of the city. He swore an oath in the temple. Who speaks against his oath? (*No answer. She ceremoniously puts her finger into the ring*.) People, war, armies, cities! I would like to sit at home and hear myself say children, friends, family—the words of my girlhood. If you were a leader, a soldier, I'd be on my knees begging: mercy, don't take such risks, don't go to the wall today. Instead you make me shout like an old hag—and blame me for it! (*Turns away from him*.) When I'm dead the Greeks can come over that wall and cut this city open. Then let them kill and burn and loot! I'll give them nothing.

The SON *goes*. PRIESTS *follow with the bier*.

A sullen child who obeys out of fear. He'll throw his father's ashes as if he was throwing them in my teeth! He understands nothing. At least there should be peace in our homes. Instead (*She doesn't finish the sentence*.) There! The same words: hate, fear, war, prison.

CASSANDRA: Give the statue to the Greeks. Without father to guide us—

HECUBA: Trust the Greeks? No, I'll never do that. What would the Greeks have to lose once they'd got it? We must hold on to it—that's the only way to save our lives.

HECUBA *and* CASSANDRA *follow the* PRIESTS *out*.

ISMENE: But why d'you say she—

NESTOR: No woman-talk in council! Well now: how long will the war last? Till it ends. When will it end? Hecuba's old—but the Trojans are long-livers. Take Priam!

HEROS: Nestor, go home. You've served Greece long enough. Spend your last years in that nice house by the sea.

NESTOR: I'm not an old dodderer yet! What would my soldiers do if I left? They love their old Nestor.

THERSITES: Send a delegation to Hecuba. Offer to go if she gives us the statue. No plunder, burning, forced labour.

AJAX: After five years? Listen to your men: When we get through those gates—women, loot, drink, arson!

NESTOR: At my age you don't live long enough to enjoy revenge when you've got it. The wine's better on my own hill, and I'm useless to women. But the men want to go home with some silver in their pockets, a piece of material for the wife, and a Trojan helmet to put on and frighten the kiddies.

THERSITES: Tell them they can leave tomorrow—or wait years for a piece of material. They'll get good wages in Athens—building the new city will pay well. Or they could have land—

AJAX: You'll hand over your estates?

THERSITES: In the colonies.

AJAX: That would mean more fighting.

THERSITES: At least it'd be a new war with different scenery.

ISMENE: I think the men would rather—

HEROS: Ismene—

ISMENE: It's obvious! Look how they try to turn their quarters into homes, as if their wives were looking after them! Some of them married girls from the countryside here—they want to take them home to their parents.

HEROS: If we promise the Trojans something we must keep our word. Remember, the goddess sees and judges. It's difficult to control men in the last days of a war. Do we want to leave Troy killing our own men when the Trojans couldn't? Is that what the goddess wants?

NESTOR: We'd have to guarantee—in the eyes of the goddess—to try to restrain them. No one could do more than that.

HEROS: Let's vote.

NESTOR *and* THERSITES *put up their hands*.

AJAX: I'm against! The enemy's lost its leader—

ISMENE: He says the leader was always Hecuba.

AJAX: —so let's wait and see how this affects their morale. This vote can change the whole course of the war. How does our commander vote?

HEROS: There's a lot to be said on both sides. I'm for sending a delegation—on balance.

THERSITES: Three one.

ISMENE: Hecuba will be more likely to listen if your delegation has a woman.

NESTOR: That's too much!

THERSITES: The situation's new. We must adapt to it. I'll go with Ismene and do the talking.

NESTOR: Then go! It's usual to send the oldest—and therefore wisest—member of the council. I give up my place to Thersites!

NESTOR *goes out*.

HEROS: So, Thersites and my wife? (AJAX *and* THERSITES *nod.* HEROS *beckons to* AJAX.) You.

HEROS *and* AJAX *go*.

THERSITES: Why did your husband vote for the compromise? He must destroy Troy—his power in Athens depends on it.

ISMENE: Wishes don't change but the cost of fulfilling them changes all the time. When Miron wanted to make the sculpture of a discus thrower the only man who could hold the pose long enough was a cripple who couldn't move. You fight beside him—what do you think?

THERSITES: You know him better than I do.

Two

Greek camp—HEROS's *quarters*.

Night . HEROS *stands before an open window looking across at Troy* .

A MAID *is folding back the bed sheets for the night* . ISMENE *comes in* . *She wears a nightgown* .

MAID：Good night sir.

HEROS：Thank you.

MAID：Ma'am.

ISMENE：Good night.

　　The MAID *goes* .

ISMENE：You're not angry?

HEROS (*looking round at her*)：At what?

ISMENE：Me going to Troy?

HEROS (*turning back*)：No.

ISMENE：I wonder what she'll look like.

HEROS：You won't see for paint. (*He goes on looking out* .) Her husband married her when he was old. That's the most ruttish sort of infatuation. My father met her. He understood Priam. All that old man's excesses lie at her door. She pushed him.

ISMENE：I meant the statue.

HEROS：Ah. When I was a child people still called Troy the fabulous city of the East. We played sacking Troy. Now I stand in front of it and it's a closed coffin with someone moving inside.

ISMENE：Will you keep your word? No killing or looting?

HEROS：Athens will want me to pay for the war. Cheap labour would have helped. (*He goes to the desk and prepares to write* .) Who shall *I* trust? God? Ask the soldiers! The government? (*He looks across to the window* .) It's a beautiful night. If I make mistakes I'm punished—by the government or the troops or God. I'm God to my men—obviously I am. Does God cheat? I don't know. (*He starts to write* .) I must tell Athens Priam's dead.

　　ISMENE *gets into bed* .

(*Writing* .) I was born at a time when I summed up a nation's strength. My father had doubts，my heirs will have weaknesses. Of course I'm only a dummy on Athens's knees：but the voice is clear in me. They say the ewe killed in the compound to celebrate my birth had human milk in the udder. (*He looks up towards the window* .) The stars are very clear tonight. (*He looks down at his hand* .) My fingers look like five white towers. (*He puts down the pen and looks across at* ISMENE.) The death of a king requires a certain prolixity. (*Slight pause* .) When circumstances change，strengths become weaknesses. Let's get home to Athens and build it quickly!—so we're still young when we lead the first kid to the altar. (*Slight pause* . *He stands* .) I'm going round the lines.

　　HEROS *goes out* .

Four

Troy—the palace.

HECUBA *and* CASSANDRA. HECUBA *is a dignified public figure.*

HECUBA: When I married your father houses had been falling down in the city for years and no one rebuilt them. There was no money, the mines were empty. I was going to wear something bright, but I thought it ought to be mourning. Lend me your belt. (*She puts on* CASSANDRA's *belt*.) Better... I never saw him when he was young. I thought I'd be able to tell what he'd looked like if I saw him asleep. But he looked even older—as if a mask had been pushed through from underneath.

The SON *comes in with the* TROIAN HIGH PRIESI, *the* SECOND TROJAN PRIEST *and the* TROJAN CHAPLAIN.

SON: Say nothing to the Greeks. Just listen.

HECUBA: I shall do anything I can to save the city—not your honour. (*To the* TROJAN PRIESTS.) The plague?

TROJAN HIGH PRIEST: We're praying. It could be over in a month. It's contagious, not infectious. People must sleep and eat and live apart. Mothers can handle children, but children can't play together. Shops are under guard: everyone gets one food ration to prepare on their own.

HECUBA: Are there many dead?

TROJANHIGH PRIEST: We don't know. It hasn't spread from the poor quarter. We must take strength from our afflictions.

SON: Amen!

HECUBA (*turning away from the* SON): I've begun to hate you young-old people. I'm tired of listening to you argue with your undertakers about the future. Even victory would now cost us more than defeat at the beginning—and what hope is there of victory?

AIDE *comes in.*

AIDE: The Greeks.

THERSITES *and* ISMENE *come in.*

HECUBA (*formally*): I speak for the Trojans.

THERSITES (*formally*): We speak for the Greeks. During the five years the Athenians have been at Troy children have grown to be intelligent youths, gardens have matured, old people have died and their graves been lost in weeds. Return our goddess and we will go without looting, burning or forced labour.

HECUBA: Whoever trusted the Greeks?

THERSITES: The gods have punished you with the plague—but it could spread to us. We want to go.

HECUBA: We have the statue. You say what luck has it brought us? If we give it up what luck could we hope for? That would be your best reason to break your word and destroy us. Perhaps I shall just destroy the statue. God knows, it's not given us much luck—

SON: We'll send our decision when we've—

HECUBA: But you still might not go. I've had five years to study the Greeks. Only a fool would stay for a statue that didn't exist, but only a fool would have sat out there for five years. Who can trust the Greeks?

THERSITES: We swear on the statue.

HECUBA: I feel as if I was talking to visitors from the past: perhaps all this was decided by Priam long ago.

THERSITES: The plague is in the present.

HECUBA: We have a chance against the plague. What chance would we have against the Greeks if we gave you the statue? Our people's will to resist would go. If you had it, would there be any limit to your ferocity? Why should I trust the Greeks? Let me speak to Ismene alone.

THERSITES: That's impossible.

HECUBA: Perhaps two women could find some way of solving this.

THERSITES: It's not possible.

HECUBA: I see! The Greeks don't trust one another but expect the Trojans to trust them.

THERSITES: Wars aren't decided by women talking!

HECUBA: We're talking of peace! Now I insist!

THERSITES: I refuse!

HECUBA: Then I ask...for a small thing when you ask me to risk so much.

ISMENE: I can only say what he can.

HECUBA: My dear, I don't even know what I wanted to talk to you about. I thought I'd try—in every way I can—to find a solution. That's the duty of all of us here.

THERSITES (*looks at the* SON, *then back to* HECUBA): Well (*Turns to* ISMENE.)—speak to her.

HECUBA: How sensible even the Greeks can be when they want something. (*Nods to the others.*) Go.

 HECUBA *and* ISMENE *are left alone.*

HECUBA: Sit down, my child. (*They both sit.*) Will you take tea?

ISMENE: No thank you.

HECUBA: How long have you been married?

ISMENE: I don't think I quite—

HECUBA: How serious you young people are! Are you always serious?

ISMENE：Seven years. I've laughed in that time.

HECUBA：And no children. Perhaps the goddess of luck would give you children. They say your husband's the most handsome man in the world.

ISMENE：He's often called that.

HECUBA：How nice. Mine was old when I married him. Very old when he died. But we had sons and daughters. I can't imagine what it's like, married to a young man. I'd like to see yours.

ISMENE：I hope you will.

HECUBA：And you miss your mother?

ISMENE：Of course.

HECUBA：There's a good girl! And a lucky one—married to the most handsome man in all the— (*Stops*.) O, I didn't mean (*She stops again*.) And one day you'll be queen.

ISMENE：Athens is a republic.

HECUBA：Yes, they call you something else. My husband doted on our children. When they went fishing they had to make their rods and lines. And hooks.

ISMENE：How sad that their lives have been wasted.

HECUBA：Tragic. Is that why you asked to come here?

ISMENE：I didn't say I'd asked.

HECUBA：O, your Greek men have sat on my doorstep for five years without having one bright idea. It must have been you.

ISMENE：My husband says Priam stole the statue because you seduced him.

HECUBA：That's not very nice of him.

ISMENE：It wouldn't have been your fault. Leaders should take their own decisions.

HECUBA：O, Priam was a born leader. Cautious—or bold. A good husband. A wise king. But useless. When the old play games they mistake that for youth—it's only senility. Troy is senile. Priam took me to bed...to make the city young again. It didn't work. So he stole the statue. That worked for a time. Look how we've resisted you! What other city could have done that? But nothing's changed. Labour for a stillborn chit. There... I shouldn't have seen you; you've made me tell the truth.

ISMENE：You've been misjudged. But what can I do? Return the statue—then we can leave you in peace.

HECUBA：One good reason?

ISMENE：The plague! Set us free—all of us—and I'll kiss your hand when we go!

HECUBA：Why should I trust your husband?

ISMENE：The Greeks. Athens is a republic.

HECUBA：Your husband.

ISMENE：He's not only handsome—he's a born leader. He makes good decisions.

HECUBA：He married you. Though I ask myself why. You're not the most beautiful woman in the world.

ISMENE：No. Now let's talk about what we—

HECUBA：Perhaps you're the wisest? Or the best?

ISMENE：No.

HECUBA：What a pity. At your age I was sensational. A great beauty! I wish you'd seen me. They called me the Venus of Asia. Of course you know that. I can still see it in the glass.

ISMENE：Yes.

HECUBA：As to Athens a republic. Well，your husband's family is the richest in Athens and money buys power. Shall we tell the truth? This is one of those times when a pinch of truth will bring out the full flavour of our lies.

ISMENE：This is too serious to play with words—

HECUBA：Let me show you something. (*She rings a bell*.) If I gave you the statue your husband would still destroy us.

ISMENE：He gives his word.

HECUBA：Yes—and you carry it.

 AIDE *comes in*.

HECUBA：Before the war they answered the moment I touched the bell. The Queen of Athens wishes to see my grandson.

 AIDE *goes out*.

Your husband will burn Troy to the ground.

ISMENE：Not if you give him the statue!

HECUBA：To the ground!

ISMENE：None of this has ever made sense!

HECUBA：Sense! What has this to do with sense? If men were sensible they wouldn't have to go to war! Is it sensible for the handsomest man in the world to marry the ugliest woman? (ISMENE *stands*.) It's certain that when he married a liar like you there'd be only one result：he'd make you the ugliest woman in the world!

 The doors open. CASSANDRA *comes in*，*leading* ASTYANAX *by the hand*.

CASSANDRA：My son's come to say a nice how-d'you-do to the lady.

ISMENE：Excuse me，I must—

HECUBA：Please don't make a scene in front of the child. One shouldn't frighten children.

CASSANDRA：Go on.

ASTAYANAX：Who is she?

HECUBA：The wife of the Greek leader.

ASTYANAX：Grandma that's naughty.

HECUBA：How my dear?

ASTYANAX：It's bad to play when you're mourning. My tutor told me.

HECUBA：Play my darling?

ASTYANAX：You said she was a Greek. The Greeks are ugly. With long tails and hair between their toes. Ugh! And their breath smells and their eyes are all gummy and when they have a cut black oozes out. My tutor's seen it.

CASSANDRA：Darling, don't talk so much.

ASTYANAX：Perhaps Greek ladies are different from Greek men, mother. But it can't be nice for the Greek ladies. (*To* ISMENE.) Does your husband have hair between his toes? Ugh!

CASSANDRA：Her husband is very handsome.

HECUBA：Kiss me. (ASTYANAX *kisses her*.) Go back to your lessons.

ASTYANAX：Yes, grandma. (*To* ISMENE.) I can make houses out of paper. Goodbye. You're a sad lady.

CASSANDRA：Hush!

ASTYANAX：Are you sad because you'll lose the war? When you're in prison I'll come and show you how to make houses out of paper. Can I grandma?

CASSANDRA：I promised your tutor five minutes.

　　CASSANDRA *takes* ASTYANAX *out*.

HECUBA：There are thousands of children like my grandson in Troy. Old people like me. Girls like my daughter. In war death's always painful and slow. You wait for it all the time. I give you the statue—my people despair, they already have the plague, and your husband waits at our gates till we give in. Then he enters and butchers!

ISMENE：I give my word!

HECUBA：You know it yet you come here like a pious nun and beg me to set you free—all of us free! Your word? You call me a seducer? You're a whore murdering children to satisfy her clients!

ISMENE：We'll take the statue and go!

HECUBA：Liar!

ISMENE：We will!

HECUBA：Liar! Tell me—under the same roof as that child—your husband will go!

ISMENE：It's easy for you now your husband's dead. Mine's alive. You tell me to make his decisions—but I have no power.

HECUBA：No, I ask you to tell the truth. You could have stayed at home—if someone else's country can be your home and worried about your dress or the evening meal. I can't make you answer my questions, but I can make you listen to them. If you ignore them you corrupt yourself. We both know the truth: your husband would take the statue and still burn and kill and loot... I can't shout any more. My son spends more and more time with the priests. When leaders do that it means you're lost. Shall I give you the statue—so at least some of you go and we can hope to hold out a little longer? Or face the worst now? No, you can take it from our dead

hands.

ISMENE: So much trouble will come from this.

HECUBA: I can't see one ray of hope.

ISMENE: I won't go back. Let me stay in Troy.

HECUBA: I haven't asked for that. How will that help us?

ISMENE: I can't go back now we've spoken. Send for Thersites.

HECUBA: I'm sorry—you'll be trapped too.

ISMENE: You must say I'm a hostage. Nothing will be gained if I stay out of shame. Say you'll let me go when they go.

HECUBA: What's the use? They'd come back.

ISMENE: I can't alter everything, but I can do this. Fetch Thersites now—so I can't change my mind. (*She rings*.)

HECUBA: What will your husband do?

ISMENE: I shall see.

　　AIDE *comes in*.

HECUBA（*nods*）：I'm ready.

　　AIDE *goes out*.

　　Protest in front of Thersites.

　　THERSITES, *the* SON, PRIESTS *and* SOLDIERS *come back*.

THERSITES: What have the ladies decided?

HECUBA: I'll give you the statue—

THERSITES: Good!

HECUBA: But there's still one problem: who can trust a Greek? I shall keep Ismene here till you're back in Athens. If you don't go, the priests will cut her throat on the goddess's pedestal which will be vacant after twenty-five years.

　　The SON *applauds*.

THERSITES: This is against the laws of war!

ISMENE: It's against all civilized laws.

HECUBA: The goddess sent me these instructions in an oracle. I'm sure your leader will respect that.

THERSITES: I won't leave without Ismene.

HECUBA: You're welcome to our hospitality. I'll send my decision back by runner.

THERSITES: At what stage would you give us the statue?

HECUBA: When you're on your ships.

THERSITES: And Ismene?

HECUBA: I'll keep her till you're back in Athens—or drowned on the way.

THERSITES: Let me speak to Ismene alone.

HECUBA: Certainly.

Everyone except ISMENE *and* THERSITES *leaves*.

THERSITES: Ismene, your husband's position will be very difficult.

ISMENE: So is mine Thersites.

THERSITES: Of course. I meant—Ajax will put pressure country before self. It's an impossible situation for your husband!

ISMENE: Why? What does the country want? The statue. Now they can have it.

THERSITES: Yes, yes. In politics you always ask for more. If we agree to this, what will they want next? Fools!—why did we let you come? I'll go now and the sooner something can be done. Goodbye.

ISMENE: Goodbye.

THERSITES *goes*. *A* SOLDIER *comes on and takes* ISMENE *away*.

Five

Greek camp—Headquarters.

NESTOR *and* HEROS.

NESTOR: It could still work out for the best: we could get Ismene and the statue.

HEROS: After they've fortified their coast. With a fortified coast they'd be impregnable. And she could still keep Ismene! What sort of welcome would I get in Athens? Come home with stone and no wife?

NESTOR: The goddess is certainly testing us.

HEROS: Troy, statue, my wife—in her hands! Now she'd like to make her revenge complete. Get rid of us and throw my wife's body after us in the sea! We're at her mercy! Why why why did I let her go? That woman is a—a—! Athens and Troy can never be at peace! Troy must be destroyed. Stone by stone. If we stay but refuse to talk—would they kill her?

NESTOR: I've seen things done in this war I wouldn't think possible. They're so commonplace we don't notice any more.

HEROS: I can't believe they'd kill her. If they did, I'd kill myself. The moment we had the statue.

NESTOR: Athens will need you even more then. I'd offer my own life.

HEROS: There are seven wonders of the world. What I'll do to Troy will be the first of the seven crimes. Call the council, Nestor.

Six

Troy—the palace.

HECUBA, ISMENE, *the* SON, THERSITES, PRIESTS *and* SOLDIERS.

THERSITES: You stole the statue of our goddess. Now you've stolen our commander's wife! We stay

here till we get both back. All Troy is shamed by this!

HECUBA: My dear child, I'm sorry the Greeks value you less than I do! (*To* THERSITES.) Well at least we have one thing your commander wants: the statue.

SON: Cut off her hair and send it back with this man! Why is she pampered? Let her starve! This woman is a killer of our children! Sparing her even so long shows more humanity than the Greeks will ever have! Yes, go back and tell them the Trojans disagree on some things but agree on this: to use this woman in any way that helps to destroy you! They think they're at war? Tell them the war starts now!

ISMENE: The Trojans are great cooks Thersites. When I'm home in Athens I'll have a Trojan cook in the kitchen. To our taste the food's exotic—but there are many things we can learn. Eat with us before you go. How well everything's worked out! The Trojans will give the Greeks what they want: the statue. And the Greeks will do what the Trojans want: go. And when they do, I'll follow. Why should the Trojans keep me? The Greeks would come back!

THERSITES: The council will do what's best, Ismene.

ISMENE: O, I'm not putting myself before the best interests of Greece. For once reason—

SON: **Heros** sent his wife here to get peace at home!

ISMENE: For once reason is on both sides. We shouldn't call this statue the goddess of Good Fortune, but the goddess of good sense.

TROJAN HIGH PRIEST: Sacrilege! I object!

SON: It's said we've offended the goddess and the only way to please her is to kill this woman!

TROJAN HIGH PRIEST: On the goddess's feast day, which falls next Wednesday.

SECOND TROJAN PRIEST: The closeness of that day to the day when the woman fell into our hands is providential.

THERSITES: If that's how you decide strategy I see why you'll lose.

ISMENE: O please don't say—

THESITES (*admonishing*): Ismene my dear—

ISMENE: I must speak! We're at war so neither side can trust the other. Why shouldn't we give the Trojans a token of our good faith? If it helps, I will! I won't go back to my husband till the Greeks go back to Greece. I don't say this lightly. War breeds fanaticism faster than plague. But I trust Hecuba to protect me.

THERSITES: What if she died of the plague? Who'd protect you then, you silly reckless woman. I demand to speak to Ismene alone!

ISMENE: No! We ask to be trusted—we must do nothing in secret!

THERSITES: I'm to go back and tell our council that!

ISMENE: Why not? The Trojans aren't going to send me back just because the council told you to come here and call them naughty! I'll be kept anyway! I'm helping the council by making

their choice easier：they can now get all they say they want by being honest! And besides，the Trojan women have a right to ask me for this!

THERSITES：Ismene!

ISMENE：Yes，a right! The Trojan women expect you to break your word—

THERSITES：What!

ISMENE：Of course you won't!—but they see you as monsters who've murdered their husbands and fathers! My husband's love for me—the Greeks' love for me—they fight you with *that* because they love their own families! That's almost a good war!

HECUBA：Now try our specialities before you go. I'm sure you're bored with army food.

They all go except the SON *and the* PRIESTS.

TROJAN HIGH PRIEST：Unwise to say so much，sir.

SON：I must speak the truth!

TROJAN HIGH PRIEST：Tchah! Truth's too precious to waste in an argument. The goddess hides the truth. It has to be divined. I've hung a pigeon in a cage high over the city where it sees everything. Tomorrow we'll cut it open and see what it's recorded.

SON：Well what?

The TROJAN CHAPLAIN *is sent out*.

TROJAN HIGH PRIEST：As my life is so close to the goddess I do sometimes hear her whisper. But I must open the pigeon to be sure.

SON：But what?

TROJANHIGH PRIEST：Doubtless the goddess will say one woman running the country is enough— and she is the woman. She'll pronounce on your mother's—if I may say so—obvious senility， and power will pass to you.

SON：I shall keep the goddess—and her priests. If the Greeks left，who'd come next? Barbarians， savages. My mother doesn't understand this! She thinks she can seduce Mars! With the goddess we can resist all our enemies! I have faith to inspire the people.

TROJAN HIGH PRIEST：When they see the Greek woman humbled their faith will already be strengthened.

They go.

四、思考题

1. 如何理解邦德的"理性剧场"? 这种戏剧理念在邦德的神话改写中是如何呈现的?

2. 比较《特洛伊女人》与《女人》中的赫库巴的形象，思考邦德对起源文本进行了哪些改写?

3. 邦德为什么要在赫库巴的形象中加入俄狄浦斯的成分?

4. 如何理解邦德对伊斯墨涅形象的塑造? 他是如何在她的形象中加入安提戈涅和利西翠妲的神话

寓意的?

5.如何理解本剧中的战争书写? 从《李尔》《女人》到《战争三部曲》,邦德一直在书写战争,这些战争主题与邦德的暴力政治的哲学观点有何种联系?

6.本剧是邦德首部以女性为主人公的剧作,如何理解本剧中的性别政治主题? 邦德在本剧中赋予了女性和男性人物怎样的政治寓意?

7.如何理解邦德对荷马神话精神的批判?

五、本节推荐阅读

［1］Billingham,Peter. *Edward Bond: A Critical Study*. Hampshire:Palgrave Macmillan, 2014.

［2］Bond,Edward. *The Hidden Plot*,London:Methuen,2000.

［3］Hay,Malcom and Roberts,Philip,eds. *Edward Bond: A Companion to the Plays*. London: Theatre Quarterly Publications,1978.

［4］Mangan,Michael. *Edward Bond*. Plymouth:Northcote House Publishers,1998.

［5］Roberts,Philip,ed. *Bond on File*. London:Methuen,1985.

第三节　汀布莱克·韦滕贝克及其《夜莺之爱》

一、汀布莱克·韦滕贝克简介

汀布莱克·韦滕贝克是一位与卡里尔·丘吉尔齐名的当代英国女性剧作家。与当代英国其他剧作家相比，韦滕贝克的最大特征就在于她的国际化背景和身份。1951 年，韦滕贝克生于纽约，父母均为英国人，后随父母移居到法国巴斯克地区，长大后去美国接受大学教育，毕业后移居希腊，教授法语，最终定居在英国并加入英国国籍。有学者认为，在一定意义上，"她也许会说，她没有国家，没有阶级，没有文化，甚至没有语言。或者是，她继承什么样的文化，完全由她自己来决定"①。这种身份的流动性就是韦滕贝克所谓的"漂流性身份"（floating identity）。这种多元的文化背景对韦滕贝克的戏剧创作产生了巨大的影响，使其在创作中形成了多维度和多元化的世界观及文化观。

20 世纪 70 年代后期，韦滕贝克开始创作戏剧，最终于 80 年代在英国舞台崭露头角。在 1980 年至 1985 年期间，她创作了《新意阐释》和《玛丽·特拉佛斯的美德》（*The Grace of Mary Traverse*，1985），并与皇家宫廷剧院建立了稳定的合作关系。1988 年，《吾国至上》（*Our Country's Good*）的上演使韦滕贝克声名大噪，随后其推出的《夜莺之爱》更是成为当代英国戏剧的经典之作，韦滕贝克也成为英国皇家宫廷剧院的终身剧作家。90 年代之后，韦滕贝克仍是佳作不断，创作了《田间飞落三只鸟》《破晓》《达尔文之后》《戴安妮娜》（*Dianeria*，1999），以及千禧年之后的力作《可信的证人》（*The Credible Witness*，2001）、《伽利略的女儿》（*Galileo's Daughter*，2004）等。

韦滕贝克的戏剧视野与当代英国戏剧的趋势很不同。多元文化背景赋予了她灵活的思维优势，她说："我对各种文化都很感兴趣，在我看来，坚守一种文化认同是错误的。"②韦滕贝克一生迁徙性的经历使她有机会体验关于民族性与文化错位的复杂情感，对国家、语言、民族身份等问题形成了独特的感受。在她的戏剧中，人物总处于旅行之中，如《新意阐释》中的伊莎贝尔喜欢冒险，《夜莺之爱》中的两姐妹从希腊旅行到色雷斯，《破晓》中的米海尔被国外家庭收养，《达尔文之后》中的达尔文一直在海上航行等。韦滕贝克笔下的人物除了英国人，还有来自世界各地的不同民族和地区的人，包括阿尔及利亚人、罗马尼亚人、希腊人、土耳其人、马其顿人、美国人、斯里兰卡人等。③

作为战后英国戏剧第三次浪潮中的主要代表者，韦滕贝克与希腊神话有着很深的渊源。20 世纪末，她先后创作了基于菲洛墨拉、忒瑞斯、普洛克涅等希腊神话人物改写而成的《夜莺之爱》，以《菲洛克忒忒斯》为起源文本的《田间飞落三只鸟》，以希腊大力神英雄赫拉克勒斯的妻子为主人公的广播剧《戴安妮娜》。在《戴安妮娜》中，韦滕贝克借希腊悲剧中的"愤怒"和"复仇"两个古老主题，影射了当今巴尔干半岛上的持续暴力、邻国间连绵不休的征战等。其最近的一部神话改写作品是《我们的埃阿斯》（*Our*

① Sophie Bush，*The Theatre of Timberlake Wertenbaker*. London and New York：Bloomsbury，2013，p.3.
② John Louis DiGaetani. *A Search for Postmodern Theatre: Interviews with Contemporary Playwrights*. New York：Greenwood，1991，p.267.
③ Peter Buse，"Timberlake Wertenbaker". 30 Jan. 2015. http://literature.britishcouncil.org/timberlake-wertenbaker.

Ajax，2013)，该剧将索福克勒斯的悲剧《埃阿斯》搬到了 21 世纪的亚洲沙漠战场上。

二、《夜莺之爱》①介绍

《夜莺之爱》是韦滕贝克的成名作，也是一部神话改写的大作。该剧以多个神话为前文本(其中的核心是菲洛墨拉、普洛克涅和忒瑞斯的故事)，从女性主义神话学的角度构建了一种基于神话话语之上的剧场叙事，以揭示被覆盖在传统神话叙述之下的"她者"故事。

根据古罗马诗人奥维德在《变形记》中的叙述，菲洛墨拉和普洛克涅是雅典国王潘底翁的女儿，当时雅典受蛮人入侵，色雷斯国王忒瑞斯出手相助，出于感激，潘底翁将长女普洛克涅嫁给了忒瑞斯。数年后，普洛克涅思念妹妹，忒瑞斯便去雅典迎接菲洛墨拉与姐姐团聚。返途中，忒瑞斯迷恋菲洛墨拉的美丽，强暴了她，并割掉了她的舌头将其幽禁。被囚的菲洛墨拉将她的经历织成了长袍送给姐姐，获知真相的普洛克涅为报复忒瑞斯，杀死了他们的孩子意特拉斯，用其肉做成饭给忒瑞斯吃，而后逃走。暴怒的忒瑞斯紧追不放，两姐妹向神祈求，神将这三人变成了鸟儿。

在《夜莺之爱》中，韦滕贝克对这一神话叙述进行了改写：① 菲洛墨拉被设定为故事的中心，本剧以其声音开始，以其失去声音为高峰，又以其找回声音结束；② 通过"剧中剧"，剧作家在主故事中插入了菲德拉和希波吕托斯的神话，不仅颠覆了它们在神话体系中的主次关系，也在两个神话之间构建起了互文关系；③ 菲洛墨拉并未用长袍，而是用酒神之夜的玩偶戏向姐姐揭露真相，这一剧情使酒神伴侣成为本剧中的另一个神话话语；④ 通过船长与菲洛墨拉的对白，该剧将阿托斯岛的神话故事也写入了剧中——阿托斯岛人视女人为灾难之源，这种厌女性是希腊神话的共同特征；⑤ 增加了奶妈这一角色，由此引入因失去十四个孩子伤心而死的尼俄柏的神话——她是丧失一切的女神的化身；⑥ 韦滕贝克不仅将神话变成了话语，还将希腊悲剧中的男/女歌队变成连接故事碎片的话语叙述者。

对神话的再写，就是对文化意义发生过程的干涉。通过对神话的重述，韦滕贝克从女性主义神话学的角度对神话的思想意义进行重读，以挖掘女神宗教中被传统叙述遮蔽和扭曲的神话真相。

在神话叙述中，权力主要通过话语表现。在本剧中，神话的政治话语性首先体现在男/女歌队中。其中，男歌队是故事的主叙述者，是社会价值的载体，作为故事的主声部，男合唱扮演的是一种维护社会秩序、默认统治暴行的历史话语；作为故事的亚声部，女合唱以唱语讲述"她者"的故事，传达主流叙述中"不便说出"的真相，与男合唱的新闻史实性语言不同，她们的话语呈现的是一种神秘的诗学特质。但在本剧中，真正体现权力话语的是色雷斯王忒瑞斯。他以武力拯救了雅典，既是希腊神话中的英雄，也是权力的化身——一个社会话语的占有者、使用者和操纵者，他因权力而拥有话语，又因拥有话语而获得权力。他穿梭于神话与现实事件之间，随心所欲地驾驭权力，既是叙述范式的制定者，也是道德的评判者。

与忒瑞斯的权力话语相反，剧中的女性则处于失语的境地。虽然从雅典王后到女合唱者、奶妈均表现出很强的语言智慧，但这些真相的洞察者无不因为话语权力的缺失而被内在叙述者(inner narrator)剥夺了言说的权利。神话女性的失语性透过菲洛墨拉的故事得以最大化地呈现。事实上，该剧聚焦的与其说是菲洛墨拉被强暴的故事，不如说是其话语被施暴的主题。作为一个雅典女人，语言是

① Timberlake Wertenbaker，*The Love of the Nightingale*. In *Timberlake Wertenbaker: Plays 1*. London：Faber and Faber，1996.

菲洛墨拉认识世界和表达自我思想的核心路径,但正是语言的力量使她在忒瑞斯的面前成为一个挑战者。忒瑞斯割去她的舌头,与其说是因为她威胁到了国家,不如说是因为她挑战了他的权威;同样,他剥夺的与其说是她的声音,不如说是她的思想。正是在这一点上,菲洛墨拉超越了个体悲剧的意义,成为希腊神话中众多女神的化身。韦滕贝克认为,在希腊神话中,虽然女神是神话世界中感情最为激烈的群体,但失语使她们成为神话世界中的影子,她说道:"她们像老哈姆雷特的幽灵一样,游荡于世间,不能平息。"[①]通过重述菲洛墨拉的故事,韦滕贝克意在从女性主义神话学的角度展现神话叙述中的盲点,揭露神话叙述中隐藏的女性认知的巨大空间。

《夜莺之爱》是一部单幕剧,共二十一场,本书节选的是其中的第一场、第三场、第五场、第八场、第十三场、第十八场。

三、《夜莺之爱》选读[②]

The Love of the Nightingale

Scene One

Athens,*the* MALE CHORUS.

MALE CHORUS:War.

Two SOLDIERS *come on*,*with swords and shields*.

FIRST SOLDIER:You cur!

SECOND SOLDIER:You cat's whisker.

FIRST SOLDIER:You flea's foot.

SECOND SOLDIER:You particle.

Pause.

You son of a bitch.

FIRST SOLDIER:You son of a lame hyena.

SECOND SOLDIER:You son of a bleeding whore.

FIRST SOLDIER:You son of a woman!

Pause.

I'll slice your drooping genitalia.

SECOND SOLDIER:I'll pierce your windy asshole.

FIRST SOLDIER:I'll drink from your skull.

Pause.

① Timberlake Wertenbaker,"The voices we hear". In Edith Hall,et al.,eds.,*Dionysus Since 69: Greek Tragedy at the Dawn of the Third Millennium*. Oxford:Oxford University Press,2004,p.362.

② Timberlake Wertenbaker,*The Love of the Nightingale*. In *Timberlake Wertenbaker: Plays 1*. London:Faber and Faber,1996, pp.291-292,pp.295-297,pp.300-307,pp.315-316,pp.326-330,pp.341-344.

Coward!

SECOND SOLDIER: Braggard.

FIRST SOLDIER: You Worm.

SECOND SOLDIER: You—man.

They fight.

MALE CHORUS: And now, death.

The FIRST SOLDIER *kills the* SECOND SOLDIER.

SECOND SOLDIER: Murderer!

FIRST SOLDIER: Corpse!

MALE CHORUS: We begin here because no life ever has been untouched by war.

MALE CHORUS: Everyone loves to discuss war.

MALE CHORUS: And yet its outcome, death, is shrouded in silence.

MALE CHORUS: Wars make death acceptable. The gods are less cruel if it is man's fault.

MALE CHORUS: Perhaps, but this is not our story. War is the inevitable background, the ruins in the distance establishing place and perspective.

MALE CHORUS: Athens is at war, but at the palace of the Athenian King Pandion, two sisters discuss life's charms and the attractions of men.

Scene Three

The palace of King Pandion. KING PANDION, *the* QUEEN, TEREUS, PROCNE, PHILOMELE, *the* MALE CHORUS.

MALE CHORUS: Athens won the war with the help of an ally from the north.

MALE CHORUS: The leader of the liberators was called Tereus.

KING PANDION: No liberated country is ungrateful. That is a rule. You will take what you want from our country. It will be given with gratitude. We are ready.

TEREUS: I came not out of greed but in the cause of justice, King Pandion. But I have come to love this country and its inhabitants.

QUEEN (*to* KING PANDION): He wants to stay! I knew it!

Pause.

KING PANDION: Of course if you wish to stay in Athens that is your right. We can only remind you this is a small city. But you must stay if you wish.

TEREUS: No. I must go back north. There has been trouble while I've conducted this war. What I want is to bring some of your country to mine, its manners, its ease, its civilized discourse.

QUEEN (*to* KING PANDION): I knew it: he wants Procne.

KING PANDION: I can send you some of our tutors. The philosophers, I'm afraid, are rather independent.

TEREUS: I have always believed that culture was kept by the women.

KING PANDION: Ours are not encouraged to go abroad.

TEREUS: But they have a reputation for wisdom. Is that false?

QUEEN: Be careful, he's crafty.

KING PANDION: It is true. Our women are the best.

TEREUS: So.

QUEEN: I knew it.

> *Pause*.

KING PANDION: She's yours, Tereus. Procne—

PROCNE: But, Father—

KING PANDION: Your husband.

PROCNE: Mother—

QUEEN: What can I say?

KING PANDION: I am only sad you will live so far away.

PHILOMELE: Can I go with her?

QUEEN: Quiet, child.

TEREUS (*to* PROCNE): I will love and respect you.

MALE CHORUS: It didn't happen that quickly. It took months and much indirect discourse. But that is the gist of it. The end was known from the beginning.

MALE CHORUS: After an elaborate wedding in which King Pandion solemnly gave his daughter to the hero, Tereus, the two left for Thrace. There was relief in Athens. His army had become expensive, rude, rowdy.

MALE CHORUS: Had always been, but we see things differently in peace. That is why peace is so painful.

MALE CHORUS: Nothing to blur the waters. We look down to the bottom.

MALE CHORUS: And on a clear day, we see our own reflections.

MALE CHORUS: In due course, Procne had a child, a boy called Itys. Five years passed.

Scene Five

The theatre in Athens. KING PANDION, TEREUS, HIPPOLYTUS, THESEUS.

KING PANDION: Procne has always been so sensible. Why, suddenly, does she ask for her sister?

TEREUS: She didn't explain. She insisted I come to you and I did what she asked.

KING PANDION: I understand, Tereus, but such a long journey... Procne's not ill?

TEREUS: She was well when I left. She has her child, companions.

KING PANDION: Philomele is still very young. And yet, I allowed Procne to go so far away... What do you think, Tereus?

TEREUS: You're her father.

KING PANDION: And you.

TEREUS: I only meant Procne would accept any decision you made. It is a long journey.

APHRODITE *enters*.

APHRODITE: I am Aphrodite, goddess of love, resplendent and mighty, revered on earth, courted in heaven, all pay tribute to my fearful power.

KING PANDION: Do you know this play, Tereus?

TEREUS: No.

KING PANDION: I find plays help me think. You catch a phrase, recognize a character. Perhaps this play will help us come to a decision.

APHRODITE: I honour those who kneel before me, but that proud heart which dares defy me, that haughty heart I bring low.

TEREUS: That's sound.

KING PANDION: Do you have good theatre in Thrace?

TEREUS: We prefer sport.

KING PANDION: Then you are like Hippolytus.

TEREUS: Who?

KING PANDION: Listen.

APHRODITE: Hippolytus turns his head away. Hippolytus prefers the hard chase to the soft bed, wild game to foreplay, but chaste Hippolytus shall be crushed this very day.

APHRODITE *exits, The* QUEEN *and* PHILOMELE *enter*.

PHILOMELE: We're late! I've missed Aphrodite.

KING PANDION: She only told us it was going to end badly, but we already know that. It's a tragedy.

Enter PHAEDRA.

QUEEN: There's Phaedra, (*to* TEREUS) Phaedra is married to Theseus, the King of Athens. Hippolytus is Theseus' son by his previous mistress, the Amazon Queen, who's now dead, and so Phaedra's stepson. Phaedra has three children of her own.

PHAEDRA: Hold me, hold me, hold up my head. The strength of my limbs is melting away.

PHILOMELE: How beautiful to love like that! The strength of my limbs is melting away. Is that what you feel for Procne, Tereus?

QUEEN: Philomele! (*to* TEREUS) Phaedra's fallen in love with Hippolytus.

TEREUS: Her own stepson! That's wrong.

KING PANDION: That's what makes it a tragedy. When you love the right person it's a comedy.

PHAEDRA: Oh, pity me, pity me, what have I done? What will become of me? I have strayed from the path of good sense.

TEREUS: Why should we pity her? These plays condone vice.

KING PANDION: Perhaps they only show us the uncomfortable folds of the human heart.

PHAEDRA: I am mad, struck down by the malice of the implacable god.

PHILOMELE: You see, Tereus, love is a god and you cannot control him.

QUEEN: Here's the nurse. She always gives advice.

The NURSE *enters.*

NURSE: So: you love. You are not the first nor the last. You want to kill yourself? Must all who love die? No, Phaedra, the god has stricken you, how dare you rebel? Be bold, and love. That is God's will.

TEREUS: Terrible advice.

PHILOMELE: No, Tereus, you must obey the gods. Are you blasphemous up there in Thrace?

KING PANDION: Philomele, you are talking to a king.

TEREUS: And to a brother, let her speak, Pandion.

NURSE: I have a remedy. Trust me.

KING PANDION: Procne has asked for you. She wants you to go back with Tereus to Thrace.

PHILOMELE: To Thrace? To Procne? Oh, yes.

KING PANDION: You want to leave your parents? Athens?

PHILOMELE: I promised Procne I would go if she ever asked for me.

KING PANDION: You were a child.

TEREUS: We have no theatre or even philosophers in Thrace, Philomele.

PHILOMELE: I have to keep my word.

TEREUS: Why?

PHILOMELE: Because that is honourable, Tereus.

QUEEN: Listen to the chorus. The playwright always speaks through the chorus.

FEMALE CHORUS: Love, stealing with grace into the heart you wish to destroy, love, turning us blind with the bitter poison of desire, love, come not my way. And when you whirl through the streets, wild steps to unchained rhythms, love, I pray you, brush not against me, love, I beg you, pass me by.

TEREUS: Ah!

PHILOMELE: I would never say that, would you, brother Tereus? I want to feel everything there is to feel. Don't you?

TEREUS: No!

KING PANDION: Tereus, what's the matter?

TEREUS: Nothing. The heat.

PHAEDRA: Oh, I am destroyed for ever.

PHILOMELE: Poor Phaedra.

TEREUS：You pity her，Philomele?

QUEEN：Hippolytus has just heard in what way Phaedra loves him. He's furious.

HIPPOLYTUS：Woman，counterfeit coin，why did the gods put you in the world? If we must have sons，let us buy them in the temples and bypass the concourse of these noxious women. I hate you women，hate，hate and hate you.

PHILOMELE：This is horrible. It's not Phaedra's fault she loves him.

TEREUS：She could keep silent about it.

PHILOMELE：When you love you want to imprison the one you love in your words，in your tenderness.

TEREUS：How do you know all this，Philomele?

PHILOMELE：Sometimes I feel the whole world beating inside me.

TEREUS：Philomele...

　　PHAEDRA *screams offstage*，*then staggers on*.

QUEEN：Phaedra's killed herself and there's Theseus just back from his travels.

THESEUS：My wife! What have I said or done to drive you to this horrible death? She calls me to her，she can still speak. What prayers，what orders，what entreaties do you leave your grieving husband? Oh，my poor love，speak! (*He listens*.) Hippolytus! Has dared to rape my wife!

TEREUS：Phaedra has lied! That's vile.

PHILOMELE：Why destroy what you love? It's the god.

THESEUS：Father Poseidon，great and ancient sea-god，you once allotted me three wishes. With one of these，I pray you now，kill my son.

QUEEN：That happens offstage. A giant wave comes out of the sea and crashes Hippolytus' chariot against the rocks. Here's the male chorus.

MALE CHORUS：Sometimes I believe in a kind power，wise and all-knowing but when I see the acts of men and their destinies，my hopes grow dim. Fortune twists and turns and life is endless wandering.

KING PANDION：The play's coming to an end，and I still haven't reached a decision. Queen...

MALE CHORUS：What I want from life is to be ordinary.

PHILOMELE：How boring.

QUEEN：Hippolytus has come back to Athens to die. He's wounded. The head.

FEMALE CHORUS：Poor Hippolytus，I weep at your pitiful fate. And I rage against the gods who sent you far away，out of your father's lands to meet with such disaster from the sea-god's wave.

KING PANDION：That's the phrase. Philomele，you must not leave your father's lands. You'll stay here.

PHILOMELE: But, Father, I'm not Hippolytus. You haven't cursed me. And Tereus isn't Phaedra, look.

She laughs.

TEREUS: I have expert sailors, I don't think we'll crash against the rocks.

KING PANDION: It's such a long journey.

TEREUS: We'll travel swiftly. Procne is so impatient to see her sister. We must go soon, or she'll fall ill with worry.

KING PANDION: When?

TEREUS: Tomorrow.

HIPPOLYTUS: Weep for me, weep for me, destroyed, mangled, trampled underfoot by man and god both unjust, weep, weep for my death.

PHILOMELE: Ah.

TEREUS: You're crying, Philomele.

PHILOMELE: I felt, I felt—the beating of wings...

KING PANDION: You do not have to go.

PHILOMELE: It's the play, I am so sorry for them all. I have to go. My promise...

KING PANDION (*to* QUEEN): It's only a visit, Philomele will come back to us.

QUEEN: Where is she going?

KING PANDION: To Thrace! Weren't you listening?

MALE AND FEMALE CHORUS (*together*): These sorrows have fallen upon us unforeseen.

MALE CHORUS: Fate is irresistible.

FEMALE CHORUS: And there is no escape.

KING PANDION: And now we must applaud the actors.

Scene Eight

The MALE CHORUS.

MALE CHORUS: What is a myth? The oblique image of an unwanted truth, reverberating through time.

MALE CHORUS: And yet, the first, the Greek meaning of myth, is simply what is delivered by word of mouth, a myth is speech, public speech.

MALE CHORUS: And myth also means the matter itself, the content of the speech.

MALE CHORUS: We might ask, has the content become increasingly unacceptable and therefore the speech more indirect? How has the meaning of myth been transformed from public speech to an unlikely story? It also meant counsel, command. Now it is a remote tale.

MALE CHORUS: Let that be, there is no content without its myth. Fathers and sons, rebellion, collaboration, the state, every fold and twist of passion, we have uttered them all. This one, you will say, watching Philomele watching Tereus watching Philomele, must be about men

and women，yes，you think，a myth for our times，we understand.

MALE CHORUS：You will be beside the myth. If you think of anything，think of countries，silence，

　　but we cannot rephrase it for you. If we could，why would we trouble to show you the myth?

　　We row Philomele north. Does she notice the widening cracks in that fragile edifice，happiness?

　　And what about Procne，the cause perhaps，in any case the motor of a myth that leaves her

　　mostly absent?

Scene Thirteen

*Moonlight．The beach．*PHILOMELE.

PHILOMELE：Catch the moonlight with your hands. Tread the moonlight with your toes，

　　phosphorescence，phosphorescence，come to me，come to me，tell me the secrets of the wine-

　　dark sea. Pause. I'm so lonely.

Pause．

Procne，come to me.

Pause．She waits．

Procne，Procne，sister. Help me.

Catch the lather of the moonlight. Spirits，talk to me. Oh，you gods，help me.

TEREUS *enters．* PHILOMELE *senses this．*

（*softly*）Phosphorescence，phosphorescence，tell me the secrets of the wine-dark sea...

TEREUS（*softly*）：Philomele，what are you doing?

PHILOMELE：Catching the lather of the sea. Moonlight，moonlight.

TEREUS：I only wish you well...

PHILOMELE：Let me bury my sister.

TEREUS：I told you，we never found the body.

PHILOMELE：Take me to the gorge，I will find it.

TEREUS：Nothing left now，weeks—

PHILOMELE：I will find the bones.

TEREUS：Washed by the river.

PHILOMELE：Let me stand in the river.

TEREUS：It's dangerous.

PHILOMELE：I don't want to stay here.

TEREUS：You have everything you want，you loved the spot when we first came.

PHILOMELE：Then...

　　Tereus，I want to see my sister's home，I want to speak to the women who were with her. I

　　want to know the last words she said，please，please take me there. Why are we here? What

　　is the point of talking if you won't answer that question?

Silence. PHILOMELE *turns away*.

Moonlight，moonlight…

TEREUS：Philomele，listen to me.

PHILOMELE：Light the shells，light the stones，light the dust of old men's bones…

TEREUS：Philomele！

PHILOMELE：Catch the lather of the sea…

TEREUS：Do you remember that day in the theatre in Athens？ The play？

PHILOMELE：Evansescence，evanescence…

TEREUS：Philomele，I am telling you.

Pause.

I love you.

PHILOMELE：I love you too，brother Tereus，you are my sister's husband.

TEREUS：No，no. The play. I am Phaedra. (*Pause*.) I love you. That way.

Silence.

PHILOMELE：It is against the law.

TEREUS：My wife is dead.

PHILOMELE：It is still against the law.

TEREUS：The power of the god is above the law. It began then，in the theatre，the chorus told me. I saw the god and I loved you.

PHILOMELE：Tereus.

Pause.

I do not love you.

I do not want you.

I want to go back to Athens.

TEREUS：Who can resist the gods？ Those are your words. Philomele. They convinced me，your words.

PHILOMELE：Oh，my careless tongue. Procne always said—my wandering tongue. But，Tereus，it was the theatre，it was hot，come back to Athens with me. My parents—Tereus，please，let me go back to Athens.

TEREUS：The god is implacable.

PHILOMELE：You are a king，you are a widower. This is—frivolous.

TEREUS：You call this frivolous.

He seizes her.

PHILOMELE：Treachery.

TEREUS：Love me.

PHILOMELE：No.

TEREUS: Then my love will be for both. I will love you and love myself for you. Philomele，I will have you.

PHILOMELE: Tereus，wait.

TEREUS: The god is out.

PHILOMELE: Let me mourn.

TEREUS: Your darkness and your sadness make you all the more beautiful.

PHILOMELE: I have to consent.

TEREUS: It would be better，but no，you do not have to. Does the god ask permission?

PHILOMELE: Help. Help me. Someone. Niobe!

TEREUS: So you are afraid. I know fear well. Fear is consent. You see the god and you accept.

PHILOMELE: Niobe!

TEREUS: I will have you in your fear. Trembling limbs to my fire.

He grabs her and leads her off. NIOBE *appears.*

NIOBE: So it's happened. I've seen it coming for weeks. I could have warned her，but what's the point? Nowhere to go. It was already as good as done. I know these things. She should have consented. Easier that way. Now it will be all pain. Well I know. We fought Athens. Foolish of a small island but we were proud. The men—dead. All of them. And us. Well—we wished ourselves dead then，but now I know it's better to live. Life is sweet. You bend your head. It's still sweet. You bend it even more. Power is something you can't resist. That I know. My island bowed its head. I came to Athens. Oh dear，oh dear，she shouldn't scream like that. It only makes it worse. Too tense. More brutal. Well I know. She'll accept it in the end. Have to. We do. And then. When she's like me she'll wish it could happen again. I wouldn't mind a soldier. They don't look at me now. All my life I was afraid of them and then one day they stop looking and it's even more frightening. Because what makes you invisible is death coming quietly. Makes you pale，then unseen. First，no one turns，then you're not there. Nobody goes to my island any more. It's dead too. Countries are like women. It's when they're fresh they're wanted. Why did the Athenians want our island? I don't know. We only had a few lemon trees. Now the trees are withered. Nobody looks at them. There. It's finished now. A cool cloth. On her cheeks first. That's where it hurts most. The shame. Then we'll do the rest. I know all about it. It's the lemon trees I miss，not all those dead men. Funny，isn't it? I think of the lemon trees.

Scene Eighteen

Music. The stage fills with BACCHAE. NIOBE *enters leading* PHILOMELE，*who carries two huge dolls. Behind her，the* SERVANT *carries a third doll.*

NIOBE: No place safe from the Bacchae. They run the city and the woods，flit along the beach，no

crevasse free from the light of their torches. Miles and miles of a drunken chain. These people are savages. Look at their women. You never see them and when you do, breasts hanging out, flutes to their mouths. In my village, they'd be stoned. Out of the way, you, out of the way.

SERVANT: We could move faster without those big dolls, Niobe.

NIOBE: She wouldn't go without them. Years she's been sewing, making them, painting faces. Look. Childlike pastime for her, what can I say? It's kept her still. And she's quiet anyway. Tereus said, get her out, quickly into the city. She'll be lost there. Another madwoman, no one will notice. Could have cut off her tongue in frenzied singing to the gods. Strange things happen on these nights, I have heard.

SERVANT: Very strange, Niobe. But she was better in the hut.

NIOBE: No. It gives her a little outing. She's only seen us and the King for five years.

SERVANT: He doesn't come much any more.

NIOBE: No. They all dream of silence, but then it bores them.

SERVANT: Who is she, Niobe?

NIOBE: No one. No name. Nothing. A king's fancy. No more.

SERVANT: I feel pity for her. I don't know why.

NIOBE: Look, some acrobats. The idiot will like it. Look. Look. See the acrobats. Now that's like my village. Except I believe they're women. Shame on them. But still, no harm in watching.

She thrusts PHILOMELE *to the front of a circle, watching. A crowd gathers around. The* ACROBATS *perform. Finish. As they melt back into the crowd, the empty space remains and* PHILOMELE *throws the dolls into the circle.* NIOBE *grabs one of them and tries to grab* PHILOMELE, *but she is behind the second doll. Since the dolls are huge, the struggle seems to be between the two dolls. One is male, one is female and the male one has a king's crown.*

NIOBE: A mad girl, a mad girl. Help me.

But the crowd applauds, makes a wider circle and waits in silence. The rape scene is re-enacted in a gross and comic way, partly because of NIOBE's *resistance and attempt to catch* PHILOMELE. PHILOMELE *does most of the work with both dolls. The crowd laughs.* PHILOMELE *then stages a very brutal illustration of the cutting of the female doll's tongue. Blood cloth on the floor. The crowd is very silent.* NIOBE *still. Then the* SERVANT *comes inside the circle, holding a third doll, a queen. At that moment,* PROCNE *also appears in the front of the crowd's circle. She has been watching. The* PROCNE *doll weeps. The two female dolls embrace.* PROCNE *approaches* PHILOMELE, *looks at her and takes her away. The dolls are picked up by the crowd and they move off. A bare stage for a second. Then* PROCNE *and* PHILOMELE *appear,* PROCNE *holding on to* PHILOMELE, *almost dragging her. Then she lets go.* PHILOMELE *stands still.* PROCNE *circles her, touches her. Sound of*

music very distant. Then a long silence. The sisters look at each other.

PROCNE： How can I know that was the truth?

Pause.

You were always wild. How do I know you didn't take him to your bed?

You could have told him lies about me，cut your own tongue in shame. How can I know?

You won't nod，you won't shake your head. I have never seen him violent. He would not do this.

He had to keep you back from his soldiers. Desire always burnt in you. Did you play with his sailors? Did you shame us all? Why should I believe you?

She shakes PHILOMELE.

Do something，make me know you showed the truth.

Pause.

There's no shame in your eyes. Why should I believe you? And perhaps you're not Philomele. A resemblance. A mockery in this horrible drunken feast. How can I know?

Silence.

But if it is true. My sister.

Open your mouth.

PHILOMELE *opens her mouth，slowly.*

To do this. He would do this.

Pause.

Justice. Philomele，the justice we learned as children，do you remember? Where is it? Come，come with me.

The BACCBAE *give wine to* PROCNE *and* PHILOMELE.

Do this.

PHILOMELE *drinks.*

Drink. Oh，we will revel. You，drunken god，help us. Help us.

They dance off with the BACCHAE.

四、思考题

1. 歌队是希腊悲剧中一种特有的话语,其主要作用是交代情节、评论行为、加入对白、舒缓紧张,但在《夜莺之爱》中,歌队则被赋予了政治功能。请对男合唱和女合唱的唱词进行话语分析,并回答以下两个问题:我们如何理解歌队在本剧中的功能？男女歌队呈现出怎样不同的话语声音？

2. 对比第五场和第十三场,忒瑞斯对菲德拉与希波吕托斯神话的评判和态度发生了很大的变化:在第五场中,他与雅典国王一家观看神话悲剧,看着菲德拉对养子希波吕托斯的爱意,他以道德的声音将菲德拉与养子的爱情界定为乱伦;在第十三场中,面对他所觊觎的菲洛墨拉,他却说:"我就是菲德

拉。"在本剧中,忒瑞斯是如何穿梭于神话与现实事件之间,通过操纵神话话语来驾驭权力的?

3. 在第八场中,男歌队唱道:"什么是神话?这个所谓的'真理'游荡于历史时空,拐弯抹角而多余,它是遥远的故事,但却承载着政治的内涵和大众的公共话语。"你如何理解歌队对神话的评述?

4. 在本剧的"前言"中,韦滕贝克这样引述伊文·博兰(Eavan Boland)的话:"听! 这就是神话中的杂音,它像影子,悄无声息,你听见了吗?"在这里,韦滕贝克意在透过引文告诉世人,在神话叙述中,有时真相像影子一样隐藏在无文字的"失语"地域。在本剧中,这种"杂音"是如何在酒神伴侣之夜通过玩偶和菲洛墨拉的肢体语言进行讲述的?

5. 如何理解剧中奶妈尼俄柏的角色和话语声音?在第十三场,她有过一段很长的独白,她在独白中说:"都结束了,一片冰冷的布落在脸颊上,那里才是最痛的地方,羞耻……"如何理解她的话?

6. 在第十八场中,玩偶表演之后,普洛克涅穿过观众席走到了菲洛墨拉的面前,"一瞬间,舞台空空,只有普洛克涅和菲洛墨拉……她们彼此凝视着,漫长的沉默"。与此同时,观众也在凝视着舞台上沉默着的普洛克涅和菲洛墨拉——菲洛墨拉慢慢张开了嘴巴,普洛克涅看到了一个空旷的没有舌头的黑暗,也听懂了玩偶话语传递的真相。在这一场景中,菲洛墨拉是如何运用一种影子般的"沉默性语言"(speaking silence)构建出一个充满隐喻的仪式性诗学话语的?

五、本节推荐阅读

[1] Babbage,Frances. *Re-visioning Myth: Feminist Strategies in Contemporary Theatre*. PhD Thesis,University of Warwick,2000.

[2] Gömceli,Nursen. "Timberlake Wertenbaker's 'Radical Feminist' Reinterpretation of a Greek Myth:*The Love of the Nightingale*". *Arbeiten aus Anglistik und Amerikanistik*,Spring (2009):79-102.

[3] Hall,Edith. "Introduction". *Dionysus Since 69: Greek Tragedy at the Dawn of the Third Millennium*. Eds. Edith Hall, et al. Oxford:Oxford University Press,2004.

[4] Sahlins,Marshall D. *Historical Metaphors and Mythical Realities: Structure in the Early History of the Sandwich Islands Kingdom*. Ann Arbor:The University of Michigan Press,1981.

[5] Wertenbaker,Timberlake. *The Love of the Nightingale*. In *Timberlake Wertenbaker: Plays 1*. London:Faber and Faber,1996.

[6] Winston,Joe. "Re-Casting the Phaedra Syndrome:Myth and Morality in Timberlake Wertenbaker's *The Love of the Nightingale*". *Modern Drama*,38.4(1995):510-519.

第六章
当代英国科学戏剧

第一节　当代英国科学戏剧概论

在战后英国戏剧第三次浪潮中，科学戏剧(Science Plays)异军突起，成为 20 世纪末英国剧坛的一股新兴力量。正如《纽约时报》剧评家卡罗尔·罗卡莫拉(Carol Rocamora)在 2000 年的文章中所写："科学成为当今剧场最热门的话题，科学戏剧已成为英国戏剧界的千禧年现象。"[①]

科学戏剧又称"剧场中的科学"(science-in-theatre)，我们通常将其理解为以科学为题材的戏剧。柯尔斯滕·谢泼德-巴尔(Kirsten Shepherd-Barr)在科学戏剧研究的奠基之作《舞台上的科学：从浮士德博士到哥本哈根》(*Science on Stage: from Doctor Faustus to Copenhagen*，2006)中将科学戏剧定义为"以科学概念为主题或以科学家为人物的戏剧"[②]。在谢泼德-巴尔看来，好的科学戏剧能将一个特定的科学观点或概念转变为深刻的戏剧隐喻。因此，从广义上讲，科学戏剧是围绕科学(包括科学家、科学概念、科学问题等)而创作的戏剧。

作为一种戏剧类别，科学戏剧有着数千年的历史，其源头可以追溯到希腊喜剧之父阿里斯托芬(Aristophanes)的《云》(*The Clouds*，423BC)，该剧被认为是首个与科学相关的剧作。此后 2 000 多年中，关于科学的戏剧层出不穷，最著名的作品有：克里斯托弗·马洛(Christopher Marlowe)的《浮士德博士的生死悲剧》(*The Tragical History of the Life and Death of Doctor Faustus*，1592)、本·琼森(Ben Jonson)的《炼金术士》(*The Alchemist*，1610)、亨利克·易卜生(Henrik Ibsen)的《人民公敌》(*An Enemy of the People*，1882)、萧伯纳的《医生的两难选择》(*The Doctor's Dilemma*，1906)、布莱希特的《伽利略传》(*Life of Galileo*，1943)。

20 世纪 90 年代，科学作为 20 世纪末期全球热点话题之一进入了西方剧作家的视域，科学戏剧迎来大发展。1988 年，斯托帕德以量子物理为主题推出了《汉普古德》一书，1993 年又以混沌理论为主题创作了经典剧作《阿卡狄亚》，1995 年这两部作品同时在纽约上演，斯托帕德也因此成为第一位有两部作品在林肯中心上演的剧作家。1998 年，随着迈克尔·弗雷恩的经典大作《哥本哈根》问世，全球掀起

① Carol Rocamora，quoted in Kirsten Shepherd-Barr，*Science on Stage: from Doctor Faustus to Copenhagen*. Princeton：Princeton University Press，2006，p.1.

② Kirsten Shepherd-Barr，*Science on Stage: from Doctor Faustus to Copenhagen*. Princeton：Princeton University Press，2006，p.1.

了一场科学戏剧的热潮。

回首 20 世纪,90 年代无疑是英国科学戏剧的一个辉煌时期,也是科学戏剧的"大爆炸"时期。在 10 年间,有近 50 部科学戏剧问世,超过了过去近 400 年的数量总和。除了《汉普古德》《阿卡狄亚》和《哥本哈根》,以进化论为主题的剧作有斯努·威尔逊(Snoo Wilson)的《达尔文洪水》(*Darwin's Flood*,1994)和韦滕贝克的《达尔文之后》,以克隆和基因工程为主题的剧作有希拉·史蒂芬森(Shelagh Stephenson)的《抽气泵实验》(*An Experiment with an Air-Pump*,1998)、汤姆·麦格拉斯(Tom McGrath)的《安全送达》(*Safe Delivery*,1999)、丘吉尔的《克隆人生》等,关于大脑和记忆的脑神经科学戏剧有西蒙·迈克伯尼(Simon McBurney)与合拍剧院(Théâtre de Complicité)共同创作的《记忆术》(*Mnemonic*,1999)等,围绕脑科学和意识认知创作的戏剧有斯托帕德的《艰难问题》(*The Hard Problem*,2015)等。不仅这些,一些 21 世纪的新话题,如人工智能、后人类、物种灭绝、人类世等也成为剧作家的创作素材,纷纷登上戏剧舞台。

在这些科学戏剧中,剧作家们不约而同地将目光投向了各种科学主题,并透过科学理论来思考人类问题。通过科学和戏剧两种异类文化的融合,剧作家们将科学概念演绎为戏剧主题和隐喻,使舞台成为探索科学思想的论坛和推动硬科学和人文学科交叉互动的重要场域。[①] 通过对科技越界和科技异托邦未来的展演,剧作家们向世人展示了人类科技"僭越"的后果,以此唤醒世人的科学伦理意识,为科学技术的发展设定边界,避免人类滑向后人类的灾难。

在这些科学戏剧中,以物理科学和生物科学为主题的剧作占有很大的比例。

一、物理科学戏剧

物理科学戏剧指以现代物理学为主题或物理学家为题材的戏剧,这类戏剧是科学戏剧中占比最多、影响最大的一个分类。

物理科学之所以成为很多剧作家创作科学戏剧的首选,主要是因为物理科学中隐含着戏剧内在冲突的某些特征——物理在带给人类进步的同时,其本身也含有造成毁灭性破坏的巨大潜力。我们所熟知的物理学理论,如牛顿运动定律、爱因斯坦的相对论、量子力学等,自出现以来便具有颠覆人类认知的冲击力,每个物理学理论的出现不仅能改变此前物理知识的疆域,也能改变人类对自然规律的认知。尤其是 20 世纪 80 年代后出现的物理大爆炸、混沌理论、不确定性原理等理论,它们在颠覆人们对牛顿力学等传统认识的同时,也成为引发全球后现代思潮的一个重要因素。在一定程度上,物理学理论的冲击性与后现代戏剧所追求的颠覆性不谋而合,物理学从而成为当代剧作家创作的理想主题。此外,由于现代物理学的发展与人类社会的存在息息相关,历史上著名的物理学家,如牛顿、伽利略、爱因斯坦、海森伯等,无不与宗教、战争及其背后的政治力量有着千丝万缕的联系,这也契合了戏剧关注社会和政治事件的特性。[②]

在以物理科学为创作主题的剧作家中,弗雷恩和斯托帕德斯无疑是最著名的。有评论称,"任何对

① Kirsten Shepherd-Barr,*Science on Stage: from Doctor Faustus to Copenhagen*. Princeton:Princeton University Press,2006,p.1.

② Kirsten Shepherd-Barr,*Science on Stage: from Doctor Faustus to Copenhagen*. Princeton:Princeton University Press,2006,pp.61-62.

科学戏剧的研究如果少了迈克尔·弗雷恩和汤姆·斯托帕德,其研究的深度与权威性都会令人质疑。"①我们由此可以看出这两位剧作家在科学戏剧中的地位。斯托帕德在科学戏剧方面的代表作是《汉普古德》和《阿卡狄亚》,弗雷恩则主要以《哥本哈根》而著称。

创作于1988年的《汉普古德》是量子力学与间谍故事的混合,也是斯托帕德剧作中构思最为巧妙的一部。该剧的背景是20世纪80年代的冷战时期,故事围绕着英国情报头目汉普古德和苏联科学家科尔纳展开:科尔纳数年前被汉普古德策反到了英方,目前他的工作是向苏联传送一些假情报,以误导对方。故事开始时,英国情报机构发现内部有卧底,他们怀疑是科尔纳,认为他在向苏联传送真情报。于是汉普古德为调查此事设下了一个圈套。根据计策,科尔纳将把一个装有假情报的箱子送给苏联人,见面地点是游泳馆的男更衣室。在那里,他们会让英国特工赖利换掉科尔纳的箱子,把另一个箱子送给对方,然后再把科尔纳的箱子转给汉普古德,以弄清科尔纳是否将星球大战的机密偷挟其中。结果出人意料,送出的情报竟是真的,截下来的却是假的。这样,科尔纳便受到了苏联和英国的双重怀疑。作为情报机构的头目,汉普古德也被卷入其中。更糟的是,她的儿子——也是科尔纳的儿子——被人绑架。而绑架他的正是苏联人,他们的目的是拿到情报。

这部剧虽情节复杂,却赢得了评论界的盛赞,原因之一是斯托帕德借用量子力学理论中的不确定性原理,将悬疑丛生的谍报叙事与光怪陆离的量子世界完美结合,展示了一种后现代科学戏剧的美学;同时,斯托帕德借助量子力学的"波粒二象性"科学原理,解释了传统认知无法解释的间谍世界和人性的复杂性。在创作上,这部戏剧得益于两位物理学家对斯托帕德的影响。1986年,斯托帕德阅读了物理学家约翰·C.波尔金霍恩(John C. Polkinghorne)的《量子世界》(*The Quantum World*,1984)一书,随后两人开始了一段"戏剧+物理"的友谊。令斯托帕德着迷的是光学物理中一个看似悖论的现象——光是光束还是粒子这一问题并非取决于光本身,而是取决于观测者,根据波尔金霍恩的理论,光可以变成你想看到的形式。另一位对斯托帕德影响深刻的物理学家是理查德·费曼(Richard Feynman),他的"双缝试验"给了斯托帕德创作本剧的直接灵感。在剧中,身为间谍和物理学家的科尔纳曾解释说,当光线透过两个挨着的裂缝,两束光交汇在一起时,光粒子就会变成光束,但如果再仔细观察它,你会发现其实光束又是光粒子。也就是说,是人们观测光束这一行为本身决定了人们所看见的物质的形式。当你不看它时,它以光束形式存在着,一旦开始观察它是怎么成为光束的,你就会发现它们的存在状态其实是粒子形式。从光的波粒二象性和不确定性中,斯托帕德看到了一个科学隐喻的载体:间谍人物身上矛盾而又神秘的行为与光的物理现象惊人地相似。科尔纳认为,一个双重间谍就像是光,人们总能在他身上得到自己想要的那个他,因为双方间谍机构都能给他足够的情报,使他在对方那里受到信任,所以当两边问"科尔纳在为我们工作吗?"这个问题时,回答都是"是的"。而科尔纳却说:"说实话,我自己都不知道我在为哪边干活,因为我根本没必要知道。"②本剧结束时,科尔纳承认,他早已是为两边工作的间谍了。

量子物理学的意象在这部剧中的隐喻非常深刻。它不仅象征着故事情节中的双重间谍,更重要的

① Eva-Sabine Zehelein, *Science: Dramatic: Science Plays in America and Great Britain 1990-2007*. Heidelberg: Universitätsverlag Winter, 2009, p.16.

② Tom Stoppard, *Hapgood*. In Tom Stoppard, *Tom Stoppard Plays 5*. London: Faber and Faber, 1999, pp.500-501. 以下出自该剧本的引文页码随文注出,不单列脚注。

是，它暗示了我们的人格在多数情况下都是一种双重的存在。每天早上起床、穿衣出门时的那个自己，不过是多重人格中的那个工作的主体，到了晚上——在失去意识的前一秒——我们会遇见作为"沉睡者"的自己。在任何情况下，我们人格中总有一部分处于隐匿或淹没的状态。在斯托帕德的隐喻中，个体的人是一个由各种情结和人格组成的复杂体，但在这个复杂体中，人是可以选择的，你可以选择这一部分，也可以选择那一部分。在剧中，汉普古德的姐姐和她一样都是真实的存在，她们都是"她"的一部分。至于到底以哪个自我出现，这往往取决于具体的情形。也许具体的情形会使她展现原本是虚假人格的那一面，但这么做时，她并不认为这不是自己，相反她会觉得，这是此前尚未发现的自己。

比起《汉普古德》，《阿卡狄亚》是一部堪称斯托帕德后期巅峰之作的科学剧作。该剧分为两幕，剧情在1809年与1989年之间转换。本剧开始时，时间是1809年，在德比郡贵族柯弗利家的西德利庄园花园里，13岁的贵族小姐托马西娜和她的家庭教师霍奇正坐在园中，窗外是一大片湖水和哥特式的园林。这对年轻人让我们想到了伊甸园神话。如夏娃一样聪颖而充满好奇心的托马西娜在向霍奇请教 carnal embrace 的意思，这位剑桥学者试图用科学的话语糊弄过去，殊不知，托马西娜早已明白该词的意思为"性爱"。于是，她质问她的老师："如果连你都不肯教给我真实的知识，谁还能呢?"(10)这种学生对老师的质疑口气贯穿了整个作品，最典型的一句话是："你认为上帝是一个牛顿理论者吗?"(13)而且她质疑的矛头总是直逼霍奇所代表的科学理念："除非你能让每一个原子都停下脚步，除非你的大脑能理解所有停滞下来的东西……否则你就不可能写出一个放之未来而皆准的定理或公式。"(13)在挑战老师的过程中，托马西娜总会在作业本上留下一些让霍奇目瞪口呆的"涂鸦"，因为他吃惊地发现，她的一些"胡思乱想"竟与当时最前沿的物理理论不谋而合。有一次，看着她的"涂鸦"之作，他说："这是一篇发表在巴黎科学杂志上的文章。我的小姐，你真该喜欢它的作者，因为你简直是他的预言者……他用公式展现了热传播的过程。当然，这样做的结果是，他彻底背离了艾萨克·牛顿的理论，成了一个异端学说者，因为他所提出的原子运行规律与牛顿学说背道而驰。"(114)就在这位女学生与家庭教师探讨这一切时，花园里乱成了一锅粥。霍奇似乎掉进了托马西娜的母亲库鲁姆夫人和诗人查尔特夫人的感情漩涡，而诗人拜伦的来访更使得这场感情风波变得错综复杂。

随着剧情的推进，托马西娜不时会拿出一些绝顶聪明的问题挑战他讲授的科学概念。她所追求的并不是知识本身——她在作业本上留下的那些让霍奇惊叹不已的算式和图形都不过是她的随性之作，而她本人并不了解也不在乎那些算式的意义。情窦初开的她只想从霍奇那儿得到一个吻和教她跳华尔兹舞的许诺。但就在托马西娜17岁生日的前夕，她在卧室里等他来教她跳舞时，烛台倒下，引燃的大火吞噬了她的生命。悲剧的发生使霍奇悔恨交加，他从此孤守在园中的小屋里，推演她留下的算式，成为阿卡狄亚隐居者的神话。而托马西娜当年留下的公式和图案、霍奇收到的情书以及隐居者神话则成为连接过去和现代的链条。

在剧中，与1809年的故事交错出现的还有20世纪的故事：180年后，还是在这个花园里，电脑数学家瓦伦丁(也是家族继承人)和园艺历史学家汉娜、大学教师伯纳德聚集于此，一同探究花园的秘密。此外，住在庄园里的还有女主人库鲁姆夫人、女儿科罗伊和沉默寡言的小儿子格斯。虽然汉娜的研究对象是园中隐居者的神话，但她对托马西娜的历史也很感兴趣，尤其是她留下的一段话："我，托马西娜·柯弗利，发现了一个了不起的方法。以此方法，自然界的一切秘密都能以数字的形式显现于我们的眼前"。(62-63)瓦伦丁认为，托马西娜说的就是现代数学中的十进位制，但他又否认它是真正意义上的科学发

现。在他看来,托马西娜的那些"发现"不过是随性的数字游戏和涂鸦而已。他坚信科学是理性的,无序之中都存在着有序,即便是灰烬的海洋中,也隐含着秩序的小岛。观众后来发现,瓦伦丁和托马西娜所做的其实是一回事,殊途而同归:她是将算式变成图案,而他则是试图将图案推回到那个算式。在剧中,瓦伦丁试图借助于电脑对园中松鸡数字的变化进行追踪,以发现其变化的规律,但却以失败告终。用他的话说,松鸡的数字变化中有太多的"杂音"和太多外来的干扰,以至于无法进行纯粹的计算。

与汉娜的园艺史和瓦伦丁的数学研究平行的是大学教师伯纳德的文学研究。他的兴趣是诗人拜伦留下的历史遗迹。凭着夹在拜伦藏书《爱神之床》中的三封信,伯纳德力图推断出拜伦与当年住在园中的查尔特夫人的恋情。但就像试图用理性数字来厘清自然中的一切的瓦伦丁那样,伯纳德的推断从一开始就错了。因为那本书其实并非拜伦的藏书,而是霍奇借给他的。在这三个研究者中,身为历史学家和园艺学家的汉娜仿佛是托马西娜在 20 世纪的代言人。她否认"非得有房子才能有个门"这种理性科学的观念,提出真正的天才应该有能力在没有房子的情况下看到一扇门。她怀疑那个神秘的隐居者就是霍奇。有趣的是,最终正是正汉娜发现了阿卡狄亚的秘密——不是通过科学推理,而是通过一个家族遗物——一个破旧不堪、上面扎着蝴蝶结带子的对开本,里面竟是托马西娜当年的图案手稿。

科学主题成为本剧的最大亮点,热力学第二定律、混沌理论、分形几何、迭代算法与园艺史、诗学混合在一起,共同传递着剧作家对科学的看法:尽管多少个世纪以来,人类一直都想靠理性寻找一个解释世间万物的科学真理,但却适得其反。人类越理性,便离真正的知识越远。在剧中,从托马西娜留下的算式和图表可以看出,她其实是在无意之间闯入了现代科学中两个截然不同的领域,即热动力和混沌数学。她只是留下了两个谜底,却无意也无法证明它的真实性。她死后,塞普提摩斯耗尽毕生精力,试图推证二者的正确性,并在这两个不相干的东西之间找到一个连接点,却因失败而疯狂,连同神智一起迷失在无限的推演之中。同样,因陷入数字推演而无力自拔的瓦伦丁曾对汉娜说道:

> 用迭代法来制出一个苹果叶?永远都别想弄清到底是哪些因素决定了万物的可预知性和不可预知性。它们才是生成自然的秘密……是问题的源头,但我们却对它几乎一无所知。人们一直不懈地探究物理学的终结,先是相对论,后又是量子物理,好像这样就可以厘清所有的症结,找到一个解释一切的万能理论。事实上,我们能解释的不过是巨大或极小之物。无论是宇宙和元素性的粒子,以及生活里的常见之物,还是诗歌里称赞的宇宙苍穹,如白云、水仙、瀑布,抑或是奶油倒入咖啡时发生的故事——这一切的一切都是无法解释的神秘,神秘得就像是希腊人眼里的众神一样。
> (68-69)

在一定程度上,瓦伦丁在这段话里流露出的无奈之意,也反映了当今世界对理性科学的绝望。

除了斯托帕德,在物理科学戏剧中,誉满全球的作品当属弗雷恩的《哥本哈根》,它被戏剧界称为"最好的科学戏剧"。该剧聚焦物理学家尼尔斯·玻尔(Niels Bohr)和沃纳·海森伯(Werner Heisenberg)在哥本哈根的会面,讲述了发生在近代科学史上最著名的一个悬案。《哥本哈根》不仅涉及海森伯的不确定性原理等颇具戏剧性的物理学理论,还涉及关乎二战最终结局的原子弹研制计划。围绕着尖端物理研究,各方政治势力卷入其中,暗流涌动,在物理学家、量子理论、政治阴谋和科学悬案几大要素的碰撞下,《哥本哈根》摆脱了科学戏剧容易陷入的说教窠臼,在一个个谜团中展开了对真相的探

寻,成为具有悬疑特征的科学戏剧,取得了前所未有的成功,引发了一场席卷全球的科学戏剧的热潮。

二、生物主题戏剧

随着 20 世纪下半叶生命科学的蓬勃发展,进化论、基因编辑、克隆等生物学主题越来越多地出现在戏剧舞台上。

正如谈及物理学戏剧时必提牛顿和伽利略一样,在生物主题的戏剧中,达尔文是一个绕不开的话题。以达尔文为话题的科学戏剧主要包括传记式戏剧、进化论戏剧等。其中,传记式戏剧主要是从达尔文的生平出发,选取其生命中的重要事件,如早年他随贝格尔号考察的经历、有关《物种起源》发表的史实、晚年他与赫胥黎等人的学术争辩等,通过文献资料及相应的虚构情节,再现达尔文作为鲜活的“人”而不是刻板的科学家的形象。此类戏剧的代表作有韦滕贝克的《达尔文之后》、斯努·威尔逊的《达尔文洪水》、克里斯平·惠特尔(Crispin Whittell)的《达尔文在马里布》(*Dwarwin in Malibu*,1994)、克雷格·巴克斯特(Craig Baxter)的《回复设计》(*Re: Design*,2009)等。其中,《回复设计》是巴克斯特受剑桥大学图书馆“达尔文通信项目”支持创作而成的,剧中的对白全部选自达尔文晚年与哈佛教授阿萨·格雷(Asa Gray)近 40 年的来往信件,展示了两人就进化论对个人思想和宗教信仰影响的讨论。

在以达尔文科学为主题的剧作中,最著名的是韦滕贝克的《达尔文之后》。该剧写于 20 世纪即将终结、新千年即将到来之际。在世纪之交的特殊时刻,韦滕贝克感到人类社会弥漫着一种恐惧感:“这个世界正在试图重新定义自己,没有人真正知道我们是谁,甚至关于人的最基本的定义都在受到怀疑。”[1]她认为,这一切的根源在于人类失去了确定性,因此,她力图通过追溯历史找到答案:也许这种确定性早在达尔文那里就已经失去了,进入 20 世纪后,科学的局限性、战争灾难等使这种确定性的失去更加深远,失去确定性的世界看起来已毫无规则可言。[2]正是在这种背景中,韦滕贝克回到达尔文科学主题,重新思考达尔文给人类带来的巨变。

《达尔文之后》是一部两幕剧,分为 19 世纪和 20 世纪末两条时间线,以演员排演达尔文在贝格尔号船上的考察为线索,通过达尔文与船长菲茨罗伊、演员伊恩与汤姆、导演米莉与剧作家劳伦斯之间的关系,展开了对进化论思想及其影响的探讨。

19 世纪的时间线属于传记式叙事,故事以“戏中戏”的形式呈现了在贝格尔号环球考察过程中发生在达尔文和船长菲茨罗伊之间的故事以及达尔文发现新物种、写作《物种起源》的历史,探讨了进化论对人类自我身份认同的影响。在 19 世纪的故事中,菲茨罗伊是一名坚定的宗教信仰者,面对达尔文提出的进化论,他感到人类作为人的身份受到了达尔文科学发现的威胁,他试图阻止达尔文,以维持现有的人类秩序和身份:“我们努力向善是因为我们有信仰,如果毁掉了它,我们就失去了道德观,那人和动物有什么区别?”(163)但在达尔文看来,科学事实一经发现,便不会以个人的意志为转移。当达尔文将加拉帕格斯群岛上雀类的研究成果呈现在惊恐的菲茨罗伊船长面前时,一切有关上帝、人类、国家和阶级的固有确定性都变得荡然无存。当意识到达尔文的发现即将出版,传统伦理世界即将终结时,这位随时

① Timberlake Wertenbaker,*Timberlake Wertenbaker Plays 2*. New York:Faber and Faber,2002,p.viii.
② Timberlake Wertenbaker. *Timberlake Wertenbaker Plays 2*. New York:Faber and Faber,2002,p.viii.以下出自该剧本的引文页码随文注出,不单列脚注。

携带《圣经》的船长最终绝望自杀。

与 19 世纪的传记式叙事不同,20 世纪的故事以现实主义的风格,通过剧场演员的排练过程,表现了演员之间为生存而互相背叛的故事,在更深层次上呼应了进化论主题。该场景由 4 个人物组成:饰演达尔文的同性恋演员汤姆、饰演菲茨罗伊的伊恩、保加利亚导演米莉和非裔美国剧作家劳伦斯。在这条线索中,所有的角色都在日趋激烈的生存竞争中面临道德困境,同时他们也"都一致认为是进化论摧毁了道德"①。剧中首要的道德困境发生在演员汤姆与伊恩之间。汤姆是一位一心想出名的演员,在排练过程中无法对角色共情,为获得更多的利益,在排演过程中突然离去。汤姆不负责任的表现给伊恩和米莉带来了巨大的伤害,但汤姆声称:"我喜欢达尔文,抱歉。"(158)面对汤姆的毁约,伊恩利用汤姆同性恋的身份进行报复,最终也陷入了为生存自相残杀的社会达尔文主义的怪圈。为了生存,剧中的人物都摒弃了道德,沦为追逐利益、没有羞耻感的怪物,如剧中导演米莉所说:"人们没有意识到,现在的我们就像动物一样,争夺着日益减少的食物,为了生存,我们做着各种可怕的事。"(171)最终,故事在剧作家劳伦斯的感叹中落下帷幕:"失去了做人的道德感,也就失去了人之为人的能力。"(172)

近年来,随着当代生物科学的发展,基因编辑和克隆人成为作家关注的热点主题。在这种大背景下,20 世纪 90 年代末及 21 世纪初,英国剧坛出现了多部以基因编辑和克隆技术为主题的科学戏剧,代表性作品有:史蒂芬森的《抽气泵实验》、丘吉尔的《克隆人生》、麦格拉斯的《安全送达》、伊丽莎白·伯恩斯(Elizabeth Burns)的《自毁》(*Autodestruct*,2001)等。

其中,《抽气泵实验》是一部探讨生命科学伦理的经典之作。剧名来自 18 世纪英国画家约瑟夫·赖特(Joseph Wright)的画作《气泵里的鸟实验》(*An Experiment on a Bird in the Air Pump*,1768)。在这幅画中,一位科学家正在演示气泵的原理,随着空气一点点抽离,可看到鸽子在气泵中正痛苦地挣扎,油画展现了科学实验的危险和带给人类的伦理灾难。在情节上,该剧和《阿卡狄亚》《达尔文之后》一样,也建立在过去(18 世纪)和现在(20 世纪)两条主线上。其中,20 世纪末的故事主要围绕女生物学家艾伦展开:受朋友凯特邀请,她参加一项 14 天的体外受精胚胎干细胞研究实验,目的是通过基因检测提前发现胎儿可能携带的致病基因并进行干预,但大学老师汤姆(艾伦的丈夫)则认为,这种实验会导致选择性堕胎、生理歧视等社会性后果,堕胎对于未出生的胎儿来说无异于谋杀,因为被用于实验的人类胚胎是一个"潜在的人"。而剧中 18 世纪的故事则围绕浮士德式的科学家阿姆斯特朗展开:为了进行畸形脊柱研究,他引诱女仆伊索贝尔爱上自己,后将其杀害并解剖,留下了一堆残缺的尸骨。在剧中,20 世纪的汤姆发现了这堆 18 世纪的白骨,两条主线由此交错汇合。最后,艾伦决定参与干细胞研究,她觉得与其被伦理道德所困惑,不如顺应现实社会的金钱法则而获得利益。本剧以科学的光明前景开始,却以人们在新纪元的科学冒险而结束,伊索贝尔的尸体取代了笼中之鸟,成为本剧生命伦理的核心寓意——史蒂芬森以最残酷的意象对人类涉足科学禁地发出了警示。

不同于《抽气泵实验》,丘吉尔的《克隆人生》则是一部以克隆人为题材的剧作。1996 年,英国科学学家伊恩·威尔穆特(Ian Wilmut)和基思·坎贝尔(Keith Campbell)成功创造了克隆羊"多莉",这成为当年轰动全球的科学事件,这种轰动与其说是来自科学的突破,不如说是来自它给人类可能带来的可怕后果——人类开始担心滥用克隆技术的后果和接下来可能出现的克隆人。作为当代英国最优秀的女

① Logan Gage,"Morality '*After Darwin*'". *Evolution News*,29 Mar. 2007. https://evolutionnews.org/2007/03/morality_after _darwin/.

性剧作家之一，丘吉尔一向关注性别政治、身份政治、家庭政治主题，克隆技术的出现为她提供了一个从基因生命的角度思考身份政治、生物伦理、人类与他类的关系等命题的机会。2002 年，《克隆人生》在伦敦皇家宫廷剧院首演，获得巨大成功，被称赞为一部宏大、深刻且发人深省的作品。

该剧讲述的是父亲萨尔特和他的三个儿子——生物学儿子伯纳德（简称 B1）、克隆儿子伯纳德（简称 B2）及克隆儿子米歇尔·布莱克的故事。在第一幕中，B2 在医院偶然看到一群和自己长相一样的人，由此发现了父亲萨尔特隐藏了多年的秘密：B2 竟然不是萨尔特的生物学儿子，而是一名克隆人。萨尔特真正的生物学儿子是 B1。B1 出生时，萨尔特是一个酒鬼，后来妻子自杀死去，萨尔特开始变态地虐待还是婴儿的 B1。最终，在社区的干预下，萨尔特将 B1 送走，但他却用 B1 的基因克隆了一个全新的 B2。萨尔特没有想到的是，在克隆的过程中，医生私下将 B1 的基因克隆了多个副本，这便导致多年后 B2 遇到一群克隆人的景象。在结构上，该剧由五幕组成。第一幕和第三幕是 B2 与萨尔特的对话，第二幕和第四幕则是 B1 与萨尔特的会面。该剧大部分内容是萨尔特的回忆，透过他的回忆，剧作家展现了这位父亲的凶狠残暴，也展示了 B1、B2 两兄弟无法承受的身份混乱，最后，就像《圣经》中的该隐和亚伯那样，B1 先杀死 B2，而后自杀。所幸的是，失去两个儿子的萨尔特找到了一个新克隆儿子布莱克，布莱克开朗乐观，丝毫不为自己的克隆身份所困。该剧在布莱克的轻松与萨尔特的失落这一强烈反差中落下帷幕，留给观众无限的思考。

通过剧名 *A Number* 的字面义"一个数字"，剧作家意在指出伯纳德是我们每一个人：在基因科学飞速发展的 21 世纪，每个人都不过是生物基因数据的集合，可以浓缩为一组基因数字。如果我们放任基因技术毫无约束地发展下去，一旦人类进入随意使用基因的时代，B1 和 B2 的悲剧将不可避免地成为人类共同的灾难。

在本章，我们将选择弗雷恩的《哥本哈根》来分析当代英国科学戏剧的特征。

第二节　迈克尔·弗雷恩及其《哥本哈根》

一、迈克尔·弗雷恩简介

迈克尔·弗雷恩是当代英国著名的剧作家和小说家,是为数不多的在两个领域均获得评论家认可和商业成功的作家。1933年,弗雷恩出生于英国伦敦巴尼特区的一个普通工人家庭,父母均是售货员。弗雷恩曾在伦敦南部的金斯顿语法学校学习,后进入军队服役两年。服兵役期间,弗雷恩对俄国产生兴趣,并开始自学俄语。对俄语的热情促使弗雷恩在20世纪60年代多次前往莫斯科,并写成《俄文翻译》(*The Russian Interpreter*,1966)一书。此后,弗雷恩进入剑桥大学伊曼纽尔学院攻读道德科学,这为他在日后创作中的哲学思考打下了坚实的理论基础。1957年,从剑桥大学哲学系毕业后,弗雷恩做了近10年的记者和专栏作家,这段经历使弗雷恩有机会深度感知现实社会,并练出平实、幽默而又犀利的文笔。他曾在一次访谈中说过:"让小说家和剧作家接触一些通讯记者的工作,这是个好办法,可以提醒他们世界永远比我们记忆中的要糟糕。"[1]

20世纪70年代至90年代是弗雷恩戏剧创作的早期阶段,他在该时期的创作延续了讽刺辛辣的风格,以讽刺喜剧创作见长。其代表作有《字母顺序》(*Alphabetical Order*,1976)、《傻瓜年代》(*Donkeys' Years*,1977)、《噪声远去》(*Noises Off*,1982)等,这些作品先后获得伦敦标准晚报奖(London Evening Standard Award)和奥利弗奖。

进入90年代后,弗雷恩的戏剧风格发生了巨变,其创作出了《哥本哈根》《民主》(*Democracy*,2003)、《余生》(*After life*,2008)等一系列哲理剧,这些作品中蕴含的哲学思考标志着他进入了严肃戏剧的创作阶段。尤其是在1998年,随着《哥本哈根》的问世,弗雷恩一跃成为全球最优秀的科学戏剧作家之一。《卫报》记者提姆·亚当斯(Tim Adams)曾评价道:"很难想象,除了斯托帕德以外,还能有剧作家能同时写出像《噪声远去》这样的滑稽喜剧和《哥本哈根》这样的哲理剧。"[2]事实上,弗雷恩的确与斯托帕德在科学戏剧创作上表现出很大的相似性:两人都对量子力学的不确定性原理情有独钟,均在戏剧中将其演绎为极具哲学伦理的隐喻。

二、《哥本哈根》介绍

《哥本哈根》取材于一段真实的历史往事。1941年,在二战正进行得如火如荼之际,德国物理学家海森伯来到哥本哈根,拜访了他昔日的老友及导师——丹麦物理学家玻尔。这次会面没有留下任何记录,但可以肯定的是,此次会面过后,两位世界闻名的物理学家近20年的友谊就此终结了。二战后,两

[1] 迈克·弗雷恩:《迈克·弗雷恩戏剧集》,胡开奇译。北京:新星出版社,2007年,第350页。以下出自该剧本的引文页码随文注出,不单列脚注。

[2] Tim Adams, "The Interview: Michael Frayn". *The Guardian*, 16 Aug. 2009. https://www.theguardian.com/stage/2009/aug/16/michael-frayn-interview.

者对此次会面的解释也大相径庭,这不禁引起了科学家、历史学家以及普通读者的好奇。海森伯为什么要去哥本哈根? 他们这次会面究竟谈论了什么? 这些疑问也正是弗雷恩创作此剧的起点。

《哥本哈根》是一部两幕剧,故事由三个角色在一个空旷的舞台上以对话的形式展开,三个角色分别是海森伯、玻尔及其妻子玛格丽特。但剧中并未采用真实的历史场景和人物,而是采用三个角色死后的灵魂以及没有明确时间的纯白剧场。剧情紧紧围绕"海森伯为什么来哥本哈根?"这个问题,通过三个灵魂展开的数次思维实验,以对话的形式将答案呈现给观众。该剧的剧情及舞台布景极其简单,以至于弗雷恩在创作之初从未预想到此剧能取得如此大的成功,他甚至一度怀疑:"怎么会有人想要排这么一部无聊抽象的戏剧呢?"(345)

在就这一问题展开讨论的过程中,海森伯的"不确定性原理"始终萦绕其中。该原理是量子力学中的一个基础理论,指在量子世界,电子的位置与动量不可能同时被确定:位置的不确定性越小,动量的不确定性越大,反之亦然。[1] 也就是说,我们无法同时准确测量电子的位置和动量,因为电子等微观粒子本质上是不确定的。

作为带有一定科学史传记意义的剧作,"不确定性原理"首先直接体现在剧中人物的身份认知和日常对话中。作为主角之一的海森伯,在最开始的自述中便提及该原理,他说关于他,世人只会记住两件事:一是不确定性原理,另一事便是1941年他去哥本哈根与尼尔斯·玻尔的神秘会面。(4)同样,在后续两位物理学家的讨论中,玻尔也直接用"不确定性原理"对滑雪等日常生活经验进行了比喻:按照你的滑速,你上升时违反了不确定性原理的关系,因为若你知道你的落点,你便不知道你的落速;而即便你知道你的落速,你又不知道你的落点。(22)除此之外,剧中还涉及量子力学的相关知识,比如互补性原理、裂变、薛定谔方程等,但这不会影响观众对剧情的理解,只是需要观众投入并进行思辨,这也充分体现了科学戏剧的智力剧特色。

在更深的哲学层面,弗雷恩试图通过"不确定性原理"揭示人类意识的不确定性本质。在他看来,人的意识本身和量子世界中的粒子一样,在本质上就是不确定的。弗雷恩对一直纠结并盘踞在历史学家脑海里的难题——二战中海森伯为何要去哥本哈根——有了全新的理解。弗雷恩意识到,海森伯去哥本哈根的意图正如量子世界的粒子,其在本质上就是不确定的。他认为,思维的不确定性和粒子的不确定性的共性并不在于某个实际困难,而在于即使是理论层面也无法实现的局限性。(130)在此思路的引导下,迈克尔·弗雷恩在剧中展开了4次思维实验,提出了关于海森伯动机的13种可能性。[2] 这些可能性之间有的互相佐证,有些却完全相悖,但它们却都有其存在的合理性,从而印证了人类意图的不确定性本质。

在量子世界中,测量手段会影响粒子的性质,使它表现出不确定性本质。为了观察量子世界中的不确定性粒子,海森伯进一步提出了"波函数坍缩"这一概念,即在量子力学的微观世界中,电子的本质是不确定的,但当我们以宏观世界的测量手段对其进行测量和观看时,电子会瞬间坍缩到一个固定的位置或速度,从而表现出可以被观察的状态。以此对照,弗雷恩意识到,战后人们对海森伯意图的揣测,仿若宏观世界对量子世界施加的测量手段,使真相变得不确定。对此,弗雷恩在剧本的"后记"中解释道:"海

[1] 张天蓉:《极简量子力学》,北京:中信出版社,2019年,第36-37页。

[2] Nicholas Ruddick, "The Search for a Quantum Ethics: Michael Frayn's 'Copenhagen' and Other Recent British Science Plays." *Hungarian Journal of English and American Studies* (HJEAS), 6.1(2000): 119-137.

森伯在战后确实处于矛盾的压力之下，这使得他特别难以解释他当时的意图。他要与纳粹划清界限，但他不想表示自己是个叛国者。他不愿向他的德国同胞们声称是他蓄意使他们输掉了战争，但他同样不愿意表示他未能帮助他们获胜只是由于他的无能。"(89-90)这段话表明，当二战中德国原子弹研制失败且全面战败的结果已经尘埃落定时，从结果出发去测量意图势必是一场徒劳：如果海森伯承认是他的蓄意放弃导致了原子弹的研制失败，进而导致了德国的战败，那么对其同胞来说，他就是一名叛国者；但如果他承认是因自己的计算失误而导致原子弹研制失败，那么这不仅说明他曾经是一名为希特勒效力的纳粹分子，而且证明了其在科研上的无能。因此，当事后人们试图通过施加测量手段去探知真相时，只能得到意图的随机坍缩，但究竟何为真相却不得而知。这也是为什么迈克尔·弗雷恩在采访中感叹："我要说的是要知道他的动机是相当困难的，这也是探究所有人类动机的一个例子——要知道人们为什么做他们在做的事情是困难的。"(348)

"不确定性原理"冲击了"严格的因果关系宇宙观"，也引发了现代科学和后现代科学的一个重要分歧，即对"不确定性"的截然不同的态度。[1] 现代科学认为，宇宙中不存在真正的随机性。那些貌似随机的现象，背后都隐藏着我们不知道的、尚未发现的"隐变量"。换句话说，现代科学坚信，隐变量是随机性的来源。[2] 但以"不确定性原理"为代表的后现代科学认为，微观世界的不确定性并非来自知识或信息的欠缺，而是来自事物的内在本质。随机性是内在的、本质的，没有什么隐藏得更深的隐变量。[3] 量子力学通过揭露微观世界的内在不确定性，打破了以牛顿力学为代表的现代科学的确定性宇宙观，将长期被排除在外的不确定性重新拉回人们的视野，也为弗雷恩重回历史和反思当下提供了理论支撑。

本书节选的是《哥本哈根》（两幕剧，不分场）第一幕的前一部分和第二幕的中间部分。

三、《哥本哈根》选读[4]

Copenhagen

Act One

MARGRETHE：But why?

BOHR：You're still thinking about it?

MARGRETHE：Why did he come to Copenhagen?

BOHR：Does it matter，my love，now we're all three of us dead and gone?

MARGRETHE：Some questions remain long after their owners have died. Lingering like ghosts. Looking for the answers they never found in life.

BOHR：Some questions have no answers to find.

MARGRETHE：Why did he come? What was he trying to tell you?

① John Fleming. *Stoppard's Theatre: Finding Order amid Chaos*. Austin：University of Texas Press，2009，p.177.
② 张天蓉：《极简量子力学》，北京：中信出版社，2019年，第39页。
③ 张天蓉：《极简量子力学》，北京：中信出版社，2019年，第39页。
④ Michael Frayn. *Copenhagen*. New York：Anchaor Books，2000. pp.3-10，pp.67-78.

BOHR: He did explain later.

MARGRETHE: He explained over and over again. Each time he explained it became more obscure.

BOHR: It was probably very simple，when you come right down to it：he wanted to have a talk.

MARGRETHE: A talk? To the enemy? In the middle of a war?

BOHR: Margrethe，my love，we were scarcely the enemy.

MARGRETHE: It was 1941!

BOHR: Heisenberg was one of our oldest friends.

MARGRETHE: Heisenberg was German. We were Danes. We were under German occupation.

BOHR: It put us in a difficult position，certainly.

MARGRETHE: I've never seen you as angry with anyone as you were with Heisenberg that night.

BOHR: Not to disagree，but I believe I remained remarkably calm.

MARGRETHE: I know when you're angry.

BOHR: It was as difficult for him as it was for us.

MARGRETHE: So why did he do it? Now no one can be hurt，now no one can be betrayed.

BOHR: I doubt if he ever really knew himself.

MARGRETHE: And he wasn't a friend. Not after that visit. That was the end of the famous friendship between Niels Bohr and Werner Heisenberg.

HEISENBERG: Now we're all dead and gone，yes，and there are only two things the world remembers about me. One is the uncertainty principle，and the other is my mysterious visit to Niels Bohr in Copenhagen in 1941. Everyone understands uncertainty. Or thinks he does. No one understands my trip to Copenhagen. Time and time again I've explained it. To Bohr himself，and Margrethe. To interrogators and intelligence officers，to journalists and historians. The more I've explained，the deeper the uncertainty has become. Well，I shall be happy to make one more attempt. Now we're all dead and gone. Now no one can be hurt，now no one can be betrayed.

MARGRETHE: I never entirely liked him，you know. Perhaps I can say that to you now.

BOHR: Yes，you did. When he was first here in the twenties? Of course you did. On the beach at Tisvilde with us and the boys? He was one of the family.

MARGRETHE: Something alien about him，even then.

BOHR: So quick and eager.

MARGRETHE: Too quick. Too eager.

BOHR: Those bright watchful eyes.

MARGRETHE: Too bright. Too watchful.

BOHR: Well，he was a very great physicist. I never changed my mind about that.

MARGRETHE: They were all good，all the people who came to Copenhagen to work with you. You had most of the great pioneers in atomic theory here at one time or another.

BOHR：And the more I look back on it，the more I think Heisenberg was the greatest of them all.

HEISENBERG：So what was Bohr? He was the first of us all，the father of us all. Modern atomic physics began when Bohr realised that quantum theory applied to matter as well as to energy. 1913. Everything we did was based on that great insight of his.

BOHR：When you think that he first came here to work with me in 1924...

HEISENBERG：I'd only just finished my doctorate，and Bohr was the most famous atomic physicist in the world.

BOHR：...and in just over a year he'd invented quantum mechanics.

MARGRETHE：It came out of his work with you.

BOHR：Mostly out of what he'd been doing with Max Born and Pascual Jordan at Göttingen. Another year or so and he'd got uncertainty.

MARGRETHE：And you'd done complementarity.

BOHR：We argued them both out together.

HEISENBERG：We did most of our best work together.

BOHR：Heisenberg usually led the way.

HEISENBERG：Bohr made sense of it all.

BOHR：We operated like a business.

HEISENBERG：Chairman and managing director.

MARGRETHE：Father and son.

HEISENBERG：A family business.

MARGRETHE：Even though we had sons of our own.

BOHR：And we went on working together long after he ceased to be my assistant.

HEISENBERG：Long after I'd left Copenhagen in 1927 and gone back to Germany. Long after I had a chair and a family of my own.

MARGRETHE：Then the Nazis came to power...

BOHR：And it got more and more difficult. When the war broke out—impossible. Until that day in 1941.

MARGRETHE：When it finished forever.

BOHR：Yes，why did he do it?

HEISENBERG：September，1941. For years I had it down in my memory as October.

MARGRETHE：September. The end of September.

BOHR：A curious sort of diary memory is.

HEISENBERG：You open the pages，and all the neat headings and tidy jottings dissolve around you.

BOHR：You step through the pages into the months and days themselves.

MARGRETHE：The past becomes the present inside your head.

HEISENBERG: September, 1941, Copenhagen... And at once—here I am, getting off the night train from Berlin with my colleague Carl von Weizsäcker. Two plain civilian suits and raincoats among all the field-grey Wehrmacht uniforms arriving with us, all the naval gold braid, all the well-tailored black of the SS. In my bag I have the text of the lecture I'm giving. In my head is another communication that has to be delivered. The lecture is on astrophysics. The text inside my head is a more difficult one.

BOHR: We obviously can't go to the lecture.

MARGRETHE: Not if he's giving it at the German Cultural Institute—it's a Nazi propaganda organisation.

BOHR: He must know what we feel about that.

HEISENBERG: Weizsäcker has been my John the Baptist, and written to warn Bohr of my arrival.

MARGRETHE: He wants to see you?

BOHR: I assume that's why he's come.

HEISENBERG: But how can the actual meeting with Bohr be arranged?

MARGRETHE: He must have something remarkably important to say.

HEISENBERG: It has to seem natural. It has to be private.

MARGRETHE: You're not really thinking of inviting him to the house?

BOHR: That's obviously what he's hoping.

MARGRETHE: Niels! They've occupied our country!

BOHR: He is not they.

MARGRETHE: He's one of them.

HEISENBERG: First of all there's an official visit to Bohr's workplace, the Institute for Theoretical Physics, with an awkward lunch in the old familiar canteen. No chance to talk to Bohr, of course. Is he even present? There's Rozental... Petersen, I think... Christian Moller, almost certainly... It's like being in a dream. You can never quite focus the precise details of the scene around you. At the head of the table—is that Bohr? I turn to look, and it's Bohr, it's Rozental, it's Moller, it's whoever I appoint to be there... A difficult occasion, though—I remember that clearly enough.

BOHR: It was a disaster. He made a very bad impression. Occupation of Denmark unfortunate. Occupation of Poland, however, perfectly acceptable. Germany now certain to win the war.

HEISENBERG: Our tanks are almost at Moscow. What can stop us? Well, one thing, perhaps. One thing.

BOHR: He knows he's being watched, of course. One must remember that. He has to be careful about what he says.

MARGRETHE: Or he won't be allowed to travel abroad again.

BOHR: My love, the Gestapo planted microphones in his house. He told Goudsmit when he was in

America. The SS brought him in for interrogation in the basement at the Prinz-Albrecht-Strasse.

MARGRETHE：And then they let him go again.

HEISENBERG：I wonder if they suspect for one moment how painful it was to get permission for this trip. The humiliating appeals to the Party，the demeaning efforts to have strings pulled by our friends in the Foreign Office.

MARGRETHE：How did he seem? Is he greatly changed?

BOHR：A little older.

MARGRETHE：I still think of him as a boy.

BOHR：He's nearly forty. A middle-aged professor，fast catching up with the rest of us.

MARGRETHE：You still want to invite him here?

BOHR：Let's add up the arguments on either side in a reasonably scientific way. Firstly，Heisenberg is a friend...

MARGRETHE：Firstly，Heisenberg is a German.

BOHR：A White Jew. That's what the Nazis called him. He taught relativity，and they said it was Jewish physics. He couldn't mention Einstein by name，but he stuck with relativity，in spite of the most terrible attacks.

MARGRETHE：All the real Jews have lost their jobs. He's still teaching.

BOHR：He's still teaching relativity.

MARGRETHE：Still a professor at Leipzig.

BOHR：At Leipzig，yes. Not at Munich. They kept him out of the chair at Munich.

MARGRETHE：He could have been at Columbia.

BOHR：Or Chicago. He had offers from both.

MARGRETHE：He wouldn't leave Germany.

BOHR：He wants to be there to rebuild German science when Hitler goes. He told Goudsmit.

MARGRETHE：And if he's being watched it will all be reported upon. Who he sees. What he says to them. What they say to him.

HEISENBERG：I carry my surveillance around like an infectious disease. But then I happen to know that Bohr is also under surveillance.

MARGRETHE：And you know you're being watched yourself.

BOHR：By the Gestapo?

HEISENBERG：Does he realise?

BOHR：I've nothing to hide.

MARGRETHE：By our fellow-Danes. It would be a terrible betrayal of all their trust in you if they thought you were collaborating.

BOHR：Inviting an old friend to dinner is hardly collaborating.

MARGRETHE：It might appear to be collaborating.

BOHR：Yes. He's put us in a difficult position.

MARGRETHE：I shall never forgive him.

BOHR：He must have good reason. He must have very good reason.

HEISENBERG：This is going to be a deeply awkward occasion.

MARGRETHE：You won't talk about politics?

BOHR：We'll stick to physics. I assume it's physics he wants to talk to me about.

MARGRETHE：I think you must also assume that you and I aren't the only people who hear what's said in this house. If you want to speak privately you'd better go out in the open air.

BOHR：I shan't want to speak privately.

MARGRETHE：You could go for another of your walks together.

HEISENBERG：Shall I be able to suggest a walk?

BOHR：I don't think we shall be going for any walks. Whatever he has to say he can say where everyone can hear it.

MARGRETHE：Some new idea he wants to try out on you, perhaps.

BOHR：What can it be, though? Where are we off to next?

MARGRETHE：So now of course your curiosity's aroused, in spite of everything.

　　　...

Act Two

　　　...

BOHR：My dear good Heisenberg, it's not open behaviour to rush a first draft into print before we've discussed it together! It's not the way we work!

HEISENBERG：No, the way we work is that you hound me from first thing in the morning till last thing at night! The way we work is that you drive me mad!

BOHR：Yes, because the paper contains a fundamental error.

MARGRETHE：And here we go again.

HEISENBERG：No, but I show him the strangest truth about the universe that any of us has stumbled on since relativity—that you can never know everything about the whereabouts of a particle, or anything else, even Bohr now, as he prowls up and down the room in that maddening way of his, because we can't observe it without introducing some new element into the situation, a molecule of water vapour for it to hit, or a piece of light—things which have an energy of their own, and which therefore have an effect on what they hit. A small one, admittedly, in the case of Bohr.

BOHR：Yes, if you know where I am with the kind of accuracy we're talking about when we're

dealing with particles, you can still measure my velocity to within—what...?

HEISENBERG: Something like a billionth of a billionth of a kilometre per second. The theoretical point remains, though, that you have no absolutely determinate situation in the world, which among other things lays waste to the idea of causality, the whole foundation of science— because if you don't know how things are today you certainly can't know how they're going to be tomorrow. I shatter the objective universe around you—and all you can say is that there's an error in the formulation!

BOHR: There is!

MARGRETHE: Tea, anyone? Cake?

HEISENBERG: Listen, in my paper what we're trying to locate is not a free electron off on its travels through a cloud chamber, but an electron when it's at home, moving around inside an atom...

BOHR: And the uncertainty arises not, as you claim, through its indeterminate recoil when it's hit by an incoming photon...

HEISENBERG: Plain language, plain language!

BOHR: This *is* plain language.

HEISENBERG: Listen...

BOHR: The language of classical mechanics.

HEISENBERG: Listen! Copenhagen is an atom. Margrethe is its nucleus. About right, the scale? Ten thousand to one?

BOHR: Yes, yes.

HEISENBERG: Now, Bohr's an electron. He's wandering about the city somewhere in the darkness, no one knows where. He's here, he's there, he's everywhere and nowhere. Up in Faelled Park, down at Carlsberg. Passing City Hall, out by the harbour. I'm a photon. A quantum of light. I'm despatched into the darkness to find Bohr. And I succeed, because I manage to collide with him... But what's happened? Look—he's been slowed down. he's been deflected! He's no longer doing exactly what he was so maddeningly doing when I walked into him!

BOHR: But, Heisenberg, Heisenberg! You also have been deflected! If people can see what's happened to you, to their piece of light, then they can work out what must have happened to me! The trouble is knowing what's happened to you! Because to understand how people see you we have to treat you not just as a particle, but as a wave. I have to use not only your particle mechanics, I have to use the Schrödinger wave function.

HEISENBERG: I know—I put it in a postscript to my paper.

BOHR: Everyone remembers the paper—no one remembers the postscript. But the question is fundamental. Particles are things, complete in themselves. Waves are disturbances in something else.

HEISENBERG：I know. Complementarity. It's in the postscript.

BOHR：They're either one thing or the other. They can't be both. We have to choose one way of seeing them or the other. But as soon as we do we can't know everything about them.

HEISENBERG：And off he goes into orbit again. Incidentally exemplifying another application of complementarity. Exactly where you go as you ramble around is of course completely determined by your genes and the various physical forces acting on you. But it's also completely determined by your own entirely inscrutable whims from one moment to the next. So we can't completely understand your behaviour without seeing it both ways at once, and that's impossible. Which means that your extraordinary peregrinations are not fully objective aspects of the universe. They exist only partially, through the efforts of me or Margrethe, as our minds shift endlessly back and forth between the two approaches.

BOHR：You've never absolutely and totally accepted complementarity, have you?

HEISENBERG：Yes! Absolutely and totally! I defended it at the Como Conference in 1927! I have adhered to it ever afterwards with religious fervour! You convinced me. I humbly accepted your criticisms.

BOHR：Not before you'd said some deeply wounding things.

HEISENBERG：Good God, at one point you literally reduced me to tears!

BOHR：Forgive me, but I diagnosed them as tears of frustration and rage.

HEISENBERG：I was having a tantrum?

BOHR：I have brought up children of my own.

HEISENBERG：And what about Margrethe? Was *she* having a tantrum? Klein told me you reduced *her* to tears after I'd gone, making her type out your endless redraftings of the complementarity paper.

BOHR：I don't recall that.

MARGRETHE：I do.

HEISENBERG：We had to drag Pauli out of bed in Hamburg once again to come to Copenhagen and negotiate peace.

BOHR：He succeeded. We ended up with a treaty. Uncertainty and complementarity became the two central tenets of the Copenhagen Interpretation of Quantum Mechanics.

HEISENBERG：A political compromise, of course, like most treaties.

BOHR：You see? Somewhere inside you there are still secret reservations.

HEISENBERG：Not at all—it works. That's what matters. It works, it works, it works!

BOHR：It works, yes. But it's more important than that. Because you see what we did in those three years, Heisenberg? Not to exaggerate, but we turned the world inside out! Yes, listen, now it comes, now it comes... We put man back at the centre of the universe. Throughout history we keep finding ourselves displaced. We keep exiling ourselves to the periphery of things.

First we turn ourselves into a mere adjunct of God's unknowable purposes, tiny figures kneeling in the great cathedral of creation. And no sooner have we recovered ourselves in the Renaissance, no sooner has man become, as Protagoras proclaimed him, the measure of all things, than we're pushed aside again by the products of our own reasoning! We're dwarfed again as physicists build the great new cathedrals for us to wonder at—the laws of classical mechanics that predate us from the beginning of eternity, that will survive us to eternity's end, that exist whether we exist or not. Until we come to the beginning of the twentieth century, and we're suddenly forced to rise from our knees again.

HEISENBERG: It starts with Einstein.

BOHR: It starts with Einstein. He shows that measurement—measurement, on which the whole possibility of science depends—measurement is not an impersonal event that occurs with impartial universality. It's a human act, carried out from a specific point of view in time and space, from the one particular viewpoint of a possible observer. Then, here in Copenhagen in those three years in the mid-twenties we discover that there is no precisely determinable objective universe. That the universe exists only as a series of approximations. Only within the limits determined by our relationship with it. Only through the understanding lodged inside the human head.

MARGRETHE: So this man you've put at the centre of the universe—is it you, or is it Heisenberg?

BOHR: Now, now, my love.

MARGRETHE: Yes, but it makes a difference.

BOHR: Either of us. Both of us. Yourself. All of us.

MARGRETHE: If it's Heisenberg at the centre of the universe, then the one bit of the universe that he can't see is Heisenberg.

HEISENBERG: So...

MARGRETHE: So it's no good asking him why he came to Copenhagen in 1941. He doesn't know!

HEISENBERG: I thought for a moment just then I caught a glimpse of it.

MARGRETHE: Then you turned to look.

HEISENBERG: And away it went.

MARGRETHE: Complementarity again. Yes?

BOHR: Yes, yes.

MARGRETHE: I've typed it out often enough. If you're doing something you have to concentrate on you can't also be thinking about doing it, and if you're thinking about doing it then you can't actually be doing it. Yes?

HEISENBERG: Swerve left, swerve right, or think about it and die.

BOHR: But *after* you've done it...

MARGRETHE: You look back and make a guess, just like the rest of us. Only a worse guess, because

you didn't see yourself doing it, and we did. Forgive me, but you don't even know why you did uncertainty in the first place.

BOHR: Whereas if *you're* the one at the centre of the universe...

MARGRETHE: Then I can tell you that it was because you wanted to drop a bomb on Schrödinger.

HEISENBERG: I wanted to show he was wrong, certainly.

MARGRETHE: And Schrödinger was winning the war. When the Leipzig chair first became vacant that autumn he was short-listed for it and you weren't. You needed a wonderful new weapon.

BOHR: Not to criticise, Margrethe, but you have a tendency to make everything personal.

MARGRETHE: Because everything is personal! You've just read us all a lecture about it! You know how much Heisenberg wanted a chair. You know the pressure he was under from his family. I'm sorry, but you want to make everything seem heroically abstract and logical. And when you tell the story, yes, it all falls into place, it all has a beginning and a middle and an end. But I was there, and when I remember what it was like I'm there still, and I look around me and what I see isn't a story! It's confusion and rage and jealousy and tears and no one knowing what things mean or which way they're going to go.

HEISENBERG: All the same, it works, it works.

MARGRETHE: Yes, it works wonderfully. Within three months of publishing your uncertainty paper you're offered leipzig.

HEISENBERG: I didn't mean that.

MARGRETHE: Not to mention somewhere else and somewhere else.

HEISENBERG: Halle and Munich and Zürich.

BOHR: And various American universities.

HEISENBERG: But I didn't mean that.

MARGRETHE: And when you take up your chair at Leipzig you're how old?

HEISENBERG: Twenty-six.

BOHR: The youngest full professor in Germany.

HEISENBERG: I mean the Copenhagen Interpretation. The Copenhagen Interpretation works. However we got there, by whatever combination of high principles and low calculation, of most painfully hard thought and most painfully childish tears, it works. It goes on working.

MARGRETHE: Yes, and why did you both accept the Interpretation in the end? Was it really because you wanted to re-establish humanism?

BOHR: Of course not. It was because it was the only way to explain what the experimenters had observed.

MARGRETHE: Or was it because now you were becoming a professor you wanted a solidly established doctrine to teach? Because you wanted to have your new ideas publicly endorsed

by the head of the church in Copenhagen? And perhaps Niels agreed to endorse them in return for your accepting *his* doctrines. For recognising him as head of the church. And if you want to know why you came to Copenhagen in 1941 I'll tell you that as well. You're right—there's no great mystery about it. You came to show yourself off to us.

BOHR: Margrethe!

MARGRETHE: No! When he first came in 1924 he was a humble assistant lecturer from a humiliated nation, grateful to have a job. Now here you are, back in triumph—the leading scientist in a nation that's conquered most of Europe. You've come to show us how well you've done in life.

BOHR: This is so unlike you!

MARGRETHE: I'm sorry, but isn't that really why he's here? Because he's burning to let us know that he's in charge of some vital piece of secret research. And that even so he's preserved a lofty moral independence. Preserved it so famously that he's being watched by the Gestapo. Preserved it so successfully that he's now also got a wonderfully important moral dilemma to face.

BOHR: Yes, well, now you're simply working yourself up.

MARGRETHE: A chain reaction. You tell one painful truth and it leads to two more. And as you frankly admit, you're going to go back and continue doing precisely what you were doing before, whatever Niels tells you.

HEISENBERG: Yes.

MARGRETHE: Because you wouldn't dream of giving up such a wonderful opportunity for research.

HEISENBERG: Not if I can possibly help it.

MARGRETHE: Also you want to demonstrate to the Nazis how useful theoretical physics can be. You want to save the honour of German science. You want to be there to reestablish it in all its glory as soon as the war's over.

HEISENBERG: All the same, I don't tell Speer that the reactor...

MARGRETHE: ...will produce plutonium, no, because you're afraid of what will happen if the Nazis commit huge resources, and you fail to deliver the bombs. Please don't try to tell us that you're a hero of the resistance.

HEISENBERG: I've never claimed to be a hero.

MARGRETHE: Your talent is for skiing too fast for anyone to see where you are. For always being in more than one position at a time, like one of your particles.

HEISENBERG: I can only say that it worked. Unlike most of the gestures made by heroes of the resistance. It worked! I know what you think. You think I should have joined the plot against Hitler, and got myself hanged like the others.

BOHR: Of course not.

HEISENBERG：You don't say it，because there are some things that can't be said. But you think it.

BOHR：No.

HEISENBERG：What would it have achieved? What would it have achieved if you'd dived in after Christian，and drowned as well? But that's another thing that can't be said.

BOHR：Only thought.

HEISENBERG：Yes. I'm sorry.

BOHR：And rethought. Every day.

HEISENBERG：You had to be held back，I know.

MARGRETHE：Whereas you held yourself back.

HEISENBERG：Better to stay on the boat，though，and fetch it about. Better to remain alive，and throw the lifebuoy. Surely!

BOHR：Perhaps. Perhaps not.

HEISENBERG：Better. Better.

MARGRETHE：Really it is ridiculous. You reasoned your way，both of you，with such astonishing delicacy and precision into the tiny world of the atom. Now it turns out that everything depends upon these really rather large objects on our shoulders. And what's going on in there is...

HEISENBERG：Elsinore.

MARGRETHE：Elsinore，yes.

HEISENBERG：And you may be right. I *was* afraid of what would happen. I *was* conscious of being on the winning side... So many explanations for everything I did! So many of them sitting round the lunch-table! Somewhere at the head of the table，I think，is the real reason I came to Copenhagen. Again I turn to look... And for a moment I almost see its face. Then next time I look the chair at the head of the table is completely empty. There's no reason at all. I didn't tell Speer simply because I didn't think of it. I came to Copenhagen simply because I did think of it. A million things we might do or might not do every day. A million decisions that make themselves. Why didn't you kill me?

BOHR：Why didn't I...?

HEISENBERG：Kill me. Murder me. That evening in 1941. Here we are，walking back towards the house，and you've just leapt to the conclusion that I'm going to arm Hitler with nuclear weapons. You'll surely take any reasonable steps to prevent it happening.

BOHR：By murdering you?

HEISENBERG：We're in the middle of a war. I'm an enemy. There's nothing odd or immoral about killing enemies.

BOHR：I should fetch out my cap-pistol?

HEISENBERG：You won't need your cap-pistol. You won't even need a mine. You can do it without

any loud bangs，without any blood，without any spectacle of suffering. As cleanly as a bomb-aimer pressing his release three thousand metres above the earth. You simply wait till I've gone. Then you sit quietly down in your favourite armchair here and repeat aloud to Margrethe，in front of our unseen audience，what I've just told you. I shall be dead almost as soon as poor Casimir. A lot sooner than Gamow.

BOHR：My dear Heisenberg，the suggestion is of course...

HEISENBERG：Most interesting. So interesting that it never even occurred to you. Complementarity，once again. I'm your enemy；I'm also your friend. I'm a danger to mankind；I'm also your guest. I'm a particle；I'm also a wave. We have one set of obligations to the world in general，and we have other sets，never to be reconciled，to our fellow-countrymen，to our neighbours，to our friends，to our family，to our children. We have to go through not two slits at the same time but twenty-two. All we can do is to look afterwards，and see what happened.

四、思考题

1. 为什么剧作家在剧中将人物设定为死去后的状态？这与哥本哈根之谜有何关系？

2. 为什么剧中人物对哥本哈根会面的细节（如时间、地点等）存在如此大的争议？人物对会面细节的争议与哥本哈根之谜之间有着何种内在联系？

3. 二战时海森伯为何选择留在德国？他的意图存在着几种可能性解释？

4. 在第二幕中，海森伯所描述的"宇宙最奇怪的真实"指的是什么？这个新科学发现的意义又是什么？

5. 为什么玛格丽特在剧中多次说道："我都打了多少遍了？"在玻尔和海森伯的科学争论之间插入这种表达是否突兀？

6. 通过阅读本剧，你认为海森伯提出的不确定性原理和玻尔提出的互补性原理的哲学内涵是什么？

五、本节推荐阅读

［1］Halpin，Jenni G. *Contemporary Physics Plays: Making Time to Know Responsibility*. Cham：Palgrave Macmillan，2018.

［2］Hentschel，Klaus. "What History of Science can Learn from Michael Frayn's 'Copenhagen'". *Interdisciplinary Science Reviews*，27.3(2002)：211 – 216.

［3］Klemm，David E. "'The Darkness inside the Human Soul'：Uncertainty in Theological Humanism and Michael Frayn's Play *Copenhagen*". *Literature & Thchnology*，18.3(2004)：293 – 307.

［4］Shepherd-Barr，Kirsten. *Science on Stage: from Doctor Faustus to Copenhagen*. Princeton：Princeton University Press，2006.

［5］Stewart，Victoria. "A Theatre of Uncertainties：Science and History in Michael Frayn's 'Copenhagen'". *New Theatre Quarterly*，15.4(1999)：301 – 307.

第七章
当代英国黑人戏剧

第一节　当代英国黑人戏剧概论

除了科学戏剧，当代戏剧界还见证了黑人戏剧的诞生，如剧评家迈克尔·麦克米兰（Michael McMillan）所说："在英国，黑人族群的内部矛盾与外界政治文化变革同步，这一点从现实一直延伸至剧场中。"[1] 二战后，整个欧洲出现了有色族裔的移民潮，大量来自加勒比海和非洲的移民涌入英国，给英国的民众带来一定的危机感。20世纪70年代后，随着英国社会中失业潮、低收入、街头暴力、青年犯罪等问题不断涌现，作为外来族裔的黑人群体与其他移民一样，被指责为社会问题的源头，受到本土英国人的迁怒，尤其是警察的歧视。1975年至1985年期间，查珀尔敦、圣保罗、布里克斯顿等地爆发了针对黑人的种族暴力，英国警方更是捕风捉影式地搜捕黑人疑犯，"英国黑人"成为一个和"印巴人"一样带有种族歧视性质的符号。

为获得话语权、摆脱弱势的社会地位，当代英国黑人戏剧应运而生。但作为一种少数族裔文化诉求的表达形式，英国黑人戏剧在诞生之初并不为主流学界与剧场所接受。在20世纪70年代前的主流剧场中，只有英国皇家剧场在1956年上演过来自特立尼达的剧作家埃罗尔·约翰（Errol John）的剧作《彩虹披肩上的月亮》（*Moon on a Rainbow Shawl*），而直至2005年，首个黑人轮演剧目剧团（Black Repertory Company）才在伦敦问世。从诞生到被大众接受，当代英国黑人戏剧走过了近半个世纪的历程。在此过程中，一大批黑人剧作家参与了英国黑人戏剧艺术的建构，通过讲述黑人族裔在英国社会中受到的政治歧视、性别暴力和代际创伤，他们揭露了黑人移民的境遇，再现了黑人族群的生存焦虑，表达了他们的政治诉求，为黑人群体在英国社会中获得个体尊严和族群尊严发出了强劲的声音。

英国黑人剧作家大致可分为三代：20世纪50年代至70年代的黑人剧作家为第一代，80年代至90年代的黑人剧作家为第二代，21世纪的黑人剧作家为第三代。[2]

[1]　Michael McMillan and SuAndi, "Rebaptizing the World in Our Own Terms: Black Theatre and Live Arts in Britain". In Paul Carter Harrison, et al., eds., *Black Theatre: Ritual Performance in the African Diaspora*. Philadelphia: Temple University Press, 2002, p.122.

[2]　Michael Pearce, *Black British Drama: A Transnational Story*. London and New York: Routledge, 2017, pp.5 - 6.

一、第一代黑人剧作家：生存困境与文化焦虑

20 世纪 50 年代至 70 年代，以阿尔弗雷德·法贡（Alfred Fagon）、穆斯塔法·马图拉、迈克尔·阿本塞特（Michael Abbensetts）为代表的第一代黑人剧作家移民来到英国。其中，法贡出生于牙买加，代表作有《压力》（*Pressure*，1976）、《回击》（*Fighting Back*，1986）等，著名的阿尔弗雷德·法贡奖（Alfred Fagon Award）就是以他的名字命名的，该奖是面向所有居住在英国的加勒比或非洲裔英国黑人剧作家的英国戏剧奖；马图拉来自特立尼达，其代表作《黑奴—白链》（*Black Slave-White Chains*）于 1975 年被搬上英国皇家宫廷剧院的舞台，马图拉成为第一代英国黑人戏剧史上最著名的剧作家之一；阿本塞特则来自圭亚那，代表作有《帝国大道》（*Empire Road*，1978）、《黑色圣诞节》（*Black Christmas*，1977）等。作为第一代移民英国的黑人剧作家，他们都与母国保持着密切的联系，通常在剧作中以自己的母国为背景，讲述身为加勒比海人却不在加勒比海的感受，表达对家乡的思念和漂泊的孤独与痛苦，助推了"英国西印度人文化"（West-Indians-in-Britain culture）的出现。①

作为第一代英国黑人戏剧中的翘楚，马图拉在他的戏剧中聚焦英国城市中黑人的生存困境与文化焦虑，成为首位将西印度黑人移民的真实经历和声音展现在英国主流舞台上的剧作家。② 马图拉的戏剧创作深受大洋彼岸的美国政治图景和反文化运动的影响，他的戏剧表现出全球化背景下黑人戏剧的文化互文性。20 世纪 60 年代，美国密西西比州爆发"梅雷迪思反恐惧游行"（Meredith March Against Fear），特立尼达裔美国民权活动家斯托克利·卡迈克尔（Stokely Carmichael）趁势发起了"美国黑人权力运动"（American Black Power），呼吁黑人与白人切断联系，建立独立的国家。一年后，他在伦敦举行演讲，鼓励黑人自我觉醒，从孤立的个体转变为全球黑人运动的一员。同时，受马尔科姆·X（Malcolm X）等人的反殖民著作的启发，非裔美国诗人阿米里·巴拉卡（Amiri Baraka）等发起"黑人艺术运动"（Black Arts Movement），主张通过黑人文化和价值体系来呈现美国种族话语真相的激进式创作风格。在此背景下，带有浓厚政治色彩的"黑人革命剧院"（Black Revolutionary Theatre）和"黑人体验剧院"（Theatre of Black Experience）先后出现，它们力求用非裔美国方言挑战白人话语体系，打破早期美国戏剧中"信奉白人理想的黑人工人阶级"这一刻板印象，以城镇黑人的真实经历来质疑主流社会对黑人的扁平化、刻板化形象塑造。

受"黑人艺术运动"政治立场的影响，马图拉明确反对 20 世纪中期黑人剧作家埃罗尔·约翰在《彩虹披肩上的月亮》中所呈现的对加勒比海落后和浪漫化的描述。在他看来，埃罗尔无疑是一位"汤姆叔叔"式的人物。与埃罗尔不同，马图拉力图描绘身处城市"前线"的英国黑人的经历。马图拉认为，1968 年是他成为剧作家的分水岭，1968 年发生在美国的政治浪潮为大洋彼岸的英国提供了强有力的艺术土壤，让新一代英国黑人剧作家发出声音。③ 马图拉决心将这种激进的政治热情引入当代英国文化中，用戏剧来呈现黑人群体的族裔创伤："关于黑人的爆炸性消息如潮水般向我涌来，我必须在创作中言

①　Michael Pearce，*Black British Drama: A Transnational Story*. London and New York：Routledge，2017，p.96.
②　D. Keith Peacock，quoted in Michael Pearce，*Black British Drama: A Transnational Story*. London and New York：Routledge，2017，p.33.
③　Michael Pearce，*Black British Drama: A Transnational Story*. London and New York：Routledge，2017.p.33.

说真相。"①在其全幕剧《时光飞逝》(*As Time Goes By*，1971)中，马图拉刻画了一位竭力迎合其白人嬉皮士客户的精神大师拉姆，以此讽刺黑人对白人文化的盲从以及由此导致的黑人身份的迷失。剧中的拉姆逃避自己是黑人的现实，终日模仿白人客户的口音腔调，其装腔作势的英语发音与妻子流利的特立尼达语形成了鲜明的对比，他最终在与白人的交往中丧失理性和自我判断力，变得墨守成规，惧怕改变。在《黑奴—白链》中，马图拉以寓言的形式表达了对黑人历史创伤的思考。在剧中，三个黑人被锁在一起，由一个守卫看守着，因守卫无故死去，三人逃跑。他们在逃亡途中经历了一个白人女子的性诱惑，遇到了一个想为他们提供救赎的白人牧师。最后，一名法官现身，承诺为三人提供工作，以帮助他们为名为自己换取住房和食物。三人中，两人接受了法官的提议，第三人拒绝接受，并吃掉了守卫的尸体。这一看似荒诞的结局似乎说明，英国社会对黑人群体的高压政治最终可能导致黑人不顾后果的暴力反抗。

马图拉的戏剧代表了第一代黑人剧作家戏剧艺术的最高成就，他对黑人自我觉醒的强调及其政治激进主义的立场虽有失偏颇，但作为剧作家，他对黑人族裔命运的探索为阿尔弗雷德·法贡等同时代和此后英国黑人剧作家的戏剧创作提供了参考。

二、第二代黑人剧作家：民族认同和身份归属

20世纪80年代，撒切尔夫人的经济政策成功推动了英国经济的振兴，进入90年代后，英国经济趋于平稳，黑人社会福利逐步提高。稳定的社会环境为黑人艺术创作的繁荣提供了土壤。在此背景下，罗伊·威廉斯(Roy Williams)、威萨·平诺克、夸梅·奎-阿尔马、杰兹·巴特沃思等第二代剧作家逐渐在剧坛崭露头角。

第二代英国黑人剧作家是第一代黑人移民的后代，他们生在英国，长在英国，在20世纪八九十年代进入戏剧创作的旺盛期。与第一代不同，他们的戏剧更多的是以移民后裔的"阈限身份"(in-between status)为出发点，关注黑人移民所承受的代际创伤、无归属性、社会歧视和文化焦虑，以及黑人作为英国公民的身份认同等问题。

罗伊·威廉斯是当代最优秀的英国黑人剧作家之一。他从20世纪90年代中期开始创作戏剧，1996年，随着其处女作《没有男孩的板球俱乐部》(*The No Boys Cricket Club*)的成功问世，威廉斯成为当代英国戏剧界炙手可热的作家之一。此后，他创作了《星光熠熠》(*Starstruck*，1998)、《礼物》(*The Gift*，2000)、《意义重大的日子》(*Days of Significance*，2007)、《突袭》(*Sucker Punch*，2010)等剧作，对后来的黑人剧作家产生了很大的影响。②

在威廉斯的作品中，《没有男孩的板球俱乐部》《星光熠熠》和《礼物》又被称为"牙买加三部曲"(Jamaican Trilogy)，也是他的代表作。在《没有男孩的板球俱乐部》中，剧情分别被设置在1958年的金斯顿和1996年的伦敦，通过主人公阿比一家人的生活，该剧揭示了当代加勒比移民家庭的代际创伤。剧中的阿比一家居住在伦敦的一座简易屋(council house)中，阿比在丈夫去世后独自抚养儿子迈克尔和女儿丹妮，但她的牙买加方言使她和在英国长大的儿女之间产生了无法克服的文化隔阂。正如本尼

① Mustapha Matura. *Matura: Six Plays*. London：Methuen Drama，1992，p.ix.
② Lynette Goddard，*Contemporary Black British Playwrights: Margins to Mainstream*. Basingstoke and New York：Palgrave Macmillan，2015，p.21.

迪克特·安德森(Benedict Anderson)所说，语言是一个民族凝聚力的关键，也是一个民族共同体得以存在的载体。[①] 剧中人物间的语言障碍所折射出的是移民后裔对母亲所代表的牙买加文化的拒斥，双方在不停的争吵、谩骂和嘲讽中逐渐疏远。最后，阿比重返牙买加，通过自我的寻根之旅来获得能量，并在返回英国后获得了面对现实、与子女进行真诚沟通的勇气。

威廉斯对加勒比移民的代际创伤书写令人瞩目，但他并未一直停留在该主题上。在《起飞》(Lift Off，1999)一剧中，威廉斯聚焦黑人与白人的文化冲突，揭示了白人文化对黑人社会身份的歧视。在剧中，白人托恩为俘获女性的芳心，刻意效仿黑人麦尔的性吸引力与男性气概，在一场摔跤赛中，托恩力压麦尔夺魁，兴奋的他称自己比对方"更像个黑鬼"。托恩的行为反转了霍米·巴巴(Homi K. Bhabha)的"模拟"(mimicry)理论，即被殖民者对殖民者的追捧与接受。但威廉斯塑造黑白对立的目的并不在此。事实上，他提出的问题是，黑人一旦接受白人对他们的种族印象的塑造，将不自觉地带上道德低俗、品性卑劣等歧视性的标签，成为证明白人至上主义合理性的牺牲品。剧中的麦尔风流成性，与托恩的姐姐发生性关系，却拒绝承担父亲的职责。当托恩咒骂他为"黑鬼"时，他反唇相讥："没错! 我就是个黑鬼……既然黑人做任何事都被视为理所当然，那干脆到处留情算了。"[②]麦尔自暴自弃的言语表明了他在思想上已完全内化白人殖民意识对他的身份设定，因此他表现出来的也是野蛮、暴戾、淫荡等黑人的刻板形象。

黑人与白人在政治文化上的交锋在《为小伙子们歌唱》(Sing Yer Heart Out for the Lads，2002)中得到延续。该剧发生在伦敦西南部的乔治国王酒吧，一支足球队正在观看2000年世界杯英格兰队与德国队的预选赛。观看期间，极端右翼代表艾伦发表的一番激进的种族言论(即"白人与黑人毫无共同之处……如果他们想实践他们的黑人文化和遗产，就应该回到自己的领土上去"[③])引发了一场关于民族归属和"英国性"的辩论，并最终导致酒吧内外两个族裔世界的对立。艾伦在种族仇恨的情绪下刺死了黑人马克，他说："他是一个黑杂种，他们全都是。"[④]艾伦的举动引发了黑人社区的暴动，"成群结队的黑男孩聚集在了酒吧门外"[⑤]。通过此剧，威廉斯意在揭示，英国所谓的兼容并蓄的多元文化主义政策实则充满了种族歧视，在白人中心主义的英国社会中，"英国性"与"黑人性"注定是不可调和的两种价值观。

在第二代英国黑人戏剧作家中，与威廉斯齐名的另一位剧作家是夸梅·奎-阿尔马。奎-阿尔马原名伊恩·罗伯茨(Ian Roberts)，1967年出生于伦敦，其父为格林纳达人。作为第一代加勒比移民的后裔，奎-阿尔马在成长过程中饱受外来移民身份带来的不公和痛苦，故将目光转向同样承受种族歧视的美国黑人，从非裔美国戏剧中汲取创作灵感。

奎-阿尔马曾称自己为"流散的非洲人"(diasporic African)，他认为自己在非洲人、加勒比海人和英国人三种文化身份之间占据着间隙性的位置。[⑥] 但就其戏剧创作而言，他作为流散的非洲人的自我意

① Benedict Anderson，*Imagined Communities: Reflections on the Origin and Spread of Nationalism*. London：Verso，1991，p.145.
② Roy Williams，*Roy Williams Plays 1*. London：Methuen Drama，2002，p.232.
③ Roy Williams，*Roy Williams Plays 2*. London：Methuen Drama，2004，p.188.
④ Roy Williams，*Roy Williams Plays 2*. London：Methuen Drama，2004，p.234.
⑤ Roy Williams，*Roy Williams Plays 2*. London：Methuen Drama，2004，p.226.
⑥ Geoffrey V. Davis and Anne Fuchs，*Staging New Britain: Aspects of Black and South Asian British Theatre Practice*. Brussels：Peter Lang，2006，p.240.

识与政治思想更多的却是通过非裔美国文化实现的。观其一生,两位非裔美国作家对他产生了深远的影响。第一位是亚历克斯·哈里(Alex Haley),他的《根:一个美国家庭的传奇》(*Roots: The Saga of An American Family*,1976)和《马尔科姆·X 的自传》(*The Autobiography of Malcolm X*,1965)使奎-阿尔马发现自己的非洲之根,也激发他开始与非洲建立联系,并找到他的真实身份。[①] 20 多岁时,奎-阿尔马去了加纳,并在那里找到了族谱,回国后便将自己的名字改为夸梅·奎-阿尔马。第二位对奎-阿尔马产生重要影响的人则是美国剧作家奥古斯特·威尔逊(August Wilson),威尔逊在戏剧中对非裔美国人的呈现为奎-阿尔马提供了创作的灵感。1990 年,在观看了威尔逊的《乔·特纳来过了》(*Joe Turner's Come and Gone*,1986)之后,奎-阿尔马说剧中流散者对非洲精神和痛苦的吟唱令他震撼和痴迷。[②]

受威尔逊戏剧的影响,奎-阿尔马在创作中对英国黑人的情感纠葛与历史创伤进行了思考。在《维修》(*Fix Up*,2004)中,通过两个黑人兄弟关于黑人生活的辩论,剧作家探讨了黑人激进主义在当代社会中的合理性。剧中的哥哥基伊主张,黑人应借历史经验来摆脱"奴役状态"并获得精神救赎,而弟弟奎西则认为,经济独立才是黑人改变命运的关键,二人各执一词,谁也不服谁。此外,该剧还展现了奎-阿尔马对威尔逊戏剧美学的借鉴。历史记忆对当下生活的影响是威尔逊戏剧的一个标志,如在《钢琴课》(*The Piano Lesson*,1987)和《海洋宝石》(*Gem of The Ocean*,2003)中,威尔逊在现实语境中插入了人物对过往经历的回忆,以此获得心理上的疗愈。与此相似,奎-阿尔马在《维修》中还借三个未出场的人物——民权运动家马库斯·加维(Marcus Garvey)、小说家詹姆斯·鲍德温(James Baldwin)和诗人克劳德·麦凯(Claude McKay),指出非洲文化和非洲精神是黑人流散族裔的治愈之路。

奎-阿尔马最负盛名的剧作当属《埃尔米娜的厨房》(*Elmina's Kitchen*,2003)。该剧于 2003 年首演,2005 年被搬上加里克剧院的舞台,成为首部在商业区上演的英国黑人戏剧。《埃尔米娜的厨房》讲述了快餐店老板德利和儿子阿什利的故事。剧中的德利曾是一名拳击手,他后来放弃了拳击,为的是避免儿子重走自己的暴力生存之路,但不幸的是,阿什利一意孤行,多次卷入聚众斗殴案件,最终惨死在伦敦街头的一场"暴力狂欢"中。通过阿什利的故事,该剧反映了剧作家对当代英国社会中"黑对黑暴力"(black-on-black violence)现象的思考。20 世纪 90 年代,随着牙买加黑人犯罪团伙"亚迪人"(yardies)涌入英国,布里克斯顿、哈克尼等城区毒品交易和枪支犯罪泛滥。这种"亚迪文化"(yardie subculture)对黑人社区产生了可怕的影响,不少黑人青少年认同亚迪人以滥杀无辜为生存方式的理念,坚信贩毒和街头暴力是获得权力和地位的快速通道。

《埃尔米娜的厨房》通过对黑人身份问题的反思揭示了黑人族群的共同体主题。在剧中,奎-阿尔马力图建构一个拥有不同语言、不同文化的黑人社区形象:客人迪戈能自由运用格林纳达本地语、牙买加语以及伦敦黑人方言,作为英国黑人的阿纳斯塔西娅能够流利使用牙买加语,来自特立尼达的克里夫顿则能用加勒比东部方言来讲述故事。该剧将具有不同文化背景的几代黑人汇聚在一个时空之中,通过这种画面,奎-阿尔马力图勾勒出一个黑人族群共同体的景观。但由德利父子折射出的家庭破裂和黑人社区暴力可看出这种族群共同体的理想不堪一击。事实上,剧名中的 Elmina(埃尔米娜)既是德利母亲的名字,也是 17 世纪欧洲重要的奴隶贸易站埃尔米纳奴隶堡(Elmina Castle)的名字。通过剧名中隐喻

① Michael Pearce, *Black British Drama: A Transnational Story*. London and New York:Routledge, 2017, p.54.
② Michael Pearce, *Black British Drama: A Transnational Story*. London and New York:Routledge, 2017, p.56.

的奴隶贸易历史,奎-阿尔马意在揭示当代黑人族群的苦难与白人对黑人所犯历史罪行的关联性,指出黑人族群仍生活在那个奴隶地牢历史遗迹的阴影中。

三、第三代黑人剧作家：黑人戏剧文艺复兴

进入 21 世纪,博拉·阿格巴耶(Bola Agbaje)和黛比·塔克·格林(debbie tucker green)等新人登上英国舞台,成为第三代黑人剧作家。经历了半个多世纪的发展,英国黑人戏剧在三代剧作家的集体助力下,呈现出"从边缘到中心"的发展势头,逐渐成为当代英国戏剧浪潮中不容忽视的一个支脉。

作为第三代英国黑人戏剧的代表,阿格巴耶在创作中展现了当代英国黑人面临的身份困境。借《太过了!》(*Gone Too Far!*,2007)、《拘留贾斯蒂斯》(*Detaining Justice*,2009)等剧,剧作家传递出了对黑人身份认同、政治庇护和道德训诫的深度思考。在《太过了!》中,剧作家通过伊库达伊西和耶米两兄弟的经历,探讨了多元文化背景下黑人移民的民族身份和归属问题。在剧中,哥哥伊库达伊西在尼日利亚长大,对自己的非洲身份深感自豪;而弟弟耶米则相反,他在英国长大,在接受英国身份的过程中放弃了自己的非洲传统。但在与孟加拉国店主、白人警察以及当地帮派的接触中,尤其在经历了伊库达伊西为救自己而被当地黑帮刺伤的事件后,耶米真正体会到了手足之情和族群之爱,开启了回归非裔民族性的旅程。在《拘留贾斯蒂斯》中,剧作家通过一对来自津巴布韦的兄妹(贾斯蒂斯和格蕾丝)申请政治庇护时的遭遇,揭露了英国多元文化政策的本质。在剧中,贾斯蒂斯和格蕾丝为了留在英国而向英国政府寻求政治庇护,格蕾丝获得批准,但贾斯蒂斯却在遭拒后被拘留。通过该剧,剧作家旨在指出,移民面临的问题并非黑人文化滞后导致的"水土不服",而是黑人携有的"非英国性"剥夺了他们本应享有的生存权利,而且英国从未给予他们容身之所。各种对待移民的强制措施突显了英国民族自我认同中的霸权主义,对黑人以及亚裔移民的恐惧甚至使《1971 年移民法》规定只有父母或祖父母在英国出生的外国人才能保留公民权。法律层面上的变化实际上是一种针对移民的"颜色禁令"(color ban),它印证了保罗·吉尔罗伊(Paul Gilroy)所说的"移民即黑人"。[①]

在第三代黑人剧作家中,另一位代表者是黑人女性剧作家黛比·塔克·格林。在《脏蝴蝶》(*dirty butterfly*,2003)、《天生坏种》(*born bad*,2003)、《乱石玛丽》(*stoning mary*,2005)、《世世代代》(*generations*,2005)等作品中,格林聚焦全球化背景下非洲黑人的身心创伤,探讨了千禧年后非洲黑人女性面临的艾滋病、抑郁症、石刑等诸多问题,展现了性暴力对黑人女性的精神戕害。其中,《脏蝴蝶》从女性家暴幸存者的视角出发,批判了公众对家暴问题置若罔闻的冷漠态度。在剧中,黑人阿米莉亚和杰森每晚都会听到邻居乔被虐待的呼喊声,虽然两人的反应不同——阿米莉亚对噪音很反感,而杰森则是彻夜不眠地趴在墙壁上窃听施虐事件——但他们都心照不宣地选择沉默,不采取任何行动来阻止虐待的发生。尼日利亚裔英国女性主义学者阿米娜·玛玛(Amina Mama)曾说:"虐待女性是一种可耻的社会顽疾,它与虐杀行为无异。但虐待的私密性助长了施虐者的施暴行为,而社会对施虐的沉默使受虐女性除顺从外别无选择。"[②]同样的道德冷漠也可见于《天生坏种》一剧。在剧中,女儿多塔童年时遭父亲

①　Paul Gilroy, *The Black Atlantic: Modernity and Double Consciousness*. Cambridge：Harvard University Press，1993，p.46.

②　Amina Mama, "Woman Abuse in London's Black Communities". In Kwesi Owusu, ed., *Black British Culture and Society: A Text Reader*. London：Routledge，1999，p.107.

性侵,在她看来,她是在替母亲做"自己不会也是不能做的事"①。畸形的母女关系颠覆了黑人社区中母亲作为家庭精神支柱的传统,多塔一开场就称她的母亲为"婊子",而母亲则咒骂她是"天生的坏种",这种母女之间的语言攻击揭示了家庭关系的破裂和母亲职责的缺失对女性造成的创伤。

除了暴力、乱伦等家庭内部矛盾,格林还在《贸易》(trade,2005)一剧中探讨了女性性旅游(female sex tourism)的话题。所谓女性性旅游,是指来自西方的白人女性在加勒比地区度假时,与当地男性发生性关系的现象。文化史学家琼·L. 菲利普斯(Joan L. Phillips)认为,性旅游的盛行所反映的是西方白人女性对黑人"性欲亢进"(hypersexuality)的痴迷,她们以这种不正当的方式来释放被压抑的性欲。② 在《贸易》中,沉迷于海外邂逅浪漫的年长白人女性"常客"(Regular)每年都会前往加勒比与当地男性幽会。虽然她的年龄意味着她在西方国家不被当作宠儿,但在加勒比海的贫困地区,她的财富却令她有资格任意挑选性伴侣。而来自工薪阶层的白人女性"新手"(Novice)则是第一次去国外享受性生活,虽然她在经济上不如"常客",但还是比大多数加勒比海人富有许多。"新手"对"一夜情"的追求是"满足某种匿名的性接触"。③ 在该剧中,格林有意对剧中人物的姓名进行抽象化处理,并将剧作设定在一个未知的加勒比海地区,以此暗示这种白人女性性旅游与跨大西洋奴隶贸易历史的相似性。在这场21世纪的"性贸易"中,白人女性用金钱购买黑人男子的性服务,这再次复制了西方存在已久的主/奴式的种族意识形态。格林在剧中强调了全球贫富差距、疾病疫情、家庭暴力给黑人造成的身心创伤,力求借舞台激发西方观众的道德意识与对黑人的情感认同,并在不同种族之间建构更加和谐的共存关系。

本章将以威萨·平诺克的代表作《说方言》为例,探讨英国黑人戏剧与英国主流戏剧的不同。

① debbie tucker green, *born bad*. London: Nick Hern, 2003, p.21.
② Joan L. Phillips, "Tourist-Oriented Prostitution in Barbados: The Case of the Beach Boy and the White Female Tourist". In Kamala Kempadoo, *Sun, Sex and Gold: Tourism and Sex Work in the Caribbean*. New York: Rowman & Littlefield, 1999, p.183.
③ Joan L. Phillips, "Tourist-Oriented Prostitution in Barbados: The Case of the Beach Boy and the White Female Tourist". In Kamala Kempadoo, *Sun, Sex and Gold: Tourism and Sex Work in the Caribbean*. New York: Rowman & Littlefield, 1999, p.189.

第二节　威萨·平诺克及其《说方言》

一、威萨·平诺克简介

威萨·平诺克是当代英国最著名的黑人女性剧作家，也是首位将作品搬上英国国家剧院的黑人女性剧作家。

20世纪90年代，受经济危机和国际秩序重组的影响，英国的安定局面被打破。从1993年的黑人少年斯蒂芬·劳伦斯（Stephen Lawrence）遇害案（劳伦斯在公交站旁被白人少年无故刺死），到2000年的哈特菲尔德火车失事事件，英国人对国家安全产生严重怀疑，其民族自信心直线下滑。如果国内局势的失衡给英国本土居民带来的是对政府信任的坍塌，那么它给少数族裔带来的则是生存的焦虑。作为20世纪末英国社会转型的亲历者，身为牙买加后裔的平诺克目睹了该时期少数族裔的生存困境与精神焦虑，见证了政局动荡给他们带来的屈辱与不公，故在作品中聚焦白人群体与少数族裔的文化冲突，为边缘群体的生存权益积极发声。

1986年，平诺克的首部戏剧《英雄的欢迎》（*A Hero's Welcome*）问世，她从此开启了戏剧创作生涯。此后其又创作了《休假》（*Leave Taking*，1988）、《水中的岩石》（*A Rock in Water*，1989）、《说方言》《骡子》（*Mules*，1996）、《你能否保守秘密？》（*Can You Keep a Secret?*，1999）等作品。在这些剧作中，她从牙买加少数族裔者的立场出发，审视英国社会中的族裔文化，传递对黑人（女性）生存困境的深度反思。

《骡子》是平诺克书写黑人女性创伤的代表作。该剧源于平诺克对霍洛韦监狱（Holloway Prison）的实地考察，她从女性囚犯的犯罪经历中了解到黑人女性将毒品运输至欧洲的过程，以及她们在此过程中经历的抢劫、监禁和死亡。在剧中，牙买加姐妹莉拉与卢受当地女性布雷迪的诱骗，怀揣梦想来到伦敦，却被迫成为在牙买加和英国之间私运毒品的"骡子"，后被警方逮捕，被遣返牙买加，最终在一个印度大麻种植园中服苦役。该剧以辛辣的笔触揭示了全球资本主义时代黑人女性遭受的性剥削，讲述了前殖民地和英国大都市中年轻黑人女性的悲惨命运。

在《你能否保守秘密？》中，平诺克回归黑白种族对立，以一名白人青年对一名黑人男孩的种族屠杀，展现了白人因丧失理智而导致的家庭悲剧。剧中，受害者德里克来自一个黑人中产家庭，这位怀有抱负的艺术生在与白人青年南希爆发冲突后被杀。南希的女友凯特目睹该起谋杀案后痛苦不已，最后决定打破沉默，冒着被逐出白人社区的风险，向警方举报了南希的罪行。在创作该剧时，平诺克对英国黑人移民问题进行了大量的研究，她将注意力集中在第三代移民身上，以呈现他们身上所反映出的街头暴力和难以调和的种族矛盾。

近年来，平诺克吸引了女性主义和文化批评家的注意，他们从不同的角度解读她的作品，讨论其笔下的种族、性别和移民主题，如伊莱恩·阿斯顿（Elaine Aston）强调平诺克的多元文化和融合主义政治，肯定了她对跨国女权主义的贡献。从移民题材到殖民记忆，再到女性气质，平诺克不断拓展创作视野和主题关切，成为当代英国黑人女性剧作家中的中坚力量。

二、《说方言》①介绍

《说方言》于1991年在皇家宫廷剧院首演,引发如潮好评。平诺克本人多次强调,创作《说方言》的目的是还原英国黑人女性在社区的真实生活:"我想谈论一些话题,如殖民与被殖民者之间的文化碰撞、种族身份,以及我生命中不同阶段里黑人社区的发展情况。"②在《说方言》中,平诺克通过女主人公莉拉的牙买加之旅,展现了语言对黑人女性保持文化主体性的意义。

《说方言》分为两幕,每一幕由七场组成。第一幕的故事发生在伦敦的一个派对上,黑人女性莉拉因遭白人歧视,心理濒临崩溃,却在女按摩师舒格的劝导下逐渐释然。舒格借按摩之际,向莉拉讲述了童年时曾看到的成年女性"说方言"的原始记忆:她们通过身体操演和言语交谈,来释放被压抑的欲望,获得主体意识的解放。舒格说,她曾目睹三个土著女性在狂喜之下与神灵交流,她还提到一个名叫伊尔玛的黑人女性,伊尔玛作为雌雄同体者的性爱经历更是令莉拉感到震撼。这一以身体为中心的开场场景为剧作设定了主题基调,它使莉拉意识到,作为一名黑人女性,她与英国文化的疏离感正是源于对母语的体悟:"我一直都十分在意说话的方式,我会发错音……因为英语不是我的母语……但我有时在想,一定存在着一种属于我自己的母语……如果你对一种语言没有归属感,你就只能有半条生命,因为你无法获得这种语言给予你的精神支撑。"(195)

在第二幕中,莉拉与女友克劳德特前往牙买加度假,以寻找在英国无法实现的精神自由。在岛上,莉拉观看了一场仪式性的身体表演,一个沉睡的白人女性被象征性地施以暴力,这一幕让她想起了在伦敦黑人社区遭受的凌辱,也激发了她对眼前白人女性的仇恨,激动中莉拉癫痫发作,她开始身体抽搐,并不自觉地说起了方言。醒来之后,莉拉却发现,经此体能的消耗,她仿佛获得了新生,方言仿佛赋予了她一种重获西印黑人身份的途径,竟使她在心中放下了对白人女性的仇恨。这也正是剧作家想要表达的主题,即通过弥合不同文化之间的裂隙,英国黑人实现了与自身的和解。

在剧中,莉拉与克劳德特展现出两种不同的对待创伤的态度。莉拉通过在牙买加岛屿上的漫步,以身体回归本土而获得精神体验,最终实现与自我精神的和解。而克劳德特则力图通过扮演一个"性旅游者"的角色,与多位当地男性发生关系来实现精神上的解放。在此过程中,她毫不在乎其行为对当地女性的情感伤害,克劳德特对待牙买加女性的态度与她自己在英国的遭遇可谓是如出一辙。在英国,白人女性可以轻而易举地从黑人女性那里夺走黑人男性。本剧结束时,莉拉最终恢复了"自我",坦言"我已习惯于在这里行走……人必须与自己的身体保持联系"(225)。莉拉的顿悟既是她对西印移民史中痛苦记忆的告别,也是她在当代多元文化浪潮中对自我身份的理解与接纳。

本书节选《说方言》第一幕的第五场至第七场,第二幕的第一场。

在第一幕中,莉拉与雌雄同体者伊尔玛进行交谈,表达了因不会说牙买加方言而缺乏种族认同的心理困惑。在第二幕中,克劳德特和莉拉在牙买加的沙滩上度假,二人分享了对跨国性行为、两性关系的不同看法,从中可窥见平诺克对黑人女性追求自我解放、重塑种族亲缘的肯定。

① Winsome Pinnock, *Talking in Tongues*. In Yvonne Brewster, ed., *Black Plays: Three*. London: Methuen, 1995.以下出自该剧本的引文页码随文注出,不单列脚注。

② Heidi Stephenson and Natasha Langridge, *Rage and Reason: Women Playwrights on Playwriting* London: Methuen 1997, p.47.

三、《说方言》选读^①

Talking in Tongues

Act One

Scene Five

Lights change. Alone, LEELA pours herself a drink, then another and another. She starts to sob quietly, rocking herself. Sound of gentle laughter. Lights up on IRMA, who's sitting on the floor in a corner of the room, cross-legged. She's wearing a multicoloured jump suit and trainers, large gold earrings and has a bald head. As LEELA sobs, she laughs softly. As LEELA's crying gets louder, she can't control her laughter and has to hold her stomach. Hearing her, LEELA looks up and her sobs subside. She walks towards IRMA.

IRMA (*wiping her eyes*): I'm sorry. I hope you're not offended. I laugh at everything.

　　LEELA *stares at* IRMA.

IRMA: You know, it's rude to stare. It's a power thing, an expression of hostility. Though I myself have never had a problem with people looking at me. It's being ignored I can't stand.

LEELA: Have we met?

IRMA: I doubt it. I just got here. I'm always late. My friends get used to it. (*Holds her hand out.*) Irma.

LEELA (*taking* IRMA's *hand*): Leela.

IRMA: You were crying. It always ends in tears. Either that or the china gets broken. (*Pause.*) You don't say much, do you? Not that it matters. I can talk the hind legs off an armchair. (*Pause.*) I was born in south London thirty years ago. [...] In the end she settled on getting rid of the male appendage, not least because she held the things in contempt but also because she felt that black men were too often in the limelight, and that a woman might quietly get things done while those who undermined her were looking the other way. However, she hadn't reckoned with the fact that she had already become attached to me and found me perfect the way I was. So even while the surgeon was sharpening his knives my mother had wrapped me in an old shawl, woven by her own grandmother, and taken me home. I hope I'm not boring you.

LEELA: No. (*Blinks and sways on her feet.*)

① Winsome Pinnock, *Talking in Tongues*. In Yvonne Brewster, ed., *Black Plays: Three*. London: Methuen, 1995, pp.193 – 207.

IRMA: You're drunk.

LEELA: Am I?

IRMA: You don't know whether you're coming or going, do you? I've an itch. Would you mind?

LEELA: Where?

IRMA: My head. Go on. Don't be scared.

LEELA *touches* IRMA's *head nervously.*

IRMA: Give it a good rub, go on. It happened while I was undergoing one of those torturous hair treatments—you know the kind where they put some foul-smelling cream on your head and tell you to shout when it starts to burn. Only when you shout out they can't hear you because they're off on their tea break. So by the time they come back they've got to call the firemen out to administer the final rinse. Not that I'm complaining. I've always been in the vanguard of fashion. You watch. In the future all black women will sport bald heads. And those who haven't had their hair ruined by hairdresser chemicals will go bald in sympathy with those who have.

LEELA (*smiles*): That's a lovely thought.

IRMA: It is, isn't it?

LEELA: I wouldn't have the guts to shave all my hair off. It wouldn't suit me.

IRMA Oh, I don't know.

LEELA *looks away.*

IRMA: Why were you crying? Distance. That's what I'd do. I'd go away. Of course our mothers had religion.

LEELA: For all the good it's done them.

IRMA: I wouldn't knock it.

LEELA: It frightened me watching my mother surrendering to the spirit every Sunday afternoon. When she fell to the ground you'd pull back her eyelid and it was like looking into the eyes of the dead. That total surrendering up of the will frightens me.

IRMA: You're not telling me you watched that and didn't yourself feel a tingling in your extremities?

LEELA: Mass hysteria.

IRMA: Never felt the spirit stirring inside you?

LEELA: Sometimes I felt I wanted to get up and whirl around the room with them, yes.

IRMA: Why didn't you?

LEELA: It would have been dishonest. Deep down I didn't feel anything. I wish I did.

IRMA: The point is that our mothers found a way of releasing the pain, they never let themselves become victims of it.

Pause.

LEELA: I've always felt really self-conscious about the way I speak. No one else seems to notice it. At least they've never said anything, but, well, words are sometimes like lumps of cold porridge sticking in my mouth. I always have to think before saying anything in case I get things wrong. I mispronounce words. Or sometimes when there's a choice of two words that sound similar I'll use the wrong one. Not all the time. Sometimes I forget and surprise myself with my eloquence, the precision of my grammar. It's because this isn't my first language, you see. Not that I do have any real first language, but sometimes I imagine that there must have been, at some time. You can feel that sometimes, can't you? If you don't feel you belong to a language then you're only half alive aren't you, because you haven't the words to bring yourself into existence. You might as well be invisible. Other people seem very real. Like you, now, at this moment, seem very real to me. Sometimes it feels as though there's something stuck down here (*Holds her tummy*.) and I want to stick my fingers down my throat and spew it all up. (*Slight pause*.) We've only just met and I'm telling you everything.

IRMA: There's nothing wrong with that.

LEELA: I've got to find my friends.

IRMA: Distance.

LEELA: It's not that easy.

IRMA: Did I say it was?

LEELA: They'll be wondering what happened to me. (*She goes*.)

Scene Six

A room. FRAN *picks up a coat and is about to leave the room when she's stopped* JEFF, *who hides a bottle behind his back*.

JEFF: People leaving already?

FRAN: It is very late.

JEFF: We haven't spoken to each other all evening. I've been ignoring you.

FRAN: You know what it's like when you're playing hostess, you don't notice things like that.

JEFF *takes the bottle and two paper cups from behind his back*.

FRAN: That's nice.

JEFF: Thought you might like something to drink.

FRAN: I think I've had too much to drink. Don't look at me like that.

JEFF: Can't I even look at you?

FRAN: You're looking right through me, I don't like it.

JEFF: Sorry.

FRAN: I must look a mess, anyway. Can you remember which is Karen's coat?

JEFF: The green one.

FRAN: You're good at things like that.

JEFF: I wish they'd all go home.

FRAN: Didn't you enjoy yourself?

JEFF: I just wish now that they'd all go home and leave us alone. We haven't been alone together for a long time.

FRAN: Don't be silly. We're alone all the time. Get fed up of each other.

JEFF: Are you?

FRAN: Sometimes. Everyone gets like that. You get ratty with me all the time.

JEFF: The first time I saw you I thought you looked like the girl in that perfume ad.

FRAN: Which perfume ad?

JEFF: The one where she's running through the street in her bare feet.

FRAN (*laughing*): Oh, that one. She's running through the street in her bare feet and her knickers, in the pouring rain. I don't look a bit like her. Men.

JEFF: I think you do. (*He is staring*.)

FRAN: I'd better give Karen her coat.

JEFF: She's still saying goodbye to people. She'll wait. Have a drink. (*He fills the cups*.)

FRAN: I'll be sick if I drink any more.

JEFF: Go on.

　　　　FRAN *takes a cup*. JEFF *looks out of a window*.

JEFF: Black night. Black black night. I love night-time.

FRAN: You used to be scared of the dark.

JEFF: Still am. (*Drinks*.)

FRAN: You'll be ill.

JEFF: I won't be ill.

FRAN: You know what you're like.

JEFF: For God's sake, I can drink.

FRAN: I'm not clearing up after you, that's all.

JEFF: I fixed your radio.

FRAN: I thought it was beyond repair. What was wrong with it?

JEFF: Nothing much.

FRAN: I didn't know you could do things like that.

JEFF: My dad used to say that you should always keep something in reserve.

FRAN: Full of good advice, your dad.

JEFF: I think we should go away.

FRAN: Oh.

JEFF：We need a holiday. We could go to the Lakes.

FRAN：Why this sudden desire to get away?

JEFF：I just fancy getting out of London.

FRAN：Is something wrong?

JEFF：Breathe the fresh air.

FRAN：You love London.

JEFF：Why don't we both take some time off work and just take off?

FRAN：I don't want to go to the Lake District.

JEFF：Why not?

FRAN：Because it's all pensioners and babies and rain.

JEFF：All right，pick somewhere else.

FRAN：I've got too much work to do.

JEFF：You'll feel better for getting away.

FRAN：You always do that. I don't need you to tell me what will make me feel better.

JEFF：I'm not trying to tell you what to do.

FRAN：What was all that about then? Let's go to the Lakes. You always do that. I don't have to go with you. We're not joined at the hip. Why don't you go on your own?

JEFF：I just thought it would be nice.

FRAN：I've said I don't want to go.

JEFF：All right. I don't want to fight.

FRAN：If I wanted to go away，I'd say.

JEFF：All right. All right.

FRAN：Look，I don't want to go away. If there's some reason why you want to go away，if there's something bothering you，then we can talk about that here.

JEFF：Like what? What could be bothering me?

FRAN：You tell me.

JEFF：There's nothing. Honest. It was just an idea.

Pause while FRAN *looks for coat and finds it*.

FRAN：You used to get angry about things，but it's all gone. You've fallen asleep. You don't care what's going on in the world，can't see beyond your own front doorstep，can you? Wake up，Jeff. (*Slight pause*.) Sorry. I didn't mean that. (*Slight pause*.)

JEFF：You're right. Even my parents had something to fight for. Their one dream was to own their own home. It kept them going，the thought that one day they'd get out. They worked themselves into the ground to achieve that dream. Okay，it's not the most admirable of dreams，but it was something to believe in，wasn't it? And they achieved it. All right，so they're still in the same council flat，but at least they own it.

FRAN: Karen'll think I've run away with her coat. Thanks for the drink.

JEFF: Fran?

FRAN: Yes?

JEFF: I fixed your radio.

FRAN: Yes, you said.

JEFF: It's still very fragile, so you've got to be careful with it, make sure you don't drop it or bang it or anything.

FRAN: Okay. (*Slight pause*.) I don't listen to it any more anyway. (*She goes*.)

Scene Seven

For the first time in this act there is no music. LEELA sits on the floor. CURLY, ill, has her head in LEELA's lap. JEFF, BENTLEY and CLAUDETTE are standing. FRAN enters with coats.

FRAN: Taxis will be here in a minute.

JEFF: Everybody hated Othello because he was black.

CLAUDETTE: In which sense do you mean black? In the biblical sense?

JEFF: I'm not talking platitudes now, about darkness within, original sin and all that shit. It's about putting yourself in the other man's shoes, isn't it? I mean, look at the world through Othello's eyes: surrounded by racists, neurotic about his age and appearance, worried about losing his job, his hair. No wonder he ran off with Desdemona.

CLAUDETTE: I thought they were supposed to be in love with each other.

JEFF: He ran off with Desdemona in order to fit into the white world and she ran away with him in order to escape from it. I suppose you could call that a sort of love, if you define love as a mutual need to fulfil each other's fantasies: he wanted to be white and she wanted to be black, or to have conferred on her what she saw as blackness, a certain mystique—all those references to voodoo. In other words, his difference turned her on.

CLAUDETTE: Why would he need to fit in?

JEFF: Everybody needs to fit in.

CLAUDETTE: Not Othello.

JEFF: He needed to fit in more than most.

CLAUDETTE: Why? Why would he need to fit in? He was the boss. The one who hired and fired, told them what to do, wrote references for them. They had to fit in with him, more like.

FRAN: Does anybody want another drink?

LEELA (*cradling* CURLY*'s head*): I think we've all had enough, don't you?

CLAUDETTE: Fitting in. That's crap.

 CURLY *groans*.

BENTLEY: You all right, Curly? (*To* LEELA.) She all right?

LEELA：Her tummy's upset，that's all.

CLAUDETTE（*to* JEFF）：Did you give her something?

JEFF：Why would I...?

CLAUDETTE：To eat，I mean. It must have been something she ate. I'm always telling her to be careful about what she puts in her mouth. Of course，she never listens.

LEELA（*to* CURLY）：Are you going to be sick，Curls?

CURLY：No.

LEELA：Tell me if you want to be，won't you?

　　FRAN and BENTLEY *are standing over* CURLY，*looking down at her*.

FRAN：She looks in a bad way. Do you think she wants a coffee?

BENTLEY（*reaching his hand out to* CURLY's *forehead*）：Has she got a temperature?

LEELA：Don't touch her. Can't you see she's hot enough as it is? The poor girl's ill. She can't breathe with you standing over her. Can't you see you're stifling her?

BENTLEY：Sorry.

　　BENTLEY *and* FRAN *are more cautious，standing back a bit*.

FRAN：Shall I get her an aspirin or something?

LEELA：She'll be all right.

BENTLEY：Go on，let Fran get her something.

FRAN：It's no trouble.

LEELA：I said she doesn't want an aspirin. If she wants one of your aspirins I'll ask you to get her one，won't I?

BENTLEY：Leela—

LEELA：What?（*Slight pause*.）What?

BENTLEY：Too much to drink.

LEELA：That's what you think.

CURLY：groans.

LEELA：Sssh. That's what he thinks.

FRAN：I'll get that coffee. Make myself useful.

　　[...]

JEFF：No，no. That's quite valid. It's just another way of looking at it，isn't it? Of course，you could look at it another way...

FRAN：Shut up，Jeff.

JEFF：Why? We're just having a harmless post-party discussion. What the hell's wrong with that?

FRAN：You're talking shit，that's what's wrong with it.

JEFF：Of course we're talking shit，we're pissed，aren't we? Though，in our defence，it has to be said that the argument has had its moments of subtlety. You've missed the finer points，

that's all.

FRAN: I don't want to hear any more points—fine, coarse or otherwise.

JEFF: What's bothering you, Fran?

FRAN: Nothing's bothering me.

JEFF: I want to know what's wrong.

FRAN (*to the others*): Your taxis will be here soon.

BENTLEY (*to* LEELA): Are you all right?

CLAUDETTE: Why shouldn't she be all right?

BENTLEY: You're acting weird.

JEFF: Must be the full moon, Bentley. You know what women are like.

CLAUDETTE: Go on, tell him what's wrong with you.

FRAN: We're all drunk. I'll get that coffee.

BENTLEY: Eh, Leela?

CLAUDETTE: I'll tell you what's wrong with her.

BENTLEY: I was talking to Leela, not the fucking ventriloquist's dummy.

LEELA: Leave her alone.

BENTLEY: I asked you a question, Leela.

LEELA (*shrugging him off*): How dare you? After touching her, how dare you come and put your hands on me?

FRAN: God.

CLAUDETTE: Amor. Omnia. Vincit.

Pause. Sound of car horn honking.

JEFF: It's all right, Fran. I've been stupid. Now we can talk.

FRAN (*to* BENTLEY): So they know. It's good. It's good they know.

BENTLEY (*to* LEELA): We've got to talk.

CLAUDETTE: Bit late for that now.

BENTLEY: I'm sorry, Leela.

CLAUDETTE: You'll be more than sorry in a minute.

BENTLEY: I sincerely didn't want it to be like this.

CLAUDETTE: Because, like all men, you wanted the best of both worlds, didn't you? To have your cake and eat eat eat.

LEELA: For God's sake, Claudette, I can speak for myself.

CLAUDETTE: Why don't you, then? Go on, speak.

Pause. Sound of taxi horn honking outside.

JEFF: You've got your coats, have you? Right, thank you all very much for coming. Happy New Year.

CLAUDETTE: Charming.

JEFF: Not that I'm rushing you or anything but, you know, the party's got to end sometime and now me and Fran want to be alone together.

FRAN: Stop it.

JEFF: Don't we?

BENTLEY: Cool it, Jeff.

JEFF: That's funny, after everything you've... Are you telling me, in my own house, you come into my house...

BENTLEY: I know how you must feel.

CLAUDETTE: Hark at Mr Sensitive.

JEFF: You don't know. Nobody knows. This is my house, Bentley. Get out of my house.

Front doorbell rings.

BENTLEY: Come on, let's go home.

FRAN: You can't leave now.

JEFF: Why didn't we talk? If you'd told me what you wanted...

FRAN: You could never be what I wanted. Bentley

CLAUDETTE: I'm not getting into any taxi with you. You go if you want to, Leela, but I'm going to try for another cab.

BENTLEY: Coming, Leela?

LEELA: No.

BENTLEY: All right. (*Slight pause.*) All right.

Persistent ringing at front doorbell.

FRAN: I think we should go. We might as well go. We can't stay here. (*Shouting through door.*) We're coming! Hold on! I'm going, anyway. You can stay if you want. (*To* JEFF.) My things... I'll call round for them...sometime.

JEFF *is on his knees.*

FRAN: Stop it, Jeff.

JEFF: I don't want you to go.

FRAN: Get up, you look stupid. (*She goes to the door.*) I'm going anyway, Bentley.

BENTLEY *walks over to* FRAN, *and they go.*

CLAUDETTE (*as they leave*): [...] Leela's too good for you, but you've been so brainwashed you can't see it. Go on, run away. You'll get a shock when you wake up in the morning and the face staring back at you in the mirror is still a black one. She can't make you white, black boy.

Pause. Sound of door slamming shut and car driving away. Pause.

CLAUDETTE: That's that then?

Silence. JEFF *pulls the string on a party popper*. *Streamers fly out*. *He zips up his jacket and leaves*.

CLAUDETTE: How're you feeling?

LEELA (*after a short while*): Frozen.

CLAUDETTE: We let them off too easily.

CURLY *sits up*, *holding her stomach*.

CLAUDETTE: Aye aye. First sign of life she's shown. Slept right through it, didn't you, Curls?

CURLY: I feel sick.

CLAUDETTE: That doesn't surprise me. Do you know what she's been up to?

LEELA: We'd better walk down to the cab office.

CLAUDETTE: You've got to admire Curly's indomitable faith in mankind, haven't you?

LEELA: Leave her alone, Claudette. This has got nothing to do with Curly.

CURLY (*sitting up*): No, let her carry on. After all, it's just Claudette, isn't it, that's the way she is. Besides, she's right. She is right, though, isn't she? Claudette always is. I deserve her contempt. (*Stands*.) After all, she's so high and mighty squeaky clean. (*To* CLAUDETTE.) Life would be so much simpler if we were all like you. We wouldn't have to question ourselves...we'd always be right. We could all feel good about ourselves all the time because we'd be so pure, like little girls who can't risk dirty puddles because they're wearing white socks. The shouting's got to stop some time. Why can't we just live together, why can't we just have some peace? (*She turns*, *is sick*, *and then leaves the room*.)

LEELA: I'd better see she's all right.

CLAUDETTE: She'll be all right. She'll have forgotten half of this in the morning. Curly always does. (*Slight pause*.) What does she know?

LEELA: Curly's not stupid.

CLAUDETTE: Curly's got no self-respect.

LEELA: Fuck self-respect, at least she's honest with herself.

CLAUDETTE: What does she know? I'm shaking, look. (*She touches* LEELA's *shoulder*.)

LEELA: I can feel you're shaking.

CLAUDETTE: Why am I shaking? I can't stop. I hate what that bastard's done to you. (*Almost laughing at herself*.) Look, I'm nearly in tears, I'm so angry.

LEELA: Poor Claudette.

CLAUDETTE (*surprised*): What?

LEELA: Poor poor Claudette.

Act Two

This entire act takes place in Jamaica.

Scene One

A beach. Dusk. LEELA is drying herself with a towel while CLAUDETTE stands, drink in hand, watching her.

LEELA: I was scared at first. Then one of them made a clicking noise in its throat and gave me a sort of gentle nudge. We swam out together. I've never swum out so far.

CLAUDETTE: You don't want to swim too far out. You know what they say about dolphins.

LEELA: I've never even seen a dolphin before. Not in the wild. The water's so clear. It's another world. (*Smiles.*) Like a wildlife film.

CLAUDETTE: Fucking Jacques Cousteau.

LEELA: You should come with me.

CLAUDETTE: I do all the communing with nature I want right here on the beach.

LEELA: I'd get bored sitting around on a beach all day long. You haven't moved from this spot since we got here.

CLAUDETTE: [...] Yesterday I had three men dancing attendance on me. All the rich young American women on the beach and they're swarming around me. You should have seen Mikie's face.

LEELA: Jealous, was he?

CLAUDETTE: Serves him right for chatting up the tourists. He was all over me. Fetching me this, bringing me that. If I didn't fancy him I'd've found it nauseating. As it was...

LEELA: You kissed and made up.

　　[...]

　　MIKIE *enters.*

CLAUDETTE: Talk of the devil.

MIKIE: I can't stay on this side of the beach too long. That damn Diamond been on my tail all the morning, say I have to walk up and down selling peanuts.

CLAUDETTE: Who buys them? Nobody wants to eat peanuts on a beach.

MIKIE: You tell Diamond. Diamond think that people would buy anything if you force it on them long enough. That woman get crazier every day.

CLAUDETTE: You've got to admire her.

MIKIE: I don't have much time. I have to talk quick.

CLAUDETTE: What is it?

MIKIE: Tonight.

CLAUDETTE: You can't make it.

　　MIKIE *nods.*

CLAUDETTE: Why, Mikie?

MIKIE：Sugar.

LEELA：I think I'd better go.

MIKIE：I'm in big trouble... Sugar believe in one man，one woman.

CLAUDETTE：Why did you tell her，stupid?

MIKIE：I ain't tell her nothing. She say she can smell it on me. That woman have nose like a dog. After I bath and everything.

CLAUDETTE：I suppose we're both in trouble.

MIKIE：Not you. She won't say anything to you. Diamond wouldn't allow her to mess with the tourists. Is me she beating up on. I got to stay in for the next few nights.

CLAUDETTE：Why? She doesn't own you. Mikie，we're only here for two more weeks，this week's almost finished.

MIKIE：Maybe，but it's better to keep Sugar sweet. You don't know how much grief she can give a man.

CLAUDETTE：I can imagine. Under that obsequious demeanour she looks like a spitfire.

MIKIE：Spitfire. Thas Sugar. Spitfire. Yes. Sugar really know how to hit a man where it hurt.

CLAUDETTE：So I won't be seeing you for a few nights.

MIKIE *shakes his head*.

CLAUDETTE：I'll just have to find someone else to take me out on the sea.

MIKIE：Two nights. That's all I need to keep Sugar sweet，just two nights. Wait for me for two nights.
They kiss.

MIKIE：Pull you shirt down.

CLAUDETTE：Why?

MIKIE：You can't see that old American watching you? Watching like a man ain't eaten for months. A so them does like to watch we woman. Sugar always telling me how American invite her to them room. But Sugar know how to cuss them. Is Diamond fault for setting Sugar on the beach to give massage to tourist. Chuh. Two nights.

CLAUDETTE：Make sure it is just two nights.

MIKIE *goes*.

LEELA：Be careful，Claudette.

CLAUDETTE：Aren't I always?

LEELA：I was thinking about Sugar.

CLAUDETTE：Sugar doesn't own him. Nobody owns Mikie. Look along the beach，Leel. Everybody knows what the score is. You don't begrudge me a little holiday fling，do you? We all use each other. Everyone goes home happy. No one gets hurt. (*She stretches out lazily*.) Even the sea smells of sex. Forget the dolphins，Leel. Dougie is besotted with you. I tell you，the man's in love. He keeps talking about you. Hell be at Diamond's barbecue.

LEELA：Which one's Dougie?

CLAUDETTE：Mikie's friend.

LEELA：The one who takes his teeth out in the middle of a conversation?

CLAUDETTE：Life and soul of the party，our Dougie.

LEELA：I think I'll stick with the dolphins.

CLAUDETTE：I wouldn't mind if you were enjoying yourself.

LEELA：I am enjoying myself.

CLAUDETTE：We don't even get to see each other during the day. You're either off swimming or walking before I've even opened my eyes.

LEELA：You should come with me.

CLAUDETTE：I can't think what you get out of it. It's not as if you meet anyone.

LEELA：I don't want to meet anyone.

CLAUDETTE：I worry about you.

LEELA：Don't you wonder what lies beyond the beach? It's more beautiful than I imagined. You can be alone yet not alone. There's a vastness about the place. It doesn't seem like an island at all. The people...they seem so at ease with themselves. They have that confidence that comes from belonging. Everyone's got a story to tell. I could listen to them all day. London seems like a figment of my imagination.

CLAUDETTE (*gets up，pours wine into a glass for* LEELA)：Now you're talking. Young women like us should be free. We shouldn't walk around with our heads bowed，apologising for ourselves. We should walk tall. We're young，healthy，beautiful girls. We were born to live like this，Leel. Sod the angst，the wretchedness—

LEELA：and the rain and the boredom—

CLAUDETTE：To two girls from London—

LEELA：two black girls—

CLAUDETTE：To hot days and balmy，passionate nights—

LEELA：To dolphins—

CLAUDETTE：and boys who flex their biceps on the beach just for us—

LEELA：To mosquito bites—

CLAUDETTE：love bites—

LEELA：long walks，coconut milk and mango. To the magnificent silence of the sea—

CLAUDETTE：and things that go bump in the night. (*Slight pause*.) To Freedom.

　　They clink glasses.

四、思考题

1. 为什么莉拉觉得当"一个人没有可以使用的语言来表述自己的存在时"，自己的身份就会被抹去？

对于被边缘化社会族群来说，母语在构建种族凝聚力中发挥着怎样的作用？

2. 当莉拉和克劳德特躺在牙买加的海滩上时，莉拉觉得"每一个人都有自己的故事，我可以就这样整天地听他们讲下去，伦敦仿佛成为我想象中的虚构"。思考一下，剧作中的伦敦和牙买加有何不同？与令人身心放松的牙买加相比，为什么莉拉会觉得伦敦仿佛是她的一种"虚构"？

3. 克劳德特享受在牙买加海滩度假的惬意，因为一旦她和莉拉返回伦敦工作，就会遭受"性禁欲"，导致这种现象的根本原因是什么？

4. 细读作品，找出剧中对莎士比亚戏剧中的人物如伊阿古、奥赛罗和苔丝狄蒙娜的指涉，并分析其深刻含义。

五、本节推荐阅读

［1］Aston，Elaine. *Feminist Views on the English Stage*. Cambridge：Cambridge University Press，2003.

［2］Edgar，David. "Winsome Pinnock". *State of Play: Playwrights on Play Writing*. Ed. David Edgar. London：Faber and Faber，1999.

［3］Gilroy，Paul. *The Black Atlantic: Modernity and Double Consciousness*. Cambridge：Harvard University Press，1993.

［4］Goddard，Lynette. *Contemporary Black British Playwrights: Margins to Mainstream*. Basingstoke and New York：Palgrave Macmillan，2015.

［5］Griffin，Gabriele. "The Remains of the British Empire：The Plays of Winsome Pinnock". *A Companion to Modern British and Irish Drama 1880－2005*. Ed. Mary Luckhurst. Malden：Blackwell Publishing，2006.

［6］Pearce，Michael. *Black British Drama: A Transnational Story*. London and New York：Routledge，2017.

［7］Brewster，Yvonne，ed. *Black Plays: Three*. London：Methuen，1995.

［8］Stephenson，Heidi and Langridge，Natasha. *Rage and Reason: Women Playwrights on Playwriting*. London：Methuen，1997.